NATIONAL GALLERY
CATALOGUES

THE EARLY
ITALIAN SCHOOLS

BEFORE 1400

By Martin Davies

Revised by Dillian Gordon

National Gallery Publications
The National Gallery
London

National Gallery Publications
Published by order of the Trustees

**British Library Cataloguing in Publication
Data**
National Gallery
 The early Italian Schools: up to 1400.—
 Rev. ed.—(National Gallery catalogues).
 1. Painting, Italian—Exhibitions
 2. Painting, Medieval—Exhibitions
 I. Title II. Davies, Martin II. Gordon,
 Dillian
 759.5 N615
 ISBN 0–947645–21–7

Designed by James Shurmer

Printed and bound in Great Britain by William
Clowes Limited, Beccles and London

FRONT COVER
Ugolino di Nerio, *The Way to Calvary* (detail)

BACK COVER
Ascribed to Giotto, *Pentecost* (detail)

Much of the text in the present volume is
based on the 1961 revised edition of *The
Earlier Italian Schools* by Martin Davies,
which covered all the Italian paintings in
the National Gallery up to about 1500.

National Gallery Catalogues

The first series of major catalogues of the different Schools of Painting in the National Gallery was launched in 1945. The series is now being extensively revised under the editorship of the Keeper of the National Gallery, and this volume is to be followed by *The Dutch School* and *The German School*.

Meanwhile six of the original text volumes have been reprinted. Each has been reissued without alteration to the text, but a list of paintings in the relevant school acquired since the publication of the last edition is added as an appendix.

Forthcoming revised editions

THE DUTCH SCHOOL by Neil MacLaren
revised by Christopher Brown

THE GERMAN SCHOOL by Michael Levey
revised by Alistair Smith

Reprints

THE EARLIER ITALIAN SCHOOLS by Martin Davies

THE SIXTEENTH-CENTURY ITALIAN SCHOOLS by Cecil Gould

THE SEVENTEENTH AND EIGHTEENTH CENTURY ITALIAN SCHOOLS by Michael Levey

THE FLEMISH SCHOOL 1600–1900 by Gregory Martin

THE EARLY NETHERLANDISH SCHOOL by Martin Davies

THE SPANISH SCHOOL by Neil MacLaren, revised by Allan Braham

The publication of this catalogue
has been made possible by
the Michael Marks Charitable Trust
in memory of
Michael M. Sacher
Trustee of the National Gallery
1982–1986
where he is remembered with gratitude
particularly for his services
to the Publications Department

Contents

Foreword

This catalogue deals with the National Gallery's paintings of the Early Italian Schools before 1400. Italian paintings after 1400 will be dealt with in subsequent revised volumes. The catalogue also records a few miscellaneous items from the Greco-Roman School.

It is based on the revision Martin Davies made in 1961 of his catalogue of the Earlier Italian Schools, which had first been published in 1951. Martin Davies, with his scrupulous scholarship, was an exemplary cataloguer and I have been very much conscious of being a dwarf on the shoulders of a giant.

Since 1961 considerable advances in research on Trecento paintings have been made by scholars in the field: their contributions will be greatly in evidence in the individual entries here. Also since 1961 invaluable scientific research has been done on the paintings by the National Gallery's Scientific Department and I owe a particular debt to Miss Joyce Plesters and Dr Ashok Roy for making available to me the results of their research and for their readiness to respond to requests for pigment analyses. The cleaning in recent years of several of the paintings by the Conservation Department has brought to light new and interesting information on painters' techniques. I am extremely grateful to David Bomford of the Conservation Department who has examined and discussed with me every painting included in this catalogue; his technical expertise has been invaluable.

I have revised Martin Davies's measurements only when the condition of a painting has changed through re-framing etc. I have tried to check all Martin Davies's references, but some of the volumes cited by him I have not been able to trace.

Generous grants from the Martin Davies Fund enabled me to travel and research in Italy.

Of the many individuals and institutions who have responded to my queries and supplied photographs, I would mention in particular Dr Erich Schleier, Gemäldegalerie, Berlin; Professor Andrea Emiliani, Pinacoteca Nazionale, Bologna; Deborah Gribbon, Isabella Stewart Gardner Museum, Boston; Dottoressa Superbi, I Tatti, Florence; the Uffizi, Florence; the Soprintendenza per i Beni Artistici e Storici, Milan; Dr R. Kultzen and Dr Cornelia Syre, Alte Pinakothek, Munich; Keith Christiansen, Metropolitan Museum of Art, New

York; S. J. Romanelli, Robert Lehman Collection, Metropolitan Museum of Art, New York; Richard Camber, Sotheby's, London; J. K. Koltz, Musée des Beaux Arts, Luxemburg; J. Treuherz, City Art Galleries, Manchester; Mme L. Faillant-Dumas, Laboratoire de Recherche des Musées de France, Paris.

Erling Skaug, Chief Restorer at the Norsk Folkemuseum in Oslo, is always generous in sharing the results of his study of punchwork. I should particularly like to thank Mme Dominique Thiébaut, Conservateur at the Musée du Louvre, for having been an invariably helpful colleague.

My debt to the staff within the National Gallery is incalculable and it would be impossible to mention all the people from the Library, Photographic Department, Secretaries' Office and Framing Department who have in so many ways contributed to this volume. I could not have done without Diana Davies and Lucy Trench, who have been painstaking and patient editors.

The manuscript has been read by the series' editor, Dr Allan Braham, who made many useful comments. I am indebted to the former Director, Sir Michael Levey, under whose directorship several of the works catalogued here were acquired; his encouragement and shrewd scholarship made the curating of the Trecento Collection an especially enjoyable task and he was kind enough to read and comment on the manuscript in his last few months at the Gallery. The present Director, Neil MacGregor, read the galleys with the eagle and learned eye of a former Editor of *The Burlington Magazine*, for which I am extremely grateful.

Perhaps my greatest debts outside the National Gallery are to Dr Joanna Cannon, who as a friend and colleague in medieval Italian painting has indirectly greatly influenced this catalogue, and to Professor Julian Gardner, whose comments on the present catalogue were extremely useful. His luminary teaching first drew me to the Trecento, and ever since he has been a staunch friend and critic.

DILLIAN GORDON
1988

Explanation of the Catalogue

SEQUENCE The paintings are arranged alphabetically according to the name of the artist or school.

ATTRIBUTION A picture entered under an artist's name is considered to be by him. '*Attributed to*' qualifies the attribution. '*Ascribed to*' indicates greater doubt. '*Workshop of*' and '*Follower of*' are self-explanatory. '*Style of*' suggests some connection with the artist. A list of attributions differing from those in the catalogue in 1961 is given on p. 124.

INVENTORY NUMBER The National Gallery inventory number is to be found to the left of the picture title.

MEASUREMENTS These are given in centimetres, followed by inches in brackets. Height precedes width.

MEDIUM All the pictures catalogued here are painted in egg tempera unless otherwise stated.

SUPPORT Wherever the species of wood has been analysed this is specified. Most early Italian pictures are painted on poplar and sometimes this is evident to the naked eye.

RIGHT AND LEFT These terms indicate the viewer's right and left, unless the context clearly implies the contrary.

BIOGRAPHICAL REFERENCES The biographical references are intended only as guidelines and are by no means comprehensive.

INDEXES The indexes at the back list the paintings by changed attributions, iconography, provenance according to collectors and patrons, provenance according to location, year of acquisition and inventory number.

FIGURES The reconstructions are intended to demonstrate arrangement. The panels are not necessarily shown to scale.

List of Paintings

	Page	Plates

CATALOGUE

ALLEGRETTO Nuzi
active 1345, died before September 1374

A painter from Fabriano whose first signed work is dated 1345. He is first documented in Florence in 1346. His work clearly shows the influence of Bernardo Daddi in particular and is close to that of the so-called Master of the Fabriano Altarpiece. Signed works include a *Maestà* dated 1345,[1] a triptych now in the Vatican dated 1365, a polyptych in San Francesco, Apiro, dated 1366, a triptych now in Macerata Cathedral dated 1369, and a *Virgin and Child* (Urbino, Galleria Nazionale delle Marche) dated 1372.[2] He worked on a number of frescoes in his native Fabriano and on some in Perugia.

He made his will on 26 September 1373 and had died by 28 September 1374.[3]

REFERENCES:
1. See B. Berenson, *Italian Pictures of the Renaissance. Central Italian and North Italian Schools*, II, London, 1968, fig. 206. M. Boskovits, *Pittura Umbra e Marchigiana fra Medioevo e Rinascimento*, Florence, 1973, p. 39, n. 98, suggests that this is identifiable with a painting of that date originally in San Domenico, Fabriano, where Allegretto Nuzi also painted frescoes.
2. R. van Marle, *The Development of the Italian Schools of Painting*, V, The Hague, 1925, pp. 130 ff.
3. A. Anselmi, 'Testamento del pittore Allegretto Nuzi da Fabriano', *Archivio Storico dell'Arte*, VI, 1893, pp. 129 ff., and idem, 'L'anno della morte e la chiesa ove fu sepolto Allegretto Nucci da Fabriano', *L'Arte*, IX, 1906, pp. 381 ff.

Ascribed to ALLEGRETTO Nuzi

5930 *Sts Catherine and Bartholomew*　　　　　　*Plate 1*
(Right wing of a triptych, or possibly polyptych)

The names are inscribed: [s]/ .CHATERINA., and S./.BARTHOLOMEV.

Wood. Painted surface, 83 × 51 (32½ × 20). The picture has an uncusped pointed-arched top, of which the upper 5 to 7.5 cm. have been cut away; the edging of the gold in this arched part is almost entirely new, but follows the original shape. Probably cut slightly at the bottom.

The condition is fair. There is a damaged area at the right-hand lower edge along the hem of St Bartholomew's robe. The profile of St Catherine's face and the profile of St Bartholomew's face and hair have partly flaked away.

Cleaned in 1967–8.

The names of the saints are on a sort of *cartellino* on the gold background, which is somewhat unusual.[1] The 'S' of St Catherine appears to have been omitted entirely.

No. 5930 used to be catalogued as Florentine School. Offner[2] attributed the painting to a Master X, to whom he also attributed a tabernacle in an unspecified private collection. Recently Erling Skaug, in a letter to the National Gallery, plausibly suggested an

attribution to Allegretto Nuzi, connecting the punchwork of No. 5930 with that in a diptych and a polyptych of the Virgin and Child with four saints, both in Philadelphia, Museum of Fine Arts, the Johnson Collection, with *Saints* in a polyptych in Houston, Texas, Museum of Fine Arts, a *Maestà* in Agen, Musée Municipal, a diptych and a triptych, which is signed and dated 1365, the two latter in the Pinacoteca Vaticana. Certainly there is a connection with the school of Fabriano, and particularly with the work of Allegretto Nuzi, both in style and in the shape of the panel, as well as in the punchwork, although the influence of Florence, and especially of Bernardo Daddi, is strong.

PROVENANCE: Purchased in 1920 from or through Alphonse Kann, Paris, by Herbert Charles Coleman,[3] by whom bequeathed, 1949.[4]

REFERENCES:
1. Comparable forms, although not exactly similar in placing, occur on a *St Catherine* (R. Offner, *A Critical and Historical Corpus of Florentine Painting*, Section III, vol. IV, New York, 1934, pl. XIII) and a *St Benedict* (G. Sinibaldi and G. Brunetti, *Mostra Giottesca*, Florence 1937, 1943, no. 154, with reproduction), both of which have been associated with Bernardo Daddi; also sometimes in earlier works.

2. R. Offner (ed. Hayden B. J. Maginnis), *A Critical and Historical Corpus of Florentine Painting. A Legacy of Attributions*, New York, 1981, p. 60, and figs. 129 and 130.
3. Letter in the National Gallery archives.
4. With an attribution to Spinello Aretino.

ANDREA DI BONAIUTO DA FIRENZE
first recorded 1346, died 1379

The earliest record of his activity dates from after January 1346, when he is recorded with Nardo di Cione in the Arte dei Medici e Speziali in Florence.[1] He lived in the parish of Santa Maria Novella, Florence, except for the years *c.*1355–65 and 1377. On 30 December 1365 he undertook to decorate within two years the Chapter House of Santa Maria Novella, later known as the Spanish Chapel. On 13 October 1377 he received the final payment for the fresco cycle of St Raniero in the Camposanto, Pisa. Already in 1370 he was ailing and on 2 November 1377 he made his will. He died between 16 May and 2 June 1379.

REFERENCE:
1. For the biographical information given here see R. Offner and K. Steinweg, *A Critical and Historical Corpus of Florentine Painting*, Section IV, vol. VI, *Andrea Bonaiuti*, New York, 1979, pp. 7 ff.

Ascribed to ANDREA DI BONAIUTO DA FIRENZE

5115 *The Virgin and Child with Ten Saints* (Altarpiece)

Plate 2

In separate compartments. From left to right: (1) St Mark, inscribed S. MARCHUS; (2) St Peter Martyr, inscribed S.PETRUS.; (3) St Thomas Aquinas, inscribed S.THOMAS.; (4) St Dominic, inscribed S.DOMINICUS; (5) St Luke, inscribed S.LUCAS; (6) the Virgin and Child, inscribed S.MARIA UIRGO.; (7) St John the Evangelist, inscribed S.IOHANNES; (8) St Gregory, inscribed S.GREGORIUS; (9) St Catherine of Alexandria, inscribed S.KATERINA; (10) The Magdalen, inscribed S.MARIA MAD; (11) a bishop with a book, inscribed S.THOMAS (D?).

Wood. The size of each compartment for the saints is 13×8 ($5\frac{1}{8} \times 3\frac{1}{8}$), rounded top; the size of the Virgin's compartment is 18×11.5 ($7\frac{1}{8} \times 4\frac{5}{8}$), pointed top. The total size, including the framing, is 28×106 ($11 \times 41\frac{3}{4}$).

The back is covered with original gesso painted dark grey, which covers all the outer mouldings, thereby confirming that the entire frame is original and complete. Most of the gold on the framing is new, except that on the central arch and below St Dominic, which is original.

The saints are in compartments separated from one another by colonnettes which, like the *pastiglia* work, appear to be of moulded gesso. The inscriptions are under each saint, on the lower part of the frame, and have been created by ultramarine painted around the gold of the letters.[1] At the top, the frame rises to a pediment above the Virgin and Child; the top finial of this has been broken away. Embedded in the *pastiglia* are semi-precious stones and beads of coloured glass.

The condition of the painted surface and gold background is generally good, except for the gold background of St Catherine, which has been renewed.

Cleaned in 1961.

Meiss[2] claimed that the St Thomas Bishop is St Thomas à Becket, and this is accepted by Kaftal.[3] However, he is not shown as a martyr[4] (St Peter Martyr and St Catherine in No. 5115 have palms); although it cannot be said to be the only possible identification, it does seem the most likely.[5]

The attribution to Andrea da Firenze was first made by Meiss[6] and confirmed by Offner and Steinweg.[7] Although this is reasonably convincing, the quality is not high and No. 5115 is more likely to be attributable to an assistant working in the workshop of Andrea da Firenze. (The question of the design of the altarpiece is discussed below.)

The mediocre quality of the style makes this altarpiece difficult to date. Comparison with the frescoes in the so-called Spanish Chapel, both on iconographic[8] and on stylistic grounds,[9] suggests a date in the mid-1360s.

Andrea da Firenze's connections with Santa Maria Novella in Florence were close (see the biography above) and No. 5115 is not only clearly associated with the Dominicans,

but, more specifically, probably with Santa Maria Novella on hagiographic grounds. Meiss showed that all ten of the saints represented in the panel were titulars of altars in this church during the fourteenth century, including St Thomas à Becket, seldom represented in Tuscan painting at this time. Meiss further suggested that since the place of honour on the Virgin's right was given to St Luke, and since St Luke was the titular of the Gondi Chapel situated immediately to the left of the choir, a member of the Gondi family might have commissioned the panel as a replica of the polyptych which once stood on the altar of the family chapel.[10] This was described by Vasari[11] as having been painted by Simone Martini, and is now lost. In fact, patronage of the Gondi Chapel did not pass to that family until 1503; in 1325 it was acquired by Margherita Tornaquinci, a member of the Guardi and Scali families, and remained with them until 1461.[12] Meiss himself pointed out that the long low retable with a higher projecting central section was reminiscent of Florentine Duecento dossals.[13] It was therefore hardly an exact replica of a fourteenth-century Sienese polyptych.

However, connections with Sienese painting do suggest that Meiss's theory may be correct on some points. First, the iconography of the Virgin and Child – with the Child clasping the Virgin's neck, one foot perched above her wrist, one below – was originally a motif common in early fourteenth-century Sienese polyptychs,[14] and adopted by some Florentine painters of the second half of the fourteenth century.[15] One may postulate that this could have been the iconography of one of the two lost fourteenth-century Sienese altarpieces in Santa Maria Novella: either the altarpiece which may have been painted for the chapel of St Luke by Simone Martini (mentioned above); or the lost altarpiece commissioned by Fra Baro Sassetti (d. 1324), probably in the 1320s, and said by Vasari to have been painted for the high altar by Ugolino di Nerio. The latter altarpiece has been plausibly reconstructed by Cannon,[16] who suggested that it resembled in format the altarpiece for Santa Croce and that it could have been a heptaptych. It is, in fact, likely to have been a heptaptych, given the width of 428 cm. of the surviving *paliotto*, invoked by Cannon, which is comparable with the original width of the Santa Croce heptaptych by UGOLINO DI NERIO (see No. 1188 et al.). Cannon suggested that the altarpiece would have included St Dominic and St Peter Martyr, both of whom are present in No. 5115. If one removes the three Evangelists and St Thomas à Becket, one is left with six saints who could plausibly have been included in such a heptaptych. If indeed No. 5115 reflects the iconography of Ugolino's altarpiece, then the date of St Thomas Aquinas's canonisation would give the polyptych a *terminus post quem* of 1323: in No. 5115 St Thomas Aquinas is shown, unusually, with stigmata-like rays emanating from his hand, illuminating a symbol of the Church. This is a quite literal interpretation of Pope John XXII's encomium, quoted in the service of canonisation in 1323: '. . . after the apostles and the first doctors, this glorious doctor illuminated further the church of God.'[17] Another unusual iconographic feature of No. 5115 is Mary Magdalene lifting the lid of her jar.

Both the latter are original iconographic details unlikely to have been created by the painter of No. 5115, and more likely to reflect a more sophisticated work, or the wishes of a learned patron, probably a friar of the convent. Although the design of No. 5115 by

Andrea da Firenze cannot be ruled out, this does not preclude the possibility that the iconography derives from an earlier work.

Evangelists combined with figures under rounded arches occur in Simone Martini's Pisa polyptych (formerly in Santa Caterina, now in Pisa, Museo Nazionale di San Matteo) of 1320, where in the predella St Mark flanks the Man of Sorrows with the Virgin (instead of the traditional St John the Evangelist), and St John the Evangelist also is included with his symbol. The small Evangelist symbols resting on the frame of No. 5115 are similar to those in the Pisa polyptych, although not as subtly conceived.

Given these Sienese elements, one may postulate tentatively that No. 5115 is a reflection of one or both of the lost altarpieces by Simone Martini and Ugolino di Nerio for Santa Maria Novella, ingeniously adapted to a Duecento format.

PROVENANCE: From the collection of Mrs F. W. H. Myers, who died in 1937. Presented by her daughter, Mrs Richard F. P. Blennerhassett, 1940.

REFERENCES:

1. The present writer is most grateful to Dr Ashok Roy for analysing the pigments of the inscription and for his comments.

2. M. Meiss, *Painting in Florence and Siena after the Black Death*, Princeton, 1951, pp. 175–6.

3. G. Kaftal, *Iconography of the Saints in Tuscan Painting*, Florence, 1952, col. 989.

4. Thomas à Becket is generally referred to as a martyr; cf. G. Richa, *Notizie Istoriche delle Chiese Fiorentine*, IV, Florence, 1756, p. 68, and Stefano Orlandi, *Il Necrologio di Santa Maria Novella*, 1955, vol. 2, p. 417 (29 December). Kaftal (loc. cit.) reproduces a figure from a predella in Santa Croce not shown as a martyr (although other figures in the predella are). This has a damaged inscription that apparently includes the name of Thomas, but in parts seems far from clear. It should be added that on the existing altar dedicated to Thomas à Becket in Santa Maria Novella the inscription (apparently of the nineteenth century) does not refer to him as a martyr, although on the altar opposite Sts Cosmas and Damian are so described; W. and E. Paatz, *Die Kirchen von Florenz*, vol. 3, Frankfurt-am-Main, 1952, p. 703, say the altar is dedicated to St Thomas Aquinas, but it seems likely that St Thomas à Becket is the correct identification (cf. V. Fineschi, *Il Forestiero Istruito in Santa Maria Novella*, Florence, 1790, p. 13). For details about St Thomas à Becket in connection with Santa Maria Novella see Orlandi, op. cit., vol. 1, p. 415.

5. There is, for instance, St Thomas de Cantalupe, whose cult may indeed have been peculiarly English, but who did die in Italy.

6. Meiss, loc. cit.

7. R. Offner (ed. Hayden B. J. Maginnis), *A Critical and Historical Corpus of Florentine Painting. A Legacy of Attributions*, New York, 1981, p. 64. Also R. Offner and K. Steinweg, *A Critical and Historical Corpus of Florentine Painting*, Section IV, vol. VI, *Andrea Bonaiuti*, New York, 1979, p. 68.

8. See note 17.

9. Offner and Steinweg, loc. cit.

10. Meiss, op. cit., pp. 175–6.

11. Vasari, *Vite* (ed. Milanesi, Florence, 1878), I, p. 549.

12. Richa, op. cit., III, pp. 69–70, and Paatz, op. cit., p. 711.

13. Meiss, op. cit., p. 47.

14. e.g. J. H. Stubblebine, *Duccio di Buoninsegna and His School*, Princeton, 1979, figs. 383, 438, 444.

15. e.g. Offner (ed. Maginnis), op. cit., figs. 1, 80, 84. The present compiler does not find the analogy with the Virgin and Child in the Carmine in Florence suggested by Meiss (op. cit., fig. 64) particularly close.

16. Joanna Cannon, 'Simone Martini, the Dominicans and the Early Sienese Polyptych', *Journal of the Warburg and Courtauld Institutes*, XLV, 1982, pp. 87–91.

17. Cited by Cannon, art. cit., p. 73 and note 32. The allegory for canon law in the Spanish Chapel by Andrea da Firenze holds a similar church to that held by St Thomas Aquinas in No. 5115, but with a campanile, and her hand is similarly poised (Offner and Steinweg, op. cit., Section IV, vol. VI, pl. I [14]).

BARNABA DA MODENA
active 1361–1383

From a Milanese family settled in Modena, Barnaba (or Barna) was mainly active in Genoa where he is documented from 1361 until 1383, in 1362 as 'civis et habitator Janue'.[1] In 1379 the Opera del Duomo in Pisa sent for him to complete a cycle of frescoes left unfinished by Andrea da Firenze. This, however, he apparently never did, although he painted a number of other works there, including a *Maestà* for the Merchants' Guild. A number of similar signed and dated panels of the Virgin and Child stretch from 1367 (Frankfurt, Städelsches Kunstinstitut) to 1377 (Alba, San Giovanni Battista).[2]

Influenced by Bolognese and Sienese painters in particular, Barnaba is distinctive in his anachronistic use of chrysography.

REFERENCES:
1. See Thieme-Becker, s.v. Barnaba da Modena. Also R. van Marle, *The Development of the Italian Schools of Painting*, IV, The Hague, 1924, pp. 368 ff. No up-to-date account of his life and work exists.
2. See L. Malvano, 'Une Vierge à l'Enfant de Barnaba da Modena au Louvre', *Revue du Louvre*, 1969, 6, pp. 339–46.

1437 *Pentecost* *Plate 3*
(Panel from an altarpiece)

The Virgin and the twelve Apostles with hands joined in prayer receive the Holy Spirit.

Wood. 54.5 × 50 (21$\frac{1}{2}$ × 19$\frac{3}{4}$).

The panel is painted up to the edges all round. Although sharp edges indicate that it has been trimmed, compositionally it does not appear to have lost much and it is probably close to its original size.

On the extreme right an Apostle's halo has been put in over the purple robe and the face of the Apostle above, and has been left unstamped. The faces of all the Apostles have been incised, except this one. Presumably a mistake was made and only eleven Apostles were shown, so one had to be added to make up the full contingent.

The punching of all the haloes was done once the figures, draperies and architecture had been painted: this is clear from inspection through a microscope which shows that paint has been pressed into the punched holes.

The overall condition is good.

No. 1437 is thought to be one panel of a composite work. Ricci[1] suggested that an *Ascension* (Fig. 1) in the Pinacoteca Capitolina, Rome, inv. 347 (formerly in the Sterbini and then Pasini collections) belongs to the same series. The present width of the *Ascension* is 46 cm.[2] That panel has evidently been trimmed, so there would be no difficulty in supposing that it had once been 50 cm., the width of No. 1437. The discrepancy in height between the *Ascension* and No. 1437 does not seem significant. No. 1437 could have been trimmed 4.5 cm. at the top and/or bottom (see above), and thus have been the same

height as the *Ascension*, which is 59 cm. high. The association of these two panels therefore seems possible.

Longhi[3] further suggested that a *Nativity* and a *Flight into Egypt* in the Pinacoteca, Bologna, also belonged to the series. However, the discrepancy in the sizes seems to argue against their association with No. 1437. Each measures only 38 and 39 cm. high respectively and neither appears to have been significantly trimmed. In width they are both substantially narrower (28 cm.) and their punched borders confirm that they have not been cut.[4] Although the halo patterns are like those of No. 1437, Barnaba da Modena's halo patterns for small-scale works seem to have been fairly standard.[5]

PROVENANCE: Purchased from Charles Simpson, Linslade House, Leighton Buzzard, 1895.[6]

REFERENCES:
1. C. Ricci, 'Barnaba da Modena', *The Burlington Magazine*, XXIV, 1913–14, p. 65.
2. R. Bruno, *Roma, Pinacoteca Capitolina*, Musei d'Italia – Meraviglie d'Italia, Bologna, 1978, p. 6, no. 18. When reproduced in van Marle it was in the Pasini Collection (R. van Marle, *The Development of the Italian Schools of Painting*, IV, The Hague, 1924, fig. 194).
3. Oral communication to Martin Davies. See *Mostra della Pittura Bolognese del 300*, Bologna, 1959, nos. 58 and 59.
4. The measurements of the Bologna panels were kindly supplied by the museum.
5. See, for example, BARNABA DA MODENA, No. 2927, or van Marle, op. cit., fig. 190.
6. As School of Giotto.

2927 *The Coronation of the Virgin; The Trinity; The Virgin and Child; The Crucifixion*

Plate 4

Four scenes, and a 'predella'. Top left, the Coronation of the Virgin. Top right, the Trinity: Christ is shown on a Cross marked .I.N.R.I., supported by God the Father; the Holy Ghost as a dove. These figures are within a vesica at the corners of which are the symbols of the four Evangelists; each holds a book inscribed with the opening words of his respective Gospel, except St Luke who has the opening words of his Chapter II. The Virgin and St John mourn at the foot of the Cross. Bottom left, the Virgin and Child; her halo is inscribed AUE. GRATIA. PLEN, and the Child holds a scroll, now illegible. Two donors, dressed in scarlet, kneel before the Virgin and Child: the woman wears a golden crown; the man is being presented by St Raphael, whose halo is inscribed SANCTUS: RAFAELIS. Bottom right, the Crucifixion; Christ is on a Cross marked .I.N.R.I., and surmounted apparently by a Pelican in its Piety. Angels carry off the soul of the good thief (St Dismas), devils that of the bad thief (Gestas). The Magdalen is at the foot of the Cross. Left foreground, the swooning Virgin attended by the Holy Women and St John; right foreground, the soldiers casting lots. The 'predella', divided into two parts, shows the twelve Apostles, not individually distinguished except for St Bartholomew.

Signed on the panel, bottom left: *barnabas. de mutina pinxit. 1374.*

Wood. The individual scenes are each 34×27.5 ($13\frac{1}{2} \times 10\frac{3}{4}$); the two parts of the 'predella' each 6.5×27.5 ($2\frac{1}{2} \times 10\frac{3}{4}$). Total, including the strip of framing round the edges, 82×60.5 ($32\frac{1}{4} \times 23\frac{3}{4}$).

On the back is a damaged seal with a triangular fringed canopy with a ball on top, over two five-point stars.

The gold backgrounds are new, but the picture is in general in a satisfactory state. The foreground of the Virgin and Child, Trinity, and Crucifixion compartments have all been repainted, indicating that the pigment was insecure or the technique faulty.

Cleaned in 1971.

The altarpiece consists of two separate vertical panels, now framed together as one. The entire surrounding moulding is modern, as is the central vertical moulding; the internal horizontal mouldings are original. The altarpiece was therefore almost certainly once a folding tabernacle, either a diptych, or the wings of a triptych. The latter is less likely, as it is difficult to suggest what the central scene could have been, given that major scenes are already present in the wings and that there is no obvious narrative sequence. The outer mouldings must have become damaged through constant folding and unfolding and therefore needed replacing. In fact, at the back, damage top and bottom, where the panels now join, indicates that there could once have been clasps or hinges. The back of the panel is a plain toned gessoed ground, unlikely ever to have been painted.

It was first suggested by Ricci that the donors might be the Doge and Dogaressa of Genoa.[1] However, Pesenti[2] pointed out that this was unlikely, since the wife of a Genoese doge would not have been shown wearing a crown. He suggested instead that the donors were Spanish: Juana Manuel (1335–81), daughter of the Condé de Carrión, and her husband, Enrico II, whom she married in 1350 and who acceded to the throne of Castile in 1369. But again, Pesenti seems to have taken no account of the fact that Enrico would surely have been shown also wearing a crown. It seems much more likely that the supplicants represent Juana Manuel and her then dead father, Don Juan Manuel, Adelantado de Murcia and Condé de Carrión. These are the two people who have been proposed as the donors in the polyptych of the *Virgin and Child*[3] attached to the polyptych of *St Lucy with Scenes from her Life* (Murcia, Museo de la Catedral). Both polyptychs bear the signature of Barnaba da Modena. Both stood originally in the Manuel Chapel in Murcia Cathedral, built by Don Juan Manuel 1337–40. It is now generally accepted that these are in reality two completely separate altarpieces, and that they were painted in Genoa and exported to Spain. On stylistic grounds they have been dated c.1370–7.[4] The donors in the Murcia *Virgin and Child* polyptych are both shown wearing scarlet,[5] as in No. 2927. Although the male figure in the Murcia altarpiece wears no head-dress, his distinctive moustache and greying bearded profile are similar to the moustachioed man dressed in scarlet in No. 2927; the woman in the Murcia altarpiece wears a similar crown with a loop of pearls down the back of the head and has similar features to the woman in scarlet in No. 2927.[6]

A possible argument against identifying the donors in No. 2927 as Juana Manuel and her dead father, Don Juan Manuel, is the fact that the male supplicant in the Murcia altarpiece is being presented by St Lucy, and St Lucy is also the patron saint in the other Murcia altarpiece painted by Barnaba for the Manuel Chapel. This was probably also commissioned by Juana and again shows her with her dead father, this time kneeling in

the Crucifixion,[7] whereas in No. 2927 he is being presented by St Raphael. However, St Raphael, as one of the three archangels, may be commending the dead father to the Virgin. Given the patronage extended to Barnaba da Modena by Juana, it is very possible that she commissioned No. 2927 at the same time as the Murcia polyptychs and is shown being presented to the Virgin and Child with her father in all three, and that all three were completed in 1374 in Genoa to be sent out to Spain.[8]

Barnaba painted a number of independent Crucifixion scenes which are similar to that in No. 2927: a *Crucifixion*, formerly in the collection of Lady Jekyll, London, now in a private collection, Milan, which is close to No. 2927, and a *Crucifixion* in the John Herron Art Institute, Indianapolis, which is even closer, have both been published by Gonzalez-Palacios,[9] who dates both shortly before 1374.

The pattern on the cloth of honour behind the Virgin and Child is used elsewhere by Barnaba da Modena; for example, on the robes of St Bartholomew and the supplicant bishop in the altarpiece for San Bartolomeo del Fossato, Genoa, painted *c.*1377–81,[10] and also on the cloth of honour in the St Catherine altarpiece which Longhi dated *c.*1375.[11]

The iconography of the Trinity combined with the four Evangelist symbols is, as far as the compiler is aware, unprecedented in Italian panel painting.[12]

PROVENANCE: Owned by Séroux d'Agincourt, *c.*1785.[13] Later in the collection of Sir James Parke, Lord Wensleydale, who lent it to Manchester, 1857 (Provisional Catalogue, no. 300; Definitive Catalogue, no. 46). Lord Wensleydale died in 1868; his widow, who died in 1879, bequeathed the picture to her grandson, Charles Howard, 9th Earl of Carlisle.[14] Presented by his widow, Rosalind, Countess of Carlisle, 1913.

REFERENCES:

1. C. Ricci, 'Barnaba da Modena', *The Burlington Magazine*, XXIV, 1913–14, p. 66, says that the man's headgear is the 'coif' worn under the ducal *corno*. However, to the present compiler it bears no resemblance to this headgear.
2. F. R. Pesenti, '"Barnabas de Mutina pinxit in Janua": i polittici di Murcia', *Bollettino d'Arte*, January–March 1968, p. 24.
3. Salvador García de Pruneda, 'El retablo de Santa Lucía en la Catedral de Murcia. ¿Quiénes fueron sus donantes?', *Boletín de la Sociedad Española de Excursiones*, LI, 1947, pp. 79–88.
4. Pesenti, art. cit., *passim*.
5. Pesenti, art. cit., p. 24.
6. The two 'donor' figures in the Murcia *Virgin and Child* polyptych are illustrated in detail in de Pruneda, art. cit., opp. p. 80.
7. Inexplicably, Pesenti is convinced that although in both Murcia polyptychs the male supplicant is uncrowned, and the female crowned, and although in both altarpieces the two supplicants are dressed in scarlet and are of similar ages, they are not identical. The illustrations of the *Crucifixion* in the St Lucy polyptych are too poor to make any judgement on that basis.
8. Longhi's argument (R. Longhi, 'Una "Santa Caterina" di Barnaba da Modena', *Paragone*, 131, November 1960, p. 33) that until 1370 Barnaba uses

minuscule and after 1374 majuscule to inscribe haloes would separate No. 2927 from the Murcia polyptychs in date. However, it does not seem to be an argument to take seriously without further substantial evidence. Longhi suggests that the St Catherine altarpiece may also have been a Spanish commission.
9. A. Gonzalez-Palacios, 'Una Crocefissione di Barnaba da Modena', *Paragone*, 181, March 1965, pp. 30–1. He points out that old photographs of the Indianapolis panel, taken before excessive restoration, show that it once had a Pelican in its Piety like No. 2927. He also publishes a signed *Coronation of the Virgin* (New York, collection of R. M. Hurd) which is close to the Coronation in No. 2927.
10. See P. Rotondi, 'Contributo a Barnaba da Modena', *Arte Antica e Moderna*, 18, April/June 1962, pp. 181–4.
11. Longhi, art. cit., *Paragone*, 1960, pp. 31–3.
12. The figures of the Virgin and John the Evangelist seated on the ground in the *Crucifixion* occur in the Lavagnola polyptych. See P. Rotondi, *Il Polittico di Barnaba da Modena a Lavagnola*, Genoa, 1955, p. 28.
13. Séroux d'Agincourt, *Storia dell'Arte*, IV, 1827, pp. 408–9; VI, 1829, pp. 394–5, and pl. CXXXIII. He did not know its provenance. Already by 1785, when he acquired it, it was framed as a single painting.
14. Label on the back.

DALMATIAN School

4250 *Altarpiece of the Virgin Mary* *Plates 5–11*

The altarpiece consists of five vertical poplar rectangular panels and a separate predella.[1]
All the panels have been gessoed completely on their front surfaces and then gilded and
painted.

The frame is a later nineteenth-century (?) addition.

CENTRE PANEL: *Plate 6*

Overall panel size, 75 × 46.8 (29⅛ × 18).
Painted surface (the panel is painted up to the side edges), height, 74.2 (29).
The Virgin and Child.
There remains a fragment of the inscription, MARIA. / (Mate)R. HVM / (ili)s (or perhaps
better, [ilitati]s). For the iconography, see the commentary below.

Each of the four outer panels has two scenes, arranged vertically. The narrative sequence
is horizontal. Each scene has a cusped gilded top, the outlines of which are marked on the
gesso with incised lines. It appears that all the edges have been slightly trimmed.

LEFT SIDE: Story of the Birth of the Virgin: *Plate 7*

1. *Outer left panel:*
Overall panel size, 63.4 × 26.8 (25 × 10½).
Painted surface (the panel is painted up to the side edges):
(a) (Outer top) *St Joachim's Offering Rejected.*
With the name, .S. / IVACHI/NVS.
Height, 30.3 (12).
(b) (Outer bottom) *The Meeting at the Golden Gate.*
With the names, .S̄. ANA., and S / IVACH/INV'.
Height, 29.3 (11½).

2. *Inner left panel:* *Plate 8*
Overall panel size, 63.8 × 27.8 (25 × 11).
Painted surface (the panel is painted up to the side edges):
(c) (Inner top) *The Angel appearing to St Joachim.*
With the name, .S̄.IV/ACHI/NVS.
Height, 30.3 (12).
(d) (Inner bottom) *The Birth of the Virgin.*
With the names, .S. ANA., and M̄P.Θ̄V. (Mother of God).
Height, 29 (11¼).

RIGHT SIDE: Miracles of the Virgin Connected with the Feast of the Conception:

3. *Inner right panel:* *Plate 9*
Overall panel size, 64 × 27.8 (25 × 11).
Painted surface (the panel is painted up to the side edges):

(e) (Inner top) *Helsinus Saved from Shipwreck.*

The visionary prelate holds a scroll inscribed, *Vis. mo/rtem. e/uader/e . conc/pciōe/z . Virg/inis . ce/lebra/bis . /vi . i/dus / dec* (8 December).

Height, 31 (12⅛).

(f) (Inner bottom) *A French Canon Drowned by Devils.*

The Virgin appears in the sky, with the inscription $\overline{\text{MP}}.\overline{\text{ΘV}}$.

Height, 29.7 (11⅝).

4. *Outer right panel:* *Plate 10*

Reverse: on the back is a later rough drawing of a head in profile.

Overall panel size, 63.8 × 26.9 (25 × 10½).

Painted surface (the panel is painted up to the side edges):

(g) (Outer top) *Helsinus preaching in favour of the Celebration of the Conception.*

In the right-hand top corner (under the frame) is the obscure scribble, *quando chō/prasemo / le pare/dane (Per I?)*; the writing seems to be old.

Height, 29.9 (11¾).

(h) (Outer bottom) *The Canon Restored to Life by the Virgin.*

The Virgin again appears, with the inscription $\overline{\text{MP}}.\overline{\text{ΘV}}$.

Height, 29.2 (11½).

On the back the outer left and inner left panels have corresponding horizontal channels, presumably for battens, just below the centre. The outer right panel has a similar channel in the corresponding place. The inner right panel appears to have been thinned slightly and, although the channel is no longer present, there remains a mark in the same position. The centre panel has similar traces of two horizontal battens.

It is apparent from the gessoing and gilding that unlike the Tuscan methods of construction, as described by Cennino Cennini, the frame was not an integral part of the front panel surface: the panels were gessoed and gilded separately, and then the frame was applied. This method may have been common among fourteenth-century Venetian and related altarpieces (see below).

PREDELLA: Christ and the Twelve Apostles *Plate 11*

Christ's book is inscribed: E(g)O S/ON LV/X. MO/NDI. / VIA./ VER/ITA/S. ET/VIT. The Apostles are each inscribed with their names: from left to right, S̄. / FELI/PV'., S̄. / MATEV', (S.Jac)HOBV'. / MINOR.,.S. / .MATIA.,.S̄. / .IACHOBV'.,.S. / .PETRV/.,.S. / .IOVANE / VĀ.,.S̄. / .BARTO/LOME/V'.,S. / .ANDRE/AS,.S̄. / TADEV'.,S. / SIMON,S̄ / T(homas).

Wood, in three pieces. From Philip to Bartholomew, the painted surface is 13 × 124.9 (5⅛ × 49); painted up to the edges except at the bottom. Andrew and Thaddeus, painted surface, 13.5 × 25 (5¼ × 9¾), exclusive of 12 mm. added to the panel on the left; painted up to the edges all round. Simon and Thomas, 13.5 × 27.5 (5¼ × 10¾), exclusive of 12 mm. added to the panel on the right; painted up to the edges all round.

The condition is generally fair, although there are considerable areas of new paint, particularly on the central panel: here much of the background is missing, both in the gilded areas and in the pink foreground. On the figure of the Virgin herself there are

11

sporadic damages in the blue mantle and half her left hand is missing. The scenes are on the whole reasonably well preserved except for (f).

The chronological sequence of each side is horizontal. This altarpiece may be intended as a representation of the Immaculate Conception. The two miracles of the Virgin are two of the three stories given in additions to *The Golden Legend* as alternative origins of the Feast of the Conception on 8 December.[2] (1) William the Conqueror, alarmed at the naval and military preparations in Denmark, sent Helsinus (Æthelsige), Abbot of Ramsey in Huntingdonshire, to enquire into the matter. On the way back, Helsinus' vessel was menaced by a violent storm; but an angel dressed as a bishop appeared standing on the water, and said that they would all be saved from shipwreck if Helsinus vowed to celebrate and persuade others to celebrate the Conception of the Virgin on 8 December. (2) A French canon, returning from fornication with a married woman, took a boat to cross the Seine, and at the same time began to recite the Office of the Virgin. A crowd of devils sent him and the boat to the bottom, and began to torment his soul; but three days later the Virgin among angels appeared, proved to the devils that the canon's soul was rightly hers, reinstated it in his body and, parting the waters, brought him safely to the bank. The Virgin made the canon promise that he would refrain from adultery, and that he would celebrate the Feast of her Conception on 8 December.[3]

The pictures vary slightly from the stories as given above; but it seems likely that the painter was working from a literary source such as *The Golden Legend*, because these subjects are rare in pictures.[4] In one scene in the second story the devils are forcing the man's soul out of his mouth, and in the other scene angels are putting it back again.

The subjects on the left side of No. 4250 are also connected with the Conception and Birth of the Virgin, from what may be called the historical point of view.

The central panel is specifically described as representing a Madonna of Humility; she has the moon at her feet, the sun as a brooch at her breast, and the background is ornamented with stars.[5] The emblem of St James the Great is shown as a whip, but it is clear that it has been changed by repaint from the usual pilgrim's staff.

No. 4250 was previously catalogued as Venetian School. Giuseppe Fiocco[6] ascribed the central panel to a follower of Lorenzo Veneziano, the rest to Stefano Veneziano (*plebanus* di Sant'Agnese). Coletti[7] ascribed the whole to Jacobello di Bonomo. These suggestions are not satisfactory; in particular, it is likely that the Virgin and Child is not by a different hand from the narrative scenes. Coletti notes the 'Bolognese vivacity' of some details, and Longhi thinks it may come from the region of Rimini.[8] Pallucchini[9] calls the artist the 'Maestro di Sant' Elsino'; he suggests that he may have been influenced by the Berlin predella panels of 1370 attributed to Lorenzo Veneziano, and also sees him as aware of Paduan painting, especially the frescoes by Altichiero in the Chapel of San Felice in the Santo.

Recently Ivo Petricioli convincingly attributed the altarpiece to a Dalmatian painter, called the Master of the Tkon Crucifix, working at the end of the fourteenth and beginning of the fifteenth centuries, mainly along the Adriatic coast. It seems certain that it is in this area that the origins of No. 4250 are to be sought.[10]

PROVENANCE: On the back (twice) P. Laurati (i.e. Lorenzetti). William Graham sale, 8 April 1886 (lot 224), bought by Clifford.[11] Bequeathed by H. E. Luxmoore, 1927. Cleaned Pictures Exhibition at the National Gallery, 1947–8 (no. 17).

REFERENCES:

1. The main part appears to be poplar. A note in the archives records that a piece of the predella was tested and found to be lime by B. J. Rendle of the Forest Products Research Laboratory. This must refer to one of the smaller pieces, which are markedly different from the main panels of the altarpiece.

2. T. Graesse, ed., *Iacobi a Voragine. Legenda Aurea. Vulgo Historia Lombardia Dicta*, 3rd ed., Bratislava, 1890, pp. 869 ff. See also *The Golden Legend*, tr. W. Caxton, II, London, 1928, pp. 126 ff. There are some variations in *La Légende Dorée*, pub. Garnier, II, Paris, n.d., pp. 334 ff. It should be noted that similar miracles are recorded of the Virgin without reference to the Feast of the Immaculate Conception, although in the present case the association with the feast should not be doubted. A window in Orsanmichele, Florence, shows a scene that is comparable, but that is not (no doubt rightly) associated with the Conception by Werner Cohn in the *Mitteilungen des Kunsthistorischen Institutes in Florenz*, IX, 1959, p. 9 (no. 9). Further information about the legends may be found in E. F. Wilson, *The Stella Maris of John of Garland*, 1946, or Sister Mary Vincentine Gripkey in *Mediaeval Studies*, XIV, 1952, pp. 9 ff. and XV, 1953, pp. 14 ff.

3. For these stories (the text was believed to be by St Anselm), see further E. D. O'Connor, *The Dogma of the Immaculate Conception*, Notre Dame, Indiana, 1958, pp. 522 ff.

4. The story of Helsinus does, however, appear in the predella of Francia's *Immaculate Conception* in San Frediano in Lucca; see Montgomery Carmichael, *Francia's Masterpiece*, London, 1909, pp. 58 ff. (For further comment on this picture, see R. Ligtenberg in the *Mededeelingen van het Nederlandsch Historisch Instituut te Rome*, 1931, pp. 65 ff.) The same story was also on a window in St Jean in Rouen; E. Mâle, *L'Art Religieux de la Fin du Moyen Age en France*, 2nd ed., Paris, 1922, p. 208. The miracle of the canon and that of Helsinus probably appear in a series in Winchester Lady Chapel; see M. R. James and E. W. Tristram in *The Walpole Society*, XVII, 1928–9, p. 33 and pl. XXI.

5. The emblems are derived from the Apocalyptic Woman and Child (Revelation xii, 1); they often accompany representations of the Madonna of Humility. They were also used in later pictures of or connected with the Immaculate Conception (cf. for instance, Francesco Podesti's fresco in the Sala dell'Immacolata in the Vatican); even the presence of a Child in pictures of this subject was sometimes considered defensible (see Francisco Pacheco, *Arte de la Pintura*, 1649, pp. 481 ff.). It may be added that M. Meiss (*Art Bulletin*, XVIII, 1936, p. 463) claims that there is no evidence of a reference to the Immaculate Conception in the Madonna of Humility; but here clearly there is.

6. Oral communication.

7. Luigi Coletti in *L'Arte*, 1931, pp. 131 ff.

8. R. Longhi, *Viatico per Cinque Secoli di Pittura Veneziana*, Florence, 1946, p. 48. Works he thinks by the same hand are reproduced in the catalogue of the Rimini Exhibition (*Mostra della Pittura Riminese del Trecento*), 1935, nos. 60–1, and by L. Serra, *L'Arte nelle Marche*, II, Rome, 1934, figs. 474–5. For further discussion of the attribution see R. Pallucchini in *Arte Veneta*, 1950, p. 10, and F. Bologna, ibid., 1952, pp. 17–18.

9. R. Pallucchini, *La Pittura Veneziana del Trecento*, Venice, 1964, pp. 207–9.

10. See K. Prijatelj, *Dalmatian Painting of the 15th and 16th Centuries*, Zagreb, 1983, p. 10, and see especially pl. I. This reference was passed to the National Gallery by C. Walter, Centre Byzantin, Athens, who said that Petricioli's article on the Master of the Tkon Crucifix appears in *Tragom Srednjorjekovnih Umjetnika*, Zagreb, 1983, pp. 99–117.

11. As Sienese School; the stencil mark of the Graham sale is on the back of the picture.

DUCCIO

active 1278, died 1318

Duccio di Buoninsegna, a painter active chiefly in Siena. In 1285 he contracted to paint a large picture for Santa Maria Novella, Florence, the so-called '*Rucellai Madonna*' (Florence, Uffizi). Duccio's principal work is the *Maestà*, the former high altarpiece of the cathedral of Siena, which was placed in the cathedral on 9 June 1311 (see below,

Nos. 1139, 1140, 1330). These are the only two documented works. A number of other works exist, whose attribution is the subject of polemic. He had a large number of assistants and followers,[1] although who exactly his pupils were is not documented.

REFERENCES:
1. For Duccio and his followers see the three recent monographs: John White, *Duccio. Tuscan Art and the Medieval Workshop*, London, 1979; Florens Deuchler, *Duccio*, Milan, 1984; J. H. Stubblebine, *Duccio di Buoninsegna and His School*, Princeton, 1979; and also the section in Enzo Carli, *La Pittura Senese del Trecento*, Milan, 1981, pp. 29 ff.

566 *The Virgin and Child with Saints* (Triptych) *Plates 12, 13, 14*

In the tympanum above the central panel are seven figures. Reading from left to right: (1) Daniel; scroll inscribed with a text from Daniel ii, 45 (cf. also v, 34), (d) *e mō/(t)e ab/cisus/ est la/pis si/ne m*(a)*/nib'* (2)Moses; scroll inscribed with a text adapted from Exodus iii, 2, *Vid*(e)*b*(am) *q'* (ru)*b'* / *ardebat* /(e)*t non/ combu/reba/tur* (3) Isaiah; the scroll is much damaged, but the text (the letters of which not even a fragment remains being printed in brackets) must be that of Isaiah vii, 14, *Ecc*(e) */ uir*(go)*/*(co)*c*(i)*p*(i)*/*(et). *et.*(pa)*ri/*(et)*fi/lium* (4) The central figure, David; the remains of his name, *uid*, is inscribed on the background (5) Abraham; scroll inscribed with a text adapted from Genesis xxii, 18, or xxvi, 4, *In seiē/tuo be/nedicen/tur om/nes gē/tes* (6) Jacob; scroll inscribed with a text from Genesis xxviii, 17, . . (do)*m'/dei et/porta/celi* (7) Jeremiah; scroll inscribed with a text adapted from Jeremiah xxxi, 22, *Nou*(um)(?) */ faciet /* (d?)*o' s t/eram / mlier / circū/dabit* (ui/rum).

Left wing, St Dominic; with the name inscribed, ŝ DO/MINIC'.

Right wing, St Aurea (?); with the remains of the name inscribed, S̄C̄A AU.

The reverse retains most of its covering of original paint, which is nearly plain for the central panel, and has a geometric but asymmetrical pattern for the wings.

Wood. The size of the central panel of the Virgin and Child, without the framing, is 42.5 × 34.5 (16¾ × 13½), rounded top; the total size of the central panel, including the framing, the tympanum and the base, is 61.5 × 39 (24⅛ × 15⅜), pointed top. For the wings, the size of St Aurea's (?) panel, excluding the framing, is 42 × 16.5 (16½ × 6½); the painted area on the reverse of this wing is 45 × 20.5 (17¾ × 8⅛). The size of St Dominic's panel, excluding the framing, is 42 × 16 (16½ × 6¼); the painted area on the reverse of this wing is 45 × 18 (17¾ × 7).

Very well preserved. Some of the painted outlines which overlap the gold have flaked, particularly around St Dominic. The frame mouldings are original. The outer mouldings have been regilded. There is a slight *pentimento* in the Child's right arm. The top angels swing censers stippled into the gold.

Cleaned in 1959.

The saint on the right wing is probably St Aurea of Ostia,[1] although the inscription is not preserved for the latter part of the name. It is true that she does not carry a martyr's palm,

as St Aurea should, but martyrs in early Sienese painting often do not. It is also true that her only emblem, a cross, does not appear to be normally associated with St Aurea. Some confirmation that St Aurea is here intended is given by two other Sienese pictures, where the name is inscribed. One is a triptych signed and dated 1358, with the Virgin and Child enthroned with Sts Dominic and Aurea, and scenes from the life of St Aurea in the wings,[2] formerly in SS. Domenico e Sisto, Rome. The other is a reliquary triptych, attributed to Lippo Vanni, showing St Aurea with John the Baptist on either side of the Virgin and Child enthroned, with St Dominic included in one wing, in the Walters Art Gallery, Baltimore.[3] Given the rarity of the depiction of St Aurea, the connection of the Lippo Vanni with Sant' Aurea in Rome[4] and the association of St Aurea with Ostia, it is possible that No. 566 was made for a member or devotee of the Dominican Order in Rome. It may be that the Dominican convent of Sant' Aurea in Rome had a particular connection with Siena, although Pecchiai notes that the majority of nuns in the fourteenth century were Roman.[5]

However, the major obstacle to arguing a provenance of No. 566 from Sant' Aurea, Rome, is that the convent may well not have been in existence in Duccio's lifetime[6] (see below for the attribution). It is recorded neither in a catalogue of Roman churches nor in a catalogue of Dominican convents in the Provincia Romana, both of 1320, although a fourteenth-century hand added it to the latter.

Cannon[7] has plausibly argued that No. 566 could have been commissioned by Cardinal Niccolò da Prato (died 1321), a Dominican, who was cardinal of Ostia (promoted cardinal in 1298) and would therefore have had good reason to venerate St Aurea. He had three altarpieces which he willed to San Domenico, Prato. From there the altarpiece would have passed eventually into a private collection in Pisa (see PROVENANCE).

The patriarchs and prophets in the tympanum seem to be mingled in no logical order. All these figures appear with similar types, and (except for Jeremiah) with the same texts as here, in polyptych no. 47 (Siena, Pinacoteca Nazionale) sometimes ascribed to Duccio.[8] Most of these texts are applicable in a mystic way to the Virgin Mary.

The triptych No. 566 was attributed by Weigelt to Duccio[9] and since its acquisition has always been catalogued as by Duccio.[10] Most critics accept the attribution to Duccio, including Carli[11] and White,[12] who dates it c.1300. The attribution to Duccio has been doubted by Stubblebine,[13] who attributed it to Simone Martini in Duccio's shop and dated it c.1310–13. He was followed in this by Deuchler,[14] who agreed with the attribution to Simone Martini and suggested a date of c.1315.

The attribution of No. 566 is entangled with that of the Boston triptych, to which it is closely related. It is White[15] who has investigated this relationship most thoroughly. He discovered that it goes beyond a general similarity in design, punching, and the similar geometric patterns painted on the outside of the shutters. He analysed to the nearest millimetre the measurements of the two triptychs, discovering that they are almost identical, and that the triptychs were designed and probably also carved by the same hand. He noted that the Sienese *braccio* of 60.1 cm. provided the primary unit and that the same system of proportions governs the design of each. He also analysed how the proportional relationships affect the composition.

15

The punching of the gold of No. 566 with a border dividing the ground on which the saints are standing from the gold background is unusual in Sienese painting, but common in Umbrian painting of the thirteenth and fourteenth centuries.

PROVENANCE: Stated to be from a private collection in Pisa.[16] Purchased with the Lombardi-Baldi Collection, Florence, 1857.[17]

REFERENCES:

1. See G. Kaftal, *Iconography of the Saints in Tuscan Painting*, Florence, 1952, cols. 123–4.

2. Reproduced by C. H. Weigelt, *Sienese Painting of the Trecento*, Florence, n.d., pl. 114.

3. See Federico Zeri, *Italian Paintings in the Walters Art Gallery*, Baltimore, 1976, p. 44, no. 26, and pl. 22.

4. P. Pecchiai, *La Chiesa dello Spirito Santo dei Napoletani*, etc., 1953, pp. 37–8. He states that the Lippo Vanni in SS. Domenico e Sisto came from Sant' Aurea when the latter was abandoned in the sixteenth century.

5. Pecchiai, op. cit., p. 12.

6. Ibid., p. 10. He uses No. 566 to argue that the convent may have been in existence before that date.

7. Joanna Cannon, *Dominican Patronage of the Arts in Central Italy: the Provincia Romana, c.1220–c.1320*, unpublished thesis for the Courtauld Institute, University of London, 1980, p. 270; p. 315, note 240. On p. 312, note 222, she cites V. Fineschi OP, *Supplemento alla Vita del Cardinale Niccolò da Prato*, Lucca, 1758, pp. 47–54, esp. p. 50.

8. See J. H. Stubblebine, *Duccio di Buoninsegna and His School*, Princeton, 1979, pp. 67 ff. and figs. 140–4.

9. C. H. Weigelt, *Duccio di Buoninsegna. Studien zur Geschichte der Frühsienesischen Tafelmalerei*, Leipzig, 1911, pp. 162 ff. Weigelt wrongly identified St Aurea as St Agnes.

10. Ralph N. Wornum, *Descriptive and Historical Catalogue of the Pictures in the National Gallery. Foreign Schools*, 27th ed., London, 1858, p. 77; Martin Davies, *National Gallery Catalogues. The Earlier Italian Schools*, London, 1951, p. 133; 2nd ed. revised 1961, p. 171.

11. E. Carli, *La Pittura Senese del Trecento*, Milan, 1981, p. 44.

12. John White, *Duccio. Tuscan Art and the Medieval Workshop*, London, 1979, pp. 46 ff.

13. Stubblebine, op. cit., pp. 63 ff. He compares the Virgin to the unrestored parts of Simone Martini's *Maestà* dating from 1315, especially St Mary Magdalene, and St Dominic to St Dominic in the Pisa polyptych. Stubblebine notes that the haloes are the same as Duccio's Perugian Madonna. The border he likens to that of the Stoclet Madonna.

14. Florens Deuchler, 'Duccio et son Cercle', *Revue de l'Art*, 51, 1981, pp. 17–22, esp. p. 22, note 22. He suggests St Aurea is the point of departure for Mary Magdalene in the St Martin Chapel, Assisi. Deuchler in particular discusses the polemic of differing attributions to Duccio by White and Stubblebine.

15. John White, 'Carpentry and Design in Duccio's Workshop: the London and Boston Triptychs', *Journal of the Warburg and Courtauld Institutes*, XXXVI, 1973, pp. 92–105. See also J. H. Stubblebine, 'The Boston Ducciesque Tabernacle, a Collaboration', in *Collaboration in Italian Renaissance Art* (ed. W. S. Sheard and J. T. Paoletti), New Haven and London, 1978, pp. 1–20. He attributes the Boston wings to the young Simone Martini and the Crucifixion to the Tabernacle 35 Master.

16. National Gallery MS catalogue.

17. For the history of the Lombardi-Baldi Collection see Appendix I.

1139 *The Annunciation* Plate 17
(Predella panel from an altarpiece)

St Gabriel approaches from the left, and the Virgin looks up from her book, which is inscribed with the prophecy of Isaiah vii, 14: *Ecce / uirgo / concipi/et & pa/(ri)et / filiū & uoc/abitur*. Above, the Holy Spirit descends from God in the form of a dove.

Wood. Painted surface 43 × 44 (17 × 17¼).

The painting is made up of two pieces of poplar: an original strip (*c.* 2 cm.), visible at the back, has been added at the bottom. The edges are unpainted and canvas shows all the way round. The original frame no longer exists. The corners of the picture were once

covered by cross-pieces of the original frame; the evidence for this can be seen at the top left-hand corner, where a small piece remains.

The paint surface has been considerably damaged along the bottom and there is some damage at the left edge. There is also some damage to the Virgin's head-dress and halo. Otherwise the condition is good. The grain of the wood runs horizontally, as is normal for a predella.

There is an anomaly in the dark orange architecture below the angel's wing, which does not appear to make sense in terms of the pink wall.

There is a *pentimento* in the little finger of the angel's blessing hand.

Cleaned in 1981–2.

No. 1139 was the opening scene on the front predella of Duccio's *Maestà*, the double-sided altarpiece painted for the high altar of Siena Cathedral, and completed in 1311 (Fig. 3).

The next narrative scene following No. 1139 on the right was the *Nativity* (Washington, National Gallery of Art). Separating the two scenes was the prophet Isaiah (also Washington, National Gallery of Art), holding a scroll which bears exactly the same text as that inscribed on the book the Virgin is reading in No. 1139. Isaiah turns away from the *Nativity* back to the *Annunciation*.[1]

No. 1139 is one of the few scenes of the *Maestà* which, as the opening scene of the front predella, and outstanding in its draughtsmanship and palette, is universally agreed to be attributable to Duccio himself. Stubblebine,[2] who argues a hypothetical journey to Rome by Duccio, suggests the vase of lilies may derive from Cavallini's *Annunciation* mosaic in Santa Maria in Trastevere, Rome.

Technically No. 1139 is interesting because it represents a rare early example of mordant gilding used in the chrysography of the Virgin's robe: the gold lines are gold leaf, stuck down on to outlines drawn with a mixture of lead white and yellow-brown ochre in an oil medium.[3]

Joanna Cannon (oral communication) has observed that the incised gesture of the angel's hand, with three as opposed to two fingers outstretched, was almost unknown in Italian thirteenth- and fourteenth-century art, but was common in Byzantine Annunciations of that date. Duccio's original source and the reason for the change to two fingers in the final version are unclear.

For a fuller description of this altarpiece and its reconstruction see pp. 19–22 below.

PROVENANCE: Purchased, Clarke Fund, from C. Fairfax Murray of Florence, 1883.

REFERENCES:
1. Ruth Wilkins Sullivan ('Some Old Testament Themes on the Front Predella of Duccio's *Maestà*', *Art Bulletin*, LXVIII, 1986, pp. 597–609) argues that the sequence of the front predella was based on the Infancy text in the Gospel of St Matthew, which is distinctive in citing six Old Testament prophecies, each one cited *after* the event fulfilled.
2. J. H. Stubblebine, *Duccio di Buoninsegna and His School*, Princeton, 1979, pp. 54–5; also pp. 6–7.
3. Joyce Plesters, Ashok Roy and David Bomford, 'Interpretation of the Magnified Image of Paint Surfaces and Samples in Terms of Condition and Appearance of the Picture – Recognition of Original Techniques and Procedures of the Artist, The Elucidation of an Early Gilding Technique', *Science and Technology in Conservation*, Washington Congress, 1982, pp. 171–2.

1140 *Jesus opens the Eyes of a Man born Blind* *Plate 15*
(Predella panel from an altarpiece)

Christ, followed by the twelve Apostles, touches the eyes of a beggar; on the right, the same beggar, having washed in the pool of Siloam, recovers his sight.

Wood. Painted surface 43.5 × 45 (17 × 17¾); painted up to the edges all round.

The panel is constructed of three pieces of wood: both top and bottom edges have original additions which are one centimetre wide.

The condition is good except for a large damaged area at the right edge which affects the top of the fountain, the beggar's face and part of the grey wall and gold background. The grain of the wood runs horizontally, as one would expect.

Cleaned in 1982–3.

Several miracles of healing the blind are recorded in the Gospels, but the subject here is undoubtedly the one described in John ix, 1 ff.[1]

No. 1140 came originally from the back predella of Duccio's *Maestà* painted for the high altar of Siena Cathedral and completed in 1311 (Fig. 4). It was probably the seventh out of nine narrative scenes, and came after *Christ and the Woman of Samaria* and before the *Transfiguration* (No. 1330).

White[2] comments on the compositional link of No. 1140 with the *Transfiguration* (No. 1330): No. 1140 would have been positioned immediately to the left of No. 1330 and the blind man with his restored sight looks up to gaze at the figure of Christ in the *Transfiguration*. Stubblebine[3] interprets the composition according to Byzantine iconography, explaining the beggar raising his eyes as deriving from a Byzantine manuscript formula.

White[4] draws attention to the complexity of the architecture, while it is this interest in spatial organisation which leads Stubblebine[5] to attribute the scene specifically to Pietro Lorenzetti.

A fourteenth-century Sienese drawing in the British Museum (1895–9–15–680) was shown by Pouncey to derive generally from No. 1140.[6]

For a fuller discussion of the altarpiece and its reconstruction see pp. 19–22 below.

PROVENANCE: Purchased, Clarke Fund, from C. Fairfax Murray of Florence, 1883.

REFERENCES:

1. For a discussion of the iconography of this scene see P. Singelenberg, 'The Iconography of the Etschmiadzin Diptych and the Healing of the Blind Man at Siloe', *Art Bulletin*, XL, 1958, pp. 105–12.
2. John White, *Duccio. Tuscan Art and the Medieval Workshop*, London, 1979, p. 122.
3. J. H. Stubblebine, *Duccio di Buoninsegna and his School*, Princeton, 1979, pp. 49, 51. Stubblebine uses the *Healing of the Blind Man* as one of the main scenes in his hypothesis that Duccio's *Maestà* derived from an unknown Byzantine manuscript source dating from the second half of the thirteenth century (idem, 'Byzantine Sources for the Iconography of Duccio's *Maestà*', *Art Bulletin*, LVII, 1975, pp. 176–85).
4. White, op. cit., pp. 109 ff.
5. Stubblebine, op. cit., p. 40.
6. P. Pouncey, 'Two Simonesque Drawings', *The Burlington Magazine*, LXXXVIII, 1946, pp. 168–72.

1330 *The Transfiguration* Plate 16
(Predella panel from an altarpiece)

Centre, Christ; on the left, Moses; on the right, Elijah. Below, the three Apostles, Peter, John and James.

Wood. Painted surface 44 × 46 ($17\frac{3}{8}$ × $18\frac{1}{8}$). The size of the panel, which is the same as that of the picture together with its frame, is 49 × 51 ($19\frac{1}{4}$ × 20). The frame is not in one piece with the panel, but is clearly the original, since original canvas runs over it. An original addition (*c.*3.5 cm. wide), visible at the back, which runs along the bottom, seems to have been removed and refixed at some time.

No original paint is left on a substantial part of the central Apostle, and in general the whole lower part of the picture is damaged. The upper part is reasonably well preserved: the figure of Christ and the gold background are in good condition.

The subject is described in three of the Gospels (Matthew xvii, 1–8; Mark ix, 2–8; Luke ix, 28–36).

Like No. 1140 above, No. 1330 came from the back predella of Duccio's *Maestà*, completed in 1311 for the high altar of Siena Cathedral (Fig. 4). It was probably the penultimate scene, located between No. 1140 and the *Raising of Lazarus* (Fort Worth, Kimbell Art Museum).

As Stubblebine[1] points out, unlike the rest of the pre-Resurrection scenes in Duccio's *Maestà*, Christ is shown in a gold-striated robe to indicate His transfigured state. He again appears in gold-striated robes from the *Harrowing of Hell* onwards (excepting His pilgrim's disguise in the *Road to Emmaus*). Stubblebine also notes the closeness of the composition to the Lenten hanging (Siena, Pinacoteca Nazionale) attributed to Guido da Siena.

For a fuller discussion of the altarpiece and its reconstruction see below.

PROVENANCE: Acquired in Siena by R. H. Wilson, a few years before he presented it to the National Gallery in 1891.[2]

REFERENCES:
1. J. H. Stubblebine, *Duccio di Buoninsegna and His School*, Princeton, 1979, pp. 56–7.
2. Letter in the National Gallery archives.

HISTORY AND RECONSTRUCTION OF THE ALTARPIECE

The three fragments Nos. 1139, 1140 and 1330 all come from the only surviving work signed by Duccio: the gigantic double-sided altarpiece painted for the high altar of Siena Cathedral, which was carried from Duccio's workshop to the Duomo amidst great jubilation on 9 June 1311.[1] A document dating from 9 October 1308[2] exists, in which Duccio promises to work continuously on the altarpiece, not to accept any commissions in the interim, and to work on the altarpiece with his own hands. Until recently it was believed by all Duccio scholars that this document represented the beginning of the commission. However, in a review of the two monographs on Duccio by Stubblebine and White (see below), Pope-Hennessy[3] plausibly argued that the document of 1308

could not possibly have been the commissioning document, since it did not stipulate the form and subject of the altarpiece, as was usual; he argued that it was an interim agreement which referred back to a lost antecedent document and that therefore the altarpiece was probably begun in 1304, 1305, or 1306. Of these 1305 or 1306 is the most likely year, since around 1304/5 Duccio was probably engaged on a polyptych for San Domenico, Perugia.[4] A document recorded in the nineteenth century and thought to date from 1308–9 records an agreement for the making of the panel for the rear face of the altarpiece consisting of thirty-four histories and little angels above, and the payment due.[5]

The *Maestà* was removed from the high altar in 1506 to make way for a new altar placed further towards the apse and bearing a bronze tabernacle by Vecchietta, originally made for Santa Maria della Scala.[6] The altarpiece was sawn into several pieces in 1771 and thereafter the fragments led a somewhat peripatetic existence.[7]

The surviving fragments in Siena (Museo dell'Opera del Duomo) are as follows:
MAIN FRONT PANEL showing the Virgin and Child enthroned with various saints, including the patron saints of Siena – Ansanus, Sabinus, Crescentius, Victor – and bearing the signature: MATER SCA DEI SIS CAUSA SENIS REQUIEI SIS DUCIO VITA TE QUIA PINXIT ITA, and an upper tier with half-length figures of ten Apostles;

FRONT PREDELLA: Infancy of Christ:
Adoration of the Magi; *Presentation in the Temple* with *David* and *Malachi*; *Massacre of the Innocents*; *Flight into Egypt* with *Jeremiah* and *Hosea*; *Teaching in the Temple*.

FRONT PINNACLES: Scenes from the Life of the Virgin:
Annunciation of the Death of the Virgin; *Arrival of St John*; *Gathering of the Apostles*; *Death of the Virgin*; *Funeral Procession of the Virgin*; *Burial of the Virgin*.

MAIN BACK OF ALTARPIECE: Passion of Christ:
Entry into Jerusalem; *Last Supper* with *Washing of the Feet*; *Judas taking the Bribe* with *Christ taking Leave of the Apostles*; *Betrayal* with *Agony in the Garden*; *Christ before Annas* with the *First Denial*; *Second Denial* with the *Third Denial*; *Christ accused by the Pharisees* with *Christ before Pilate*; *Christ before Herod* with *Christ in the Robe before Pilate*; *Flagellation* with *Crowning with Thorns*; *Pilate washing his Hands* with *Carrying of the Cross*; *Crucifixion*; *Deposition* with *Entombment*; *Maries at the Tomb* with *Harrowing of Hell*; *Noli me Tangere* with *Apparition on the Road to Emmaus*.

BACK PREDELLA: Ministry of Christ:
Temptation on the Temple; *Feast at Cana*.

BACK PINNACLES: post-Resurrection scenes:
Apparition behind Closed Doors; *Incredulity of St Thomas*; *Apparition on the Sea of Tiberius*; *Apparition in Galilee*; *Apparition at Supper*; *Pentecost*.

Fragments no longer in Siena are as follows:
FRONT PREDELLA SCENES: *Annunciation* (No. 1139) and *Nativity* with Isaiah and Ezekiel (Washington, National Gallery of Art).

BACK PREDELLA SCENES: *Temptation on the Mountain* (New York, Frick Collection); *Calling*

of Peter and Andrew (Washington, National Gallery of Art); *Christ and the Woman of Samaria* (Lugano, Thyssen Collection); *Healing of the Blind Man* (No. 1140); *Transfiguration* (No. 1330); *Raising of Lazarus* (Fort Worth, Kimbell Art Museum). Possibly associated with the *Maestà* are four angel pinnacles in the John G. Johnson Collection, Philadelphia; Mount Holyoke College, South Hadley, Mass.; J. W. van Heek Collection, Castle Bergh, the Netherlands; formerly Stoclet Collection, Brussels.

Various scholars have attempted a reconstruction of the original appearance of the *Maestà*.[8] Of all the reconstructions the most rigorously methodical and therefore the most convincing is that made by White (Figs. 3 and 4).[9] He proposes that the front predella consisted of seven scenes from the Infancy of Christ, starting with the *Annunciation* (No. 1139) and ending with the *Teaching in the Temple*, the scenes being separated by prophets. The back predella showed nine scenes from the Ministry of Christ beginning with a now lost scene, probably the *Baptism of Christ*[10] and ending with the *Raising of Lazarus*. The main front panel showed the Virgin and Child enthroned with angels and saints, and Apostles above. On the back were the twenty-six scenes from the Passion starting at the bottom left-hand corner with the *Entry into Jerusalem* and ending at the top right-hand corner with the *Apparition on the Road to Emmaus*. The pinnacles on the front showed six scenes from the Last Days of the Virgin from the *Annunciation of the Death of the Virgin* to the *Burial*; missing in the centre would have been probably the *Assumption* and *Coronation*. The back pinnacles continued the Passion of Christ, starting with the *Apparition behind Closed Doors* and ending with the *Pentecost*; missing in the centre were probably the *Ascension* and either the *Resurrection* or *Christ in Majesty*.[11] Finally the truncated pyramids of the pinnacles were surmounted by half-length angels, of which only four survive. The front face was made up of eleven vertical planks and the back face of five horizontal planks. The front predella consisted of a separate single horizontal piece of wood, as did the back predella.

White's reconstruction was refined by Gardner von Teuffel[12] with regard to the outer structure and support of the altarpiece. She pointed out that a frame box was unlikely in the context of such a gigantic free-standing altarpiece, and that although the predella had some supporting function, it would have been inadequate on its own. She argued that the altarpiece was originally supported by lateral buttresses, possibly decorated with fictive *cosmati* patterns of the kind found in the Virgin's throne. This was a revolutionary solution invented by Duccio to solve the particular problem of this unprecedented type of altarpiece, and its repercussions, she maintained, were far-reaching and long-lasting.

White[13] discusses in full the proportional system used in the designing of the *Maestà*, its significance for Siena, its setting in the Duomo, and the sequence of execution and development of the scenes.[14]

The attribution of the individual parts of the *Maestà* remains problematic. Although all critics acknowledge workshop collaboration, White rightly warns against the attribution of specific scenes to individual painters, while Stubblebine is zealous in apportioning scenes to Segna di Bonaventura, Ugolino di Nerio, the Lorenzetti and Simone Martini. He is emphatic that the only narrative scenes painted by Duccio himself are the seven scenes of the front predella.[15]

REFERENCES:

1. See J. H. Stubblebine, *Duccio di Buoninsegna and His School*, Princeton, 1979, pp. 33 ff.; hereafter cited as Stubblebine, *Duccio*. See also John White, *Duccio. Tuscan Art and the Medieval Workshop*, London, 1979, pp. 46–7 and 196; hereafter cited as White, *Duccio*.

2. See White, *Duccio*, pp. 192 ff., for the document and a translation.

3. J. Pope-Hennessy, 'A Misfit Master', *New York Review of Books*, 20 November 1980, pp. 45 ff.

4. The Perugian polyptych, of which the surviving central panel of the Virgin and Child is generally accepted as autograph, most probably preceded the *Maestà*. Dated by Stubblebine *c.*1302 (*Duccio*, pp. 30–1), by White *c.*1300–5 (*Duccio*, pp. 62–3), and *c.*1300 by F. Deuchler (*Duccio*, Milan, 1984, p. 46). Only Gardner von Teuffel (art. cit., see note 12 below, pp. 44–5 and n. 55) considers the Perugia polyptych a 'late' work by Duccio, dating it after the *Maestà*. She cites W. Krönig ('Hallenkirchen in Mittelitalien', *Kunstgeschichtliches Jahrbuch der Bibliotheca Hertziana*, II, 1938, pp. 91–104) for 1304 as the beginning of the building of the present church of San Domenico, which gives a possible *terminus post quem*. It must be said that, judging from the document of 1308 (see above, p. 19), Duccio may well have sometimes taken on commissions which he neglected or left largely to assistants. It could well have been the Perugia polyptych, which is surely autograph, which distracted him from total commitment to the *Maestà* and necessitated the drawing up of the 1308 agreement.

5. Although White considers the entire structure to have been completed before painting began (*Duccio*, p. 93), elsewhere he stresses the *ad hoc* nature of the process and the necessity of finding solutions as problems arose (ibid., p. 82).

6. Stubblebine, *Duccio*, p. 35.

7. See Stubblebine, *Duccio*, p. 35; and White, *Duccio*, p. 179, note 1 to Chapter VI. Stubblebine gives a detailed account of the history of the altarpiece after its dismantling. See also Deuchler, op. cit., pp. 68–73.

8. Previous reconstructions of the *Maestà* are listed by Stubblebine, *Duccio*, p. 37, and illustrated by him (ibid., figs. 581–93); see also Deuchler, op. cit., pp. 76–7. Most critics, except Lusini and Cooper, agree that the front predella consisted of the seven surviving panels showing the Infancy of Christ.

9. White, *Duccio*, pp. 80 ff., 201 ff. and figs. 51 and 52. See also idem, 'Measurement, Design and Carpentry in Duccio's *Maestà*', I, II, *Art Bulletin*, LV, 1973, pp. 334–66 and 547–69.

10. It has been suggested that this scene is reflected in a *Baptism* (Budapest, Magyar Szépművészeti Múzeum, no. 6) attributed to a follower of Ugolino di Nerio (Stubblebine, *Duccio*, pp. 186–7 and fig. 466). Stubblebine argued that the *Maestà* stood on a box predella painted with scenes at the side edges: he suggested that the series began with *The Baptist bearing Witness* at the side; under the main panels this was followed by the now lost *Baptism* and *Temptation in the Wilderness*; then came the eight extant scenes, of which the *Raising of Lazarus* was situated at the opposite end to *The Baptist bearing Witness*, on the other side (J. H. Stubblebine, 'The Back Predella of Duccio's *Maestà*', in *Studies in Late Medieval and Renaissance Painting in Honour of Millard Meiss*, New York, 1977, pp. 430–6). Stubblebine's box predella arrangement was accepted by Ruth Wilkins Sullivan, who, however, suggested the (lost) *Baptism* in place of *The Baptist bearing Witness* at one end, and the *Anointing in Bethany* (now lost) at the other, in place of the *Raising of Lazarus*. The sequence under the main panels she suggested as running from the (lost) *Temptation in the Wilderness* followed by the eight extant scenes which finished with the *Raising of Lazarus* (Ruth Wilkins Sullivan, 'The Anointing in Bethany and Other Affirmations of Christ's Divinity on Duccio's Back Predella', *Art Bulletin*, LXVII, March 1985, 1, pp. 32–50).

11. For the criticisms made by Gardner von Teuffel see note 12.

12. C. Gardner von Teuffel, 'The Buttressed Altarpiece: A Forgotten Aspect of Tuscan Fourteenth Century Altarpiece Design', *Jahrbuch der Berliner Museen*, 21, 1979, pp. 34 ff. Gardner von Teuffel disagreed with White's reconstruction of the centre top pinnacles, arguing that the *Assumption* would have surmounted the *Coronation* in the centre front, given the dedication of the cathedral to the *Assunta*, and that they would have been matched by the *Resurrection* and *Ascension* on the back (ibid., p 36, n. 27).

13. White, *Duccio*, pp. 102 ff. Hayden B. J. Maginnis ('The Literature of Sienese Trecento Painting 1945–75', *Zeitschrift für Kunstgeschichte*, XL, 1977, pp. 279 ff.) points out that White's speculations about the proportional system used are missing the crucial measurement of the width, including the frame, which is unknown.

14. See also discussions of the *Maestà* by H. W. van Os in his *Sienese Altarpieces 1215–1460*, Groningen, 1984, pp. 39 ff., and esp. pp. 46 ff. for No. 1139; also Florens Deuchler, 'Duccio *Doctus*: New Readings for the *Maestà*', *Art Bulletin*, LXI, 1979, pp. 541–9.

15. Stubblebine, *Duccio*, pp. 39 ff.

Follower of DUCCIO

6386 *The Virgin and Child with Four Angels* *Plate 18*
(Wing of a diptych?)

Wood. Painted surface 36×23.5 ($14\frac{1}{4} \times 9\frac{1}{4}$); including the frame 41×28.5 ($16\frac{1}{4} \times 11\frac{1}{4}$).

The condition in general is excellent. The frame, which is original, has been regilded. The outside edge is painted with red which may be original.

The back has a gesso ground which according to the report in the National Gallery dossier may be original. It is marbled with various pigments, including azurite, which have turned a translucent brown.

On the right side marks of two plates with nail holes indicate that at some stage the panel was hinged to another. *Duccio Senese* is written in a nineteenth-century hand on the bare wood of the back where the gesso has fallen away.

Cleaned in 1968.

When it was acquired in 1968 this panel was attributed to Duccio by Martin Davies,[1] who dated it contemporary with the *Maestà* of *c*.1308–11, perhaps a little earlier. Stubblebine[2] accepts the attribution to Duccio, but dates it considerably earlier, to the late 1290s or *c*.1300. He places it after the hypothetical journeys of Duccio to Paris and Rome, citing the influence of Cavallini for the mosaic throne. However, most writers doubt the attribution to Duccio and vary considerably in their dating of the panel. White[3] rejects the attribution to Duccio on the grounds of the heavy opaque quality of the colours, the texture of the paint, the unusual amount of foreground space, the small size of the Virgin's head and the elongated figures of the angels, and attributes it to the Master of Città di Castello, dating it *c*.1315. Deuchler,[4] who describes it only as by a follower of Duccio, accepts White's dating, calling it *c*.1315–20. As no comparable small-scale work attributable to the Città di Castello Master exists, this does not seem a tenable attribution. If anything, No. 6386 seems to have some stylistic affinities with works usually grouped around the Badia a Isola Master,[5] although it is softer and presumably later in style, and again no small-scale comparable work exists. Julian Gardner (oral communication) has suggested that it may be by the same painter responsible for the *Virgin and Child with Saints and a Dominican Donor* in the Ryerson Collection in the Chicago Art Institute.[6]

One panel which may possibly be by the same hand as No. 6386 is the small fourteenth-century Sienese *Maestà* surmounted by a gable with the *Crucifixion* (ex-Florence Gould Collection),[7] which appears to have the same elongated figures and chalky colours. In the absence of any firm evidence it seems best to regard No. 6386 simply as by a follower of Duccio.

The iconography of the Child reaching up to the Virgin's veil is common in fourteenth-century Sienese painting, as is the inlaid marble throne. What is unusual is the absence of any back to the throne, replaced entirely by the cloth of honour.

A number of small-scale rectangular *Maestà* panels exist from the Sienese School of the fourteenth century.[8] Closest, however, is the *Maestà* in the Kunstmuseum, Bern,[9] which is smaller, but has a similar frame moulding, and in which the throne back is also obscured by the cloth of honour, although the painting is clearly by a different hand.

The hinge marks at the side (see above) indicate that No. 6386 was perhaps once the left wing of a diptych. Certainly the description in the Manchester Catalogue of 1878,[10] 'St Anna of Sienna [sic] with the Virgin and Child Jesus', implies that it was then still a diptych. Although in Sienese fourteenth-century painting there is an instance of St Anne being shown with the Virgin only, it is in a single example.[11] Richard Camber in a written communication to the National Gallery suggested that Anna was an inexperienced reading of St Ansanus, given that there is no such person as St Anne of Siena, and that therefore the right wing of the diptych originally showed St Ansanus, one of the patron saints of Siena. However ingenious a theory, it must be said that confusion between a male and female saint seems unlikely, that there is no comparable surviving work, and that small panels of the *Maestà* subject were normally paired with the *Crucifixion*.[12]

PROVENANCE: In the collection of James F. Hutton of Manchester;[13] probably lent by Hutton to the Art Treasures Exhibition in Manchester, May–July 1878 (catalogue p. 114, no. 3 of the picture section);[14] sold as property of J. F. Hutton dec'd at Christie's, 16 July 1890, lot 156;[15] bought by Hassan; sold as property of T. R. Bridson at Aldwick Court, Wrington, Somerset, 26 March 1968, lot 23;[16] purchased by Julius H. Weitzner; acquired in 1968 by the National Gallery after an export licence had been withheld by the Reviewing Committee on the Export of Works of Art, with help from donations from the NACF (Eugene Cremetti Fund) and an anonymous donor.

REFERENCES:

1. Martin Davies, 'Duccio: An Acquisition', *The Burlington Magazine*, CXI, 1969, pp. 4 ff. See also idem, *National Gallery Report*, 1967–8, pp. 29–30.
2. J. H. Stubblebine, *Duccio di Buoninsegna and His School*, Princeton, 1979, pp. 28–30 and fig. 41; hereafter cited as Stubblebine, *Duccio*.
3. John White, *Duccio. Tuscan Art and the Medieval Workshop*, London, 1979, pp. 152–3.
4. Florens Deuchler, *Duccio*, Milan, 1984, p. 216, no. 8.
5. Especially the *Maestà* in the Cini Collection, Venice. See Stubblebine, *Duccio*, fig. 176.
6. Stubblebine, *Duccio*, fig. 444.
7. Stubblebine, *Duccio*, fig. 472. He ascribes it to a follower of Ugolino. For a colour reproduction see Sotheby's, *Old Master and 19th and 20th century Paintings and Drawings from the Estate of Florence J. Gould*, New York, 25 April 1985, lot 88, where it is described as by a follower of Duccio.
8. e.g. Stubblebine, *Duccio*, figs. 212, 216, 257, 258, 259, 266, 444.
9. Robert Steiner, 'Die Berner Maestà von Duccio di Buoninsegna', *Mitteilungen des Berner Kunstmuseums*, 103, July–August 1968, pp. 1–7. Stubblebine (*Duccio*,

pp. 126–7) distances this work from Duccio's circle and suggests that the backless throne was inspired by No. 6386. He dates it *c.* 1305. White (op. cit., p. 152) attributes it to the circle of Duccio and dates it *c.* 1305–10(?).
10. See note 14.
11. e.g. Stubblebine, *Duccio*, fig. 419.
12. e.g. Stubblebine, *Duccio*, figs. 212 and 213, 216 and 217.
13. Born 1826, died 1890. For information on this collector see J. A. and C. P. Hutton, *Hutton Families*, 1939, pp. 14 ff.
14. Information supplied to the National Gallery by Sir Geoffrey Agnew in 1968. Julian Treuherz of Manchester City Art Gallery was kind enough to supply the present compiler with a photocopy of the relevant page.
15. As Duccio (of Siena), *St Anna of Siena, with the Virgin and Child*.
16. As 'Sienese School (Fifteenth Century)'. It had been purchased about fifty years previously by T. R. Bridson's father, Harry. Information kindly supplied to the National Gallery by the Lady Robinson, niece of Harry Bridson.

FLORENTINE School

3120 *Head of a Male Saint*
(Fragment)

Plate 66

Fresco. Irregular shape, 42×33 ($16\frac{1}{2} \times 13$).

Much damaged; the corners at the bottom right and left are new.

This fragment is from the church of the Carmine in Florence;[1] there is good evidence that it is from the chapel dedicated to St Andrew, founded by Ugolino di Bonsi after 1365.[2] Some fragments from the same series, in very poor condition, are stated to be still in the chapel, behind more modern decoration.[3] The concave surface of No. 3120 rather suggests that it was from a vault; but it is impossible to say of what scene this head formed a part. No. 3120 is too badly damaged to make an attribution possible.

PROVENANCE: From the Chapel of Sant' Andrea in the Carmine in Florence (see above). The Carmine was largely destroyed by fire in 1771 and thereafter reconstructed, with an altered arrangement of the chapels. No. 3120 is presumably one of the fragments discovered in the Carmine in September 1859;[4] in the collection of Sir Austen Henry Layard by 1864.[5] Exhibited in South Kensington, 1869 (no. 53); Layard Bequest, 1916.[6]

REFERENCES:

1. Layard MSS, in the National Gallery.
2. J. A. Crowe and G. B. Cavalcaselle, *A New History of Painting in Italy*, I, London, 1864, p. 365, mention No. 3120 as being from the Velluti Chapel. Velluti is, however, a mistake and the correction to Bonsi was made in the Italian edition (II, 1883, p. 35). The correction was doubtless due to Santi Mattei, *Ragionamento intorno all'antica chiesa del Carmine di Firenze*, 1869, p. 13. Mattei does not mention No. 3120 explicitly, but does refer to the passage in Crowe and Cavalcaselle, claiming that the chapel in question is the Bonsi Chapel, that he, Mattei, discovered the remains of frescoes in it in September 1859, and that it

was he who showed these remains to Cavalcaselle and to Ugo Baldi. For the history of the chapel, see Ugo Procacci in the *Rivista d'Arte*, 1932, pp. 156–7 and 192. It may be mentioned that this chapel is distinct from the Manetti Chapel in the Carmine in Florence, from which comes No. 276 by SPINELLO ARETINO.
3. Procacci, loc. cit.; but Procacci in the *Bollettino d'Arte*, 1933–4, p. 332, states that attempts to find further remains in the chapel revealed nothing.
4. Santi Mattei, as in note 2.
5. Crowe and Cavalcaselle, as in note 2.
6. For the history of the Layard Collection see Appendix II.

3895 *The Dead Christ and the Virgin*
(Wing of a diptych)

Reverse: a painted Cross, with some of the Instruments of the Passion (spear, sponge, hammer, three nails, and vessel for vinegar[?]).

Wood. Painted surface 58.5×38.5 ($23 \times 15\frac{1}{4}$). The size of the painting on the reverse is 59×39.5 ($23\frac{1}{8} \times 15\frac{1}{2}$). The condition of the gold patterning on the front shows that the picture has been cut about 1.25 cm. at the top, the width of the outside border, and has lost some of the edging with the removal of the original frame.

Very considerably damaged, the worst losses being in the lining of the Virgin's mantle; but the extensive overpainting, removed during the cleaning, covered much original paint not badly preserved. The reverse has many lacunae.

Cleaned in 1951–2.

The pot on the reverse of No. 3895 would seem to be the 'vessel full of vinegar' of John xix, 29, although the nails are actually placed in it.

The other wing of this diptych (Fig. 2) is in the Robert Lehman Collection, Metropolitan Museum of Art, New York (no. 1975.1.102). It represents St John the Evangelist and presumably the Magdalen; it is cradled, and apparently retains no painting on the back.[1]

The diptych operates on several different levels: it refers to the *Pietà* with the Virgin holding the body of Christ, to the Crucifixion with the presence of mourning angels, and to the Lamentation through the presence of John the Evangelist and Mary Magdalene. The arrangement of No. 3895 is, to the present writer's knowledge, unique. It was common to represent the Man of Sorrows,[2] usually with His arms folded across His body, either as the right wing of a diptych, with the Virgin and Child in the left wing,[3] or at the centre of a triptych with the mourning Virgin in the left wing and St John the Evangelist in the right wing.[4] No. 3895 represents a conflation of the two formulae,[5] adding to them the presence of Mary Magdalene. The combination of these four figures occurs also in a signed altarpiece by Giovanni da Milano dated 1365 (Florence, Accademia)[6] where they are all united in a single panel. It is difficult to say whether No. 3895 derives from or leads up to that type of altarpiece. Although found in Sienese, Florentine and Neapolitan painting, the theme of the Man of Sorrows seems to have been particularly deep-rooted in Venetian painting from the thirteenth until at least the fifteenth century. A thirteenth-century wing of a Venetian diptych, formerly in the Stoclet Collection, Brussels, shows the Man of Sorrows with mourning angels.[7] A triptych with the Man of Sorrows and Madonna of Humility, with Instruments of the Passion on the outsides of the wings, is in the Accademia in Venice.[8]

No. 3895 entered the Gallery as by Ambrogio Lorenzetti,[9] but it appears rather to be Florentine. Gronau calls it style of Daddi;[10] Berenson in his 1936 *Lists* doubtfully suggests a Neapolitan follower of Giotto; Coletti puts it into relation with 'Giottino'.[11] Some critics find it not quite Florentine in style;[12] but in any case No. 3895 is near to a somewhat damaged *Crucifixion* in the Louvre,[13] which is sometimes said to be by the same hand.[14] Most recently it was attributed by Bologna[15] to the Neapolitan painter Roberto d'Odorisio.

PROVENANCE: Thomas Watson Jackson sale, 14 May 1915 (lot 49),[16] bought by Wagner. Presented by Henry Wagner, 1924.

REFERENCES:

1. Published by H. D. Gronau, 'Notes on Trecento Painting', *The Burlington Magazine*, LIII, 1928, pp. 78 ff.

2. For a discussion of the iconography of the Man of Sorrows see E. Panofsky, 'Imago Pietatis', in *Festschrift für Max J. Friedländer*, 1927, pp. 261 ff., and Hans Belting, *Das Bild und sein Publikum im Mittelalter. Form und Funktion früher Bildtafeln der Passion*, Berlin, 1981, esp. pp. 53 ff. and pp. 263 ff.

3. e.g. the fourteenth-century Sienese diptych in the Horne Museum, Florence (Belting, op. cit., fig. 10).

4. Ibid., fig. 12.

5. Compare a diptych painted on ivory in the Ambrosiana, Milan, reproduced by P. Toesca, *Storia dell'Arte Italiana: Il Trecento*, Turin 1951, fig. 672, which shows the Virgin and John the Evangelist in one wing and the Man of Sorrows in the other.

6. See L. Marcucci, *Gallerie Nazionali di Firenze. I Dipinti Toscani del Secolo XIV*, Rome, 1965, pp. 86–8, no. 49.

7. Belting, op. cit., fig. 101.

8. S. Moschini Marconi, *Gallerie dell'Accademia di Venezia, Opere d'Arte dei Secoli XIV e XV*, Rome, 1955, no. 16.

9. Borenius in *The Burlington Magazine*, XXVII, 1915, p. 27, calls it style of the Lorenzetti. The Lehman wing has also been associated with the Sienese School; S. Ameisonowa in the *Rivista d'Arte*, 1939, pp. 118–19, as Master of the St George Codex.

10. H. D. Gronau, loc. cit. in note 1.

11. L. Coletti in *Emporium*, 1942, pp. 470–2. L. Venturi, *Pitture Italiane in America*, Milan, 1931, pl. XLII, calls the Lehman picture Florentine. J. Pope-Hennessy, *The Robert Lehman Collection. I. Italian Paintings*, The Metropolitan Museum of Art, New York, 1987, pp. 93–5.

12. G. M. Richter in *The Burlington Magazine*, LIX, 1931, p. 251, is reminded of the Maestro delle Vele in the types of the Lehman picture, but sees a Sienese character in the goldwork.

13. Seymour de Ricci's catalogue, *Ecoles Etrangères, Italie et Espagne*, 1913, p. 190, no. 1665A, as Sienese; reproduced by L. Coletti in *Emporium*, 1942, p. 474, fig. 14.

14. Berenson in his 1936 *Lists* calls the Louvre picture 'Maso'. Coletti, loc. cit., sees an identity of hand. Sergio Bettini, *Giusto de' Menabuoi e l'Arte del Trecento*, Padua, 1944, p. 57, does not.

15. F. Bologna, *I Pittori alla Corte Angioina di Napoli 1266–1414*, Rome, 1969, pp. 14, 301–3.

16. As Sienese.

Agnolo GADDI
active 1369, died 1396

A Florentine painter, a son of Taddeo Gaddi.[1] He is first documented in 1369, working in the Vatican as an assistant, probably to his brother Giovanni. A number of documents of the 1380s and 1390s show him active in Florence, chiefly working on the Loggia dei Lanzi and Duomo. Frescoes in the choir of Santa Croce, Florence, are attributed to him by a good tradition. A series of frescoes in the Cappella della Cintola in the cathedral of Prato are documented 1392–5, and in 1395 he was paid for a fresco of the *Assumption of the Virgin* for Prato Cathedral, now lost. An altarpiece in San Miniato, Florence, is documented 1394–6. It is probable that in all these works the execution is partly by assistants. Other pictures have at one time or another been ascribed to Agnolo Gaddi, but critical opinion about most of them has varied considerably. One of his chief patrons was the merchant of Prato, Francesco Datini.

REFERENCE:
1. Most recently see Bruce Cole, *Agnolo Gaddi*, Oxford, 1977.

Attributed to AGNOLO GADDI

568 *The Coronation of the Virgin* *Plate 21*
(Part[?] of an altarpiece)

Wood. 182 × 94 (71¾ × 37), arched top; the edges show that it has been trimmed all round (presumably the arched top and steps of the throne were once complete).

The picture is in good condition for a work of the period, but is not free from retouching on some of the important parts. Nevertheless, except for a split down the middle, some

damage at the bottom, and the renewal of the gold background, it is in a satisfactory state. The original frame no longer exists.

The attribution of No. 568 to Agnolo Gaddi, first made by Sirèn,[1] is generally accepted (see below).

The panel was stated to have come from the Convent of Minori Osservanti in San Miniato[2] and Martin Davies suggested that this might be identifiable with San Miniato al Tedesco between Florence and Pisa, which has a convent of San Francesco dating back to 1221.[3] Boskovits[4] suggested it was originally taken to San Miniato al Tedesco from San Giovanni de' Fieri (near Pisa): his argument is based on the association of No. 568 with two wings showing paired standing saints – Bartholomew and Anthony Abbot, and Peter and James – coming from that church. He observes that these standing, lateral saints now in the Museo Nazionale di San Matteo, Pisa (inv. nos. 1689 and 1692), which would have been to the right of No. 568, stand on the same red brocade ground.[5] He places No. 568 as an early work by Agnolo Gaddi, c.1380. Bruce Cole,[6] who rejects Boskovits' attribution of the Pisan saints to Gaddi, nevertheless remarks that No. 568 is unlikely to have been an independent panel; he also attributes it to Agnolo Gaddi and places it stylistically close to the Berlin polyptych of 1388. It presumably may be dated shortly before the *Coronation of the Virgin* (Washington, National Gallery of Art), given the less elaborate design of the cloth of honour and positioning of the angels.

It has often been pointed out how closely related No. 568 is to the Baroncelli altarpiece.[7]

PROVENANCE: Purchased with the Lombardi-Baldi Collection, Florence, 1857.[8]

REFERENCES:
1. O. Sirén, 'Notizie critiche su quadri sconosciuti nel Museo Cristiano', *L'Arte*, IX, 1906, p. 327; see also Roberto Salvini, *L'Arte di Agnolo Gaddi*, Florence, 1936, p. 29, n. 12.
2. National Gallery catalogue. The picture is listed as by Giotto with no provenance in an undated Lombardi-Baldi catalogue, no. 8; the copy of the catalogue in the Uffizi Library is claimed to be of 1845. Paatz lists No. 568 as coming from an unknown location in San Miniato al Monte, Florence. (See W. and E. Paatz, *Die Kirchen von Florenz*, vol. 4, Frankfurt-am-Main, 1952, p. 245.) However, clearly San Miniato al Monte, as a Cistercian foundation, is excluded. In 1373/4 it passed from Cluniacs to Olivetans (ibid., pp. 211 ff.).
3. See E. Repetti, *Dizionario Geografico Fisico Storico della Toscana*, V, 1843, p. 91, cited by Davies, and J. R. H. Moorman, *Medieval Franciscan Houses*, New York, 1983, p. 430.

4. M. Boskovits, 'Some Early Works of Agnolo Gaddi', *The Burlington Magazine*, CX, 1968, pp. 209–15, esp. pp. 210–11.
5. They measure 196 × 52 cm. each (measurements given by Boskovits, loc. cit.). See ibid., p. 210, n. 9, for the history of the attribution of these saints. Boskovits argues that the regilding of No. 568 may have been caused by the need to remove traces of cusps which would have been similar to those of the Pisan saints. Boskovits sees in No. 568 the influence of Barnaba da Modena's *Madonna dei Mercanti* of c.1379–80, also from San Giovanni de' Fieri.
6. Bruce Cole, *Agnolo Gaddi*, Oxford, 1977, p. 1, n. 2; pl. 39, p. 83; pp. 16–19; and pp. 28–9.
7. Boskovits, art. cit., p. 209.
8. For the history of the Lombardi-Baldi Collection see Appendix I.

GIOTTO
1266/7(?) – 1337

Giotto di Bondone was probably born in 1266/7.[1] His oeuvre is complicated by the fact that of the three paintings bearing his signature which survive (the Louvre *Stigmatisation*, the Bologna polyptych and the Baroncelli altarpiece), none is unanimously agreed to be autograph. It is now generally accepted that he did not paint the St Francis cycle in the Upper Church of San Francesco, Assisi. Undisputed works include the frescoes in the Arena Chapel, Padua, and in the Bardi and Peruzzi Chapels in Santa Croce, Florence. He worked in Florence, Padua, Rome and Naples. He died in 1337.

Already his contemporaries, such as Dante, recognised that Giotto changed the course of painting. In the sixteenth century Vasari was to say that he changed the language of painting from Greek to Roman.

REFERENCE:
1. The literature on Giotto is too vast to list here, even selectively. For the bibliography up to 1970 see R. Salvini, *Giotto Bibliografia*, Rome, 1938; and Cristina de Benedictis, *Giotto: Bibliografia*, II (1937–70), Rome, 1973.

Ascribed to GIOTTO

5360 *Pentecost* *Plate 22*
(Panel from a series)

The twelve Apostles are shown gathered together in an enclosure; tongues of fire are on their heads, and the Holy Ghost descends in the form of a dove. Outside, the multitude of the different nations are gathered, each man marvelling at hearing the Apostles speak his own language.

Poplar.[1] Painted surface 45.5×44 ($18 \times 17\frac{1}{4}$); painted up to the edges all round. The panel has been slightly cut at the top and bottom, and planed at the bottom. It has been sawn at the left and right edges, but a comparison with the others in the series (see below) indicates that it has not been significantly reduced in size. The gesso at the right edge rises slightly to form a 'lip'.

The back shows that the panel tapered slightly and a wedge-shaped original insert completes the base at the lower right-hand corner. The back has traces of old gesso bearing the imprint of linen and a minute fragment of porphyry-like red paint. These originally covered a vertical batten, placed slightly off-centre, which has since been removed to reveal the holes of the nails which attached the battens to the panel. The number 99 (see PROVENANCE and note 3) has been painted over the batten mark.

The overall condition of the painted surface is good.

Cleaned in 1983.

The subject is from Acts ii, 1–13. It is unusual to omit the Virgin Mary from the scene, but Giotto does this in his fresco of the subject in the Arena Chapel in Padua.[2]

No. 5360 is one of a series of which the other panels are: the *Nativity cum Epiphany* (New York, The Metropolitan Museum of Art, 11.126.1); the *Presentation* (Boston, Isabella Stewart Gardner Museum); the *Last Supper* and *Crucifixion* (both Munich, Alte Pinakothek), the *Entombment* (Florence, Villa I Tatti, Berenson Collection), the *Descent into Limbo* (Munich, Alte Pinakothek). Four of the series, including No. 5360, came from the Poniatowski Collection in 1839.[3] Otherwise the panels are linked together by style, iconography, measurement and technique. All the panels have the distinctive characterisic of their gilding having been done with 'terre verte'.[4]

The series has been variously reconstructed as sacristy cupboard doors,[5] as shutters around a statue of the Virgin and Child or a reliquary,[6] and most recently and convincingly by Christiansen as one complete horizontal series (Fig. 5).[7] Christiansen's reconstruction has the merit both of taking account of the horizontal grain of the wood and also of not requiring any lost scenes for completion. His reconstruction also confirms that the *Epiphany* and *Pentecost* scenes which have a 'lip' of gesso at the left and right edges respectively (see above) were the two outermost scenes. X-radiographs taken of all the scenes (Fig. 6)[8] confirm a horizontal reconstruction in the strong pattern of wood grain which is continuous from one to the other. The *Pentecost* has the traces of a vertical batten (see above), also present in the *Epiphany*, *Last Supper* and *Entombment*. The *Epiphany*, *Entombment* and *Descent into Limbo* also have traces of the porphry-like red paint found on the back of the *Pentecost* (see above). The battens were not centred, but irregularly placed. In a chronological horizontal reconstruction they occur alternately. Their function would probably have been to prevent the long panel from bowing and contain it within the frame, rather than helping to fix it to panels above,[9] and they are not necessarily an argument for an upper tier and an interpretation of the series as a predella. Although some writers have described the seven panels as predella panels,[10] their almost square shape and large size almost certainly preclude this.

The attribution and dating of the panels are problematic. The series has variously been attributed to Giotto and to his workshop.[11] In the *Pentecost* two hands are clearly in evidence: the boldly drawn figures symmetrically placed in the foreground are clearly of a higher quality than most of the Apostle figures in the background. This distinction of hands appears to correspond with the two hands evident in the panels of *St Stephen* (Florence, Horne Museum), the *Virgin and Child* (Washington, National Gallery of Art), and the *St John the Evangelist* and *St Lawrence* (both Châalis, Musée Jacquemart André).[12] These panels, which are all of similar design, have been reconstructed as a polyptych, with which the present series has been linked by several writers.[13] The present writer inclines to an attribution of the design and part of the execution of No. 5360 to Giotto,[14] with the rest being completed by the author of the Châalis panels. The outlining of the features in brown is close to the technique of the Bardi Chapel, with which the present series is also often stylistically linked.[15]

The date is usually put somewhere between the Arena Chapel of *c.*1305 and the Peruzzi Chapel of *c.*1328.[16]

It has been implausibly suggested that the series forms one of the altarpieces from the four chapels stated by Ghiberti to have been decorated by Giotto in Santa Croce, Florence: Longhi, who attributed it to Giotto, suggested it came from the Peruzzi Chapel;[17] and Christiansen suggested it was originally in the Bardi Chapel.[18] However, the tall and narrow chapels, which are only *c*. 432 cm. wide, are unlikely to have housed an altarpiece which would have been at least *c*. 308 cm. wide if the format of that altarpiece was the long low dossal suggested here.

Martin Davies[19] first suggested that the series might be identifiable with a painting by Giotto described by Vasari as 'di piccole figure', which Vasari said was brought from San Sepolcro to Arezzo after the death in 1327 of Bishop Guido Tarlati by the bishop's brother, Piero Saccone, and broken up ('se n'è ita in pezzi'); the pieces were retrieved by Baccio Gondi and taken to Florence in the sixteenth century.[20] Bologna, drawing the logical conclusion from the presence of St Francis at the foot of the Cross in the Munich *Crucifixion*, suggested that the altarpiece came originally from the church of San Francesco in San Sepolcro, noting that the altarblock was sculpted in 1304 and later bore the double-sided altarpiece commissioned from Sassetta in 1437.[21] Bologna dated the panels around 1327 on the grounds that according to Vasari they were acquired by Piero Saccone soon after the death of Guido Tarlati, Bishop of Arezzo, in 1327. However, even if the circumstances of acquisition were correct, this would only give 1327 as a *terminus ante quem*.

The church of San Francesco in San Sepolcro was founded in 1258 by Fra Tommaso da Spello; the choir was restored in 1752.[22] The original altar survives with the inscription: ANNO D.M. CCC. IIII. IN FESTO OIUM SCO . SCS . RANIERUS MIGRAVIT AD DOMINUM . QUO ANNO . HOC ALTARE . COEBURGI FIERI FECIT AD HONORE DEI & MAGNIFICIENTIAM DEI SCI AM.[23] Blessed Raniero is buried in the crypt below, but Kern suggested that the altar was originally dedicated to St Francis,[24] which would explain the presence of St Francis in the Munich *Crucifixion*. The altar *mensa* measures *c*. 342.5 cm.[25] and could comfortably have borne the seven Giottesque panels as a single horizontal dossal, whose width would have been slightly over 308 cm. allowing for losses in the dismantling and not counting the frame. Frame-mouldings and borders dividing the seven scenes could account for the extra *c*. 34.5 cm. The division of the altar by seven arches, modelled on the high altar of the Lower Church, San Francesco, Assisi,[26] may have prompted the division of the panel into seven scenes.

The altar of San Francesco, San Sepolcro, would have merited a commission from Giotto's workshop, since it was important enough to earn the attention of Napoleone Orsini, Cardinal Legate in Umbria. In 1306 he granted 100 days' indulgence to whoever visited the main altar of the church of San Francesco, San Sepolcro: 'qui predictam ecclesiam venerabiliter visitaverunt et devote eiusdem ecclesie altare maius, in quo sacre reliquie requiescunt.'[27]

The fact that the altarblock was erected in 1304 and that in 1306 an indulgence was granted to that very altar, not merely the church, could suggest that it was around this time that attention was focused on the high altar of San Francesco. This would fit with the date of *c*. 1305–28 suggested by the style of the altarpiece (see above).

A parallel arrangement of altarpiece over tomb existed in another Umbrian Franciscan context. This, also a long low dossal placed above the tomb of a local *Beato*, is the double-sided altarpiece with scenes from Christ's Passion on the reverse, probably painted for San Francesco al Prato in Perugia.[28]

However, another possibility is that the altarpiece came from San Francesco, Rimini.[29] There are some Riminese iconographic features such as the conflation of the Nativity and Epiphany into a single scene and the dossal was also a common Riminese design. Vasari[30] said that Giotto painted under the patronage of the Malatesta in San Francesco, Rimini, and a Crucifix attributed to Giotto came from there.[31] Riccobaldo Ferrarese,[32] writing 1312/13, said Giotto painted in the Franciscan churches of Assisi, Padua and Rimini.

The identity of the donors in the Munich *Crucifixion* remains a problem, and is the key to the original location. The man appears not to be wearing clerical dress and does not seem to be tonsured; the woman is certainly not wearing a nun's habit.[33] Her robe was originally blue.[34]

San Francesco, Rimini, was in effect the burial church of the Malatesta family,[35] and it is possible that the donors represent Malatesta di Verucchio, who died in 1311 and asked to be buried in San Francesco, Rimini, and his third wife, Margherita, who survived him.[36]

PROVENANCE: With three others of the series, in the Prince (Stanislas) Poniatowski of Florence sale, London, 9 February 1839; No. 5360 was lot 99 (see below), bought by Hall. Bequeathed by William Coningham, a well-known collector, to his son, W. J. C. Coningham, who bequeathed it to his widow. She gave it in 1922 to Major Henry Coningham. Bequeathed to the National Gallery by his widow, Geraldine Emily Coningham, in memory of Mrs Coningham of Brighton and of her husband, Major Henry Coningham, 1942.[37]

REFERENCES:

1. Identified as such by the Scientific Department at the National Gallery. The Isabella Stewart Gardner Museum, Boston, have also identified their panel as poplar. Although an old catalogue of Munich Alte Pinakothek (1960, p. 39) describes their three panels as chestnut, H. von Sonnenburg of the Bayerische Staatsgemäldesammlungen in a letter to the National Gallery is certain they are poplar. The present writer is grateful to the Isabella Stewart Gardner Museum, to the Berenson Collection at I Tatti and to the Alte Pinakothek, Munich, for having allowed her to examine their panels off the wall.
2. See also the thirteenth-century manuscript described as Umbro-Laziale (I. Toesca, in *Paragone*, 273, November 1972, fig. 31).
3. The *Last Supper* in Munich was acquired in 1805, the other two pictures in Munich in 1813. The four other existing pictures of the series are first recorded in the Prince (Stanislas) Poniatowski of Florence sale, London, 9 February 1839, lots 101–4. Martin Davies says that lot 101 bought by Hall is the *Nativity* in New York; lot 102 is the *Presentation* in Boston (bought by Simes and nearly a century later bought from Simes by Henry Willett (see P. Hendy, *Gardner Museum Catalogue*, Boston, 1931, p. 171)); lot 103 is the *Entombment* in the Berenson Collection (bought by Hall); and lot 104 is the *Pentecost* No. 5360. However, the *Pentecost* bears the number 99 on the back, the *Nativity* the number 100, the *Presentation* number 102, and the *Entombment* 101 (?) – the last digit is covered by a label (see below). It seems therefore that the panels were intended to be lots 99–102. At one time the *Epiphany* and *Entombment* were framed together: the latter bears an inscription: 'A picture divided into two parts; first part representing the *Birth* of our Saviour, and the second part showing his *Entombment*: Early Italian School. From the collection of the late General C. R. Fox.' That they were framed together and not a single panel is made clear by the entry in the General Fox sale, 4 July 1874, lot 37, 'Early Italian, The Nativity and the Entombment – in one frame', bought by Daniell. The two pictures had *not* been framed together at the time of the Poniatowski sale, 1839. From the Daniell Collection the *Entombment* entered the Steinmeyer Collection, Paris. In 1907 the *Entombment* was bought by Berenson (information in the archives at I Tatti). From the Daniell Collection the *Epiphany* entered the collection

of William Fuller-Maitland, Stansted House, Essex, by 1893, where it remained until it entered the Metropolitan Museum, New York, in 1911 (see Federico Zeri and Elizabeth E. Gardner, *Italian Paintings. A Catalogue of the Collection of The Metropolitan Museum of Art, Florentine School*, New York, 1971, pp. 13–16).

4. Identified by Joyce Plesters at the National Gallery. Tests have also been carried out by H. von Sonnenburg on the Munich panels and identified 'terre verte' under the gold leaf. The other panels in the same series have the same feature. 'Terre verte' is mentioned by Cennino Cennini for gilding, if rarely used (*The Craftsman's Handbook*, trs. Daniel V. Thomson Jr., New York, 1933, p. 80).

5. Everett Fahy, 'Italian Paintings at Fenway Court and Elsewhere', *Connoisseur*, 198, May 1978, pp. 28–9. He does not suggest the subject of the hypothetical missing eighth scene.

6. G. Previtali, *Giotto e la sua Bottega*, Milan, 1967, p. 143, no. 212. He suggests that they numbered originally thirteen or fifteen.

7. Keith Christiansen, 'Fourteenth-century Italian Altarpieces', *The Metropolitan Museum of Art Bulletin*, XL, 1982, 1, pp. 54–5.

8. The present writer is most grateful to Keith Christiansen, Curator at the Metropolitan Museum of Art, New York, Dr H. von Sonnenburg, Director General of the Alte Pinakothek, Munich, Kristin Mortimer of the Isabella Stewart Gardner Museum, Boston, and Dottoressa Superbi of the Berenson Collection, I Tatti, for having supplied X-radiographs of their panels. In the *Epiphany*, the *Last Supper* and the *Pentecost* it is evident that the haloes were originally intended to be larger and were reduced in size.

9. That battens do not necessarily imply an upper tier is evident from the construction of the Santa Croce altarpiece. See UGOLINO DI NERIO, Nos. 1188 et al.

10. e.g. C. Gnudi, *Giotto*, Milan, 1958, pp. 220 ff. He attributed the series to Giotto.

11. For a summary of previous attributions (up to 1969) see Zeri and Gardner, op. cit., pp. 14–16; and (up to 1972) Philip Hendy, *European and American Paintings in the Isabella Stewart Gardner Museum*, Boston, 1974, pp. 105–6.

12. See *Les dossiers du département des peintures. Retables italiens du XIIIᵉ au XVᵉ Siècle*, Editions de la Réunion des Musées Nationaux, Paris, 1978, p. 11, nos. 5 and 6. Julian Gardner (oral communication) has doubted their reconstruction as a polyptych. Mme L. Faillant-Dumas of the Laboratoire de Recherche des Musées de France very kindly agreed to sample the Châalis panels and in a letter to the National Gallery confirms that no trace of 'terre verte' was found under the gold leaf, although it was used for the flesh modelling. This finally dissociates No. 5360 from the Louvre panels.

13. e.g. F. Bologna, *Novità su Giotto*, Turin, 1969, pp. 97–9.

14. See also the conclusion reached on the *Epiphany* by Zeri and Gardner (op. cit., p. 13), and by L. Vertova, 'I Tatti', *Antichità Viva*, VIII, 1969, 6, p. 73.

15. e.g. F. Zeri, 'Due appunti su Giotto', *Paragone*, 85, January 1957, p. 78; F. Bologna, *I Pittori alla Corte Angioina di Napoli 1266–1414*, Rome, 1969, pp. 190 ff. and p. 229, notes 79–81.

16. Previtali, op. cit., p. 112; Zeri and Gardner, op. cit., p. 13. The Baptist cycle of the Peruzzi Chapel had probably been completed by 1328. See L. Tintori and E. Borsook, *Giotto. The Peruzzi Chapel*, Turin, 1965, pp. 10 ff.

17. R. Longhi, 'Presenza di Masaccio nel trittico della Neve', *Paragone*, 25, 1952, p. 8.

18. Christiansen, op. cit., p. 54. Also suggested for the Bardi Chapel is the fragmentary *Crucifixion* attributed to Ugolino di Nerio (see Hayden B. J. Maginnis, 'The Thyssen-Bornemisza Ugolino', *Apollo*, CXVIII, 1983, pp. 16 ff.) and the Bromley-Davenport polyptych attributed to Taddeo Gaddi (see F. Zeri, 'Italian Primitives at Messrs Wildenstein', *The Burlington Magazine*, CVII, 1965, p. 252).

19. Martin Davies, *National Gallery Catalogues. The Earlier Italian Schools*, London, 1951, p. 181.

20. Martin Davis, loc. cit.; Vasari, *Vite* (ed. Milanesi, Florence, 1878), I, pp. 395–6.

21. F. Bologna, *I Pittori alla Corte Angioina di Napoli 1266–1414*, loc. cit., and idem, *Novità su Giotto*, Turin, 1969, pp. 97–9.

22. Lorenzo Coleschi, *Storia della Città di Sansepolcro*, Città di Castello, 1886, p. 169.

23. See Julian Gardner, 'Some Franciscan Altars of the Thirteenth and Fourteenth Centuries', *The Vanishing Past. Studies of Medieval Art, Liturgy and Metrology presented to Christopher Hohler*, 1981, p. 32. H. van Os, 'St Francis of Assisi as a second Christ in early Italian painting', *Simiolus*, 7, 1974, no. 3, p. 123, has a typographical error, saying that the altar was erected in 1403 instead of 1304.

24. L. Kern, 'Le Bienheureux Rainier de Borgo San Sepolcro de l'Ordre des Frères Mineures', *Revue d'Histoire Franciscaine*, VII, 1930, pp. 233–83, esp. p. 243.

25. Van Os, op. cit., p. 123, no. 23, gives the width as 344 cm. Gardner, op. cit., p. 32, as 342.5 cm.

26. Gardner, loc. cit., points out the dependence of the San Sepolcro altar on the Assisi altar, although the latter is much wider (380 cm.).

27. Kern, loc. cit.

28. Dillian Gordon, 'A Perugian provenance for the Franciscan double-sided altar-piece by the Maestro di San Francesco', *The Burlington Magazine*, CXXIV 1982, pp. 70–7.

29. For a fuller discussion of the points raised here see Dillian Gordon's forthcoming article in *The Burlington Magazine*.

30. Vasari, *Vite* (ed. Milanesi, Florence, 1878), p. 392.

31. Previtali, op. cit., pp. 368–9 and pl. XXXV.

32. Muratori, *Rerum Italicarum Scriptores*, IX, col. 255. Also P. Murray, 'Notes on Some Early Giotto Sources', *Journal of the Warburg and Courtauld Institutes*, XVI, 1953, pp. 59 ff. He says Riccobaldo could have been writing as late as 1318/19.

33. R. Oertel, *The Munich Pinakothek. Italian Painting from the Trecento to the End of the Renaissance*, Munich, 1961, p. 11, says the man is dressed as a deacon and the woman as a nun.

34. The pigment analyses were kindly made available to the present compiler by the Doerner Institute, Munich.

35. See C. Ricci, *Il Tempio Malatestiano*, Milan, 1924, pp. 192–6. See also Augusto Campana; 'Per la storia delle cappelle trecentesche della chiesa Malatestiana di S. Francesco', *Studi Romagnoli*, 2, 1951, pp. 17–37.

36. See L. Tonnini, *Storia de Rimini*, III, *Rimini del Secolo XIII*, Rimini, 1862, pp. 92, 244–54; IV, 2, *Rimini nella Signoria de' Malatesti*, Rimini, 1880, pp. 22–3.

Malatesta di Verucchio is said to have been the unlikely age of 100 when he died. He is first documented in 1274. P. Farulli, *Cronologia dell'antica famiglia de Malatesti*, 1724, p. 9, says he died in 1313.

37. Information concerning the Coningham provenance in the National Gallery archives.

GIOVANNI DA MILANO
documented 1346–1369 (?)

Apparently from Caversaccio near Uggiate (region of Como); known from documents and his signed pictures as Giovanni da Milano. First recorded in the Arte dei Medici e Speziali in Florence in 1346, and inscribed again between 1358 and 1363. He became a Florentine citizen in 1366. He seems to be identical with the Iohannes de Mediolano working in the Vatican in 1369. His first surviving signed altarpiece is that commissioned by Fra Francesco da Tieri (died 1363) for the church of the Ospedale in Prato. An important altarpiece for the church of Ognissanti in Florence is now dispersed; a *Pietà* in the Accademia in Florence is signed and dated 1365. It was also in 1365 that Giovanni da Milano was working on his documented frescoes in the Guidalotti (later Rinuccini) Chapel in Santa Croce, Florence.[1]

REFERENCE:

1. For the details of his life and for an up-to-date bibliography see the exhibition catalogue, ed. Luigi Cavadini, *Giovanni da Milano*, Comune di Valamorea, 1980, pp. 19–32.

579A *Christ of the Apocalypse, the Virgin and St John the Baptist*
(Three pinnacles from an altarpiece)

Plates 23, 24, 25

Christ holds two golden keys and a globe with seven stars. St John the Baptist holds a scroll inscribed: ECCO VIRGO CŌCIPIET (Isaiah vii, 14). Above each of the three figures is a seraph in a quatrefoil.

Wood. Compartment with Christ, painted surface 64×25.5 ($25\frac{1}{4} \times 10$), pointed top; the other two, painted surfaces each 57.5×25.5 ($22\frac{3}{4} \times 10$), pointed tops; the three quatrefoils with seraphim, painted surface, diameter $c. 6.5$ ($2\frac{1}{2}$) each. Including the frames, the central panel is 94×37.5 ($37 \times 14\frac{3}{4}$); the others 89.5×37.5 ($35\frac{1}{4} \times 14\frac{3}{4}$). In each case the

frame is new at the sides and base; parts of the outer mouldings at the top may be old. The *pastiglia* is original but regilded.

The panel with St John the Baptist is the least well preserved. The right-hand two-thirds of the gold background is missing, as well as part of the right foot and the foreground to the right. Otherwise the figure of the saint is in reasonable condition. The scroll appears to have been damaged (see below).

The figure of the Virgin is mostly well preserved. There is a large loss in the gold to the right of her head and a vertical missing strip runs adjacent to the punched border, crossing it at the top.

The figure of Christ is generally well preserved. The gold background has scattered areas of damage and most of the halo has been regilded and repunched.

Two horizontal lines, now mostly painted out, cross the mouth of Christ; there is no certainty that these are more than an indication of intention, not carried as far as the painting stage. By some mistake, the stamping of the pattern of the haloes continues across the neck and beard of St John the Baptist and of Christ.

Cleaned in 1956.

The central panel represents Christ of the Apocalypse:[1] He is 'clothed with a garment down to the foot, and girt about the paps with a golden girdle'; His head and hair are 'white like wool, as white as snow'; in His right hand He holds the seven stars and in His left the keys of death and hell; at one stage He seems to have held the two-edged sword in His mouth (see above), although this is no longer clearly visible – all as described in Revelation i, 13 ff.

Because of the inscription St John the Baptist carries, he has in previous catalogues been identified as Isaiah. However, the figure wears the hair-shirt worn by John the Baptist, and there are reasons to suppose that the inscription is not authentic: the typography is modern and not consistent with other inscriptions in Giovanni da Milano's work, notably the panels supposedly forming part of the same altarpiece (see below); the scroll appears to have been damaged down the centre and the faintest shadow of other letters is discernible beneath the existing ones. The most likely explanation is that the scroll originally read 'Ecce Agnus Dei qui tollit peccata mundi', or as much of this as would fit on the scroll. It was probably damaged at some unknown date and then repaired with the inscription from Isaiah, when the Virgin was wrongly interpreted as a Virgin Annunciate[2] rather than as an intercessor. The presence of John the Baptist as intercessor, rather than Isaiah, also makes more sense in the general apocalyptic iconography of the altarpiece (see below).

The attribution to Giovanni da Milano, first made by Crowe and Cavalcaselle,[3] has never been disputed.[4]

The three panels are evidently pinnacles of an altarpiece. They were first plausibly associated by Boskovits[5] with a polyptych (Fig. 7) of which two main panels survive: *Christ Enthroned*, with four adoring angels, carrying texts from the Apocalypse: *Ego sum / alpha et / omega primus et / novissimus / inititium et / finis Rex R/equm et dominus / dominatium*

/ *scurtans [sic]* (s)r/encs et c(or) / *da et dabo* / *uniqque ve/strum sec/undum oper/a vestra n/unc ergo* . . . (Milan, Pinacoteca di Brera, no. 1008); *Eleven Saints*, including James, Peter, Bartholomew, Stephen, Lawrence, a Benedictine saint and a female Benedictine saint (Turin, Galleria Sabauda, no. 652). Two predella panels showing the *Incredulity of St Thomas* and the *Resurrection* together with *St Peter walking on Water* and '*Noli me Tangere*' (Paris, Bacri Collection) have also been associated with the altarpiece. Missing are the main right-hand panel and possibly a third predella panel. There are no grounds for reconstructing the altarpiece as a pentaptych rather than a triptych.[6]

Not only do the widths of two of the National Gallery pinnacles correspond with the summits of the two surviving main tier panels, but the apocalyptic iconography (see above) of these panels makes their association plausible: the apocalyptic figure has above Him the seraph, while the Virgin and John the Baptist, to left and right, intercede for mankind. The text on the enthroned Christ's book below (in the main tier) also derives from the Apocalypse. Christ is seated on the lion-headed throne of Solomon, implicitly that of judgement.[7]

The original location of the original altarpiece remains in doubt. Marcucci[8] suggested it might be identifiable with the altarpiece Vasari said Giovanni da Milano painted for Santa Croce in Florence. However, the complete absence of any Franciscan saints in the Turin panel makes this extremely unlikely.

Mina Gregori[9] is cited as having suggested that the altarpiece is identifiable with that commissioned by Piero Pelagio in 1371 for the Chapter House of Santa Maria degli Angeli in Florence. However, there are several arguments against this: the present altarpiece would have been considerably larger and more complex than the others of that series, but the Pelagio altarpiece actually cost less than the others[10] (see NICCOLÒ DI PIETRO GERINI, No. 579). Also, the iconography of the altarpiece differs considerably from the formula adhered to by the series: as with the others, one would expect the scenes to be dominated by the name saint of the patron, in this case St Peter. But although St Peter is situated on the right of the enthroned Christ, and although the unusual scene of St Peter attempting to walk on water is shown in the proposed predella scenes, scenes from the life of the saint are not exceptionally prominent. Finally, although it is true that the three pinnacle panels were once attached to No. 579 and that No. 579 originally came from Santa Maria degli Angeli, No. 579 is likely to have been moved from Florence by the fifteenth century,[11] and the altarpiece commissioned by Piero Pelagio was seen by Rosselli still in Santa Maria degli Angeli in 1756.[12] There is no reason why the pinnacles should not have been attached to No. 579 when they were all in the Lombardi-Baldi Collection.[13] Any connection with Santa Maria degli Angeli deriving from the association of No. 579A with No. 579 would then become spurious. It seems best to leave the original location as Benedictine or Camaldolese on the basis of the habits of the assembled saints, until further evidence comes to light.

The altarpiece is generally accepted as a mature work by Giovanni da Milano, datable *c*.1364–6.[14] A comparison of the Brera *Christ Enthroned* with the Rinuccini tondo, which is documented as having been painted in 1365, makes this date likely.[15] However, it has also been argued that the altarpiece shows a knowledge of the Stefaneschi altarpiece in the

Pinacoteca Vaticana and is therefore datable after Giovanni da Milano's visit to Rome in 1369.[16]

PROVENANCE: In the Lombardi–Baldi Collection, Florence, 1845 (no. 11);[17] purchased with other pictures from Lombardi and Baldi, 1857.[18]

REFERENCES:

1. In previous catalogues described as the Almighty. The same apocalyptic figure appears in roundels of the Stefaneschi and Bologna altarpieces from Giotto's workshop.

2. The Virgin Annunciate is normally situated in the right-hand gable or pinnacle, opposite the Angel Gabriel, and not on the left as in No. 579A.

3. J. A. Crowe and G. B. Cavalcaselle, *A New History of Painting in Italy*, I, London, 1864, pp. 367 and 409.

4. Most recently see the exhibition catalogue, ed. Luigi Cavadini, *Giovanni da Milano*, Comune di Valmorea, March 1980, pp. 90–9.

5. M. Boskovits, *Giovanni da Milano*, 'I Diamanti dell'Arte', 13, Florence, 1966, pp. 23–6. Boskovits also interprets the right-hand figure as St John the Baptist. The Brera and Turin panels were first associated together by A. Marabottini, *Giovanni da Milano*, Florence, 1950, pp. 48–53.

6. For the reconstruction see Cavadini, op. cit., p. 91. For a detailed discussion of the Brera and Turin panels, including restoration, see ibid., pp. 111–25.

7. For a discussion of the lion-headed throne see Venturoli in Cavadini, op. cit., pp. 112–13.

8. L. Marcucci, *Gallerie Nazionali di Firenze. I Dipinti Toscani del Secolo XIV*, Rome, 1965, p. 85.

9. 'Il Cristo Giudice di Giovanni da Milano per la Pinacoteca di Brera', *Bollettino dell'Associazione degli Amici di Brera e dei Musei Milanesi*, October 1970 – January 1971, pp. 6–8; also Cavadini, op. cit., p. 112.

10. The total cost for the Pelagio altarpiece was 300 gold florins, compared with, for example, 500 florins for the surviving smaller Dini altarpiece and No. 579.

See under NICCOLÒ DI PIETRO GERINI, No. 579, and Florence, Archivio di Stato, Conventi Soppressi, 86, 95, f. 34.

11. See under NICCOLÒ DI PIETRO GERINI, No. 579.

12. Rosselli, Sepoltuario Fiorentino, III, 1657 (Florence, Biblioteca Nazionale, Cod. Magliabech., XXVI, 24, f. 1253). Rosselli says that the altarpiece bore the arms of the Pelagio family. The chapel, commissioned by Pietro Neri del Pelagio, who died in 1372, had the first Mass said there on 25 December 1371 (see MS cited in note 10, loc. cit.).

13. In the Lombardi-Baldi Collection, the pictures forming No. 579A were believed to be the pinnacles of No. 579. No. 579A was first given a separate number at the National Gallery in the 1888 catalogue.

14. M. Boskovits, 'Notes sur Giovanni da Milano', *Revue de l'Art*, 11, 1971, p. 57.

15. Venturoli (see Cavadini, op. cit., p. 115, n. 8) sees that very comparison as indicating different dates for the works, and dates No. 579A *c*.1371 in accordance with Mina Gregori's hypothesis. See note 9 above.

16. Venturoli (ibid., p. 112). See also note 1 above.

17. The catalogue is not dated, but the copy in the Uffizi Library is claimed to be of 1845. The attribution of No. 579A (and of No. 579, to which No. 579A was attached) was to Tadéus (*sic*) Gaddi. No. 579A was long catalogued at the National Gallery as of the School of Taddeo Gaddi; first as Giovanni da Milano in the 1912 catalogue.

18. For details concerning the Lombardi-Baldi Collection see Appendix I.

Style of GIOVANNI DA MILANO

1108 *Christ and the Virgin with Saints* *Plate 26*

Above, Christ and the crowned Virgin, each holding orbs and sceptres. Below, six saints, from left to right: St John the Baptist, a Bishop with a book, St Lawrence, St Catherine of Alexandria, St Clare(?) and St Lucy.

Wood. Painted surface 40×28 ($15\frac{3}{4} \times 11$). Including the framing, the size is 45×34 ($18 \times 13\frac{1}{2}$).

The back and outer mouldings of the frame, which are all original, are covered over with

gesso and a dark reddish–black porphyry-like paint. There are no traces of hinges or any other attachment, excluding the possibility that the panel was ever one wing of a diptych or ever had a gable.

The condition is fair.

Originally catalogued as Sienese. Pouncey suggested a connection with Giovanni da Milano, with which Berenson (oral communication, 1936) agreed.[1] Pouncey classed it as from the studio of Giovanni da Milano, but this seems rather too precise for No. 1108, especially as the quality is low. Gregori[2] attributed it to a Lombard follower of Giovanni da Milano, which also seems excessively precise.

Gregori identified the subject as God the Father enthroned with Christ, saying that the Virgin is always seated on Christ's right, and suggested that it may once have had a dove to complete the representation of the Trinity.[3] However, there are no traces of there ever having been a dove between the two figures, and the panel never had a gable (see above). Representations of the Virgin and Christ enthroned holding orbs and sceptres are common, although usually both are crowned and the Virgin is always on Christ's right.[4] A panel in Esztergom by a mid-fourteenth-century Umbrian painter, known as the Poldi-Pezzoli Master, which is similarly divided in two, with saints (and a seraph) below, and Christ and the crowned Virgin on His right on a similar throne (although not holding orbs or sceptres),[5] is close enough to suggest that the identification of No. 1108 as Christ and the Virgin enthroned with saints is correct.

PROVENANCE: Purchased from Alessandro Castellani, Rome, 1881.

REFERENCES:
1. Notes by P. Pouncey in the National Gallery archives.
2. Mina Gregori, 'Giovanni da Milano: storia di un polittico', *Paragone*, 265, March 1972, p. 16.
3. Ibid., p. 33, n. 62.
4. e.g. the manuscript illumination attributed to Don Simone dei Gherarducci (London, Victoria and Albert Museum, F.F. 1553). See M. Boskovits in *Paragone*, 265, March 1972, fig. 28a. There are Umbrian versions of the *Assumption* where the Virgin is seated on Christ's left, e.g. the thirteenth-century fresco in Santa Giuliana, Perugia. See M. Boskovits, *Pittura Umbra e Marchigiana fra Medioevo e Rinascimento*, Florence, 1973, fig. 19.
5. M. Boskovits, 'Ipotesi su un pittore umbro del primo Trecento', *Arte Antica e Moderna*, 30, April/June 1965, fig. 39.

GIOVANNI DI NICOLA
documented 1326–1360

The only autograph work by Giovanni di Nicola da Pisa is the *Virgin and Child* (no. 58) in Pisa (Museo Nazionale di San Matteo), signed 'Iohes. Niccol . . . me pinxit . . . A.D. MCCC . . .'. Carli[1] suggested a date of 1350 on the grounds that the inscription left room for only one more letter. A now lost altarpiece of St John the Baptist signed and dated 1360 was recorded in the eighteenth century.[2] Payments of 1326 from the Commune of Siena for a painting of St Ansanus refer to him as a pupil of Lippo Memmi,[3] who is documented as working in Pisa in 1325 on a now lost altarpiece for San Paolo a

Ripa d'Arno and may have recruited Giovanni di Nicola then. In 1358 a 'Iohannes Nicole pictor' was elected member of the Consiglio del Popolo in Pisa.

Giovanni di Nicola's work is typical of Pisan painting under the influence of Sienese painting in the 1320s and is closely associated with the Master of the Glorification of St Thomas, whether he is identifiable with Lippo Memmi or not.

REFERENCES:
1. Enzo Carli, *Pittura Pisana del Trecento*, II, Milan, 1961, pp. 37–41.
2. Ibid. Recorded by Da Morrona in 1792.
3. Pèleo Bacci, *Fonti e Commenti per la Storia dell'Arte Senese*, Siena, 1944, pp. 149–50. He is named as 'Giovanni suo disciepolo da Pisa'.

3896 *St Anthony Abbot* *Plate 29*
(Panel from a polyptych)

St Anthony Abbot in monastic habit rests on a Tau-shaped crutch and carries a book.[1]

Wood. The size of the picture is 55×31.5 ($21\frac{1}{2} \times 12\frac{1}{2}$), cusped and rounded top; the size including all the framing is 61.5×36 ($24\frac{1}{4} \times 14\frac{1}{4}$).

The outer rectangular moulding is modern. The arch of the moulding and the cusps are original but regilded. The *pastiglia*, with intermittent finely stippled dots, is original, but coarsened through regilding. The inner vertical and bottom mouldings are new.

The overall condition of the paint surface and gold background is fair, but along the bottom an irregular strip 2 cm. wide has been completely repainted. The underdrawings of clasps on St Anthony's book, visible to the naked eye, seem never to have been painted.

This panel was once ascribed to Bartolo di Fredi.[2] However, an attribution to Giovanni di Nicola, first made by Offner (oral communication, 1936), was endorsed by Carli[3] and Meiss.[4] The Sienese element is attributable to Giovanni di Nicola's association with Lippo Memmi.[5] The stylistic attribution to Giovanni di Nicola has convincingly been substantiated by Skaug,[6] who compares the punchwork with that in the signed *Virgin and Child* (Pisa, Museo Nazionale di San Matteo, no. 58) and the fragmentary polyptych[7] divided between Pisa (Museo Nazionale di San Matteo, nos. 61–4) and Assisi (Perkins Collection).

On the basis of a comparison with the Pisa–Assisi altarpiece, one may assume that No. 3896 was originally part of a similar polyptych, placed on the left of a central panel of the Virgin and Child. Carli[8] suggested that that panel of the Virgin and Child is the one attributable to Giovanni di Nicola and now in an Italian private collection (Milan, collection Prof. Luigi Gallone). However, although the panel of the Virgin and Child is similar in style and concept, sharing the cusped mouldings, *pastiglia* in the spandrels and double-rosette punch, these seem to be the hall-marks of Giovanni di Nicola's work and are similarly found in his Pisa polyptych (nos. 61–4). Indeed, the sequence of the halo pattern in No. 3896 is closer to the latter. The proportions (as also noted by Skaug[9]) throw doubt on the association of the Gallone panel with No. 3896.

Datable *c.*1350 by analogy with the only dated work, the *Virgin and Child* of 1350 in the Museo Nazionale di San Matteo, Pisa (see biography above). A late dating would accord with the fashion for the cusped arch used widely by such artists as Paolo di Giovanni Fei, NICCOLÒ DI BUONACCORSO (see No. 1109) et al.

The taste for ornamental *pastiglia* in the spandrels was probably introduced into Pisa by Simone Martini in his altarpiece for Santa Caterina, Pisa, in 1320.

PROVENANCE: Henry Willett Collection, Brighton; exhibited at the New Gallery, 1893–4 (no. 12);[10] sale, 10 April 1905 (lot 48), bought by Wagner. Presented by Henry Wagner, 1924.

REFERENCES:

1. For St Anthony see G. Kaftal, *Iconography of the Saints in Tuscan Painting*, Florence, 1952, col. 61, no. 24.

2. Catalogued as Ascribed to Bartolo di Fredi by Martin Davies, *National Gallery Catalogues. The Earlier Italian Schools*, London, 1951, p. 36, and (2nd ed. revised) London, 1961, p. 42. Davies noted that Berenson attributed the panel to Bartolo di Fredi. He also noted that van Marle ascribed it to Andrea Vanni, and Offner to Giovanni di Nicola.

3. Enzo Carli, *Pittura Pisana del Trecento*, II, Milan, 1961, pp. 40–1. He relates it to polyptych no. 67 in Pisa, Museo Nazionale di San Matteo.

4. Letter dated 1 March 1944 in National Gallery dossier.

5. Connected by Gertrude Coor ('Two unknown paintings by the Master of the Glorification of St Thomas and some closely related works', *Pantheon*, XIX, 1961, p. 133, n. 9) to the Master of the Glorification of St Thomas, sometimes identified with Lippo Memmi. Giovanni di Nicola was a pupil of Lippo Memmi (see above under Biography).

6. E. Skaug, 'The St Anthony Abbot ascribed to Bartolo di Fredi in the National Gallery, London', *Acta ad Archaeologiam et Artium Historiam Pertinentia (Institutum Romanum Norvegiae)*, 6, 1975, pp. 141–50.

7. Reconstructed by M. Boskovits, 'Un'apertura per Francesco Neri da Volterra', *Antichità Viva*, VI, 1967, fasc. 2, pp. 3–11, esp. p. 8 and fig. 9. Boskovits in his *Pittura Umbra e Marchigiana fra Medioevo e Rinascimento*, Florence, 1973, p. 20, attributes No. 3896 to a certain 'Francesco pittore', author of an altarpiece commissioned for Santa Caterina, Pisa, in 1363. However, he also says (ibid., p. 40, n. 109), that No. 3896 was possibly by both 'Francesco pittore' and Giovanni di Nicola working in collaboration.

8. Enzo Carli, 'Una Madonna Inedita di Giovanni di Nicola da Pisa', *Mitteilungen des Kunsthistorischen Institutes in Florenz*, XVII, 1973, pp. 223–8.

9. Skaug in a written communication to the National Gallery in 1976 points out that the height of the Gallone panel is $\frac{1}{10}$ more than No. 3896, whereas elsewhere in Giovanni di Nicola the relationship of the central to the lateral panels is 4:3 or 5:4.

10. Label on the back. Here, and in the sale, as Florentine School.

GIUSTO DE' MENABUOI
active *c.*1349, died 1387/91

Although Florentine by birth, Giusto is first documented in Padua in 1373. His known works are all in Lombardy and Padua.[1] It has been suggested that he trained with Bernardo Daddi or Maso di Banco, and left Florence in 1348 during the Black Death. Frescoes in the Abbazia di San Pietro in Viboldone, dating from 1349 to the mid-1360s, have been attributed to him. The only two documented works from his Lombard period are No. 701 and the polyptych now divided between the Schiff-Giorgini Collection in Rome, and the Kress Study Collection at the University of Georgia, Museum of Art, Athens (Ga.). This polyptych was commissioned by a member of the Milanese nobility, Isotta de Terzago, and signed and dated March 1363. In Padua he painted among other

things the frescoes in the Baptistery. In 1387 he was still enrolled with the Florentine guild. He died between 24 July 1387 and 19 May 1391, possibly on 28 September 1390.[2]

REFERENCES:
1. For the life given here and for a bibliography see S. Bettini, *Giusto de' Menabuoi e l'Arte del Trecento*, Padua, 1944, and J. Delaney, 'Giusto de' Menabuoi in Lombardy', *Art Bulletin*, LVIII, 1976, 1, pp. 19–35.
2. See A. Sartori, 'La cappella di S. Giacomo al Santo di Padua', *Il Santo*, VI, 1966, p. 333.

701 *The Coronation of the Virgin, and Other Scenes* (Triptych)

Plates 27 and 28

Central panel: the Virgin is crowned by Christ. Foreground, from left to right, St Margaret, an unidentified female saint, Sts Catherine, Peter, John the Baptist and Paul. At the sides are other saints, angels, etc., including Sts Ambrose (with his scourge), Francis, Dominic, Benedict (?), Anthony Abbot (?), Stephen (?) and Lawrence (?).

Left wing: the Nativity (with two midwives) and the Annunciation to the Shepherds. Above, in the spandrels, two figures done in gold under glass: the left one is unidentifiable, the right one is inscribed MATEUS; at the top, the Angel of the Annunciation.

Right wing: Christ Crucified, with the Holy Women and St John; the Cross is marked .Y.N.R.I. Above, in the spandrels, Daniel and David, the names being inscribed *daniel* and (d)*avit*, done in gold under glass; at the top, the Virgin Annunciate.

Reverse of the wings: the two wings when folded together show six scenes, which, reading from left to right and from top to bottom, are the Expulsion of Joachim, the Angel appearing to Joachim, the Meeting at the Golden Gate, the Birth of the Virgin, the Presentation of the Virgin, and the Marriage of the Virgin (with Joseph's rod in blossom, and an unsuccessful suitor breaking his own rod). Presumably the reverse of the wings also once had their spandrels filled with gilded glass, now missing.

Reverse of the central panel: red paint, with the signature towards the middle: (ju)*stus pinxit in mediol.*

At the base of the central panel, at the front, is the date stippled on a gold ground: *ano. dni. m./.ccc.lxvii.*

Poplar. Central panel 44.5 × 21 ($17\frac{1}{2}$ × $8\frac{3}{8}$), pointed top; including the framing, 48 × 25 (19 × $9\frac{3}{4}$). The gold ground on which is the date is 3 × 31 ($1\frac{1}{8}$ × $12\frac{1}{8}$), on a piece of wood with wedge-shaped restorations at the ends. The sizes of the scenes on the inside of the wings are: lower scene 28 × 11.5 ($11\frac{1}{8}$ × $4\frac{1}{2}$), pointed top; spandrels, *c*.4 × 3 ($1\frac{1}{2}$ × $1\frac{1}{4}$); upper scene 17 × 10 ($6\frac{5}{8}$ × 4), irregular. The width of the two wings differs slightly. Total size, including the framing, 48 × 13.5 (19 × $5\frac{1}{4}$).

Considerably restored. All the frame mouldings are new, as are the columns supporting the wings. Although there is no reason to suppose that the fields of the pictures have been reduced, unless perhaps by a very slight amount, the central panel itself has almost certainly been cut. The wood forming the base, which is original, may well not have been reduced in width, but there is no definite evidence concerning this.

The cutting of the central panel is indicated by the state of the signature, the authenticity of which is not doubted.[1] The last letter, read as an 'l', was recorded for the first time by Martin Davies; it had been almost completely covered over by a careless application of the gold paint used for the frame, and was uncovered in 1959. This letter is now on the extreme edge of the wood, and it seems unlikely that this would have been so originally. The wood assumed to be missing here, with (for symmetry) much the same amount missing from the other side, could have made the original width of the central panel about the same as the width of the base at present.

As for the signature itself, the beginning of the first word is illegible, but the word was read as *justus* already in 1827.[2] There is no evidence that any letters preceded it on a part of the wood cut away. The name of the place is certainly Milan; there might have been room, before a cutting of the panel, for the unabbreviated word *mediolano*.[3]

It has been questioned whether the gold with the date, at the base of the central panel, is authentic; but it is almost certainly original.[4] The date was recorded already in the Œttingen-Wallerstein catalogue of 1827.

Together with the polyptych dated March 1363 and commissioned by a member of the Milanese nobility, Isotta de Terzago (see above), this is the only documented Lombard altarpiece by Giusto de' Menabuoi. Numerous writers, from van Marle[5] to Delaney,[6] have pointed out the derivation of the tall triptych format with the Coronation of the Virgin in the centre, the Nativity and Crucifixion in the side compartments, with prophets in the spandrels and the Annunciation spread across the two gables, from the Florentine tabernacles by Bernardo Daddi of the 1330s.[7] Delaney goes so far as to suggest that Bernardo Daddi was Giusto's master. However, the style and iconography are also imbued with North Italian characteristics. Delaney points out the derivation of the scenes on the exterior of the wings from Giotto's frescoes in the Arena Chapel in Padua of *c.*1305.

Delaney cites Giovanni da Milano's frescoes in the Rinuccini Chapel, Florence, to explain the iconography of the Birth of the Virgin,[8] particularly for the woman pouring water over Anna's hands.

Other North Italian features include the aureole of rays surrounding the Virgin and Christ in the Coronation, and the Child in the Nativity, often used by North Italian painters (see, for example, BARNABA DA MODENA, No. 2927), and the basket-weave nature of the crib in the Nativity, found, for example, in the work of Vitale da Bologna.[9]

Gregori notes that the iconography of St Paul is the same as that used for St Paul in the frescoes attributed to Giusto de' Menabuoi in the Abbazia of San Pietro in Viboldone.[10] The Presentation and Angel of the Annunciation correspond in some degree with Giusto de' Menabuoi's treatment of the same subjects in the Baptistery in Padua, probably not later than 1376.[11] The Coronation of the Virgin is somewhat similar to a fresco of the subject in the Santo in Padua which Bettini attributes to Giusto and dates in the 1380s.[12]

Van Marle[13] noted that an unusual iconographic detail is the midwife reaching for the Child in the Nativity.

The gilded glass in the spandrels, first studied by Pettenati,[14] deserves some comment.

Although the technique was practised in Florence, it was not common to combine it with panel-painting. Again, in the case of No. 701 it appears to be a North Italian feature. A reliquary tabernacle combining gilded glass with paintings attributed to Tommaso da Modena indicates that it was a technique practised by North Italian painters.[15] The closest parallel, however, occurs in a mid-fourteenth-century panel of the *Virgin and Child* in the Benaki Museum, Athens (no. 538), of seemingly Venetian/Byzantine origin, with gilded-glass Apostles in the spandrels identified by inscription.[16]

PROVENANCE: Stated to have been in the collection of Count Joseph von Rechberg, Mindelheim, and bought in 1816 by Prince Ludwig von Œttingen-Wallerstein.[17] Alternatively, stated to have been acquired from the lithographer Stunz in Munich, i.e. J. B. Stuntz.[18] Œttingen-Wallerstein catalogues, c.1826 and 1827 (no. 18). Exhibited at Kensington Palace (for sale), 1848 (nos. 15–23), bought with the rest of the collection by the Prince Consort. Recorded at Kensington Palace in 1854.[19] Exhibited in Manchester, 1857 (Provisional Catalogue, no. 288; Definitive Catalogue, no. 38). Presented by Queen Victoria at the Prince Consort's wish, 1863.

REFERENCES:

1. The comments on the condition of the triptych are based on Martin Davies's account of a technical examination carried out in 1959 by N. S. Brommelle and Joyce Plesters, in the National Gallery dossiers. It should be mentioned that, at the back, the gesso under the red paint on which the signature is written differs in composition from the gesso under gold in various places; in fact, it is the composition of the latter that is unusual, the gesso under the red paint being of the type commonly found in Italian pictures.

2. Œttingen-Wallerstein catalogue, 1827 (no. 18).

3. Professor Francis Wormald made his comments orally to Martin Davies on the lettering. The transcription was given with several inaccuracies in the first edition of this catalogue; Longhi in *Paragone*, March 1957, p. 7, and July 1957, p. 40, rightly claimed that the place referred to must be Milan. At one time it was wrongly supposed to be Arquà. In comment on the transcription *mediol*, the form of the *d* with an upright stroke does indeed occur, as Longhi points out, at the time (see plates in P. Toesca's *La Pittura e la Miniatura nella Lombardia*, Milan, 1912); the letter here cannot be said to be well written, but doubt that it is a *d* may be abandoned. The mark after the *i* seems not to be an apostrophe, but a dot mixed up with an accidental blemish. The last letter, being as noted at the edge of the wood, could theoretically be, not an *l*, but the left-hand part of a different letter; however, *l* should not be doubted.

4. Longhi, loc. cit., protested against the doubt. The technical examination already referred to revealed nothing suspicious; the only point might seem the craquelure, which is markedly different at the base and in the rest of the triptych, but the expansions and contractions of the base are likely to have been different from those of the other parts. It is, perhaps, not common to have an inscription in such a place consisting only of a date; but compare some pictures associated more or less closely with Daddi (G.

Sinibaldi and G. Brunetti, *Mostra Giottesca*, Florence 1937, 1943, nos. 155, 156, 169, with reproductions and comments on the condition). It is patent that the date in No. 701 is carelessly executed; but this is not an argument against the authenticity of the inscription – indeed, it has been suggested above that the position of the signature, when the central panel was intact, may have been asymmetrical.

5. R. van Marle, *The Development of the Italian Schools of Painting*, IV, The Hague, 1924, pp. 164–6.

6. Bradley J. Delaney, 'Giusto de' Menabuoi in Lombardy', *Art Bulletin*, LVIII, 1976, 1, pp. 19–35.

7. e.g. the Seilern triptych now in the Courtauld Institute Galleries. See R. Offner and K. Steinweg, *A Critical and Historical Corpus of Florentine Painting*, Section III, vol. VIII, New York, 1979, pl. IV.

8. Delaney, art. cit., *Art Bulletin*, 1976, p. 29. He uses this to suggest a visit to Florence made between 1365 and 1367.

9. e.g. the ruined fresco of the *Nativity* attributed to Vitale da Bologna (Bologna, Pinacoteca).

10. Mina Gregori, 'Presenza di Giusto dei Menabuoi a Viboldone', *Paragone*, 293, July 1974, p. 10.

11. Sergio Bettini, *Giusto de' Menabuoi e l'Arte del Trecento*, Padua, 1944, pls. 85 and 81 and p. 17.

12. Bettini, op. cit., pls. 140 ff. and p. 101.

13. Van Marle, op. cit., p. 165.

14. Silvana Pettenati, 'Vetri a oro del Trecento padano', *Paragone*, 275, January 1973, pp. 72–3.

15. See F. Zeri, *Italian Paintings in the Walters Art Gallery*, Baltimore, 1976, no. 38, pp. 63–5, pls. 32 and 33.

16. The possibly Venetian thirteenth-century(?) ivories framing the Virgin and Child were published by J. G. Beckwith, 'Problèmes posés par certaines sculptures sur ivoire du Haut Moyen-Age', *Les Monuments Historiques de la France*, 1966, nos. 1–2, pp. 13–14 and fig. 14. Beckwith dated the panel of the Virgin and Child to the fifteenth century, but it is

more likely to be fourteenth-century. Only the right-hand glass is legible and appears to read *Agios Mateos*.
17. Letter from Dr Noack, 20 November 1909, noted by E. K. Waterhouse. See further *Kunst-Blatt*, 1824, pp. 318 and 353.

18. See G. Grupp in the *Jahrbuch des Historischen Vereins für Nördlingen und Umgebung*, VI, 1917, p. 97.
19. Waagen's catalogue, 1854 (no. 13); see also G. F. Waagen, *Treasures of Art in Great Britain*, IV, London, 1857, pp. 221–2.

GRECO-ROMAN School

Various portraits of this class were recorded in the catalogue of 1929. All those there recorded, except Nos. 3931 and 3932 below, were lent to the British Museum in 1936; some of them, under the heading *Greco-Alexandrian Portraits*, were in the Exhibition of Greek Art at the Royal Academy, 1946 (nos. 316–23). The three examples at present in the National Gallery are merely listed here; they are outside the tradition of the main schools of European painting as represented in the National Gallery Collection. The following entries are taken from the catalogue of 1961.

3931 *A Young Woman* Plate 31

Wood. 41 × 22 (16¼ × 8½).[1] Probably encaustic.

PROVENANCE: Found in the neighbourhood of the village of Er-Rubiyat, north-east of Medînet-el-Faiyûm. Acquired from a Greek dealer by Th. Graf of Vienna, and from him in 1893 by Ludwig Mond.[2] Exhibited at the Grafton Gallery, Fair Women, 1894 (no. 1 or no. 32). Mond Bequest, 1924.

REFERENCES:
1. Measurements from the 1929 catalogue.
2. J. P. Richter, *The Mond Collection*, 1910, II, Table of Contents and pp. 597 ff. Richter gives a reference to George Ebers, *Die hellenistischen Portraits aus dem Fayum*, 1893, p. 11.

3932 *A Man with a Wreath* Plate 32

Wood. 42 × 22 (16½ × 8⅜).[1] Probably encaustic.

PROVENANCE: From Er-Rubiyat and Th. Graf, as No. 3931 above. Ludwig Mond Collection, 1893; Mond Bequest, 1924.

REFERENCE:
1. Measurements from the 1929 catalogue.

5399 *A Young Woman with a Wreath* Plate 30

Wood. 28.5 × 19 (11¼ × 7½); cut at the top corners. Probably encaustic.

PROVENANCE: Presented by Major R. G. Gayer-Anderson Pasha, and Col. T. G. Gayer-Anderson, C.M.G., D.S.O., 1943.

JACOPO DI CIONE
active 1362(?), died 1398/1400

Jacopo di Cione was the youngest of the three Cione brothers.[1] He appears to have received less prestigious commissions than his brothers, Andrea (called Orcagna) and Nardo. The problem of identifying his style lies in the lack of surviving documented works and in the fact that where documented works do survive, they were executed with collaborators. A *Virgin and Child* (formerly Brussels, Stoclet Collection) dated 1362 is sometimes attributed to him. His first surviving documented commission was the completion of the St Matthew triptych (Florence, Uffizi) for the Arte del Cambio, to be placed in Orsanmichele; on 25 August 1368, Andrea di Cione was ill and unable to complete the painting, so Jacopo was commissioned to finish it. Other documented commissions show him collaborating with Niccolò di Pietro Gerini: they worked together on lost frescoes for the guild hall of Judges and Notaries in Florence in 1366,[2] on the *Coronation of the Virgin* (Florence, Accademia) for the Zecca in Florence in 1372–3, on frescoes in Volterra in 1383, and it is generally accepted that the two painters collaborated on the altarpiece for San Pier Maggiore in Florence c.1370–1 (see Nos. 569–78).

Jacopo matriculated with the Arte dei Medici e Speziali in 1369. He is last mentioned in 1398 and is not included in the Prestanza list for 1400: he therefore died between May 1398 and 1400.

REFERENCES:
1. For the details of his life and documents concerning him, see R. Offner and K. Steinweg, *A Critical and Historical Corpus of Florentine Painting*, Section IV, vol. III, New York, 1965, pp. 1 ff. Also R. Fremantle, *Florentine Gothic Painters from Giotto to Masaccio*, London, 1975, pp. 161 ff.
2. Eve Borsook, 'Jacopo di Cione and the guild hall of the Judges and Notaries in Florence', *The Burlington Magazine*, CXXIV, 1982, pp. 86–8.

Ascribed to JACOPO DI CIONE and WORKSHOP

569 *The Coronation of the Virgin, with Adoring Saints*
(Main tier of an altarpiece)

Plates 34 and 35

Centre panel, Christ crowns the Virgin Mary; music-making angels below.

Left panel, five rows of saints, *A–E*, numbered from right to left.
A. (1) St Peter; on his knee is the model of a church, which stands for the Church, and also for San Pier Maggiore in Florence, where No. 569 formed part of the high altarpiece. In the tympanum over the main entrance of the model church are a Cross and crossed keys (2) St Bartholomew (3) St Stephen.
B. (1) St John the Evangelist, holding a book with a quotation reduced from Revelation vii, 9: *Vjdi tur/bam ma/gnā quaz.dinumeā/re nemo / poterat. / ex omībus / gentibus / stantes an/*

te thronū /&in con(spectu)/*agni amicti* (2) St Philip (?) (3) St Miniato (?) (4) St Zenobius (?) (5) St Francis (6) The Magdalen, her robe embroidered with \overline{XPS} and \overline{IHS}.

C. (1) St Andrew (?) (2) A youthful saint (3) St Blaise (4) St Gregory (5) St Benedict (6) St Lucy.

D. (1) An Apostle (2) St Luke (?) (3) A martyr pope (4) St Ambrose or Giles (?) (5) One of the Magi, Caspar (?).

E. (1) and (2) The two remaining Magi, Melchior (?) and Balthasar (?) (3) St Reparata (?).

Right panel, five rows of saints, *A–E*, numbered from left to right:

A. (1) St Paul, holding a book with a quotation from II Corinthians iii, 18: *Nos ōs / reuelata / facie glo/riam do/mini spe/culantes / in eadem /ymagi/nē trans/formam'/ a clarita/te in cla/ritatem / tanquā* (2) St Matthew, holding a book with a fragment from his gospel, i, 1: *Libe / intio / ihu x / filij d / filij a/braaz* (3) St Lawrence.

B. (1) St John the Baptist (2) A youthful saint (3) St Julian (?) (4) St Nicholas (5) St Dominic (6) St Catherine of Alexandria.

C. (1) St James the Greater (2) An Apostle (3) St John Gualberto (?) (4) St Bernard (?) (5) St Anthony Abbot (6) St Agnes.

D. (1) An Apostle (2) St Mark (?) (3) A holy martyr pope (4) St Augustine (?) (5) St Jerome (6) St Scholastica.

E. (1) St Ambrose (?) (2) A young saint with a sword (Julian?) (3) St Ursula (?).

Wood. Central panel, painted surface 206.5 × 113.5 ($81\frac{1}{2}$ × $44\frac{3}{4}$), pointed top; side panels, each painted surface 169 × 113 ($66\frac{1}{2}$ × $44\frac{1}{2}$) with twin pointed tops. The painted parts extend to the edges of the panels, except along the bottom. The frame is not original.

No. 569 was once the central panel of the high altarpiece of San Pier Maggiore, Florence, painted *c.*1370–1.

The iconography of No. 569 is complex. Many of the identifications of the saints are necessarily conjecture.[1] The patron saints of Florence are likely to appear in a picture such as this, which may justify the suggestions for Sts Zenobius, Miniato and Reparata. St Reparata ought properly to appear as a martyr; the figure here identified as her has no palm, but a figure apparently accepted as St Reparata in Bernardo Daddi's polyptych in the Uffizi has no palm either.[2] Sts Mark and Luke may be expected, since the two other Evangelists are present; the figures identified hold pens and correspond well enough with the types traditional for these saints. Sts Ambrose and Augustine are suggested since Sts Gregory and Jerome are certainly present, and the four figures often appear together as the four Doctors of the Church. St Blaise is certainly identifiable, and later on the church of San Pier Maggiore possessed an important relic of this saint; St Ursula is dubiously identified, since (later on) the head of one of her companions was another prized relic.[3] St Julian was a very popular saint in Florence at the time of this picture, and is likely either to be Right Panel, *B*(3), or Right Panel, *E*(2). Although San Pier Maggiore belonged to Benedictine nuns (see below), there is not the preponderance of Benedictine saints one might have expected. The inclusion of the three Magi is an iconographical oddity. It is just possible that it is in some way connected with the procession which took place annually in Florence on the feast of the Epiphany.[4]

The model of the church held by St Peter is a fairly accurate representation of San Pier Maggiore (Fig. 8), which was destroyed in the eighteenth century[5] (see PROVENANCE on p. 53).

The Coronation of the Virgin was, from Giotto's Baroncelli altarpiece in Santa Croce, Florence, onwards, one of the most popular representations in Florentine art.[6]

For a fuller discussion of this altarpiece see pp. 51–4.

REFERENCES:

1. For the adjustment and refinement of some of the identifications made by Martin Davies see R. Offner and K. Steinweg, *A Critical and Historical Corpus of Florentine Painting*, Section IV, vol. III, New York, 1965, p. 40.
2. R. Offner, *A Critical and Historical Corpus of Florentine Painting*, Section III, vol. III, New York, 1930, pl. XIV[15].
3. G. Richa, *Notizie Istoriche delle Chiese Fiorentine*, I, Florence, 1754, p 138.
4. See Rab Hatfield, 'The Compagnia de' Magi',

Journal of the Warburg and Courtauld Institutes, XXXIII, 1970, pp. 107–61.
5. The church is shown also in a fourteenth-century miniature (Biblioteca Medicea Laurenziana, MS Edili 107, f. 367[r]; published by P. Metz in the *Jahrbuch der Preussischen Kunstsammlungen*, LIX, 1938, p. 127, Abb. 5).
6. For the iconography of the Virgin, and particularly in Florence, see Offner, op. cit., Section III, vol. V, pp. 243–50.

570 *The Trinity* *Plate 36*
(Pinnacle from an altarpiece)

Wood. Painted surface 87 × 40 (34¼ × 15¾), irregular top; the painted parts of this picture and of all the subsequent pictures up to No. 578 continue to the edges of the panels.

The condition is generally good. The tip of the peak (5 cm.) has been regilded.

No. 570 was once a pinnacle panel on the high altarpiece of San Pier Maggiore, Florence, painted *c.* 1370–1. For a fuller discussion see No. 578 and pp. 51–4 below.

571 *Seraphim, Cherubim and Adoring Angels* *Plate 37*
(Pinnacle from an altarpiece)

Wood. Painted surface 87 × 37.5 (34¼ × 14¾), irregular top.

The gold background has been completely regilded.

No. 571 was once a pinnacle panel on the high altarpiece of San Pier Maggiore, Florence, painted *c.* 1370–1. For a fuller discussion see No. 578 and pp. 51–4 below.

572 *Seraphim, Cherubim and Adoring Angels* *Plate 38*
(Pinnacle from an altarpiece)

Wood. Painted surface 87 × 37.5 (34¼ × 14¾), irregular top.

The background of the peak has been regilded.

No. 572 was once a pinnacle panel on the high altarpiece of San Pier Maggiore, Florence, painted *c.* 1370–1. For a fuller discussion see No. 578 and pp. 51–4 below.

573 The Nativity, with the Annunciation to the Shepherds and the Adoration of the Shepherds

Plate 39

(Pinnacle from an altarpiece)

Wood. Painted surface 95 × 49 (37½ × 19½), irregular top.

The tip of the peak (4 cm.) has been regilded.

Cleaned in 1985–7.

The Virgin seated on the ground adoring the Child in the crib occurs in other Florentine paintings.[1]

The Annunciation to the Shepherds shown in the background, painted in a brownish monochrome, represents one of the earliest attempts to show the event as a night scene against the gold-leaf background of a panel painting.[2]

No. 573 was once a pinnacle panel on the high altarpiece of San Pier Maggiore, Florence, painted c. 1370–1. For a fuller discussion see No. 578 and pp. 51–4 below.

REFERENCES:
1. See R. Offner and K. Steinweg, *A Critical and Historical Corpus of Florentine Painting*, Section IV, vol. III, New York, 1965, p. 40, N[12] and idem, Section III, vol. II, pt. II, add. pl. XV[1].
2. In the Baroncelli Chapel, Taddeo Gaddi had already shown the event as a night scene, but in the easier medium of fresco against a dark sky (see A. T. Ladis, *Taddeo Gaddi*, Columbia and London, 1982, pl. 4b–5). Here the position of the shepherds is possibly derived from that fresco. Joseph's pose may also owe something to the Baroncelli Chapel frescoes (ibid., pl. 4b–6).

574 The Adoration of the Magi

Plate 40

(Pinnacle from an altarpiece)

Wood. Painted surface 95 × 49 (37½ × 19½), irregular top.

Cleaned in 1985–7.

The motif of the king kissing the Child's foot occurs in the *Meditationes Vitae Christi*.[1] It is the only example known to the compiler of the Child handing the first king's gift to St Joseph. In a panel attributed to the Master of the Fabriano Altarpiece (Worcester Art Museum),[2] and in the Giottesque panel in the Metropolitan Museum of Art, New York, Joseph is shown already holding the gift (see Fig. 5 and entry under No. 5360, Ascribed to GIOTTO).

No. 574 was once a pinnacle panel on the high altarpiece of San Pier Maggiore, Florence, painted c. 1370–1. For a fuller discussion see No. 578 and pp. 51–4 below.

REFERENCES:
1. See R. Offner, *A Critical and Historical Corpus of Florentine Painting*, Section III, vol. V, New York, 1947, p. 212, N[1]., where this iconography is discussed.
2. Offner, loc. cit., pl. XLVIII.

575 *The Resurrection* *Plate 41*
(Pinnacle from an altarpiece)

Wood. Painted surface 95 × 49 (37½ × 19½), irregular top.

The condition is generally good. The tip of the peak (4.5 cm.) has been regilded.

Cleaned in 1985–7.

The letters SPQR occur on two of the soldiers' shields.

The foliage of the trees, some of which is painted in a light ochre colour, is intended to show the effects of divine light shed by the figure of Christ.

Offner and Steinweg suggest that the iconography derives from the frescoes in the Spanish Chapel in Santa Maria Novella, Florence, by Andrea da Firenze of 1365–7.[1] Certainly the pose of the foremost prostrate soldier sprawling on the left is extremely close.[2]

No. 575 was once a pinnacle panel on the high altarpiece of San Pier Maggiore, Florence, painted *c.*1370–1. For a fuller discussion see No. 578 and pp. 51–4 below.

REFERENCES:
1. R. Offner and K. Steinweg, *A Critical and Historical Corpus of Florentine Painting*, Section IV, vol. III, New York, 1965, p. 41, N[14].
2. Offner and Steinweg, op. cit., Section IV, vol. VI, pl. VIII. See also ibid., p. 62, N[1] for a discussion of the iconography of the *Resurrection*.

576 *The Maries at the Sepulchre* *Plate 42*
(Pinnacle from an altarpiece)

Wood. Painted surface 95 × 49 (37½ × 19½), irregular top.

The gold background has been entirely regilded, except for two small patches above the landscape, left and right.

The event is as described in Luke xxiv, 1 ff.

No. 576 was once a pinnacle panel on the high altarpiece of San Pier Maggiore, Florence, painted *c.*1370–1. For a fuller discussion see No. 578 and pp. 51–4 below.

577 *The Ascension* *Plate 43*
(Pinnacle from an altarpiece)

Wood. Painted surface 95 × 49 (37½ × 19½), irregular top.

The top *c.* 3 cm. of the peak have been regilded.

Offner and Steinweg[1] note that this type of standing Christ in the Ascension follows the Syriac tradition and may derive from the frescoes in the Spanish Chapel in Santa Maria Novella, Florence, painted by Andrea da Firenze 1365–7.[2] They also note the prominence given to St Peter, prompted by the dedication of the church and altarpiece to this

saint (see below), although pointing out that a similar composition occurs in Taddeo Gaddi's lunette of the sacristy cupboard from Santa Croce (Florence, Accademia).[3]

For two angels in white with the Apostles see Acts i, 10–11.

No. 577 was once a pinnacle panel on the high altarpiece of San Pier Maggiore, Florence, painted c.1370–1. For a fuller discussion see No. 578 and pp. 51–4 below.

REFERENCES:
1. R. Offner and K. Steinweg, *A Critical and Historical Corpus of Florentine Painting*, Section IV, vol. III, New York, 1965, p. 41, N[15].
2. Offner and Steinweg, op. cit., Section III, vol. VI, p. 138, n. 3, and op. cit, Section IV, vol. VI, pl. IX.
3. L. Marcucci, *Gallerie Nazionali di Firenze. I Dipinti Toscani del Secolo XIV*, Rome, 1965, fig. 31.

578 *Pentecost* *Plate 44*
(Pinnacle from an altarpiece)

Above, the Holy Ghost descends upon the Virgin and the assembled Apostles; below, the people marvel that each man hears his own language spoken.

Wood. Painted surface 95 × 49 (37½ × 19½), irregular top.

The top c. 3 cm. of the peak have been regilded.

No. 578 was once a pinnacle panel on the high altarpiece of San Pier Maggiore, Florence, painted c.1370–1. The following description relates to Nos. 570–8.

Painted on a plain arched panel, made up of one single poplar piece with an addition for the top of the arch. The overall shape of the arch is pointed, but the main part of the panel forms a semi-circle within this arch; the additional piece of wood converts the semi-circle into a pointed arch. The gilding on the addition is clearly new. The punched border indicates that the gilding originally terminated in a point (as it now does), and that therefore the new gilding probably reconstructs the original form correctly.

The present structure (see, for example, Fig. 10) presents some anomalies. The explanation appears to be as follows. There were two stages of alteration. The first change was the cutting down of the arch into a semi-circle. The second was the reconversion of the arch to its presumed original pointed shape by the addition of a wooden strip. Some of the panels were damaged below the semi-circular top and these areas were regilded when the arch was converted back to a point. All the panels have been slightly trimmed all round. The sequence of construction seems to have been as follows: the entire panel was covered with fabric and then the elaborately shaped frame was applied, and the panel and frame gessoed and gilded. At the sides it is clearly visible where the asymmetrical capitals have been removed, leaving bare wood.

The back bears traces of two horizontal battens. The bottom one has a short vertical projection with a nail mark.

Offner and Steinweg point out how unusual it is to divide the composition of the Pentecost (No. 578) into two zones[1] and suggest that it derives from Andrea da Firenze's fresco of 1365–7 in the Spanish Chapel in Santa Maria Novella, Florence.[2] They note that it combines two elements: the representation of the Pentecost in an open loggia with the

Apostles seated in two rows, and the Byzantine scheme of showing the Apostles in a semi-circle above, while below are representatives of different races.

For a fuller discussion of the altarpiece see below.

REFERENCES:
1. R. Offner and K. Steinweg, *A Critical and Historical Corpus of Florentine Painting*, Section IV, vol. III, New York, 1965, p. 41, N[16].
2. Offner and Steinweg, op. cit., Section III, vol. VI, pl. VI.

ORIGINAL LOCATION OF THE ALTARPIECE

There can be no doubt that Nos. 569–78 all come from the high altarpiece of San Pier Maggiore, Florence, belonging to Benedictine nuns. Not only does the model held by St Peter correspond to the appearance of the church of San Pier Maggiore (Fig. 8) (see above under No. 569), but the altarpiece was seen there by Vasari.[1] It remained in the church in the Cappella della Rena until at least 1677.[2] The church itself was destroyed in 1783.[3]

RECONSTRUCTION OF THE ALTARPIECE

The altarpiece was first reconstructed by Gronau[4] and Offner (Fig. 9),[5] who recognised that the predella still existed, fragmented in various collections. The reconstruction has been fully described and analysed by Offner and Steinweg,[6] as follows. The *Coronation of the Virgin* (No. 569) was originally surmounted by the *Resurrection* (No. 575) and the *Maries at the Sepulchre* (No. 576), finally topped by the *Trinity* (No. 570). Paired above the left panel of saints were the *Nativity* (No. 573) and *Adoration of the Magi* (No. 574), finally topped by *Seraphim, Cherubim and Adoring Angels* (No. 571). Paired above the right panel of saints were the *Ascension* (No. 577) and *Pentecost* (No. 578), finally topped by *Seraphim, Cherubim and Adoring Angels* (No. 572).

A predella, cited in a document of 1371 (see below) and dedicated to the Life of St Peter, consisted of six paired scenes below the main panels. According to Offner and Steinweg,[7] who are quoted below, it was arranged as follows:

'The left pair represented the Taking of St Peter (Providence, Rhode Island School of Design, Museum of Art) and the Liberation of St Peter (Philadelphia, Johnson Collection), the central pair, St Peter Raising the Son of Theophilus and the Chairing of Peter at Antioch (Rome, Pinacoteca Vaticana), the right pair, the Last Meeting of SS. Peter and Paul in Rome (formerly Lugano-Castagnola, Galerie Schloss Rohoncz) and the Crucifixion of St Peter (Rome, Pinacoteca Vaticana). The right-hand pair only survives in fragments. The piece in Lugano was originally composed of two parts like the corresponding panel (Liberation of St Peter) on the left. The missing part of the Lugano panel probably showed St Peter before Prefect Agrippa. In the *Legenda Aurea* this event exactly precedes the Last Meeting of the Apostles. The missing part of St Peter's Crucifixion undoubtedly represented the judge who is usually connected with the martyrdom in Trecento panels.

'The scenes were so grouped that the events occurring in Jerusalem were at the left, those in Antioch, in the centre, and those in Rome, at the right. They glorify the three feasts of St Peter: the feast of *S. Petrus in Vinculis* (symbolised by his Liberation), the feast of *Cathedra Petri* (symbolised by the Chairing of Peter), and the feast of his name day

51

(symbolised in the martyrdom scene). These three feasts commemorate the threefold veneration of St Peter in the Church: in the *ecclesia malignantium*, in the *ecclesia militantium* and in the *ecclesia triumphantium*.

'In the S. Pier Maggiore altarpiece, St Peter occupies the place of honour in the left leaf. The corresponding figure at the right is St Paul who has the same name day as the patron of S. Pier Maggiore. This is why he also has an important role in the predella scenes. He is shown together with St Peter in the two central panels of the predella and in the adjacent scene at the right (the Last Meeting). Then follows the martyrdoms of the two apostles, but it is quite justified that the martyrdom of St Paul (wherein the saint is not accompanied by St Peter) was relegated to the base of the right pilaster. This leaves open to question which scene was represented in the corresponding space of the left pilaster. We can only assume that the Calling of St Peter was shown here, since other cycles of the life of St Peter usually begin with this scene (cf. the panel by the school of Guido da Siena, Siena, Pinacoteca, No. 15, and the approximately contemporary panel by the Magdalen Master in the Jarves Collection, No. 3).

'Each pilaster of the altarpiece probably contained four saints arranged vertically, one above the other. The four Evangelists occupied the uppermost compartments (only the right-hand pair has survived: St Matthew, formerly in the Hutton Collection; St John the Evangelist, in the van Gelder Collection). The lower left pair were SS. Paul the first Hermit and Romuald (van Gelder Collection), and the lower right pair, SS. Stephen and Magdalen (formerly Hutton Collection). The saints of the right pilaster (SS. Matthew, John the Evangelist, Stephen and the Magdalen) already appear in the lateral leaves of the polyptych: SS. Stephen and Matthew prominent in the first row (left and right panels), the two others in the second row of saints (left panel). This repetition might be due to the special wishes of the patron.'

It is likely that the altarpiece was of the 'buttressed' type, analysed extensively by Gardner von Teuffel.[8] Also see below.

ATTRIBUTION OF THE ALTARPIECE

A few documents from San Pier Maggiore relevant to the altarpiece survive. They show that in 1370 a certain 'Niccolaio dipintore' was paid for designing the altarpiece ('per disegnare la tavola dell'altare di San Piero').[9] What exactly 'disegnare' involved is problematic. It is, however, generally accepted that the 'Niccolaio' concerned is NICCOLÒ DI PIETRO GERINI. It is also generally accepted that although some scholars, for example Martin Davies, were reluctant to describe the altarpiece more precisely than as 'Style of Orcagna', the overwhelming majority of them have felt that the altarpiece is attributable to Jacopo di Cione, on stylistic grounds, even though he is not named in any of the few surviving documents.[10] It is known that Niccolò di Pietro Gerini and Jacopo di Cione collaborated on a number of occasions: in 1366 on the now lost frescoes for the guild hall of Judges and Notaries in Florence;[11] in 1372–3 on a *Coronation* (Florence, Accademia) for the Zecca Vecchia (Old Mint) in Florence;[12] in 1383 on a fresco in Volterra.[13]

The other painters mentioned in the extant documents concerning Nos. 569–78 are Tuccio di Vanni and Matteo di Pacino.[14] It is recorded that a *colmo*[15] was removed from his house some time during 1370; it is not stated, but it appears likely, that he had been painting this *colmo*. One picture, also a *Coronation of the Virgin*, is known, signed and

dated 1360, by Matteo di Pacino;[16] it is in an Orcagnesque style, and a good deal weaker than any part of Nos. 569–78, but it is possible that, working ten years later on another man's design, he might have produced some parts of the present altarpiece.[17]

A stylistic analysis confirms that several hands were involved in the execution of the altarpiece. Offner and Steinweg[18] made a detailed study of composition and style. They note, for example, the similarity of the central *Coronation* to that in the Zecca Vecchia panel. They attribute to Jacopo di Cione himself the *Coronation* group, the two bottom rows of saints on the left wing and the bottom row on the right, and the predella. The rest they attribute to workshop intervention. The painter of the pinnacles they describe as belonging to the Orcagnesque circle. The situation may be clearer when all the panels have been cleaned.

The other surviving document concerning the altarpiece and dated 1371, records various payments.[19] These include payments for fifty small pots (for mixing) and for pigments: white lead, vermilion, lead tin yellow, ash and ultramarine, eggs, gold for the fringes and draperies of the figures, and gold leaf for the central main panel (?); also for transporting the altarpiece and predella to and from Santa Maria Nuova for varnishing. The document includes payments for nails for the '*colonelli*', presumably the supporting lateral buttresses. The altarpiece was hung with a curtain: there are payments for 24 curtain rings, for strong string to support the curtain, and for orpiment and minium (?) for decorating (?) the curtain. There are payments to a certain Tuccio for colours for the arch of the chapel and for gold for decorating the arch. Finally, a mason, Niccolò, provided an assistant to make holes – perhaps for the hanging of the curtain, or for fixing the buttresses of the altarpiece frame into the floor.

Although no donor is recorded, it is possible that a private patron was involved in payment for the commission. And although the altarpiece at one stage was in the possession of the della Rena family (see PROVENANCE), it is possible that the Albizzi family was involved in the original commission, since they dominated San Pier Maggiore, having five chapels there.[20]

PROVENANCE: Painted to be the high altarpiece of San Pier Maggiore in Florence, it was after a time removed to the chapel belonging to the della Rena family.[21] The church was destroyed following an accident in 1783.[22] Although there is no reason to suppose that the della Rena family had commissioned the picture, they appear to have taken it away with them when their chapel ceased to exist, and it is stated that the picture thereafter passed by inheritance into the possession of the Marchese Roberto Pucci.[23] Acquired from him in 1846 by Francesco Lombardi and Ugo Baldi,[24] purchased from the Lombardi–Baldi Collection, Florence, 1857.[25]

REFERENCES:

1. 'in san Pier Maggiore in una tavola assai grande l'incoronazione di nostra Donna.' Vasari ascribed the altarpiece to Orcagna (Vasari, *Vite*, ed. Milanesi, Florence, 1878, I, p. 595).
2. F. Bocchi, enlarged by G. Cinelli, *Le Bellezze della Città di Firenze*, 1677, pp. 353–4; G. Richa, *Notizie Istoriche delle Chiese Fiorentine*, I, Florence, 1754, p. 145. Both these writers state that the picture had been the high altarpiece, which indeed the character of the picture and of the documents confirms. The date of its removal from the high altar has not been established, but it may have been taken away when

Desiderio da Settignano's ciborium was set up *c*.1450–60. See also W. and E. Paatz, *Die Kirchen von Florenz*, vol. 4, Frankfurt-am-Main, 1952, p. 653, n. 54. It was clearly no longer on the high altar in the middle of the sixteenth century; apart from Vasari's not very clear references, see a letter of 1566 quoted by F. Moisè, *Santa Croce di Firenze*, Florence, 1845, p. 124.
3. (Follini and Rastrelli) *Firenze Antica e Moderna*, III, Florence, 1791, p. 375, and VIII, Florence, 1802, p. 335.
4. H. D. Gronau, 'The San Pier Maggiore Altarpiece:

A Reconstruction', *The Burlington Magazine*, LXXXVI, 1945, pp. 139 ff.

5. R. Offner, 'A Florentine Panel in Providence and a Famous Altarpiece', *Studies*, Museum of Art, Rhode Island School of Design, Providence, 1947, pp. 53 ff.

6. R. Offner and K. Steinweg, *A Critical and Historical Corpus of Florentine Painting*, Section IV, vol. VII, New York, 1965, pp. 31–2 and pls. III, III¹–III³³.

7. Quoted from Offner and Steinweg, loc. cit.

8. C. Gardner von Teuffel, 'The buttressed altarpiece: A forgotten aspect of Tuscan fourteenth-century altarpiece design', *Jahrbuch der Berliner Museen*, 21, 1979, pp. 21–65 *passim*.

9. Florence, Archivio di Stato, San Pier Maggiore, vol. 50, f. 6ᵛ. Published in Offner and Steinweg, op. cit., Section IV, vol. III, pp. 41–2; see also p. 37.

10. For a full list of attributions of this altarpiece see the bibliography in Offner and Steinweg, op. cit., Section IV, vol. III, pp. 43–7.

11. Eve Borsook, 'Jacopo di Cione and the guild hall of the Judges and Notaries in Florence', *The Burlington Magazine*, CXXIV, 1982, pp. 86–8.

12. Ibid., pp. 85–6, and L. Marcucci, *Gallerie Nazionali di Firenze. I Dipinti Toscani del Secolo XIV*, Rome, 1965, pp. 109–11.

13. Offner and Steinweg, op. cit., Section IV, vol. III, p. 115.

14. Died 1374; see R. G. Mather, 'Il primo registro della Compagnia di S. Luca', *L'Arte*, 1938, fig. 2 opp. p. 352.

15. H. D. Gronau (loc. cit.) has stated that *colmo* means one of the top parts of Nos. 569–78. This may be so; but it could also mean one of the main parts, to judge from the use of the word *colmus* in a document of 1372 concerning the Abbey of Passignano (G.

Milanesi, *Documenti per la Storia dell'Arte Senese*, I, Siena, 1854, pp. 269–71).

16. Reproduced by A. Muñoz, *Pièces de Choix de la Collection du Comte Grégoire Stroganoff*, II, 1911, fig. VI, and by B. Berenson, 'Quadri senza casa – Il Trecento Fiorentino', *Dedalo*, 1931, p. 985.

17. There are indeed slight divergencies of style between various parts of Nos. 569–78; and it is a curious fact that the saints who appear both in the large panels and in the small scenes differ rather markedly in their features. See also below.

18. Offner and Steinweg, op. cit., Section IV, vol. III, pp. 35–7.

19. Florence, Archivio di Stato, San Pier Maggiore, vol. 50, ff. 8ᵛ, 9. Fully published in Offner and Steinweg, op. cit., Section IV, vol. III, p. 42. Gronau's transcription of the document (art. cit., p. 144) is incomplete.

20. See Richa, op. cit., I, 1754, p. 135, and Paatz, op. cit., vol. 4, 1952, p. 638.

21. See note 2.

22. See note 3.

23. National Gallery Catalogue, 1859, presumably on information supplied to Eastlake. It is the break in the provenance at this point that justifies the statement that the provenance is not in the strictest sense proved; but there seems to be no justification for disputing it. Follini and Rastrelli (*Firenze Antica e Moderna*, V, Florence, 1794, p. 99) say that at the time of the destruction of San Pier Maggiore the pictures were taken away by the owners of the chapels, or sold.

24. MS catalogue.

25. For the history of the Lombardi–Baldi Collection see Appendix I.

1468 *The Crucifixion* Plate 33
(Altarpiece)

In the centre, Christ hangs on the Cross, marked .ɪ.ɴ.ʀ.ʏ. Angels receive in basins the blood from the wounds in His hands and side. Left, the good thief (St Dismas); he is haloed, and two angels carry up his soul to heaven. Right, the bad thief (Gestas); two devils hold a brazier(?) above his head. In the foreground, centre, the Virgin is supported by the Magdalen and three other Maries; St John stands near. Left, the soldiers apparently casting lots. Right, various figures, including a soldier with a shield marked s.ᴘ.ǫ.ʀ. A little behind is a man with the sponge at the end of a pole, and various groups of soldiers on horseback, some with s.ᴘ.ǫ.ʀ. on their jerkins or the banners attached to their spears. The rider with a spear near the Cross, with his right hand to his mouth, may be St Longinus. A man towards the right is breaking the legs of the bad thief.

Left and right of this scene are compartments one above the other, with saints. Left, Sts John the Baptist and Paul; right, Sts James the Greater and Bartholomew.

The predella contains five roundels, set in decorative *pastiglia*. From left to right: (1) A female saint with a red cross and a book. (2) St Bernard, holding a book insribed: *Dic mat'* / *domini si* / *in ierusalē* / *eras quā/do captus* / *fuit filius* / *tuus & uī/tus. Cui /illa R'it.* / *In ierusa/ lem erā* / *quādo* / *hoc aud*(i)/*ui. & gres*(su). (3) The Virgin and Child. (4) St Anthony Abbot (?), in white, with book, crutch and black hog (?). (5) St Catherine of Alexandria, with wheel, crown and palm.

At the top are seven cusped canopies, the insides painted blue with stars. Two pilasters at the sides are ornamented with decorative *pastiglia* and with shields (indecipherable remains of blue and red).

Wood. Crucifixion, painted surface 108 × 84 ($42\frac{1}{2}$ × 33), cusped top; measured to the top of the painted surface in the central cusp, which is higher than the others. St John the Baptist, painted surface 49.5 × 13 ($19\frac{1}{2}$ × $5\frac{1}{8}$), pointed top; St Paul, painted surface 51.5 × 13 ($20\frac{1}{4}$ × $5\frac{1}{8}$), pointed top; St James, painted surface 50.5 × 12.5 (20 × $4\frac{7}{8}$), pointed top; St Bartholomew, painted surface 50.5 × 12.5 (20 × $4\frac{7}{8}$), pointed top. There are simple mouldings, not included in the above measurements, separating these five compartments. The diameter of the roundels in the predella is in each case 15 ($5\frac{7}{8}$). For the whole altarpiece, including the framing, the greatest height is 154 ($60\frac{1}{2}$), the greatest width 138.5 ($54\frac{1}{2}$).

There are various damages, e.g. in the head of the white horse next to the Cross; but in general the altarpiece is very well preserved. Most of the gold is original; the part most restored is on the canopies. The frame is original. The predella is on a separate piece of wood, attached to the main panel, which continues behind. The pilasters are on separate pieces of wood from the main panel. They appear to be not only original, but in their correct position. One change carried out during the cleaning was the removal of a strip of wood about 3 cm. high that ran along the bottom of the central panel and of the compartments with St Paul and St Bartholomew; the rocky edge to the ground in the *Crucifixion* is now clearly visible.

Cleaned in 1955.

The inscription on the book held by St Bernard is from the *Liber de Passione Christi et doloribus et planctibus matris ejus*, ascribed to St Bernard. The full text runs: 'Dic mihi si in Jerusalem eras quando fuit captus filius tuus, et vinctus, et ductus, ad Annam tractus? At illa: in Jerusalem eram, quando hoc audivi, et gressu quo potui ad Dominum meum flens perveni.'[1] The same text is quoted on the *Vision of St Bernard* ascribed to Orcagna and others, in the Accademia, Florence.[2]

From the rather prominent position of St Bernard, No. 1468 may perhaps have had a Cistercian destination. It is rather small to have been over the altar of a chapel; it could have been in some sacristy, or in a private oratory.

Although Martin Davies catalogued No. 1468 as Style of Orcagna, it is often attributed to Jacopo di Cione.[3] Offner and Steinweg,[4] who discuss the altarpiece extensively under the heading 'Iacopo di Cione and Orcagnesque Master with Workshop', divide the attribution as follows. To Jacopo di Cione they attribute the three Crosses, the group of mourning women and St John, making reference to the *Trinity*

(No. 570) and *Coronation* (No. 569) in the San Pier Maggiore altarpiece, and the St Matthew triptych (Florence, Uffizi). To a second painter they attribute the groups of horsemen and figures to the left of the mourning women and right of St John. The predella medallions they attribute to a third painter connected with the Master of the Ashmolean Predella. They also note the connection of the frame with other Florentine polyptychs and baldachins,[5] and the derivation of the iconography of the crucifixion of the two thieves from Andrea da Firenze's version of 1365–7 in the Spanish Chapel.[6]

PROVENANCE: Stated in the 1823 Fonthill sale catalogue to have come from the Camposanto in Pisa. Not in the Beckford sale catalogue, Fonthill, 1822 (sale not held); but in the Beckford and additions sale, Fonthill, 10 October 1823 (lot 34), bought by Bentley.[7] Collection Revd J. Fuller Russell, where seen by Waagen;[8] exhibited at the RA, 1877 (no. 151); Fuller Russell sale, 18 April 1885 (lot 123), bought by Ash.[9] Bequeathed by the Revd Jarvis Holland Ash, 1896.[10]

REFERENCES:

1. Migne, *Patrologia Latina*, vol. 182, col. 1133 ff.
2. Reproduced by R. van Marle, *The Development of the Italian Schools of Painting*, III, The Hague, 1924, fig. 261.
3. e.g. by H. D. Gronau in Thieme-Becker (s.v. Orcagna); approved by R. Offner in *The Burlington Magazine*, LXIII, 1933, p. 84. Cf. also O. Sirén, *Giotto and Some of his Followers*, Cambridge, Mass., 1917, I, pp. 258–9.
4. R. Offner and K. Steinweg, *A Critical and Historical Corpus of Florentine Painting*, Section IV, vol. III, *Iacopo di Cione*, New York, 1965, pp. 75–8.
5. Ibid., p. 76, N.[6].
6. Ibid., p. 75, N.[1].
7. As Andrea Orcagna. The provenance from Fonthill is stated in the Fuller Russell sale catalogue. It is genuinely a Beckford picture, being mentioned (with provenance from the Camposanto di Pisa) in John Rutter, *A Description of Fonthill Abbey*, 2nd ed., 1822, p. 52.
8. G. F. Waagen, *Treasures of Art in Great Britain*, II, London, 1854, p. 463, as Spinello.
9. As Spinello. The chalk marks of the Fuller Russell sale are still on the back of the picture. No. 1468 has been confused with another picture by Langton Douglas and S. Arthur Strong in their edition of J. A. Crowe and G. B. Cavalcaselle, *A New History of Painting in Italy*, II, London, 1903, p. 179, as Daddi (original edition, I, 1864, pp. 453–4, as Bernardo of Florence). This other picture was in the Ottley Collection; G. F. Waagen, *Kunstwerke und Künstler in England*, I, 1837, p. 396; probably Warner Ottley sale, 30 June 1847 (lot 20), as Taddeo Gaddi. Seen by Waagen, *Treasures* cit., 1854, p. 264, as Spinello, in the Eastlake Collection; Eastlake sale, 2 June 1894 (lot 54), bought by H. Quilter. Quilter sale, 7 April 1906 (lot 75), as Early Florentine. To judge from the description and the size, this picture is identical with the Orcagnesque *Crucifixion* in the Lehman Collection, New York, reproduced by O. Sirén, *Giotto and Some of his Followers*, Cambridge, Mass., 1917, II, pl. 218; see the entry under MASTER OF THE LEHMAN CRUCIFIXION, No. 3894.
10. As Spinello, and so catalogued until 1906; then catalogued as by Jacopo di Cione.

LIPPO DI DALMASIO
*c.*1352(?)–1410 or later

Of a Bolognese family named Scannabecchi. He is said to have been born *c.*1352;[1] he is first surely recorded in 1373. His father, Dalmasio, was also a painter.[2] Between 1377 and 1389 he was living, perhaps settled, in Pistoia; thereafter in Bologna. He made his will in 1410, and was dead by 1421.[3] Several signed works have survived.

REFERENCES:

1. Antonio Bolognini Amorini, *Vite dei Pittori ed Artefici Bolognesi*, I, Bologna, 1841, p. 16.
2. Robert Gibbs, 'Two Families of Painters at Bologna in the later Fourteenth Century', *The Burlington Magazine*, CXXI, 1979, pp. 560–8.

3. In addition to the bibliography in Thieme-Becker (s.v. Scannabecchi), see Francesco Filippini and Guido Zucchini, *Miniatori e Pittori a Bologna*, Florence, 1947, pp. 57–61 and pp. 153–61, s.v. Dalmasio and Lippo, for documents and recorded works.

752 *The Madonna of Humility* — Plate 45

The Virgin, holding the Child, is seated in a flowery meadow, with a glory behind her; she has a crown of twelve stars, and the moon is at her feet. Signed: *.lippus dalmasii pinxit*.

Canvas. 110×87 ($43\frac{1}{4} \times 34\frac{1}{4}$).

Much damaged with various splits and tears, and repainted, so that the style is considerably affected. A few fragments of the original gilding in the rays remain, but the gilding from the haloes has entirely disappeared and been replaced with gold paint.

In the past No. 752 was considered to have been painted originally on panel and transferred to canvas. However, it seems more likely that it was originally painted on canvas, for the following reasons. First, X-radiographs reveal that the damages are those of tears in canvas, rather than splits in panel – this sort of damage could not have occurred if the painting had been transferred. Secondly, X-radiographs also reveal that half-way down is a single horizontal (not vertical) seam where two strips of canvas have been stitched together, as one would expect with an original canvas. This stitching is markedly different from the repairs to the tears, which have merely been stuck together. It seems likely that the restoration process in 1773 was exactly as described, namely a relining of the pieces of original canvas which had torn in four and not a transfer from panel to canvas.[1]

The moon and the stars refer, as is quite common with the Madonna of Humility, to Revelation xii, 1. It seems clear that the glory behind the Virgin represents the words in the same verse, 'clothed with the sun'.[2]

It is possible that the eighteenth-century Bolognese provenance (see below) actually indicates that it was always in Bologna. It may have been a confraternity banner, painted for one of the Bolognese confraternities.[3]

Cennino Cennini[4] in his *Libro dell'Arte* discusses the technique of painting and gilding banners.

PROVENANCE: In the Malvezzi Collection in Bologna in 1773,[5] and therefore presumably the same as the undescribed picture owned by Lucio Malvezzi in 1678.[6] Recorded in 1816 in the Hercolani Collection, Bologna,[7] where it still was in 1861.[8] Purchased from Michelangelo Gualandi, 1866.

REFERENCES:

1. It was retouched by Domenico Pedrini in 1773; Francesco Filippini and Guido Zucchini, *Miniatori e Pittori a Bologna*, Florence, 1947, p. 160, referring to Oretti, MS B 123 in Bologna, p. 72. The passage concerning the condition is 'ma tutta volta in quattro pezzi rimessa *in una nuova tela* [present writer's italics], il Betusti (?) la fece ritoccare al S‎ʳ Domenico Pedrini l'anno 1773'. If the seam concerned the stitching together of the four fragments during restoration, rather than the original stitching together of two

pieces of canvas, one would expect at least one other seam.

2. For a picture by or after Paolo da Modena in Modena, which is iconographically similar and has LA NOSTRA DONNA D UMILTA inscribed on it, see M. Meiss, 'The Madonna of Humility', *Art Bulletin*, XVIII, 1936, p. 438, no. 15 and fig. 7, and R. Pallucchini, *I Dipinti della Galleria Estense di Modena*, 1945, no. 3 and fig. 3. For a picture, also iconographically similar, on which the text from Revelation is quoted,

see the Ranuccio d'Arvari in Legnago; reproduced by Trecca in *Madonna Verona*, 1909, pp. 149 ff., and by Fiocco, ibid., 1912, pp. 229 ff.

3. Surviving banners are rare. For a Genoese confraternity banner, for example, attributed to Barnaba da Modena, see M. Kauffmann, 'Barnaba da Modena and the Flagellants of Genoa', *Victoria & Albert Museum Bulletin*, 1966, pp. 12–20.

4. Trs. Daniel V. Thompson Jr., *The Craftsman's Handbook*, New York, 1933, pp. 103–4.

5. Oretti, MS B 123 in the Biblioteca dell'Archiginnasio in Bologna. Oretti appears to record No. 752 twice; on p. 71 'Casa Maluezi del Sig^r Luzio, un altra Imag^e della Madonna', and p. 72 (an addition to the first form of the MS), 'Casa del Senatore Maluezzi', with identifying description and the record of the condition quoted in note 1 above. Oretti, in another MS also in the Biblioteca dell'Archiginnasio in Bologna (B 104, Part I), again appears to record No. 752 twice. On p. 54, in the Palazzo Malvezzi, Palazzo del Sig^re Luzio, 'e incontro alla Chiesa de PP.

di S. Giacomo', he mentions 'Una Madonna di Lippo Dalmasio'; on p. 100, Palazzo Malvezzi del S^r. Senatore da S. Sigismondo, 'Aggiunta di altre pitture', he notes 'Una Madonna col Bambino di Lippo Dalmasio'.

6. Carlo Cesare Malvasia (ed. G. P. Zanotti), *Felsina Pittrice*, I, 1678, reprinted Bologna, 1841, p. 36.

7. Petronio Bassani, *Guida agli Amatori delle Belle Arti . . . per la Città di Bologna*, I, i, 1816, p. 211, Q. La B.V. col Bambino ec., m.f. On p. 206 the author records that Conte Astorre Hercolani married Marchesa Maria Malvezzi da San Sigismondo, through whom some Malvezzi property passed into the Hercolani possession.

8. The picture was seen by Eastlake in the Hercolani Collection in 1861; it was no. 9 of an inventory of January 1861, *Collezione della Principessa Donna Maria Hercolani in Bologna* (inventory kindly communicated to Martin Davies by the Avv. Ambrosini of Bologna).

Ambrogio LORENZETTI
active 1319, died 1348/9

A Sienese painter whom Ghiberti considered greater than Simone Martini. He was the younger(?) brother of PIETRO LORENZETTI (see p. 60) with whom he also collaborated. A *Virgin and Child* in Vico l'Abate, not signed or documented but generally accepted as his earliest surviving work, is dated 1319. He is documented in Florence in 1321 and matriculated with the Arte dei Medici e Speziali there in 1327.[1] His surviving Florentine works include the St Nicholas stories and altarpiece of 1332 for San Proccolò (both Florence, Uffizi). Otherwise he worked mainly in Siena: the frescoes of *Good and Bad Government* in the Palazzo Pubblico, 1338–40, the *Purification of the Virgin* dated 1342 for Siena Cathedral (Florence, Uffizi), and the signed and dated *Annunciation* of 1344 for the Nove (Siena, Pinacoteca Nazionale) are his main surviving documented works for that city. He made his will in 1348 and is presumed to have died in the Black Death.[2]

REFERENCES:
1. For most of the documents concerning his life see George Rowley, *Ambrogio Lorenzetti*, Princeton, 1958, vol. 1, pp. 127 ff. For a brief account of his work see Eve Borsook, *Ambrogio Lorenzetti*, 'I Diamanti dell'Arte', Florence, 1966.
2. Valerie Wainwright, 'The Will of Ambrogio Lorenzetti', *The Burlington Magazine*, CXVII, 1975, pp. 543–4.

1147 *A Group of Poor Clares* (Fragment)

Plate 46

Fresco. Irregular shape; greatest height 58.5 (23); greatest width 52 (20½).

Considerably damaged; but the face of the principal figure is well preserved. Although the *intonaco* appears to crack in an arc at the top right-hand corner, and the paint beyond it is paler, the *intonaco* and the paint beyond the arc appear to be original.

This fragment comes from San Francesco, Siena (see PROVENANCE), probably from a large wall-painting, the subject of which was perhaps the *Body of St Francis halted at San Damiano and mourned by St Clare and her Companions.*[1] The original location of the fragment within San Francesco is not certain. Martin Davies suggested it may be identifiable with paintings of an unspecified subject, described by Milanesi as having been in a room which was originally part of the Chapter House.[2]

The figures are comparable in style and quality to those in the fresco of *St Boniface receiving St Louis as a Novice* from the Chapter House of San Francesco, which is datable *c.*1329 on the basis of similarity to the predella of Pietro Lorenzetti's Carmelite altarpiece completed in 1329.[3] Despite the uneven condition, the attribution to Ambrogio Lorenzetti is beyond doubt. It is now clear that Ambrogio was involved in two decorative programmes in San Francesco: the frescoes in the cloister described by Ghiberti, of which fragments have recently been discovered;[4] and the frescoes in the Chapter House, which were discovered in the middle of the last century (see PROVENANCE). Frescoes from the Chapter House attributed to Ambrogio are *St Boniface receiving St Louis as a Novice* (see above) and the *Martyrdom of Franciscans.*[5]

On the wall facing the entrance to the Chapter House were a *Crucifixion* and a *Resurrected Christ*, both attributed to Pietro Lorenzetti.[6] (See also discussion under PIETRO LORENZETTI, Nos. 3071 and 3072.) Collaboration between the two brothers on a fresco cycle is documented in the now lost façade of the Ospedale of Santa Maria della Scala, Siena, in 1335.[7] No. 1147 is clearly stylistically distinct from Nos. 3071 and 3072 which also supposedly come from San Francesco, Siena.

PROVENANCE: The Chapter House frescoes in San Francesco, Siena, were discovered under whitewash shortly before 1855.[8] It seems that No. 1147 was then removed by the *maestro di casa* to his own room, where it remained apparently unrecorded. Purchased from him through Charles Fairfax Murray and Cav. P. Lombardi of Siena, 1878.[9]

REFERENCES:

1. The habit is correct for Poor Clares; although the figures look rather like Dominicans. The subject suggested occurs in the Upper Church of San Francesco, Assisi, in the nave.

2. The original positions of the four subject-pieces in the Chapter House are described by Milanesi in the *Monitore Toscano*, 27 January 1855; reprinted in his *Sull'Storia dell'Arte Toscana, Scritti Varij*, Siena, 1873, pp. 360–1. He notes that other fragments came from a second room, formerly part of the same Chapter House; No. 1147 may be one of these other fragments.

3. Eve Borsook, *The Mural Painters of Tuscany*, 2nd revised ed., Oxford, 1980, pp. 32–4.

4. Max Seidel, 'Wiedergefundene Fragmente eines Hauptwerks von Ambrogio Lorenzetti', *Pantheon*, XXXVI, 1978, pp. 119–27.

5. Seidel, art. cit. in *Pantheon*, 1978, *passim*, and also idem, 'Gli Affreschi di Ambrogio Lorenzetti nel Chiostro di San Francesco a Siena: ricostruzione e datazione', *Prospettiva*, 18, July 1979, pp. 10–20. Borsook considered that No. 1147 might have come from the Chapter House itself (Borsook, op. cit., p. 33). The two Franciscan scenes were transferred to

the church in 1857; see V. Lusini, *Storia della Basilica di San Francesco in Siena*, Siena, 1894, p. 214.

6. Seidel, op. cit., *Pantheon*, pp. 123 ff.

7. See George Rowley, *Ambrogio Lorenzetti*, Princeton, 1958, I, p. 130.

8. See note 2.

9. Letter from C. Fairfax Murray, 2 August 1877, in the National Gallery archives; National Gallery MS catalogue, and Report for 1878.

Pietro LORENZETTI
active 1320, died 1348(?)

A Sienese painter, much praised by Vasari, probably the elder brother of AMBROGIO LORENZETTI (see p. 58). His first signed work is the polyptych for the Pieve in Arezzo, for which a contract dated 1320 survives.[1] Other documented panel paintings include the Carmelite altarpiece of 1329,[2] a signed *Maestà* (Florence, Uffizi) and the *Birth of the Virgin* for Siena Cathedral (see No. 1113 below). He is documented as collaborating with his brother Ambrogio on frescoes for the façade of Santa Maria della Scala in 1335. Outside Siena, he worked on frescoes in the Lower Church of San Francesco, Assisi.[3] Although not actually documented as working in Florence like his brother, he was, like Ambrogio, heavily influenced by Giotto. He is last documented in a sale of land in 1345 and probably died in the Black Death in 1348.

REFERENCES:

1. For documents concerning Pietro Lorenzetti see Pèleo Bacci, *Dipinti Inediti e Sconosciuti di Pietro Lorenzetti, Bernardo Daddi etc. in Siena e nel Contado*, Siena, 1939, pp. 75 ff.

2. See especially H. W. van Os, *Sienese Altarpieces 1215–1460*, Groningen, 1984, pp. 91 ff; and also Joanna Cannon, 'Pietro Lorenzetti and the history of the Carmelite Order', *Journal of the Warburg and Courtauld Institutes*, L, 1987, pp. 18–28.

3. See Hayden B. Maginnis, *Pietro Lorenzetti and Assisi: The Study of a Problem*, Princeton University Ph.D., University Microfilms International, 1975.

Ascribed to Pietro LORENZETTI

1113 *St Sabinus before the Governor (?)* Plate 49
(Predella panel from an altarpiece?)

Wood. Painted surface 30.5 × 27 (12 × 10¾). Including the original frame, the total size is 37.5 × 33 (14¾ × 13). The frame is original (the original canvas is exposed under the gesso and gilding of the left top and base mouldings), but no longer in one piece with the picture. The frame moulding at the right edge ends in a raised lip; that at the left edge begins to curve down again in a similar fashion to the inner edge. The main panel is made up of two pieces: a piece 34.8 cm. and a narrow attachment of 2.7 cm. at the top.

Very good condition, in spite of some prominent scratches.

At the left edge (on the right seen from the back), the back of the panel has been cut away

to a width of 3.5 cm. to accommodate a vertical batten; this batten may have overlapped an adjacent panel, which may have been cut out in a similar way (see below).

Cleaned in 1938.

The subject-matter of this panel has been plausibly identified as a scene from the life of St Sabinus: the Governor of Tuscany, Venustianus (later canonised), summoned Bishop Sabinus and his two deacons, Marcellus and Exuperantius, before him, and tried to make them worship an image of Jupiter; Sabinus threw it to the ground; Venustianus cut off Sabinus' hands and tortured the deacons.[1]

Sabinus was one of the four patron saints of Siena and his remains are buried in Siena Cathedral.[2]

The rarity of the subject-matter, not found in any known thirteenth- or fourteenth-century painting, makes it likely that Bacci was correct in connecting it with a first instalment of 30 gold florins, the payment made to Pietro Lorenzetti by the Opera del Duomo in 1335 for painting 'la tavola di santo Savino'.[3] This coincides with the date of a payment for a piece of poplar 'per mettare ne la terza tavola che si farà' and also with the date of a payment made to a 'maestro Ciecho' for translating the story of St Sabinus 'in volgare per farla ne la tavola'. What is more problematic is whether this panel can have been part of the predella for the altarpiece of the *Birth of the Virgin* (Fig. 11, Siena, Museo dell' Opera del Duomo) completed for the altar of St Sabinus seven years later, signed and dated 1342, as first suggested by Fairfax Murray[4] and accepted by Bacci and subsequent writers.

The altarpiece of the *Birth of the Virgin* by Pietro Lorenzetti was part of a coherent programme of altarpieces, dedicated to scenes from the Life of the Virgin, placed on the altars of the four patron saints of Siena:[5] the *Annunciation* dated 1333 by Simone Martini (Florence, Uffizi); the *Purification of the Virgin* by Ambrogio Lorenzetti dated 1342 (Florence, Uffizi), and the *Nativity* (Cambridge, Mass., Fogg Art Museum) by Bartolommeo Bulgarini.

The central narrative scenes were flanked by standing saints reflecting the dedication of the altar and it is known from inventories of 1429 and 1446 that the *Birth of the Virgin* was flanked by Sts Sabinus and Bartholomew.[6] The altarpiece is presumed to have had a predella: in 1854 Milanesi[7] saw the *Birth of the Virgin* with 'le storiette . . . del gradino di essa tavola', by then dismantled. Although No. 1113 is slightly smaller than, for example, the predella panel of the St Victor altarpiece (see below),[8] the traces of an inset vertical batten (see above) do suggest that it was part of a larger structure. The evidence so far suggests that No. 1113 was indeed part of a predella for the *Birth of the Virgin*: the altarpiece by Simone Martini may have had a predella;[9] payments for a predella for Ambrogio's altarpiece are documented in 1339,[10] and the *Nativity* probably had a predella which included a *Crucifixion* (Paris, Louvre), flanked by small scenes, including the *Blinding of St Victor* (Frankfurt, Städelsches Kunstinstitut), as reconstructed by Beatson, Muller and Steinhoff.[11] Preiser[12] suggested this type of predella for the *Birth of the Virgin*, placing No. 1113 at the extreme left, under the now lost figure of St Sabinus. However, if No. 1113 was indeed part of a predella, then the siting of the original inset batten (see above) suggests that No. 1113 was the outermost *right*-hand predella panel.

This is confirmed by the outermost side mouldings (see above): that at the right edge seems likely to have abutted the outer frame, while the left-hand moulding slopes down and probably formed part of the frame of the adjacent scene. Beatson, Muller and Steinhoff suggest that the date of 1342 in the inscription of the *Birth of the Virgin*, coinciding as it does with the date on Ambrogio's *Purification* altarpiece, represents the date of installation for both these altarpieces; this would explain the long gap between 1335 and 1342.[13]

Although it is likely on the basis of the reconstruction of the *Nativity* altarpiece that the predella began with a scene from the life of St Bartholomew followed by scenes from the Life/Passion (?) of Christ, the panel of *Christ before Pilate* (Vatican, Pinacoteca), which has been suggested as having been part of the series, must be excluded. Not only is the Vatican panel painted on the back,[14] but it has a punched border which No. 1113 has not and never can have had since the frame is original (see above).

Although generally accepted as from the altarpiece of the *Birth of the Virgin*, the panel has been divided in attribution between Pietro himself[15] and his workshop.[16]

The altarpiece was probably situated in the transept facing the altarpiece of St Crescentius in the opposite transept.[17]

PROVENANCE: Presented by Charles Fairfax Murray, 1882. Cleaned Pictures Exhibition at the National Gallery, 1947–8 (no. 13).

REFERENCES:

1. Identified as such by Martin Davies. For St Sabinus see G. Kaftal, *Iconography of the Saints in Tuscan Painting*, Florence, 1952, col. 913, no. 277.

2. St Sabinus was mistakenly thought to have been the first Bishop of Siena. Even in the thirteenth-century cathedral there was a cult of Sabinus, Ansanus and Crescentius. Sabinus occurs in the window of 1287 and on the Virgin's right in Duccio's *Maestà*. For the history of St Sabinus and the cathedral see H. W. van Os, *Sienese Altarpieces 1215–1460*, Groningen, 1984, pp. 77 ff. See also L. Iacobilli, *Vite de Santi et Beati dell'Umbria*, III, 1661, pp. 249–50. The story, with some variation, is illustrated in two scenes of the Arca di San Savino in Faenza; see L. Dussler, *Benedetto da Majano*, Munich, 1924, pls. 1 and 2.

3. Pèleo Bacci, *Dipinti Inediti e Sconosciuti di Pietro Lorenzetti* etc., Siena, 1939, pp. 90 ff.; he gives the reference as Siena, Op. Duomo, Entr. – Usc. 1 July 1335 – 1 January 1336 filza 45, reg. 4, ff. 52–8. The first instalment of the payment to Ambrogio Lorenzetti for *his* altarpiece for the Duomo dated 1342 (see below) was for an identical sum (G. Milanesi, *Documenti per la Storia dell'Arte Senese*, I, Siena, 1854, p. 196). C. Gardner von Teuffel ('Ikonographie und Archäologie: das Pfingsttriptychon in der Florentiner Akademie an seinem ursprünglichen Aufstellungs-ort', *Zeitschrift für Kunstgeschichte*, 1978, XLI, p. 28, n. 54) points out that the dowel holes for the side panels are still visible in the *Birth of the Virgin*.

4. Fairfax Murray *ap.* J. A. Crowe and G. B.

Cavalcaselle, *Storia della Pittura in Italia*, III, Florence, 1885, p. 201, n. 1.

5. Van Os, loc. cit.

6. Bacci, loc. cit. He gives the reference as Siena, Op. Duomo, no. 510, inv. 1429, f. 17 and 1446 (without folio reference).

7. Milanesi, op. cit., p. 194: 'Nella sagrestia del Duomo di Siena, oltre la tavola della Natività di Maria Vergine dipinta nel 1342, sono di mano del nostro Pietro, le storiette, ora divise, del gradino di essa tavola.' See also note 11 below.

8. It measures 40 × 39 cm. The panel with the standing St Victor is 50 cm. wide. See the article by Beatson, Muller and Steinhoff cited in note 11 below.

9. See the article cited in note 11 below.

10. Milanesi, op. cit., p. 196.

11. See E. H. Beatson, N. E. Muller and J. B. Steinhoff, 'The St Victor Altarpiece in Siena Cathedral: A Reconstruction', *Art Bulletin*, LXVIII, 1986, pp. 610–31. The present writer is grateful to the authors for allowing her to read the typescript of their article before its publication. They cite a description of all four altarpieces in an inventory of 1594: 'Tutti li sopradetti Altari hanno le loro predelle.'

12. A. Preiser, *Das Entstehen und die Entwicklung der Predella in der Italienischen Malerei*, Hildesheim and New York, 1973, pp. 299 ff. and pl. 297c.

13 Beatson, Muller and Steinhoff, art. cit., *Art Bulletin*, 1986, p. 615, n. 41.

14. Pointed out by Hayden B. Maginnis, 'Pietro

Lorenzetti: A Chronology', *Art Bulletin*, LXVI, 1984, p. 190, n. 27. He refers to the Metropolitan Museum of Art exhibition catalogue, *The Vatican Collections, The Papacy and Art*, New York, 1982, pp. 137–8. Martin Davies also rejected the small panel of the *Funeral of a Saint* (Assisi, Mason Perkins Collection) suggested as part of the same predella by G. Sinibaldi

(*I Lorenzetti*, Siena, 1933, pp. 177–8 and pl. XXVII).
15. e.g. C. Volpe in *Paragone*, 13, January 1951, p. 49.
16. Maginnis, loc. cit. It was attributed by E. T. De Wald in *Art Studies*, 1929, p. 158, and Sinibaldi (loc. cit.) to the Master of the Dijon Triptych.
17. See Beatson, Muller and Steinhoff, art. cit., *Art Bulletin*, 1986, p. 611, and n. 9.

Workshop of PIETRO LORENZETTI

3071 *A Crowned Female Figure (St Elizabeth of Hungary ?)* (Fragment)

Plate 47

Fresco. Irregular shape; greatest height 38 (15); greatest width 33 (13).

Much damaged and repainted.

Inciscd lines forming a gable top, and apparently the remains of similar lines at the left and left bottom, indicate clearly that this figure was once in a hexagon. A figure of a canonised king (Fig. 12) carrying a fleur-de-lis sceptre (St Louis?), also in a hexagon surrounded by a painted *cosmati* frame, forming part of a decorative border from the same fresco cycle, shows the original context of this fresco as part of a decorative border framing a large fresco. For a discussion of this cycle see No. 3072 below.

PROVENANCE: As for No. 3072.

3072 *A Female Saint in Yellow* (Fragment)

Plate 48

Fresco. Irregular shape; greatest height 39 (15½); greatest width 28 (11).

A good deal damaged.

In a barbed incised and painted quatrefoil; sufficient parts of the border exist for the shape to be quite clear.

Nos. 3071 and 3072 are stated in 1864 and 1869 to be from San Francesco, Siena.[1] In his MS catalogue, Layard dubiously inserted Sant' Agostino as the name of the church, but it is fairly certain that this was due merely to a lapse of memory.[2] There can, indeed, be little doubt that Nos. 3071 and 3072 are from San Francesco, probably from the Chapter House, just like No. 1147 above (AMBROGIO LORENZETTI).

No. 3071 is similar in style and design to a border figure (St Louis?, Fig. 12), now in Siena (Pinacoteca Nazionale, Deposito), which came originally from the middle of the east wall of the Chapter House.[3] It therefore seems reasonable to suppose that No. 3071

also was hexagonal, within a painted *cosmati* band and also formed part of the decorative borders which surrounded the main scenes in the Chapter House.

The four main scenes in the Chapter House were described by Milanesi[4] as being the *Crucifixion* and *Resurrection* on the end wall, *St Boniface receiving St Louis as a Novice*, and a *Martyrdom of Franciscans*.[5]

Seidel associated both Nos. 3071 and 3072 with the border figure of the king.[6] However, the incised barbed quatrefoil border of No. 3072 is completely different from the remains of the border of No. 3071, and (in so far as one can make any judgements where the condition is so poor) No. 3072 seems closer to the fragment showing a Franciscan saint, now in the City Museum of Birmingham, both in style and in the halo pattern.

The fragment in Birmingham was first published by Seidel,[7] who related it to the frescoes by Ambrogio Lorenzetti in San Francesco. Seidel, however, suggested that this fragment came from the fresco cycle on the east wall of the cloister of San Francesco, the second decorative programme in San Francesco attributed to Ambrogio Lorenzetti. The cycle, now lost, survives in a very few fragments which Seidel[8] identified as those Scenes of Franciscan Martyrdom by Ambrogio Lorenzetti described by Ghiberti. He convincingly interprets them as scenes of the martyrdom of the local Franciscan martyr, Pietro da Siena, and links them as a single iconographic programme with the Petroni Portal in San Francesco, dated 1336, in which he identifies Pietro da Siena as the Franciscan martyr to the right of the Virgin. On the grounds that the frescoes on either side of the portal would have been completed soon afterwards, he dates the frescoes shortly after 1336.

However, the shrinking pose of the figure in No. 3072[9] could have flanked scenes of martyrdom in either the cloister or Chapter House. And similar painted *cosmati* borders seem to have been used in both cycles.[10] It seems best, therefore, to leave the question of location with regard to No. 3072 open, although No. 3071 may plausibly be said to have come from the Chapter House.

The question of attribution is a difficult one, not made easier by the condition of the fragments. Although Ghiberti attributed the cloister frescoes to Ambrogio, and of the Chapter House frescoes, the *Martyrdom of Franciscans* and *St Boniface receiving St Louis as a Novice* are generally attributed to Ambrogio,[11] the *Crucifixion* and *Resurrection* are usually given to Pietro. Collaboration between the two was presumably quite common, one specific instance being documented in 1335.[12] Moreover, one would expect border figures to have been executed by assistants rather than by the masters. However, some stylistic similarities between Nos. 3071 and 3072 and the *Resurrection* attributed to Pietro do seem to exist, and it seems reasonable to attribute them to his workshop.

Although the date of shortly after 1336 given by Seidel to the cloister cycle is entirely reasonable, there are no grounds for supposing that the various decorative schemes by the Lorenzetti in San Francesco were necessarily contemporary and the dating of Nos. 3071 and 3072 must remain for the time being uncertain.

Nos. 3071 and 3072 are quite distinct in style from No. 1147, although the latter, attributed to AMBROGIO LORENZETTI, also comes from San Francesco, Siena.

PROVENANCE: Purchased by Sir Austen Henry Layard 'from a man who had cut them out of the wall'.[13] As explained above, Layard dubiously says that the wall was in Sant' Agostino, Siena; but they are mentioned in 1864 by Crowe and Cavalcaselle as being from San Francesco, presumably the Chapter House. Exhibited at the South Kensington Museum, 1869 (nos. 41 and 42). Layard Bequest, 1916.[14]

REFERENCES:

1. J. A. Crowe and G. B. Cavalcaselle, *A New History of Painting in Italy*, II, London, 1864, p. 136; South Kensington Museum Exhibition, 1869 (nos. 41, 42).
2. The text is 'fragments of a fresco painted in the church of Sant' Agostino (?) at Siena – described by Ghiberti & Vasari'. The lighter colour of the ink for 'Sant' Agostino (?)' shows that the space was left blank at first; then the name was inserted and blotted at once. Ghiberti and Vasari record frescoes by Ambrogio Lorenzetti both in San Francesco and in Sant' Agostino in Siena: Ghiberti, *I Commentarii*, ed. Schlosser, Berlin, 1912, i, pp. 40–1, and ii, pp. 142–4, and Vasari, *Vite* (ed. Milanesi, Florence, 1878), I, pp. 521–2. What appear to be fragments of the Sant' Agostino series are reproduced by G. Sinibaldi, *I Lorenzetti*, Siena, 1933, pl. XXXIII.
3. See M. Seidel, 'Wiedergefundene Fragmente eines Hauptwerks von Ambrogio Lorenzetti', *Pantheon*, XXXVI, 1978, p. 120, col. pl. II and p. 124, fig. 6. Seidel attributes the fragment to Ambrogio Lorenzetti.
4. G. Milanesi, *Sull'Storia dell'Arte Toscana, Scritti Varij*, Siena, 1873, p. 360.
5. See Eve Borsook, *The Mural Painters of Tuscany*, 2nd revised ed., Oxford, 1980, pp. 32–4.
6. Seidel, art. cit., *Pantheon*, p. 123.
7. M. Seidel, 'Gli Affreschi di Ambrogio Lorenzetti nel Chiostro di S. Francesco a Siena: ricostruzione e datazione', *Prospettiva*, 18, July 1979, pp. 10–20. M. Boskovits ('Considerations on Pietro and Ambrogio Lorenzetti', *Paragone*, 439, September 1986, pp. 8–9) argues that the cycle in San Francesco is datable 1326 and that the scene usually described as *St Boniface receiving St Louis as a Novice* in fact is *St Louis accepting the Bishopric of Toulouse*, since he is already dressed as a friar. He argues that the pope shown is John XXII and not Boniface VIII and that the scene is an allegory referring to the reconfirmation of obedience to Pope John XXII which the Sienese Franciscans made in 1326 at the laying of the foundation stone of their new church.
8. Seidel, art. cit., *Pantheon* and *Prospettiva*, *passim*.
9. Although this suggests a Virgin Annunciate, it is an unlikely subject in the context of the other surviving frescoes from the Chapter House or cloister.
10. Seidel, art. cit., *Prospettiva*, figs. 4 and 5.
11. Seidel, art. cit., *Pantheon*, pp. 123 ff.
12. See George Rowley, *Ambrogio Lorenzetti*, Princeton, 1958, I, p. 130.
13. Layard MS catalogue in the National Gallery; cf. note 2.
14. For the history of the Layard Collection see Appendix II.

LORENZO Veneziano
active 1356–1372

A Venetian painter active chiefly in Venice and the Veneto.[1] The dates of his activity are based on his dated works which go from 1356, the signed Maffei *Virgin and Child*, to 1372, the signed Louvre *Virgin and Child*. He is documented working in Bologna in 1368 and he also worked in Sant'Anastasia, Verona. His most important signed surviving works are the Lion polyptych, 1357–9 (Venice, Accademia), and the De' Proti polyptych, 1366 (Vicenza, Cathedral).

REFERENCE:

1. For details of his life and work given here, see R. Pallucchini, *La Pittura Veneziana del Trecento*, Venice and Rome, 1964, pp. 163–81.

Attributed to LORENZO VENEZIANO

3897 *The Madonna of Humility with Sts Mark and* Plate 50
John the Baptist

Inscribed on the central picture, SC̄A / MARIA D'LAUMI / LITADE. (see below) and .S. / MAR / CHVS: (the M has been slightly altered by restoration) on the background of St Mark. The Baptist holds a scroll inscribed, ECCE / A(G?)N' / DEI / ECCE / QVI / TOLIS / PECA·TA / MVN/ DI. / MIS/ERE/RE; his name is on the background, S. / .IOHĒS / .BT̄I.

The three pictures with their framework are on one panel; total size (excluding the outermost moulding of the frame all round, which is new), 31 × 57.5 (12¼ × 22½). The three pictures each have cusped tops; sizes of the picture surfaces (centre) 23 × 18 (9⅛ × 7⅛), (sides) 23 × 12 (9⅛ × 4¾).

Good condition; the main damaged area is in the left-hand bottom corner of St Mark's compartment. The gilding of the framework has been repaired and the panel is considerably warped. The pitted spandrels are filled with azurite.[1]

Cleaned in 1970.

It was thought to be too risky to remove the outermost frame to inspect the edges. It is most likely, however, to be an independent altarpiece, rather than part of a predella. A similar altarpiece in The Hague (Dienst Verspreide Rijkscollecties, no. NK 1469), also attributed to Lorenzo Veneziano, is similarly judged to be an independent work.[2]

The inscription presumably was supposed to read, SCA. MARIA DE HUMILITATE. It has not been repainted but is in original paint. The reason for the error is unclear.

The Madonna of Humility in the centre has the crescent moon at her feet, and there are stars on the background. For this iconography see LIPPO DI DALMASIO, No. 752 and DALMATIAN SCHOOL, No. 4250 in the present catalogue. Meiss[3] noted the popularity of this type in Venice. From comparative Venetian examples,[4] it seems likely that a small roundel representing the sun, of which a faint trace remains, was originally on the neckline of the Virgin's robe in No. 3897.

Acquired as by Tommaso da Modena, an attribution generally rejected. Sandberg Vavalà ascribed it to Lorenzo Veneziano, with which Toesca and Berenson agreed, as did Martin Davies.[5] Coletti[6] called it Giovanni da Bologna. Gronau (oral communication, 1936) put it between Paolo Veneziano and Lorenzo Veneziano. Bologna ascribed it to a painter he names the Master of Arquà.[7] Puppi rejected this attribution and attributed it to Iacobello di Bonomo.[8] Pallucchini[9] attributed it to Lorenzo Veneziano. It appears to be datable between the Lion polyptych (Venice, Accademia), dated by inscription 1357–9, and the De' Proti polyptych (Vicenza, Cathedral), dated by inscription 1366.

The presence of St Mark could indicate it was made for a Venetian patron.

PROVENANCE: In the collection of the Revd J. Fuller Russell, where possibly seen by Waagen;[10] exhibited in Manchester, 1857(?);[11] at the RA, 1878 (no. 200); sale, 18 April 1885 (lot 99), bought by (Henry) Wagner. Exhibited at the New Gallery, 1893–4 (no. 25); presented by Henry Wagner, 1924.

REFERENCES:

1. Identified by Joyce Plesters of the National Gallery Scientific Department.

2. Ed. H. W. van Os, *The Early Venetian Paintings in Holland*, Maarssen, 1978, pp. 103–5, cat. no. 24, fig. 62. It shows the Madonna of Humility with two donors, St Blaise and St Helen(?). It measures 26 × 46.5 cm. including the frame.

3. Millard Meiss, 'The Madonna of Humility', *Art Bulletin*, XVIII, 1936, pp. 435–64, esp. p. 441.

4. R. Pallucchini, *La Pittura Veneziana del Trecento*, Venice and Rome, 1964, figs. 488, 558, 559, 593, 594, 596, 597.

5. E. Sandberg Vavalà in *Art in America*, February 1930, pp. 54 ff. P. Toesca, *Storia dell'Arte Italiana: Il Trecento*, Turin, 1951, p. 711, n. 236, and Berenson, 1957 *Lists*.

6. Luigi Coletti, 'Sul polittico di Chioggia e su Giovanni da Bologna', *L'Arte*, 1931, p. 135.

7. F. Bologna, in *Arte Veneta*, 1951, pp. 24 ff. In *Arte Veneta*, 1952, pp. 17 ff., he does not agree that this painter is identical with the Master of Sant' Elsino (see DALMATIAN SCHOOL, No. 4250 of the present catalogue); the styles of Nos. 3897 and 4250 are indeed different.

8. L. Puppi, 'Contributi a Jacobello di Bonomo', *Arte Veneta*, XVI, 1962, pp. 19–30.

9. Pallucchini, op. cit., p. 173 and fig. 523. He calls it a predella panel.

10. G. F. Waagen, *Treasures of Art in Great Britain*, II, London, 1854, p. 462, as Berna or Barna da Siena; the description does not fit well, but it may be the picture. He describes this 'little picture' as 'Three Gothic pediments' showing the Virgin and Child with Sts Paul and John the Baptist. Waagen may well be responsible for the attribution to Barnaba, which was still current at the 1893–4 exhibition.

11. It does not seem to be either in the provisional or in the definitive catalogue of the exhibition; but there are Manchester labels on the back.

MARGARITO OF AREZZO
active 1262(?)

Called Margaritone by Vasari,[1] who devotes a good deal of space to him as an early painter from his home town. There is uncertainty about his dates, although several signed pictures have survived. A documentary mention of 1262 apparently refers to him.[2] His pictures are most probably of the second half of the thirteenth century. They consist largely of dossals showing the enthroned Virgin and Child, with or without lateral scenes, and dossals with St Francis.[3]

REFERENCES:

1. Vasari, *Vite* (ed. Milanesi, Florence, 1878), I, pp. 359 ff.

2. See Thieme-Becker, s.v. Margaritone, and Vasari (ed. Milanesi, cit., p. 359).

3. See A. M. Maetzke, 'Nuove ricerche su Margarito d'Arezzo', *Bollettino d'Arte*, 1973, pp. 95–112.

564 *The Virgin and Child Enthroned, with Scenes of the* Plate 51
Nativity and the Lives of Saints

Centre, the Virgin and Child within a mandorla; in the corners, the symbols of the four Evangelists. Scenes on each side, from left to right and top to bottom: 1. The Nativity, with the Annunciation to the Shepherds; inscribed, DE PARTV VIRGINIS MARIE & ADNⅤTIATIŌE PASTORVM. 2. St John the Evangelist in a cauldron of boiling oil; he was placed in the cauldron by Domitian outside the Latin Gate in Rome, but survived unharmed and was exiled to Patmos. Inscribed, HIC BEAT' JOH̄ES EⅤG. A FERVORE OLEI LIBERATVR. 3. St John the Evangelist resuscitating Drusiana; inscribed, H¹ SC̄S JOH̄ES EⅤG

SVSCITAT DELVSIANAM. 4. St Benedict tempted in the Sacro Speco at Subiaco. The temptation was the thought of a beautiful woman he had seen in Rome; St Benedict conquered it by rolling in the brambles outside his cave. Inscribed, Hᴵ .S̄. BN̄EDICT' IP IECIT SE Ī SPINAS FVGIĒS DIABOLI T̄ETATIŌE. 5. The Decapitation of St Catherine. After the torture of the wheel (which is her proper attribute), St Catherine was beheaded and angels carried her body to the summit of Mount Sinai. Inscribed, Hᴵ SC̄A CATTARINA SVSCEPIT MA(R)TIRIV̄ & Ī MŌTE SINJ AB ĀGLIS Ē DLATA. 6. Miracle of St Nicholas. The devil in disguise had given a deadly oil to some pilgrims about to visit St Nicholas, with the request that they would anoint the walls of his house with it. St Nicholas appeared and warned them of the danger; they threw the oil into the sea, which burst into flame. Inscribed, Hᴵ SC̄S NICOLAVS PRECEPIT NAVTIS VT VAS COL/TVM A DIABULO·Ī MARI IP ICERĒT. 7. St Nicholas by a miracle saves three innocent men from decapitation. Inscribed, Hᴵ SC̄S NICOLAVS LIBERAT CŌDĒNATOS. 8. St Margaret in prison is swallowed by a dragon, and escapes unhurt; the cross by means of which the miracle was performed is seen floating in the air, top left. Inscribed, Hᴵ SC̄A MARGARITA..........ORE ERVPTIS/VISCERIBVS........

The picture is signed, centre bottom, MARGARIT' DE ARITIO ME FECIT.

Wood. Excluding the framing and the top of the Virgin's mandorla, which extends over part of the framing, the size is 76 × 169 (30 × 66½). Total size 92.5 × 183 (36½ × 72). The individual scenes are approximately within rectangles formed by painted lines, the inside measurements of which are 26 × 25 (10⅛ × 9⅞) each.

The picture is obviously damaged, but is not badly preserved for a work of the time, except towards the right.

The paint and gold on the framing are new. The frame moulding is original.

No. 564 was probably a retable rather than an altar frontal.[1]

 No. 564 was included in the purchase of part of the Lombardi–Baldi Collection 'to show the barbarous state into which art had sunk even in Italy previously to its revival'.[2] Anatole France at greater length says much the same thing.[3]

 The predominance of scenes dedicated to Sts John the Evangelist and Nicholas, who have two scenes each, as distinct from the one each devoted to the Virgin, St Catherine, St Benedict and St Margaret,[4] suggests that the dossal came originally from an altar or church dedicated to those saints.[5]

 The iconography of the Virgin and Child is very similar to that of the *Virgin and Child* from Santa Maria, Montelungo, near Arezzo,[6] and the *Virgin and Child* in the National Gallery of Art, Washington (Kress Collection),[7] both of which bear the same signature as No. 564. In all three panels the Virgin wears a Byzantine type of crown.[8] The lion-headed throne was already current in twelfth-century French wood sculpture.[9] Maetzke pointed out that the iconography of the Nativity is identical to one of the lateral scenes in the dossal from Monte Savino, Santuario di Santa Maria delle Vertighe, attributed to Margarito.[10]

PROVENANCE: Wrongly supposed to come from Santa Margherita, Arezzo.[11] Acquired before 1845 in the neighbourhood of Arezzo by Lombardi and Baldi of Florence;[12] purchased with other pictures from their collection, 1857.[13]

REFERENCES:

1. See H. Hager, *Die Anfänge des Italienischen Altar-bildes* (*Römische Forschungen der Bibliotheca Hertziana*, XVII), Munich, 1962, pp. 101–8, for a discussion of the evolution of the dossal from the antependium.

2. National Gallery Report, 1858. See also Appendix I.

3. Anatole France, *L'Ile des Pingouins*, III, chapter V.

4. A much later dossal with St Margaret and scenes from her life, from Santa Margherita a Montici, Florence, attributed to the St Cecilia Master, has a similar iconography of St Margaret and the dragon behind the grid of a prison. See G. Sinibaldi and G. Brunetti, *Mostra Giottesca*, Florence 1937, 1943, p. 391 and fig. 119a.

5. Vasari (*Vite*, ed. Milanesi, Florence, 1878, p. 365) says Margaritone painted for the church of San Nic-colò in Arezzo, although he does not specify what the work or works were. According to Milanesi (loc. cit., note 3) a panel with St Nicholas and scenes from his life, also in the Lombardi-Baldi Collection, could have come from San Niccolò, Arezzo.

6. See *Arte nell' Aretino. Recuperi e Restauri dal 1968 al 1974*, Florence, 1974, pp. 15–18.

7. F. Rusk Shapley, *Paintings from the Samuel H. Kress Collection: Italian Schools XIII–XV Century*, London, 1966, pp. 3–4 and fig. 1.

8. See C. H. Weigelt in Thieme-Becker, s.v. Margaritone.

9. See I. H. Forsyth, *The Throne of Wisdom. Wood Sculptures of the Madonna in Romanesque France*, Princeton, 1972, *passim*.

10. A. M. Maetzke, 'Nuove ricerche su Margarito d'Arezzo', *Bollettino d'Arte*, 1973, pp. 95–112, esp. p. 104.

11. Vasari, ed. Le Monnier, I, Florence, 1846, p. 303, or ed. Milanesi, Florence, 1878, I, pp. 360. Vasari's description of the Santa Margherita picture does not fit: he says the work is painted on linen stuck down on to wood and shows scenes from the Life of the Virgin Mary and of St John the Baptist.

12. For the provenance, see the National Gallery Report, 1858. For the date, see the Lombardi–Baldi catalogue (*Collection de Tableaux Anciens*, etc.) n.d., but the copy in the Uffizi Library is claimed to be of 1845 (no. 5); see also the 1846 edition of Vasari, as in previous note.

13. For the history of the Lombardi–Baldi Collection see Appendix I.

MASTER OF THE BLESSED CLARE
active mid-14th century

This Riminese painter was so named by Zeri after No. 6503. For further details see below.

6503 *Vision of the Blessed Clare of Rimini* Plate 52
(Panel from an altarpiece)

Wood. Painted surface 55.9 × 61 (22 × 24). The panel has been trimmed on all four sides. The paint and gesso layers have been transferred from the original wooden support and attached to a coarse canvas which is visible in X-radiographs. The canvas has been stuck down on to an old poplar(?) panel. Wooden strips cover the edges and obscure the various layers used in the transfer.

The condition is generally good, with some minor damage. Small losses affect the halo and cloak of St Peter, the wound in Christ's side, St John the Evangelist's drapery, the floor and gold background. Christ's robe is of silver leaf; it has been painted with a semi-transparent light blue, partly scratched away to reveal the silver, and also painted with a pattern on top. The gold background is inscribed with an acanthus-leaf pattern. The

book held by St John the Evangelist bears the inscription: [Pax] *mea*[m] *do v*[obis]. *Pax* [meam]. *relinquo vobi*[s].

The painting shows the vision of the Blessed Clare of Rimini (died 1326?), who kneels in the left-hand corner: Christ appears to her, together with the Apostles and St John the Baptist, showing her His wounds suffered on the Cross. He gives St John the Evangelist a book for her inscribed: *Pax meam do vobis. Pax meam relinquo vobis.* The vision was first identified by Zeri[1] as a scene from the Life of the Blessed Clare of Rimini, written probably in the fourteenth century by an anonymous, possibly Franciscan author. The Life was published by Garampi[2] in the eighteenth century. The painting corresponds quite closely to the scene described in the text,[3] but with a few notable differences. The text says that Christ was surrounded by the Apostles, whereas in the painting the Apostles are crowded to one side. The text describes how Christ appeared to Clare, seated on a wonderfully large throne of exceptional size which was richly and beautifully ornamented. In the painting Christ appears standing, without a throne. It is possible that the changes were made to isolate and therefore give emphasis to the figure of Christ, and in the interests of the strong diagonal slant of the composition.

Zeri also identified the companion piece to No. 6503 as the *Adoration of the Magi* (Fig. 14A) in Florida (Coral Gables, Lowe Art Museum, University of Miami) which is by the same hand and has the same measurements and halo patterns.[4] He confirmed his association of the two panels by analogy with an altarpiece by a different hand. (Fig. 14B), now in the Musée Fesch, Ajaccio.[5] This altarpiece also shows the rare scene of the Vision of the Blessed Clare (these are the only two surviving examples), combined with the *Adoration of the Magi* and a *Crucifixion*, and Zeri concluded that No. 6503 was to be reconstructed in a similar context with the Miami *Adoration* and a now lost *Crucifixion*.

The two altarpieces were described by Garampi in 1755 as being in the Monastero degli Angeli, Rimini.[6] Some subsequent writers[7] have given the original provenance as San Francesco, Rimini. There is, however, no evidence for this. Garampi, whose description of both altarpieces is extremely detailed, merely says, in connection with the National Gallery/Miami altarpiece: 'gia servi per qualche altro Altare della vecchia Chiesa e ora si conserva nel Monastero'.[8] Ricci, in his monograph on the Tempio Malatestiano, does not refer to the paintings in his section on San Francesco, but does include them in his chapter on Santa Maria degli Angeli.[9] Evidently the presence of St Francis in the Fesch *Crucifixion* indicates a Franciscan or Clare provenance. The problem of the original location of the altarpieces is complicated by the fact that the Blessed Clare of Rimini apparently lived in no established convent (see below). The convent she founded was amalgamated with Santa Maria in Muro *c.*1354, which was in turn amalgamated with Santa Maria degli Angeli in 1457, the convent from then on taking that name.[10] The date of 1354 would seem to be too late for the style of the paintings (see below).

Both altarpieces were probably originally simple horizontal dossals, consisting of the three scenes and no more. The dossal, divided into narrative scenes, was a popular Riminese format.[11] The Fesch panels were once a single horizontal plank of wood, painted with the three narrative scenes divided by decorative bands.[12] They retain traces of intervening borders between the scenes and running along the top and bottom of the

panels: these borders consist of two strips incised into the gold-leaf background, hatched and punched, on either side of a painted band of vermilion with a silver-leaf *sgraffito*. The *Adoration of the Magi*, *Crucifixion* and *Vision* still have traces of dowel holes for slotting the panel into a containing frame and traces of the three vertical battens on the back. It is likely that the whole was surrounded by a plain frame moulding. By analogy the National Gallery/Miami altarpiece was also a plain horizontal dossal. There can be no doubt as to the sequence of the scenes. The Fesch *Vision of the Blessed Clare* has a marked diagonal fault visible in the cut left edge of the panel which corresponds to an identical fault in the right edge of the Fesch *Crucifixion*.

It is almost certain that the National Gallery/Miami altarpiece is the later of the two. The altarpiece contains a number of iconographic differences from the Fesch version, such as the fact that in No. 6503 St Peter is not carrying a key, while in the Fesch version he is; St John the Baptist is distinguished from the Apostles only by his hair-shirt, whereas in the Fesch version he carries the inscription ECCE AGNUS DEI.....; St John the Baptist is partly concealed by the Apostles, whereas in the Fesch version he figures prominently in the foreground. Most telling, however, is the up-dating of the iconography of the Virgin and Child in the Miami *Adoration of the Magi*: while the Fesch version is based on the iconography of the thirteenth century (e.g. the fresco of the *Nativity* in the nave of the Upper Church of San Francesco, Assisi, where the recumbent Virgin lies beside the Child in the crib),[13] the Miami panel is based on the *Nativity* in the fresco of *c.*1319 in the right transept of the Lower Church of San Francesco, where the Virgin, seated more upright, almost in the shape of a right angle, holds the Child.[14] This up-dating of the iconography suggests that the National Gallery/Miami altarpiece, which is also larger in its dimensions than the Fesch version,[15] derived from and possibly even replaced the latter.[16]

The choice of scenes in the two altarpieces may be connected with the Blessed Clare's life. Evidently, the vision of Christ was one of the major occurrences. One of the feasts she celebrated was the Epiphany,[17] hence the opening scene. She identified so strongly with the Passion of Christ that she even had herself bound to a column on Good Friday[18] – hence the inclusion of the *Crucifixion*.

The exact nature of the chequered habit worn by the Blessed Clare in No. 6503 is problematic.[19] In the Life her attire is described as a white tunic over a shirt made of heavy and rusty iron.[20] It is probable that she belonged to no established Order,[21] and that she was neither a Clare, nor a member of the Third Order, but lived the pious life of charitable works and self-abnegation led by many religious of the fourteenth century.[22] After leading a licentious and luxurious life, a vision in the church of San Francesco (presumably in Rimini) inspired her to change her ways: she went barefoot and wore an iron collar round her neck, arms and knees; she lived on bread and water; she sometimes slept upright by the city wall;[23] and so on. She died probably in 1326.[24] Her chequered habit is probably supposed to represent merely humble cloth and not the habit of any Order. Her bound head-dress is unusual, and lacks a veil. It is very different from, for example, the head-dress of Blessed Margherita of Cortona, who was certainly a member of the Third Order:[25] Blessed Margherita is depicted in a similar chequered tunic,

presumably the humble cloth permitted by the rules of the Third Order, with a full-length covering mantle of black which was also permitted.[26] In the Fesch version the habit of the Blessed Clare, with its full-length whitish covering mantle and garment resembling the habit of a Franciscan, is apparently that of a member of the Third Order.[27]

The lack of any comparable Riminese works which are documented, signed or dated, makes No. 6503 difficult to place.[28] The bold clear draughtsmanship and soft palette are very different from the more tremulous style of the Fesch altarpiece where the figures have markedly small heads and long bodies. The Fesch altarpiece itself has no overriding characteristics to link it with any surviving Riminese works.[29] Zeri[30] plausibly dated the altarpiece from which No. 6503 comes *c*.1340 and attributed it to a painter whom he called, after No. 6503, the 'Master of the Blessed Clare'.

PROVENANCE: Seen in the Monastero degli Angeli, Rimini, in the eighteenth century by Garampi (see above). The monastery was demolished in 1810. Entered the Ashburnham Collection at an unknown date, probably before 1878, since no paintings were added to the collection after the death of the 4th earl in 1878.[31] Sold out of the Ashburnham Collection, Sotheby's, 24 June 1953, lot 14. Bought by Mrs Gronau for £10,000. Exhibited Early Italian Paintings and Works of Art 1300–1480, Matthiesen Fine Art Ltd., 1983, no. 19, as lent from an anonymous British private collection. Purchased from a private collector through Matthiesen Fine Art Ltd., after an export licence had been withheld by the Reviewing Committee on the Export of Works of Art, 1985.

REFERENCES:

1. Federico Zeri, 'The Triptychs of the Beata Chiara of Rimini', *The Burlington Magazine*, XCII, 1950, pp. 247–51.

2. G. Garampi, *Memorie Ecclesiastiche Appartenenti all' Istoria e al Culto della B. Chiara di Rimini*, Rome, 1755.

3. Garampi, op. cit., p. 27. It seems likely that the painted version is based on the written text, rather than vice versa.

4. F. Rusk Shapley, *Paintings from the Samuel H. Kress Collection: Italian Schools XIII–XV Century*, London, 1966, pp. 70–1. She gives the measurements of the Miami panel as 57.8 × 59.4 cm.

5. See the exhibition catalogue by M. Laclotte, *De Giotto à Bellini*, Editions des Musées Nationaux, 1956, no. 39, p. 26. The Fesch altarpiece entered the Ajaccio Museum in 1839. See also note 12 below.

6. Garampi, op. cit, pp. 436 ff. Earlier the Fesch altarpiece is mentioned as being in the Monastero degli Angeli in the process of 1697 when it hung 'in pariete supra gratam dicti Parlatorii' (Garampi, op. cit., pp. 434–5).

7. Laclotte, loc. cit.; C. Volpe, *La Pittura Riminese del Trecento*, Milan, 1965, p. 79, no. 59; pp. 86 and 87, nos. 99 and 100.

8. Garampi, op. cit., p. 439. Which church is meant by 'vecchia Chiesa' is debatable.

9. C. Ricci, *Il Tempio Malatestiano*, Milan, 1924, p. 525. Zeri (art. cit., p. 247) mentioned that one of the paintings was reproduced in this volume and this may have given rise to a misunderstanding regarding San Francesco.

10. Garampi, op. cit., pp. 363 ff.

11. e.g. Volpe, op. cit., figs. 198, 208, 210. Garampi (loc. cit.) described the altarpiece as 'tavole'.

12. See Dominique Thiébaut, *Ajaccio, Musée Fesch. Les Primitifs italiens*, Inventaire des collections publiques françaises 32, Paris, 1987, p. 144, nos. 38–40. She dates the Fesch altarpiece *c*.1330 and the National Gallery/Miami altarpiece *c*.1340–5. She suggests the latter is close to the Master of Verucchio, and attributes to the same hand as No. 6503 the *Angel of the Annunciation* in a private collection in Bergamo (Volpe, op. cit., fig. 277). The present author is most grateful to M. M. Laclotte and to Mme Dominique Thiébaut, from the Département des Peintures, Louvre, for allowing her to see the Fesch panels while they were in the process of being cleaned and restored.

13. H. Belting, *Die Oberkirche von S. Francesco in Assisi*, Berlin, 1977, pl. 2.

14. Hayden B. Maginnis, 'Assisi Revisited: Notes on recent observations', *The Burlington Magazine*, CXVII, 1975, pp. 511–17.

15. All the surviving panels of both altarpieces have been marginally cut down, leaving either nothing or minimal traces of their original outside borders. The Fesch *Adoration*, 51.5 × 46.5 cm., compares with the Miami *Adoration*, 57.8 × 59.4 cm.; the Fesch *Vision*, 51 × 46.2 cm., compares with the National Gallery *Vision*, 55.9 × 61 cm. The Fesch *Crucifixion* measures 51.5 × 46.5 cm. The total width of the Fesch altarpiece would have been approximately 40 cm. shorter than the National Gallery/Miami version.

16. See Dillian Gordon, 'The Vision of the Blessed

Clare of Rimini', *Apollo*, CXXIV, 1986, pp. 150–3. Zeri (art. cit, p. 248) considered the Fesch altarpiece to be the model, and the National Gallery/Miami altarpiece 'simply a derivation'. However, Shapley (loc. cit.) inverted the relationship.

17. Garampi, op. cit, p. 92.

18. Garampi, op. cit., chapter IX, *passim*, pp. 44 ff.

19. She is shown in a similar chequered habit in a now lost scene from Santa Maria degli Angeli, probably a fresco dating from the fourteenth century (Garampi, op. cit., illustrated opp. p. 443. He describes it as being 'in un altro muro'. See also G. Kaftal, *Iconography of the Saints in the Painting of North East Italy*, Florence, 1978, fig. 278), and also in a much later scene, again probably a fresco, probably of the fifteenth century (Garampi, op. cit., illustrated opp. p. 440. He says of it: 'che tuttavia si vede sul Muro del capitolo, gia Chiesa interiore del Monastero degli Angeli'). It is described in the process of 1697 (ibid., pp. 436–7. See also Kaftal, loc. cit., fig. 277). In the Fesch version she is shown wearing a white veil and cloak over a brown habit of the type worn by Franciscans, apparently as a tertiary, and it may be that the Fesch altarpiece was commissioned by someone, perhaps a Franciscan, who wanted to show her as a tertiary and, therefore, within the fold of the official Franciscan Order (see Dillian Gordon, art. cit., *Apollo*, 1986, *passim*).

20. Garampi, op. cit., p. 11.

21. Garampi, op. cit., p. 127. See also A. Vauchez, *La Sainteté en Occident aux derniers Siècles du Moyen Age d'après les Procès de Canonisation et les Documents Hagiographiques*, Ecole française de Rome, 1981, p. 231.

22. A comparable example is the life led by the Blessed Clare of Montefalco, who also belonged to no established Order. See the life published by M. Faloci-Pulignani, 'Vita di S. Chiara da Montefalco scritta da Berengario di S. Africano', *Archivio Storico per le Marche e per l'Umbria*, 1884, I, fasc. iii, pp. 557–625. Frescoes of *c.* 1333 in the chapel of Santa Croce in Santa Chiara, Montefalco, show her as a Franciscan tertiary.

23. Garampi, op. cit., chapter III, *passim*, pp. 9–16.

24. The date of her death varies according to different writers. Garampi (op. cit., p. 76, note hh) says that although the date of her death is given as 1346 in the Life, this is probably a mistake for 1326. Kaftal, op. cit., cols. 229–32, also gives the date as 1326. Zeri (art. cit., p. 248) gives the date as 1328. Vauchez (loc. cit.) accepted the date of 1346 given in the Life. However, Vauchez kindly replied to a query from the present compiler, saying that on the basis of internal evidence in the Life he is now convinced that she in fact died in 1326. François Avril, Conservateur en Chef at the Bibliothèque Nationale, Paris, was kind enough to check the documents of the process (H. 820 and 821), which took place in 1782 and was published in 1784. He found in document no. 1768, bound with H. 821, confirmation of the date of death as 1326 in the synopsis of her Life (pp. 2 and 6).

25. G. Kaftal, *Iconography of the Saints in Tuscan Paintings*, Florence, 1952, no. 200, cols. 668, 669, 670.

26. See G. Meersseman, *Ordo Fraternitatis. Confraternite e Pietà dei Laici nel Medioevo*, I, Rome, 1977, p. 395, for the rules regarding the habit for the sisters of the Third Order. The present writer owes this reference to Dr David d'Avray and is grateful to him for his comments on the problem of the Blessed Clare's habit. The covering cloak could also be white.

27. See Dillian Gordon, art. cit., *Apollo*, 1986, *passim*.

28. The Miami panel has some iconographic similarities to the Parry *Adoration of the Magi* (London, Courtauld Institute). See Volpe, op. cit., fig. 282. Keith Christiansen, in a written communication to the National Gallery, has expressed the opinion that the style is very close to that of a detached fresco showing the Agony in the Garden in the Casa Romei, Ferrara. See Ranieri Varese, *Trecento Ferrarese*, Milan, 1976, p. 35, pl. XIX, figs. 28a and b.

29. For the various attributions made for the Miami panel see Rusk Shapley, loc. cit. It does not seem to the present writer that No. 6503 or the Miami panel have any outstanding similarities to the works mentioned. See Volpe, op. cit., pp. 79–80, no. 59, and pp. 86–7, nos. 99 and 100, for attributions for both altarpieces.

30. Zeri suggested that the painting belonged to the same group gathered by Longhi which consisted of the Strasbourg *Crucifixion* and Urbino *Crucifix*, and that the Master of the Blessed Clare was a forerunner of Giovanni Baronzio.

31. The Sotheby's catalogue of the Ashburnham sale of 24 June 1953 describes the formation of the Ashburnham Collection: most of the Italian 'primitives' were bought by the 3rd earl (1760–1830) who lived in Florence. With very few exceptions, the provenance of the Italian 'primitives' is not known. No. 6503 does not figure in any of the Ashburnham inventories, except in an undated inventory (typescript in the National Gallery Library), where it is probably identifiable with the *Mystical Subject, Early Italian School*, located in the Store Room. Unfortunately, Waagen was denied access to the Ashburnham Collection (*Treasures of Art in Great Britain*, III, London, 1854, p. 28) although this is the sort of work he would surely have recorded had he seen it in the collection. No. 6503 had been separated from at least one of its companion pieces, definitely by 1918 and probably before 1864, when the Miami *Adoration of the Magi* was in the collection of G. A. Hoskins (see the sale catalogue in which the Miami panel was sold: Christie's, 15 November 1918, lot 112, as by Segna di Bonaventura).

MASTER OF THE CASOLE FRESCO
active first half of the 14th century (c.1317?)

Sienese School. This master is so called after an extremely damaged fresco in the Collegiata at Casole in Val d'Elsa, near Siena,[1] which may date from c.1317.[2] A painter in the Ducciesque manner, he shows some influence of Pietro Lorenzetti. A number of works, both panel paintings and frescoes, have been attributed to him.

REFERENCES:
1. See J. H. Stubblebine, *Duccio di Buoninsegna and His School*, Princeton, 1979, pp. 110 ff.
2. Brandi argues that the donor of the Casole fresco, *Rainerius Episcopus Cremonensis*, is Raniero Casole, Bishop of Cremona in 1296, who died in 1317, and that this gives a *terminus ante quem* for the fresco (C. Brandi, *Duccio*, Florence, 1951, p. 149).

565 *The Virgin and Child with Six Angels* Plate 53
(Fragment)

Transferred from wood. 188 × 165 (74 × 65), pointed top.

The picture would seem to have been cut, especially along the bottom; probably the Virgin was originally shown full length. Incised lines are visible at the edges of the top part and, less clearly, here and there at the sides and bottom; these incisions were probably made when the picture was cut down.

The state of preservation is not very satisfactory, and some parts are modern reconstructions, principally the angels. The chief new parts of the angels on the left are as follows: for the topmost one, part of the hair, the wing and most of the dress; for the middle one, his right hand; for the lowest one, his left wing and hand and the pink dress around the hand. On the right-hand side, the face and hair of the topmost angel are new. There are also some other small reconstructions of important parts. When the wood support had been removed from the picture during transfer, some very slight drawings and a short inscription (apparently illegible) were found on the back of the original canvas that had covered the wood; these were photographed.

Cleaned in 1956–9.

This picture is stated to come from Santa Croce in Florence,[1] and is apparently identical with a *Virgin and Child* ascribed to Cimabue, which Vasari recorded as hanging on a pilaster in the choir of the church.[2] It was therefore ascribed to Cimabue from the time of its acquisition by the National Gallery in 1857, until in 1898 Richter recognised that it is Sienese.[3] It has been suggested at various times that one or other of the pictures associated with No. 565 (see below) might be early works of Pietro Lorenzetti, and Weigelt makes some such suggestion for No. 565;[4] an attribution to the young Pietro Lorenzetti is possible, but must be considered at present as extremely uncertain.

The most convincing attribution, which was not excluded by Martin Davies, is to the painter known as the 'Master of the Casole Fresco'.[5] Despite the damaged condition of this fresco,[6] the rather grim style of the painter is recognisable in the *Virgin and Child*

no. 18,[7] and in the *Virgin and Child* no. 592 (both Siena, Pinacoteca Nazionale).[8] Stubblebine dates No. 565 about 1325.[9] This seems rather late, particularly given the *terminus ante quem* of 1317 proposed for the Casole d'Elsa fresco (see the biography above), although it is difficult to assess how long this type of *Maestà* remained fashionable.

This type of formal gigantic gabled *Maestà* was commonly commissioned from Sienese artists by patrons from outside Siena and beyond.[10] No. 565 was related by Coor-Achenbach[11] to the *Maestà* originally in the Collegiata of San Quirico d'Orcia, now in the National Gallery of Art, Washington (Kress Collection).[12]

PROVENANCE: Apparently the *Virgin and Child* recorded by Vasari on a pilaster in the choir of Santa Croce, Florence;[13] Vasari's picture is apparently the same as an undescribed work recorded in a different place in the church by Bocchi in 1591.[14] Bocchi's picture is recorded as having been removed to the Tosinghi-Spinelli chapel in 1595, where it is listed (as a *Madonna*) in Rosselli's *Sepoltuario*, MS of 1657.[15] No. 565 was purchased by Lombardi and Baldi from the Convent of Santa Croce;[16] acquired with other pictures from the Lombardi–Baldi Collection, Florence, 1857.[17]

REFERENCES:

1. National Gallery MS catalogue, and printed catalogue and Report of 1858; no doubt the statement had been supplied by Lombardi and Baldi.

2. Vasari, *Vite*, 1550 ed., p. 127; 1568 ed., I, p. 83; Milanesi's 1878 ed., I, p. 249; Frey's 1911 ed., I, pp. 392 and 429–30. The picture is also mentioned by Antonio Petrei; see *Il Libro di Antonio Billi*, ed. Frey, Berlin, 1892, p. 57.

3. J. P. Richter, *Lectures on the National Gallery*, London, 1898, p. 8.

4. C. H. Weigelt, *Sienese Painting of the Trecento*, Florence, n.d., p. 71.

5. See C. Brandi, *Duccio*, Florence, 1951, p. 149. J. H. Stubblebine, *Duccio di Buoninsegna and His School*, Princeton, 1979, pp. 110 ff.; for No. 565 see pp. 114–15 and fig. 275. Stubblebine attributes a number of works to this master. The present compiler feels that only the works listed below can with certainty be attributed to this painter.

6. Stubblebine, op. cit, pp. 113–14 and figs. 272–3.

7. See Stubblebine, op. cit., pp. 115–16 and fig. 276. First associated with No. 565 by G. de Nicola, 'Duccio di Buoninsegna and his School in the Mostra di Duccio at Siena', *The Burlington Magazine*, XXII, 1912–13, p. 147.

8. Stubblebine, op. cit., p. 111 and fig. 267.

9. Stubblebine, op. cit., p. 115.

10. e.g. those in Città di Castello and Arezzo (Stubblebine, op. cit., figs. 185 and 320).

11. See Gertrude Coor-Achenbach, 'The Early Nineteenth-Century Aspect of a Dispersed Polyptych by the Badia a Isola Master', *Art Bulletin*, XLII, 1960, p. 143, n. 6.

12. Stubblebine, op. cit., p. 90 and fig. 198.

13. See note 2.

14. Francesco Bocchi, *Le Bellezze della Città di Fiorenza*, 1591, p. 153.

15. From W. and E. Paatz, *Die Kirchen von Florenz*, vol. 1, Frankfurt-am-Main, 1940, pp. 595 and 687–8, partly on information from P. Saturnino Mencherini, *Santa Croce*, 1929, p. 31. Cinelli's revision of Bocchi's guide to Florence, 1677, p. 316, merely records that the picture mentioned by Bocchi had been removed. Presumably Bocchi's picture is the same as the '*madone*' seen in 1739 in Santa Croce by Charles de Brosses, *Lettres Familières sur l'Italie*, ed. Yvonne Bezard, I, 1931, pp. 357–8 (the passage is reprinted in *Emporium*, July 1942, p. 299).

17. For the history of the Lombardi–Baldi Collection see Appendix I.

MASTER of the LEHMAN CRUCIFIXION
active second half of the 14th century

This painter, working in Florence during the second half of the fourteenth century and painting in the style of Orcagna, was so called by Offner after a *Crucifixion* now in the Robert Lehman Collection, Metropolitan Museum of Art, New York. See No. 3894 below.

3894 *'Noli me Tangere'* Plate 54
(Pinnacle from an altarpiece)

The Magdalen kneels before Christ.

Wood. 55.5 × 38 (22 × 15).

None of the original frame exists. The panel has been cut top and bottom. At the top the truncated curves of the punched border on either side clearly indicate that it had a lobed top (see below). At the bottom the panel has been scraped bare in a pointed arch revealing the vertical grain of the wood. Traces of bole and gold along the edges of the arch show that the original moulding followed this arch exactly; No. 3894 therefore once surmounted another arched panel painted on the same plank of wood (see below).

The panel has been slightly trimmed at each side. On either side of the punched borders at each edge remains a strip of bare wood which was once covered by the outer vertical frame. The painted lower part of the panel is 5 cm. wider than the rest, up to a height of 15.6 cm. and 15.3 cm. on the right and left sides respectively. Where the bare wood and painted surface meet at each side there are traces of bole and gold left by the frame moulding. The inference must be that the panel originally extended outward at each side in this lower area. These technical features, and the association of the panel with the Lehman *Crucifixion* (see below), indicate that it once was exactly the same shape as that panel, curving outward at the base, and with a lobed and pointed top.

The condition of the painted surface is generally very good. There are several *pentimenti*. The incised lines defining the folds of drapery in the robe of Mary Magdalene and outlining Christ's robe are clearly visible.

No. 3894 was catalogued in 1929 as by Jacopo di Cione and by Martin Davies as style of Orcagna. Other attributions have been made,[1] including an attribution made by Boskovits[2] to Don Silvestro dei Gherarducci. The present compiler feels that the most sensible course is to follow Offner[3] and call the painter the Master of the Lehman Crucifixion.

The panel was first connected stylistically with the *Crucifixion* in the Lehman Collection (no. 1975.1.65) in New York by Martin Davies[4] and has since been convincingly proposed by Boskovits as part of the same altarpiece (Fig. 13).[5] Not only do the panels correspond in style and in the punched decoration of borders and haloes, but the truncated lobe and similar design of No. 3894 confirm that the panel was originally the same shape as the Lehman *Crucifixion* (see above).[6] The same foliage, landscape and

figure of Mary Magdalene are common to both. Both the Lehman *Crucifixion* and No. 3894 have beneath them the tip of a severed arch, and the visible vertical grain of No. 3894 confirms that they both originally surmounted a main tier. Boskovits has suggested that these main panels were composed of two pairs of saints: one shows an array of female saints including Agnes with Mary Magdalene in the place of honour (Rome, private collection[7]), and the other Sts Peter, Paul and John the Baptist (Luxemburg, Musée d'Histoire et d'Art[8]). The panels with saints had first been associated together by Zeri,[9] who suggested they originally flanked a lost *Coronation of the Virgin* and attributed them to Don Silvestro dei Gherarducci. Boskovits further associated them with No. 3894 and the Lehman *Crucifixion*, adding a predella panel with the *Man of Sorrows* in Colorado, Denver Art Museum (no. 1961.154). The latter, which has also been attributed to Jacopo di Cione,[10] shares the punched decoration of No. 3894.

It is possible that the counterpart to No. 3894, which is now lost but would have surmounted the Luxemburg saints, would have been a *Resurrection*.

The subject of *'Noli me Tangere'* is taken from John xx, 14–17;[11] here the painter has interpreted the text literally by showing Christ carrying a hoe.

Offner and Steinweg suggested that No. 3894 derives from the fresco of the same subject by Andrea da Firenze in the Spanish Chapel of Santa Maria Novella, *c.*1365–7.[12] Boskovits, who dates the altarpiece *c.*1370–5, suggested it was the missing triptych dated 1372 originally in a chapel dedicated to St Peter in Santa Maria degli Angeli.[13] There appears nothing overt in the iconography to link the altarpiece with that church or that chapel. Moreover, those triptychs followed a very specific formula (see NICCOLÒ DI PIETRO GERINI, No. 579), to which this altarpiece does not conform.

PROVENANCE: Stated to be from the Abate Casali's collection in Florence.[14] Lent by Edward Granville Harcourt Vernon to Manchester, 1857 (Provisional Catalogue, no. 26; Definitive Catalogue, no. 21);[15] sale 18 June 1864 (lot 275), bought by Bale.[16] Charles Sackville Bale sale, 14 May 1881 (lot 294), bought by Wagner.[17] Exhibited New Gallery, 1893–4 (no. 28), and Grafton Galleries, 1911 (no. 18). Presented by Henry Wagner, 1924.[18]

REFERENCES:

1. Attributed to Agnolo Gaddi by R. Fry, 'Exhibition of Old Masters at the Grafton Galleries', *The Burlington Magazine*, XX, 1911–12, p. 72. Rejected by R. Salvini, *L'Arte di Agnolo Gaddi*, Florence, 1936, p. 185, and described as Gerinesque under Gaddesque influence. Accepted by E. Sandberg Vavalà in *Art Bulletin*, XVIII, 1936, p. 423, in her review of Salvini. Described by Berenson, *Lists* of 1932, as Giottesque after 1350, close to Giovanni da Milano. Martin Davies called it 'Style of Orcagna'.

2. M. Boskovits, *Pittura Fiorentina alla Vigilia del Rinascimento 1370–1400*, Florence, 1975, p. 423 and fig. 269. See also J. Pope-Hennessy, *The Robert Lehman Collection. I. Italian Paintings*, The Metropolitan Museum of Art, New York, 1987, pp. 68–70.

3. R. Offner (ed. Hayden B. J. Maginnis), *A Critical and Historical Corpus of Florentine Painting. A Legacy of Attributions*, New York, 1981, p. 7.

4. Martin Davies, *National Gallery Catalogues. The Earlier Italian Schools*, London, 1951, p. 309.

5. M. Boskovits, 'Su Don Silvestro, Don Simone e la "scuola degli Angeli"', *Paragone*, 265, March 1972, pp. 35–61, esp. pp. 36–9, and figs. 21–4.

6. The Lehman panel is approximately one quarter bigger. S. Romanelli, Curatorial Assistant at the Robert Lehman Collection, very kindly measured the panel for the present writer.

7. Rome, collection of Emilio Greco (ex-Cook Collection, Richmond. 66 × 111.5 cm.).

8. Inv. no. 1942–74–6. Sold Christie's, 3 June 1932, lot 59, as Spinello Aretino; from the collection of Lord Aberdare. The width of the panel is 67 cm., the height of the original panel 113.5 cm. Both the Rome and Luxemburg panels have had their arches truncated, while both No. 3894 and the Lehman panel retain the top arched segment of the main panel which was originally below. The maximum width of the exposed wood at the base of No. 3894, beneath the arch, is 28 cm. This is 4.5 cm. wider than the maximum top width of the original panel in Luxem-

burg which measures 23.5 cm. This means that No. 3894 cannot have been above the Luxemburg panel, but would have to have been above the Rome panel. The height of the modern replacement, completing the arch of the Luxemburg saints, is 5.5 cm., corresponding well with the height of the exposed arch of No. 3894, which measures 4.5 cm. from the base to the tip. (Measurements of the Luxemburg saints kindly supplied by the museum.) In his text (art. cit., *Paragone*, 1972, p. 37), Boskovits says that No. 3894 would have gone above the Luxemburg saints, to the right of the *Crucifixion*, but in his reconstruction (ibid., p. 38) he places it on the left.

9. F. Zeri, 'Sul catalogo dei dipinti Toscani del Secolo XIV nelle Gallerie di Firenze', *Gazette des Beaux-Arts*, LXXI, 1968, p. 75.

10. F. Rusk Shapley, *Paintings from the Samuel H. Kress Collection: Italian Schools XIII–XIV Century*, London, 1966, p. 33 and fig. 78. She gives the measurements as 31.1 × 66 cm. The width therefore accords with that of the Luxemburg saints, which presumably means that all three main tier panels were identical in width. See note 8 above.

11. R. Offner and K. Steinweg, *A Critical and Histori-cal Corpus of Florentine Painting*, Section IV, vol. VI, *Andrea Bonaiuti*, New York, 1979, p. 65, n. 3.

12. Ibid., p. 67.

13. Boskovits, art. cit., *Paragone*, 1972, p. 37.

14. In the Manchester exhibition catalogue (*Catalogue of the Art Treasures of the United Kingdom collected at Manchester in 1857*, London, 1857). He may be identical with the Abate(?) Giulio Cesare Casali, Florence, who in 1857 owned four saints, which in 1857–8 were acquired by Jarves and are now at Yale (catalogue by O. Sirén, 1916, nos. 27–8, as Lorenzo di Niccolò, reproduced); information from Eastlake's notebook, 1857, and Mündler's Diary, 1857 and 1858 in the National Gallery archives.

15. As Orcagna; there is a Manchester exhibition label on the back of No. 3894.

16. As Taddeo Gaddi; cutting from the sale catalogue on the back of No. 3894. The buyer is recorded in Scharf's sketchbook, no. 69 ff. 7v and 84, in the National Portrait Gallery.

17. Here, and in the two subsequent exhibitions, as Taddeo Gaddi.

18. As Jacopo di Cione.

MASTER OF THE PALAZZO VENEZIA MADONNA
active mid-14th century

This Sienese painter,[1] a follower of Simone Martini, is so called after a *Virgin and Child* once in the Palazzo Venezia in Rome, now housed in the Galleria Nazionale, Palazzo Barberini, Rome. See Nos. 4491 and 4492 below.

REFERENCE:
1. For this painter see Cristina de Benedictis, *La Pittura Senese 1330–1370*, Florence, 1979, *passim*.

4491 *Mary Magdalene* *Plate 55*
(Panel from a polyptych)

Wood. Painted surface 59.5 × 33.5 (23½ × 13¼), cusped and pointed top. Trimmed all round. The measurements are taken to the extreme point of the present panel. The piece at the top, 5.5 cm. high, is a modern addition. The original panel has been reduced to 3 mm. and mounted on a walnut(?) panel.

The condition of the painted surface is largely good, except for a damaged area in the saint's neck.

Cleaned in 1966.

For the commentary and PROVENANCE see No. 4492 below.

4492 *St Peter* *Plate 56*
(Panel from a polyptych)

Wood. Painted surface 59.5 × 33.5 (23½ × 13¼), cusped and pointed top. Trimmed all round. A piece 5.5 cm. high at the top is new, as with No. 4491 above. The original panel has been reduced to 3 mm. and mounted on a walnut(?) panel.

The condition of the painted surface is generally good.

Cleaned in 1966.

St Peter is shown with startlingly blue eyes. One of the keys he carries is silver leaf, the other gold leaf.

Previously catalogued as Sienese School.

Nos. 4491 and 4492 are obviously two panels from the right side of a polyptych (Fig. 15). They were first associated with a *Virgin and Child* (once in the Palazzo Venezia in Rome and now in the Galleria Nazionale, Palazzo Barberini, no. 1545) by Sandberg Vavalà.[1] Not only are they stylistically close, but the cusping and *pastiglia* are similar, although the punching around the cusps and haloes is not. However, the Palazzo Venezia panel is also missing a piece from the top at the same juncture as Nos. 4491 and 4492 (see above), which would seem to confirm that all three were once part of the same altarpiece.

A third panel from the altarpiece exists showing St Paul (private collection).[2] St Paul carries a sword, also in silver leaf like St Peter's key, and a book inscribed *Ad Romanos*. The back of the panel is covered in gesso painted a reddish brown and incised with a barbed quatrefoil, presumably reflecting the original state of the backs of Nos. 4491 and 4491 now concealed by modern panels (see above).

Lonjon, in a detailed analysis of the reconstructed altarpiece, describes the eclectic sources of the painter: the *St Paul* she says derives from his counterpart in Simone Martini's polyptych for San Francesco, Orvieto (now Boston, Isabella Stewart Gardner Museum), the *Virgin and Child* from that in Lippo Memmi's altarpiece for Colle di Val d'Elsa (now Berlin–Dahlem, no. 1067), *Mary Magdalene* from the same altarpiece (Providence, Rhode Island) and *St Peter* from an altarpiece by Lippo Memmi. The present location of the Lippo Memmi *St Peter* is unknown.[3]

There are interesting connections, also noticed by H. S. Francis, between this altarpiece and a *Virgin and Child* (Cleveland Museum of Art)[4] attributed to the school of Lippo Memmi. Frinta[5] noticed that the same punch tool was used in the halo of the Christ Child in both the Cleveland and Palazzo Venezia paintings. The Cleveland panel has a punched and painted design on the back, similar in concept to the decoration on the back of the St Paul panel, and like Nos. 4491 and 4492 and their related panels has a truncated top.

PROVENANCE: Belonged to the Cumming family since the middle of the nineteenth century.[6] In the early twentieth century, they belonged to Charles D. Cumming of 'Hayling', Epsom,[7] who deposited them with Sir Charles Holroyd (d. 1917). Presented through Mr Holroyd by the Misses Cumming, in memory of their father, Charles D. Cumming, 1930.

REFERENCES:

1. E. Sandberg Vavalà, 'Some Partial Reconstructions – I', *The Burlington Magazine*, LXXI, 1937, p. 177, and note 6; it was exhibited at the RA, 1930 (no. 56; memorial catalogue, no. 14 and pl. VIII), as by Simone Martini. A. Santangelo, *Museo di Palazzo Venezia, Catalogo, I, Dipinti*, 1947, p. 26; Nolfo di Carpegna, *Catalogo della Galleria Nazionale, Palazzo Barberini, Roma*, 1955, p. 42. It comes from a private collection in Chieti; see *L'Arte*, 1904, p. 309.

2. Sold Sotheby's, Wednesday, 8 April 1981, lot 110, as by the Master of the Palazzo Venezia Madonna. Connected with Nos. 4491 and 4492 by Sotheby's in a written communication to the National Gallery. Sotheby's very kindly allowed the present writer to examine the panel. It measures 59.5 × 34 cm. and has an identically truncated top. At some stage triangular pieces were added at the corners to make the panel rectangular. The gold background is in poor condition having once been painted over with blue paint. The halo pattern is similar to the National Gallery panels. See also M. Lonjon in the exhibition catalogue *L'Art Gothique Siennois*, Avignon, Musée du Petit Palais, 26 June – 2 October 1983, no. 44, pp. 145–6.

3. Lonjon, loc cit.

4. See *European Paintings Before 1500*, The Cleveland Museum of Art, 1974, p. 99, no. 36 and fig. 36a.

5. Mojmír Frinta, 'An Investigation of the Punched Decoration of Medieval Italian and Non-Italian Panel Paintings', *Art Bulletin*, XLVII, 1965, p. 261, figs. 22 and 23.

6. A note of the history of the pictures by E. K. Waterhouse is in the National Gallery archives.

7. In Berenson's *Central Italian Painters*, New York and London, 1909, p. 261, the pictures are listed with a misprint of this address.

MASTER OF ST FRANCIS
active *c*.1260–1272

The Master of St Francis, commonly known as the 'Maestro di San Francesco', was active in Umbria, chiefly in Perugia and Assisi. He is so called after the eponymous panel of the saint in Santa Maria degli Angeli, Assisi.[1] The only fixed point for his career is provided by the monumental *Crucifix* dated 1272, painted for San Francesco al Prato, Perugia, and now in the Galleria Nazionale dell'Umbria.[2] The dates of his activity may be taken back a little by the fresco cycle paralleling scenes from the lives of Christ and St Francis in the nave of the Lower Church, San Francesco, Assisi, probably datable between 1247 and 1260–3.[3]

REFERENCES:

1. J. Schultze, 'Ein Dugento–Altar aus Assisi? Versuch einer Rekonstruktion', *Mitteilungen des Kunsthistorischen Institutes in Florenz*, 10, I–IV, 1961–3, pp. 59–66; and idem, 'Zur Kunst des "Franziskusmeisters"', *Wallraf-Richartz-Jahrbuch*, XXV, 1963, pp. 109–50.

2. F. Santi, *Galleria Nazionale dell'Umbria. Dipinti, Sculture e Oggetti d'Arte di Età Romanica e Gotica*, Rome, 1969, no. 5.

3. See B. Brenk, 'Das Datum der Franzlegende der Unterkirche zu Assisi' in *Roma Anno 1300, Atti della IV Settimana di Studi di Storia dell'Arte Medievale dell'Università di Roma 'La Sapienza' (19–24 Maggio 1980)*, Rome, 1983, pp. 229–34; also Joanna Cannon, 'Dating the frescoes by the Maestro di San Francesco at Assisi', *The Burlington Magazine*, CXXIV, 1982, pp. 65–9; and Serena Romano, 'Le Storie parallele di Assisi; il Maestro di San Francesco', *Storia dell'Arte*, 44, 1982, pp. 63–81. Also J. Poeschke, 'Der "Franziskusmeister" und die Anfänge der Ausmalung von S. Francesco in Assisi', *Mitteilungen des Kunsthistorischen Institutes in Florenz*, XXVII, 1983, 2, pp. 125–70. For an up-to-date bibliography of the Master of St Francis see P. Scarpellini, *Il Tesoro della Basilica di San Francesco ad Assisi. Saggi e Catalogo*, Assisi, 1980, pp. 45–6.

Attributed to the MASTER OF ST FRANCIS

6361 *Crucifix* *Plate 57*

Poplar. 92.1 × 71 (36¼ × 27¾).

Inscriptions: in the top terminal, white on a red ground, not original, but perhaps an erroneous transcription of the original:

ECCE·HIC·EST·CHRISTUS·IESUS
REX·IVDEORUM·SERVATOR (*sic*) MV
NDI. SALVUS. NOSTRE. QUI. PRO. N
OBIS. PEPENDIT IN LIGNO VITAS (*sic*)

and on the arm of the cross in gold: REX GLORIE (from Psalm 23,24).

Although Martin Davies described the side terminals as modern restorations,[1] X-radiographs show that they are probably original: the cracking of the gesso is similar to that of the main panel and it has a similar fabric under it. Examination of the back confirms this: the panel is integral and original. The Crucifix was carved out of a single panel (unlike the Paris Crucifix where the terminals are separate and have been attached with wooden dowels, see below). Pigment analyses show that in No. 6361 the terminals have been partially repainted: on the left terminal from Christ's fingers onwards and on the right terminal from the tips of His fingers onwards the blue and flesh paint is new.

The roundels may be original.

The outer moulding, which is original, consists of separate pieces of wood, applied with glue, and the linen fabric extends over it, as in the Paris Crucifix (see below), and wraps around the sides most of the way round. It seems to have come away in places (e.g. at the top and base). The outer surface of the frame has been re-gessoed and painted red. The panel is approximately 1.8 cm. thick.

There are rough saw-marks on the back, and clean longitudinal worm-hole channels suggest that the panel was once much thicker and has been reduced to its present thickness by sawing. The back has a modern cradle covering Florentine customs stamps.

The panel has been sporadically re-gilded, although original gilding remains, particularly in the tooled haloes.

Christ's halo is on a separate piece of wood, let into the main panel, and covered with linen. It is inscribed with a burin, with the traces of green lozenges. The haloes are a plain dot punched along and within the circumference, filled with a foliate pattern inscribed with a burin.

In general the condition is good, apart from minor losses in Christ's left shoulder and His feet and the repainting described above.

The hollowed-out roundel above Christ (6.3 cm. in diameter) contains traces of adhesive.[2]

Infra-red photography reveals detailed underdrawing of the draperies.

Cleaned in 1965.

The Crucifix shows the crucified Christ wearing a lilac *perizoma* (loin-cloth) with fine chrysography, against a lapis lazuli blue cross. On the left of the apron are the three Maries; on the right are St John the Evangelist with the Centurion who recognised Christ as the Son of God.

First attributed to the Master of St Francis by Bautier in 1927.[3] The attribution was accepted by Sandberg-Vavalà,[4] and considered likely by van Marle.[5] Garrison[6] considered it to be by a close follower of the Master of St Francis, whom he named the Master of the Stoclet Crucifix after No. 6361 (see PROVENANCE).

It was first fully published as by the Master of St Francis by Martin Davies (1965).[7]

In the opinion of the present writer it is attributable to the Master of St Francis, and datable after the Perugian Crucifix of 1272, possibly as late as 1285, as suggested by Garrison, who dated it *c.*1285–95. Poeschke suggested a *terminus post quem* of 1268 based on the iconographic derivation of the three Maries hunched over each other from Nicola Pisano's Siena pulpit dated 1268.[8]

Closely related in design, style, colouring and iconography is a Crucifix acquired in 1981 by the Louvre, Paris,[9] and attributed to the Master of St Francis. The chief difference is that although the two Crucifixes are identical in height and width, the internal proportions of the apron of the London Crucifix are narrower and the outward swing of Christ's body more accentuated, suggesting a later date for the latter.[10]

The location of full-length standing figures in the apron rather than in the terminals appears to be an anachronistic survival from the monumental Umbrian crucifixes, which was transferred to smaller crucifixes towards the end of the thirteenth century.[11]

On the basis of analogies with the double-sided Crucifix in Assisi attributed to the 'Blue Crucifix Master'[12] and with one in Perugia (Galleria Nazionale dell'Umbria) attributed to a follower of the Master of St Francis,[13] the Crucifix may once have been double-sided. This is not ruled out by the physical evidence of the back, which has been sawn and reveals clean longitudinal worm-holes indicating that the panel was once thicker (see above). Such double-sided crucifixes may have been carried in processions. The Louvre Crucifix has traces of an indentation in the lowermost frame moulding, which may have been caused by the removal of a supporting pole for carrying it in processions.[14] Such medium-sized double-sided crucifixes appear to have been primarily an Umbrian phenomenon of the late thirteenth–early fourteenth century. It may or may not be significant that also in the Stoclet Collection was a St Peter attributable to the Master of St Francis, a fragment of an altarpiece which can be shown to have been painted originally for the church of San Francesco al Prato in Perugia,[15] and that this could indicate a specifically Perugian provenance for No. 6361 which came from the same collection.

A dual function as a reliquary cannot be ruled out. The circular indentation above Christ's halo, which contains traces of adhesive, is likely to be original, and perhaps contained a relic of the True Cross, as indicated by the reference in the inscription to the

Lignum Vitae, and was perhaps covered with a disc of *verre eglomisé*.[16] Examples of small double-sided crucifixes containing relics exist.[17] In Umbria particularly, where there were apparently no metal workshops and metalwork had to be imported from Siena, painted reliquaries would have provided a cheap and more quickly available alternative.[18]

PROVENANCE: 1925, collection of M. Adolphe Stoclet, Brussels. Sold from the collection of M. Philippe Stoclet, Sotheby's, New York, 24 March 1965, lot 7. Purchased 1965 with the aid of the NACF and an anonymous benefactor.

REFERENCES:
1. Martin Davies in the *National Gallery Report*, 1965–6, pp. 15–16.
2. Analysed by Ashok Roy of the National Gallery Scientific Department, who also examined several pigments from the Crucifix.
3. P. Bautier, 'I primitivi italiani della collezione Stoclet a Bruxelles', *Cronache d'Arte*, IV, 1927, p. 312 and fig. 1.
4. E. Sandberg Vavalà, *La Croce dipinta Italiana e L'Iconografia della Passione*, 1929, pp. 832–4 and fig. 521. See also G. Sinibaldi and G. Brunetti, *Mostra Giottesca 1937*, Florence, 1943, pp. 133 and 143.
5. R. van Marle, 'Italian Paintings of the Thirteenth Century in the Collection of Monsieur Adolphe Stoclet in Brussels', *Pantheon*, 1929, p. 316 and fig. 1. He considered it as probably by the Master of St Francis and likely to be a late work.
6. E. B. Garrison, *Italian Romanesque Panel Painting. An Illustrated Index*, Florence, 1949, p. 184, no. 462.
7. Martin Davies, 'An early Italian Crucifix at the National Gallery', *The Burlington Magazine*, CVII, 1965, pp. 627–8.
8. J. Poeschke, 'Der "Franziskusmeister" und die Anfänge der Ausmalung von S. Francesco in Assisi', *Mitteilungen des Kunsthistorischen Institutes in Florenz*, XXVII, 1983, 2, pp. 125–70, esp. p. 157, Ab. 23.
9. See Musée du Louvre, *Nouvelles Acquisitions du Département des Peintures (1980–1982)*, Editions de la Réunion des Musées Nationaux, Paris, 1983, pp. 78–9.
10. Dillian Gordon, 'Un crucifix du Maître de San Francesco', *Revue du Louvre*, 1984, pp. 253–61.
11. Ibid., *passim*.
12. P. Scarpellini in *Il Tesoro della Basilica di San Francesco ad Assisi. Saggi e Catalogo*, Assisi, 1980, pp. 38–41, no. 3, figs. 14–19. It measures 109.5 × 77 cm.
13. F. Santi, *Galleria Nazionale dell'Umbria. Dipinti, Sculture e Oggetti d'Arte di Età Romanica e Gotica*, Rome, 1969, no. 8, fig. 9. It measures 129 × 77 cm.
14. Dillian Gordon, art. cit., *Revue du Louvre*, *passim*.
15. Dillian Gordon, 'A Perugian provenance for the Franciscan double-sided altar-piece by the Maestro di San Francesco', *The Burlington Magazine*, CXXIV, 1982, pp. 70–7.
16. *Verre eglomisé* (gilded glass) was commonly used for reliquaries in Umbria during the late thirteenth and early fourteenth centuries.
17. e.g. from Sant'Alo, Trevi; see B. Toscano, 'Antichi reliquari di un convento benedettino di Spoleto', *Commentari*, 1953, pp. 99–106.
18. See Dillian Gordon, *Art in Umbria c.1250–c.1350*, ch. VII, unpublished thesis for the Courtauld Institute, University of London, 1978.

MATTEO DI PACINO
See JACOPO DI CIONE, Nos. 569–78.

NARDO DI CIONE
active 1343, died 1365/6

Nardo di Cione was one of three brothers of Andrea di Cione, called Orcagna. He matriculated in the Arte dei Medici e Speziali in Florence in 1343 and is sporadically documented until 1365 when he made his will 'corpore languens'; bequests executed according to his will on 16 May 1366 make it certain that he had died by that date.[1]

No signed or documented paintings by him survive. His tightly knit and relatively small oeuvre[2] is based on the attribution to him, made by Ghiberti[3] and generally accepted, of the frescoes in the Strozzi Chapel in Santa Maria Novella, Florence, for which Andrea di Cione painted an altarpiece in 1357.[4]

REFERENCES:
1. See Thieme-Becker, s.v. Orcagna.
2. See the volume devoted to Nardo di Cione, R. Offner, *A Critical and Historical Corpus of Florentine Painting*, Section IV, vol. II, New York, 1960.
3. Ghiberti, *I Commentari* (ed. J. von Schlosser), Berlin, 1912, I, p. 40.
4. C. Gardner von Teuffel, 'The buttressed altarpiece: A forgotten aspect of Tuscan fourteenth century design', *Jahrbuch der Berliner Museen*, 21, 1979, pp. 24–30.

581 *St John the Baptist with St John the Evangelist(?) and St James* Plate 58
(Altarpiece)

Inscribed: EGO. VOS. CLAMANTE/IN DEXERTO. PARATE VIA (Matthew iii, 3).

Poplar. Total height 159.5 (62¾); total width 148 (58¼). Painted on two unequal panels; a vertical join runs between the left-hand (50 cm. wide) and centre compartments. Two strips, *c*.2 cm., added left and right are also original. The nineteenth-century frame was removed during cleaning in 1981–2. The original frame no longer exists, except for the raised rebate around the inside of the arches and the *pastiglia* in the spandrels which has been regilded.

At the base of the panel, a horizontal strip 14.5 cm. deep has been left bare; the gesso ends in a raised lip, indicating that the panel terminated in a raised moulding of some kind, although this would not have been large enough to accommodate a painted narrative predella.

The punching of the gold on the painted brocade has been omitted where the bases of the columns dividing the figures would have been. The points of attachment for the capitals also show on the gilded surface.

Cleaned in 1981–2.

The attribution to Nardo first made by Offner[1] is generally accepted,[2] although the execution of the side saints is sometimes given to assistants.[3] The uniformity of the pen and ink underdrawing, seen in infra-red reflectography[4] but also clearly showing through in places where the pigments have become transparent, suggests design by a single hand.

Skaug in a written communication to the National Gallery has suggested that No. 581 is to be dated *c*.1365, towards the end of Nardo's life, on the basis of the tooling of the haloes. Skaug's theory, in brief, is that *c*.1363–5 Giovanni da Milano introduced into the Florentine repertoire a series of distinctive punches not found in Florence before that date, but used by Sienese artists in the circle of the Ovile Master; after that date the punches are widely used by Florentine artists, including Nardo, Andrea di Cione, Jacopo di Cione et al.[5] The date of *c*.1365 would be consistent with the apparently minimal development of Nardo's style.

Detailed technical analyses made by the Scientific Department of the National Gallery have shown the altarpiece to have been produced, with only a few variations, precisely according to the methods described by Cennino Cennini.[6] The pigments used in the altarpiece have been extensively analysed and are too numerous to itemise here. One unusual feature highlighted by Plesters and Roy as almost unprecedented in their experience is the combination of lead-tin yellow with ultramarine to produce green drapery. The medium used to temper the pigments has been identified as egg. Particularly interesting is the complex technical evolution of the brocade-patterned floor. This brocade pattern, deriving presumably from a cloth of honour, is frequently used by Nardo.[7]

The altarpiece probably had a plain predella moulding (see above), perhaps decorated with painted patterns or an inscription. Although a triptych consisting entirely of three figures is unusual in early Italian painting, there are parallels with contemporary frescoes,[8] and No. 581 is likely to be a complete altarpiece.[9] A *St Peter* in SS. Stefano e Cecilia in Florence has by several writers been wrongly supposed to be part of the same altarpiece as No. 581.[10]

Although the panel is '*pala*-like' in forming one continuous surface, there are traces of dividing colonettes which appear to be original (see above). This makes the altarpiece very much transitional between polyptych and *pala*.[11]

The central position of St John the Baptist suggests that the altarpiece probably once came from an altar or church dedicated to that saint. And in the National Gallery catalogue of 1858 (presumably on the basis of information supplied to Eastlake) the provenance is stated to be the Hospital Church of SS. Giovanni e Niccolò, near Florence (see below). This church was identified by W. and E. Paatz[12] as San Giovanni Battista della Calza, Florence, which was originally known as San Giovanni Gerosolomitano and, as early as 1362 at least, belonged to the Knights of Malta, remaining in their possession until 1529.[13] In 1373 Bindo di Lapo Benini said he had built it at the behest of his brother Bartolommeo, Prior of the Order in Pisa.[14] In fact, Paatz suggests that the presence of the Benini arms on the doors of the church[15] confirms that the family actually built it. Offner plausibly suggested that the altarpiece was commissioned by Benini for the high altar, with St John the Baptist as dedicatee of the church, St James the Greater commemorating Bartolommeo's father, Lapo (Jacopo), and St John the Evangelist as St James's brother.[16] Another altarpiece inscribed as having been commissioned by *Bindus quondam Lapi Benini* and dated 1364 was that for a chapel in Santa Maria degli Angeli, Florence, also dedicated to St John the Baptist, containing the unusual iconographic

feature of St John the Baptist, as a side saint, wearing the robes of the Knights Hospitaller.[17]

PROVENANCE: Purchased with other pictures from Lombardi and Baldi, Florence, 1857.[18]

REFERENCES:

1. R. Offner, *A Critical and Historical Corpus of Florentine Painting*, Section IV, vol. II, *Nardo di Cione*, New York, 1960, pp. 111 ff., and pp. 37 ff.
2. R. Fremantle, *Florentine Gothic Painters from Giotto to Masaccio*, London, 1975, pp. 147–8.
3. Offner, op. cit, p. 37. ·
4. See fig. 5 of the article cited in note 6.
5. See E. Skaug, 'Punch-Marks – What are they worth? Problems of Tuscan Workshop Interrelationships in the Mid-Fourteenth Century: The Ovile Master and Giovanni da Milano', in *La Pittura nel XIV e XV Secolo. Il Contributo dell'Analisi Tecnica alla Storia dell'Arte*, (Ed. H. W. van Os), Comité International d'Histoire de l'Art, Bologna 1979, published Bologna 1983, pp. 253–82. See also E. Skaug, 'The Rinuccini Tondo – An 18th Century Copy or a 14th Century Original?', in *Atti del Convegno sul Restauro delle Opere d'Arte, 1976*, I, Florence, 1981, pp. 333–9.
6. For details of the technical analysis made of the altarpiece by the National Gallery's Scientific and Conservation Department, see Dillian Gordon, David Bomford, Joyce Plesters and Ashok Roy, 'Nardo di Cione's "Altarpiece: Three Saints"', *National Gallery Technical Bulletin*, 9, 1985, pp. 21–37.
7. e.g. Offner, op. cit., pls. II, Va, XVI,
8. Offner, op. cit, p. 37.

9. Offner, loc. cit.
10. Offner, loc. cit.
11. C. Gardner von Teuffel, 'From Polyptych to Pala: Some Structural Considerations', in *La Pittura nel XIV e XV Secolo. Il Contributo dell'Analisi Tecnica alla Storia dell'Arte*, op. cit., pp. 323–44.
12. W. and E. Paatz, *Die Kirchen von Florenz*, vol. 2, Frankfurt-am-Main, 1941, p. 279. Paatz said No. 581 probably once stood on the high altar, but wrongly said it must have been part of a triptych of which the centre would have shown the Virgin and Child.
13. Paatz, op. cit, pp. 272 ff.
14. Ibid. Paatz cites G. B. Uccelli, *S. Giusto alle Mura*, 1865, which the compiler has not been able to consult.
15. Paatz, op. cit., p. 279, n. 6. See also G. Richa, *Notizie Istoriche delle Chiese Fiorentine*, IX, Florence, 1761, p. 97.
16. Offner, op. cit, p. 38.
17. L. Marcucci, *Gallerie Nazionale di Firenze. I Dipinti Toscani del Secolo XIV*, Rome, 1965, no. 78. See also A. Luttrell, 'A Hospitaller in a Florentine Fresco: 1366/8', *The Burlington Magazine*, CXIV, 1972, Appendix on p. 366.
18. For details concerning the Lombardi–Baldi Collection see Appendix I.

NICCOLÒ DI BUONACCORSO
active 1355, died 1388

Sienese School. He joined the guild of painters in Siena in 1355.[1] A polyptych signed and dated 1387 survives in fragments. No. 1109 below is the only other signed work.

REFERENCE:
1. See E. Carli, *La Pittura Senese del Trecento*, Milan, 1981, p. 234.

1109 *The Marriage of the Virgin*
(Panel from a triptych?)

Plate 59

St Joseph holds a leafy rod, from which a dove emerges. Joachim and Anna behind, among the spectators.

Signed: NICHOLAUS: BONACHVRSI: DE SENIS: ME PN̄XT̄.

Reverse: a geometric design, painted and punched.

Wood. The size of the picture is 43 × 26.5 (17 × 10½), cusped and rounded top; the total size, including the framing, is 51 × 33 (20 × 13). On the reverse, the size of the pattern, excluding the mouldings forming the framing, is 47.5 × 29.5 (18¾ × 11¾).

The front is in good condition, except for the framework, which is original but has been regilded. The sides have been slightly shaved. The reverse has been considerably damaged.

Two other panels clearly from the same series are known. One, the *Presentation of the Virgin*, was in the Hospital of Santa Maria Nuova, Florence, and is now in the Uffizi, Florence;[1] the other, the *Coronation of the Virgin*, is in the Robert Lehman Collection, Metropolitan Museum of Art, New York (no. 1975.1.21).[2]

As the sides of No. 1109 have been slightly trimmed (see above), no traces of hinges or clasps remain. The fact that the back has a punched and painted diamond design (Fig. 19) implies that No. 1109 was part of a folding tabernacle (Fig. 18). Martin Davies noted that the decoration on the back of the Uffizi panel is identical and Marcucci notes that it has a '*borchia*' (metal boss) at the left.[3] The Lehman panel has the same decoration.

The tabernacle may have been a triptych, with No. 1109 at the centre. If there was one more panel in the series,[4] then the extra missing panel would perhaps have been a Birth of the Virgin. However, the central position of the signature suggests that it was a triptych.

The flowering of Joseph's rod as a dove is not unknown in the context of Sienese and Florentine painting of the late fourteenth century. It occurs in the fresco of the *Marriage of the Virgin* at the Eremo di San Leonardo al Lago, attributed to Lippo Vanni.[5] It also occurs on a polyptych dated 1375 (Impruneta, Collegiata di Santa Maria), attributed to Pietro Nelli.[6]

It is possible that No. 1109 was at one time in Santa Maria Nuova, with the *Presentation*.[7] The fact that the painter adds 'from Siena' to his name in the signature suggests that in any case it was probably painted for some destination other than Siena.[8]

PROVENANCE: Doubtless identical with a picture (subject undescribed) seen by Fairfax Murray for sale in Florence in 1877.[9] Purchased from C. Fairfax Murray, 1881.

REFERENCES:

1. Luisa Marcucci, *Gallerie Nazionali di Firenze. I. Dipinti Toscani del Secolo XIV*, Rome, 1965, p. 169, cat. no. 117; size 51 × 34 cm. It is described (while still in Santa Maria Nuova) by G. B. Cavalcaselle and J. A. Crowe, *Storia della Pittura in Italia*, III, Florence, 1885, p. 255. Its transfer to the Uffizi is referred to by E. Ridolfi in *Le Gallerie Nazionali Italiane*, IV, 1899, pp. 169–70.

2. J. Pope-Hennessy, *The Robert Lehman Collection. I Italian Paintings*, The Metropolitan Museum of Art, New York, 1987, pp. 33–5. When in the Hendecourt Collection, Paris, it was described and reproduced by F. Mason Perkins, 'Dipinti senesi Sconosciuti o Inediti', *Rassegna d'Arte*, 1914, pp. 98–9. It is presumed to be identical with an *Assumption*, stated

by Langton Douglas to have been in the Sciarra Collection; see J. A. Crowe and G. B. Cavalcaselle, *A New History of Painting in Italy*, III, London, 1908, p. 133, note.

3. Marcucci, op. cit., p. 169.

4. Marcucci, loc. cit., also notes that the series may not be complete.

5. See E. Carli, *La Pittura Senese del Trecento*, Milan, 1981, fig. 264.

6. See R. Fremantle, *Florentine Gothic Painters from Giotto to Masaccio*, London, 1975, fig. 694.

7. Ridolfi, loc. cit., seems to imply this, but he may not have had positive information.

8. The polyptych dated 1387, of which possibly the *Virgin and Child* and *St Lawrence* survive (see M.

Boskovits, 'Su Niccolò di Buonaccorso, Benedetto di Bindo e la pittura senese del primo Quattrocento', *Paragone*, 359–61, January–March 1980, pp. 4 ff and pls. 4 and 5), was painted for Santa Margharita, Costalpina, which is just outside Siena, and according to Milanesi was merely signed NICHOLAUS BONACHURSI ME PINXIT A DNI 1387 (see G. Milanesi, *Documenti per la Storia dell'Arte Senese*, I, Siena, 1854, p. 32). For some comments on the carpet pattern see J. Mills, *Carpets in Pictures* (Themes and Painters in the National Gallery), London, 1975, pp. 4–5.

9. Letter of 6 December 1877 in the National Gallery archives.

NICCOLÒ DI PIETRO GERINI
first recorded 1368, died 1415

First definitely recorded in 1368 when he is inscribed with the Arte dei Medici e Speziali in Florence.[1] He appears mainly to have worked in Florence, although ruined frescoes in the Chapter House of San Francesco, Pisa, were recorded as bearing his signature and the date 1392, and a signature was recorded on frescoes in the Chapter House of San Francesco, Prato.[2] No other signed works survive. Most of his documented surviving works were shared with other painters. It is presumed that he is identifiable with the 'Niccolaio dipintore' who may have collaborated with Jacopo di Cione in 1366 on the now lost frescoes for the guild hall of Judges and Notaries in Florence,[3] and on the San Pier Maggiore altarpiece in 1370 (see JACOPO DI CIONE, No. 569 et al.); a *Coronation of the Virgin* for the Zecca Vecchia (Florence, Accademia) was in 1372 documented as a similar collaboration between the two painters, as was a fresco of 1383 in Volterra.[4] In 1386 a contract for a fresco on the façade of the Bigallo, Florence, names his collaborator as Ambrogio di Baldese. His collaborators named in the contract for the high altarpiece for Santa Felicita, Florence, in 1399 were Spinello Aretino and his son, Lorenzo di Niccolò.[5] In Prato he worked for Francesco Datini with other Florentine painters, including Agnolo Gaddi, in 1391–2 and again in 1394 and 1411. After his death the remainder due on the high altar of Santa Verdiana in Florence was paid.

REFERENCES:
1. See Thieme-Becker, s.v. Gerini, for details of his life.
2. R. Offner, *Studies in Florentine Painting*, New York, 1927, pp. 89–94. For the remarkably large number of works attributed to this somewhat nebulous painter see M. Boskovits, *Pittura Fiorentina alla Vigilia del Rinascimento 1370–1400*, Florence, 1975, pp. 410–15.
3. Eve Borsook, 'Jacopo di Cione and the guild hall of the Judges and Notaries in Florence', *The Burlington Magazine*, CXXIV, 1982, pp. 86–8. She suggests he may be the 'Niccholao cofanerio' mentioned.
4. R. Offner and K. Steinweg, *A Critical and Historical Corpus of Florentine Painting*, Section IV, vol. III, *Iacopo di Cione*, New York, 1965, pp. 37, 86, 115.
5. L. Marcucci, *Gallerie Nazionali di Firenze. I Dipinti Toscani del Secolo XIV*, Rome, 1965, no. 69, pp. 109–11.

Ascribed to NICCOLÒ DI PIETRO GERINI

579 *The Baptism of Christ, with Sts Peter and Paul* Plate 60
(Altarpiece)

Centre, St John baptises Christ; the Almighty and the Holy Spirit above. At the top, an angel in a medallion. Left wing, St Peter, with the (apparently old) inscription S. PETRUS. APL. Right wing, St Paul, with the (apparently old) inscription SCS. PAULUS. APS. Predella in two divisions: left, the angel (St Gabriel) appearing to Zacharias, and the Birth of St John the Baptist; right, St John the Baptist decapitated, the Feast of Herod, and Salome bringing the Baptist's head to Herodias. At the extreme ends of the predella, St Benedict (left) and St Romuald (right).

Wood. The size of the painted surface of the central scene is 160 × 76 (63 × 30), pointed top; diameter of the medallion, 12.5 (5); of the saints at the sides, each 123 × 37 (48½ × 14½), pointed tops. Including the frame, but excluding the predella, the total size is 190 × 171 (75 × 67½). The scenes of the predella are each 33.5 × 68 (13¼ × 26¾); the saints of the predella each 33.5 × 11.5 (13¼ × 4½); all the corners being cut. The total size of the predella with its framing is 47.5 × 200 (18¾ × 78¾).

In good condition in general; obvious losses on Christ's body etc. and along the bottom of the predella. The frame is in essentials apparently old, but has been a good deal restored, and entirely regilded. The twisted columns are modern replacements but may reflect the original structure. The cusping appears to be modern. The outer moulding encasing the whole upper part of the altarpiece appears to be a modern addition. Much of the lower moulding encasing the inscriptions below Sts Peter and Paul is new: parts of the inscription have been truncated. The outer moulding of the predella also appears to be new.

A strip approximately 6.35 cm. deep along the bottom of the compartments with Sts Peter and Paul is marked off by an incised line. Below this line the gold leaf of the textile pattern is not punched, and the darker orange of the design is achieved by using vermilion, as opposed to the red lead used above the line in the rest of the textile, apparently in an attempt to create the impression of a ledge.[1]

No. 579 was first attributed to Niccolò di Pietro Gerini by Sirén, who detected the collaboration of Lorenzo di Niccolò in the predella.[2] The attribution to Niccolò di Pietro Gerini, maintained by Offner,[3] is generally accepted,[4] although the name of Jacopo di Cione, with whom Niccolò often collaborated,[5] has also been mentioned.[6]

 When No. 579 entered the National Gallery, and previously when it was in the Lombardi–Baldi Collection in Florence, three pinnacles by GIOVANNI DA MILANO (see No. 579A) were attached to it; nothing is known of when they were first added to it.[7] It may be that it is missing three pinnacles and pilasters at either side. Boskovits has suggested that a pinnacle panel (Fig. 16) with the *Blessing Redeemer* (Munich, Alte

Pinakothek, no. 644), attributed to Niccolò di Pietro Gerini, formed part of the altarpiece.[8]

When No. 579 entered the National Gallery, there was recorded below the central compartment a half-obliterated inscription, to the effect that the picture was painted by order of Filippo Neroni in 1337(?).[9] The only possible place for the inscription is the strip of the frame running along the bottom. This is now covered with new gold. Removal of some pieces of the gold revealed a sheet of iron. As the removal of the iron might have disrupted the whole altarpiece, it was thought best not to try, and the gold was fixed back again on top. On stylistic grounds a reading of the date as 1387 makes more sense,[10] and the documentation of the altarpiece confirms that this is correct (see below).

The presence of Camaldolese saints in the predella indicates a Camaldolese provenance. The original location of Santa Maria degli Angeli in Florence was first put forward by Cohn,[11] who discovered documents concerning a certain Don Filippo di Nerone Stoldi, who was a monk at the Angeli from 1357 to 1400.[12] His mother, Angiola, and his stepbrother, Federigo, left property to the Angeli which was to be sold and the money used for the construction of a chapel dedicated to St John the Baptist,[13] specifically 'San Giovanni Decollato'; this chapel was founded in 1386 and dedicated to San Giovanni Decollato, and the first Mass was said in it on 23 September 1387 on the feast-day of St Matthew Apostle; at a total cost of 500 gold florins, the furnishings included 'l'altare e tavola e paramenti e calice' and everything else pertaining to a chapel.[14] Given the coincidence of documents with the details of the recorded inscription, and the dedication of the main scene and narrative predella to St John the Baptist, it is beyond reasonable doubt that No. 579 was the altarpiece commissioned for the Stoldi Chapel by the family of Don Filippo di Nerone and completed in 1387. The location of the chapel is described as being 'de capo l'infermeria'.[15] The infirmary was begun in 1386 and still incomplete in 1387.[16]

The triptych format with a central (narrative) scene flanked by standing saints, resting on a predella reflecting the dedication of the altar, follows that established for the five altarpieces in the Chapter House of Santa Maria degli Angeli, of which four survive.[17] The earliest is the *Purification of the Virgin* with Sts John the Baptist and Benedict, which according to the inscription was commissioned in 1364 by *Bindus quondam Lapi Benini*, and is attributed to Giovanni del Biondo (Florence, Accademia).[18] Two altarpieces attributed to Nardo di Cione, also from the Chapter House, follow the same format: the *Trinity* with Sts Romuald and John the Evangelist (Florence, Accademia), dated 1365 by the inscription which also records the donor as Giovanni Ghiberti;[19] and another altarpiece, also attributed to Nardo di Cione and dated 1365, commissioned by Tellinus Dini and showing the *Virgin and Child Enthroned* with St Gregory and Job (Florence, Santa Croce).[20] A fourth altarpiece commissioned by the Corsi family in 1364 was dedicated to St Anthony.[21] The fifth, dedicated to St Peter, was commissioned by Pietro Neri da Palagio or Pelagio(?) and dated 1372.[22] The church of Santa Maria degli Angeli was refurbished in 1372[23] and the refurbishment seems to have precipitated or encouraged an exceptionally large number of donations for altarpieces.[24]

It is an iconographic curiosity that an altarpiece commissioned probably in the same

year as No. 579 for the Nobili Chapel (completed in 1388) in Santa Maria Novella, contained a predella panel which is almost identical to the right side of the predella of No. 579.[25] The Nobili altarpiece, which was recorded by Richa,[26] is now in Berlin, and attributed to Agnolo Gaddi.[27] The predella, which contains scenes from the lives of Sts James and John the Baptist on either side of a Crucifixion, is in the Louvre.[28] It was first identified with the Nobili altarpiece by Gronau,[29] then attributed to Lorenzo Monaco. Both No. 579 and the Louvre predella derive from Giotto's *Feast of Herod* in the Peruzzi Chapel in Santa Croce,[30] although both omit the onlookers with arms entwined.

No. 579 appears to be the first known altarpiece to isolate the Baptism of Christ as the central narrative scene for an altarpiece. It may well have influenced Piero della Francesca's *Baptism*,[31] particularly as it seems that at some stage[32] it was probably moved to the Camaldolese Abbey of San Giovanni Decollato del Sasso near Arezzo (see below) where it could have served as the high altarpiece. Piero's *Baptism* also came from a Camaldolese church in San Sepolcro.[33]

The removal of No. 579 from Santa Maria degli Angeli at an early date would explain why it is not mentioned by Rosselli (1657)[34] or by Richa (1759).[35]

PROVENANCE: Original location Santa Maria degli Angeli (see above), Florence. Stated to be from the Abbey del Sasso di Camaldoli.[36] Probably what was meant is the Camaldolese Abbey of San Giovanni Decollato del Sasso near Arezzo, for which No. 579 could have served as the high altarpiece.[37] By 1845, in the Lombardi–Baldi Collection, Florence;[38] purchased from that collection with other pictures, 1857.[39]

REFERENCES:
1. Pigments analysed by Ashok Roy of the National Gallery Scientific Department.
2. O. Sirén, 'Di Alcuni Pittori Fiorentini', *L'Arte*, 1904, p. 338., n. 1; he later attributed it to Jacopo di Cione in *Giottino*, 1908, pp. 79 and 90; and then reverted to Niccolò di Pietro Gerini in Thieme-Becker, 1920, s.v. Gerini.
3. R. Offner, *Studies in Florentine Painting. The Fourteenth Century*, New York, 1927, pp. 84–5 and 91. See also R. Offner (ed. Hayden B. J. Maginnis), *A Critical and Historical Corpus of Florentine Painting. A Legacy of Attributions*, New York, 1981, p. 74.
4. M. Boskovits, *Pittura Fiorentina alla Vigilia del Rinascimento 1370–1400*, Florence, 1975, p. 410.
5. He probably collaborated with Jacopo di Cione on the San Pier Maggiore altarpiece (see No. 569) and is definitely documented working with him on the Zecca *Coronation of the Virgin* in 1372 and on a fresco of the *Annunciation* in Volterra in 1383 (see R. Offner and K. Steinweg, *A Critical and Historical Corpus of Florentine Painting*, Section IV, vol. III, *Iacopo di Cione*, New York, 1965, pp. 89–90 and 115).
6. Basile Khvoshinsky and Mario Salmi, *I Pittori Toscani*, II, *I Fiorentini del Trecento*, Rome, 1914, p. 32. The authors' reference to this picture on p. 56, where they listed it again, but under Niccolò di Pietro Gerini, was an error; see their *Errata-Corrige*.
7. Already noted as attached in a Lombardi–Baldi catalogue (*Collection de Tableaux Anciens* etc.) no. 11;

the catalogue is not dated, but the copy in the Uffizi Library is claimed to be of 1845
8. Boskovits, loc. cit. It measures 63 × 40 cm. Measurements kindly supplied by the Alte Pinakothek.
9. Scharf in April/May 1858 copied the inscription thus: CCCXXII. DOMN. PHILIPP'NERONIS. FECIT. FIERI HANC … (C?) E AGEELE. MA … SVE. & SUORUM MON. (Scharf sketchbooks, No. 51, f. 52r, in the National Portrait Gallery, London; photograph in the National Gallery archives.)
10. The National Gallery catalogue maintained the date 1337 (with which was associated an attribution to Taddeo Gaddi) until 1863; thereafter, the date was changed to 1387. The change may have been made to meet the wishes of Crowe and Cavalcaselle, who in 1864 published their preference on stylistic grounds for the year 1387 rather than 1337 (J. A. Crowe and G. B. Cavalcaselle, *A New History of Painting in Italy*, I, London, 1864, p. 367, n. 2).
11. W. Cohn, 'Notizie storiche intorno ad alcune tavole fiorentine del '300 e '400', *Rivista d'Arte*, XXXI, 1956, pp. 66–7.
12. Recorded in the necrology of Santa Maria degli Angeli in Florence, Archivio di Stato, Conventi Soppressi 86, 95, f. 87v.
13. Florence, Archivio di Stato, Conventi Soppressi 86, 95, f. 17v. Cohn (loc. cit.) gives this

reference incorrectly as Conventi Soppressi 86, 96.

14. Cohn (loc. cit.) gives this reference incorrectly. It should be Florence, Archivio di Stato, Conventi Soppressi, 86, 95, f. 47ᵛ. Cohn inexplicably omits the mention of 'tavola' in his transcription of this source.

15. Ibid., loc. cit.

16. The funds to complete the infirmary were given by Bernardo di Cino Bartolini de Nobili (G. Richa, *Notizie Istoriche delle Chiese Fiorentine*, Florence, 1759, VIII, pp. 148–9).

17. This format originated in the narrative altarpieces for Siena Cathedral. See LORENZETTI, No. 1113.

18. L. Marcucci, *Gallerie Nazionali di Firenze. I Dipinti Toscani del Secolo XIV*, Rome, 1965, no. 78. See also Florence, Archivio di Stato, Conventi Soppressi, 86, 95, f. 30. The chapel was dedicated to St John the Baptist. The cost was 120 florins and the first Mass was said there on 1 November 1364.

19. Marcucci, op. cit., no. 43. The chapel was dedicated, not to St John the Evangelist as Marcucci says, but to St Romuald; Giovanni Ghiberti was brother of Fra Michele Ghiberti, prior of the convent (Florence, Archivio di Stato, Conventi Soppressi 86, 95 ff. 30 and 83).

20. Marcucci, op. cit., no. 44. See also Florence, Archivio di Stato, Conventi Soppressi, 86, 95, f. 30. The chapel was dedicated to St Job; the cost was 500 gold florins and the first Mass was said there on 1 November 1364.

21. According to W. and E. Paatz, *Die Kirchen von Florenz*, vol. 3, Frankfurt-am-Main, 1952, p. 126, this is identifiable with Florence, Accademia, no. 8610. The latter, attributed by Procacci to Lorenzo di Niccolò and dated 1404, in fact was commissioned by the Corsi family for San Benedetto de' Camaldolesi outside Porta a Pinti and was moved to the Corsi chapel in Santa Maria degli Angeli in 1529 (U. Procacci, *La R(egia) Galleria dell'Accademia di Firenze. Itinerari dei Musei e Monumenti d'Italia*, Rome, n.d., p. 35, illustrated p. 86). No. 8610 has been attributed by Boskovits to Niccolò di Pietro Gerini. See Boskovits, op. cit., p. 408.

22. It cost 300 florins and was next to the chapel of St Anthony (Conventi Soppressi, 86, 95, f. 34). It was seen by Rosselli, who transcribed the coat of arms (Sepoltuario Fiorentino, III, 1657, Florence, Biblioteca Nazionale, Cod. Magliabech. XXVI, 24, f. 1253).

23. Archivio di Stato, Conventi Soppressi, 86, 95, f. 35.

24. One now lost altarpiece was that dedicated to St Andrew, commissioned by Andrea Ugonis Lotteringhi in 1371 at a cost of 90 florins (Conventi Soppressi, 86, 95, f. 34) and inscribed 1372. According to Rosselli it bore the della Stufa/Lotteringhi arms (Sepoltuario Fiorentino, III 1657, Florence, Biblioteca Nazionale, Cod. Magliabech. XXVI, 24, f. 1253). It is possible that part of the predella of this altarpiece is the scene of *St Andrew driving out Demons* (Santa Barbara, California Museum of Art) attributed to Niccolò di Pietro Gerini (see Fabio Bisogni, 'Una rara scena della leggenda di S. Andrea di Niccolò di Pietro Gerini', *Mitteilungen des Kunsthistorischen Institutes in Florenz*, XVII, 1973, pp. 195–200). It measures 22.4 × 41.7 cm.

25. The connection between No. 579 and the Louvre predella was also noticed by P. Schubring, 'Die primitiven Italiener im Louvre', *Zeitschrift für christliche Kunst*, 12, 1901, p. 366. He attributed both to Taddeo Gaddi.

26. Richa, op. cit., p. 166. He comments on its magnificence.

27. Bruce Cole, *Agnolo Gaddi*, Oxford, 1977, p. 75, pl. 1.

28. Ibid., p. 84, pls. 46–8.

29. H. D. Gronau, 'The Earliest Works of Lorenzo Monaco – II', *The Burlington Magazine*, XCII, 1950, pp. 217–22. The chapel was dedicated to Sts James and John 'Decollato', and erected at the expense of Bernardo di Cino Bartolini de Nobili. It was founded on 25 July 1387, the feast of St James, and furbished with vestments, missal, chalice and altarpiece and 12 choir stalls, costing 700 florins over and above the 500 florins spent on the building. Mass was first said there on 29 March 1388. F. Zeri, 'Investigations into the early period of Lorenzo Monaco', *The Burlington Magazine*, CVI, 1964, p. 554, suggested that the *Baptism of Christ*, Florentine School, No. 4208 in the National Gallery, was part of the altarpiece.

30. The entire predella is based on the Peruzzi cycle. See L. Tintori and E. Borsook, *Giotto. The Peruzzi Chapel*, Turin, 1965, p. 28.

31. Martin Davies, *National Gallery Catalogues. The Earlier Italian Schools*, 2nd ed. revised 1961, London, no. 665, pp. 426–8.

32. It may have been moved as early as 1413. See Davies, ibid., p. 388, n. 11.

33. The connection is also noted by Marilyn Aronberg Lavin, *Piero della Francesca's 'Baptism of Christ'*, Yale, 1981, p. 136. The history of how Piero's *Baptism* came to be associated with the Graziani altarpiece is not relevant here. But what may be significant is that Matteo di Giovanni's altarpiece, in which Piero's *Baptism* was awkwardly set, is close in design to No. 579 – with

twisted columns, cusped arches etc., and Sts Peter and Paul flanking the central scene. This may well be another argument for the presence of No. 579 in the area at an early date. For the original location of Piero's *Baptism* see C. Ginzburg, *The Enigma of Piero*, London, 1985, pp. 22–3.

34. Rosselli (Sepoltuario Fiorentino, III, 1657, Florence, Biblioteca Nazionale, Cod. Magliabech. XXVI, 24, ff. 1253–5) records a number of altarpieces in Santa Maria degli Angeli.

35. Richa, op. cit.

36. National Gallery 1858 catalogue, s.v. Taddeo Gaddi.

37. A mention of this Abbey is made by G. Farulli, *Istoria Cronologica . . . degli Angioli di Fir-*

enze, Lucca, 1710, p. 196; also by Richa, op. cit., vol. 8, 1759, p. 159. The Abbey, however, appears to have housed black Benedictines, and although connected with the Camaldolese not to have become itself Camaldolese until 1413–14. See G. B. Mittarelli and A. Costadoni, *Annales Camaldulenses*, V, 1760, pp. 308–9, and VI, 1760, p. 264. Furthermore, E. Repetti, *Dizionario Geografico Fisico Storico della Toscana*, V, 1843, p. 202, says that it was by then a ruin; a ruin is an unlikely place for No. 579 to come from, and it is not known at what date the Abbey was still intact.

38. See note 7 above.

39. For the history of the Lombardi–Baldi Collection see Appendix I.

SEGNA DI BONAVENTURA
active 1298, died 1326/31

Sienese School. Apparently a nephew of Duccio. Recorded in Arezzo in 1319. Four signed works exist. See Pèlco Bacci[1] and also Stubblebine[2] for a discussion of works by Segna, his pupils and followers.

REFERENCES:

1. Pèleo Bacci, *Fonti e Commenti per la Storia dell'Arte Senese*, Siena, 1944, pp. 3 ff. (Review by Enzo Carli in *Emporium*, April–June 1944, pp. 58–9.)

2. J. H. Stubblebine, *Duccio di Buoninsegna and His School*, Princeton, 1979, pp. 130 ff.

Style of SEGNA DI BONAVENTURA

567 *Crucifix*
Plate 61

The Virgin and St John are shown at the ends of the Cross, left and right. Inscribed (new): IHS NAZARENUS / R.E.X. / IUDEORUM.

Wood. Total size, including the framing, 213.5 × 184 (84 × 72½). The outer edge (about one centimetre) of this framing all round is new wood; the inner part may be original. Size of the panels of the Virgin and St John, excluding the framing, each, 35.5 × 22 (14 × 8½).

Much damaged. Over a part of Christ's left arm and hand, length 31 cm., and over about 10 cm. of His right arm, the paint is wholly new. The figure of Christ in general is poorly preserved. St John is well preserved, the Virgin less well. The stamped background behind the Virgin and St John, and on part of Christ's halo, preserves the original pattern with some remains of the original gold over it. The patterning on the picture not

stamped, but merely painted and gilded, is new, perhaps following old indications. The framing has been regilded.

By analogy with other Crucifixes of the time, a roundel of God the Father should once have surmounted No. 567.

No. 567 has been ascribed to Segna at the National Gallery since the catalogue of 1858. This attribution has not always been accepted; Berenson, in his *Lists* of 1932, includes No. 567 under Segna's name with a question mark, and F. Mason Perkins in Thieme-Becker, s.v. Segna, rejects the attribution. It is certainly wrong.

No. 567 is, however, close to two Crucifixes connected with Segna: the Crucifix signed by Segna (Moscow, Pushkin Museum of Fine Arts)[1] and the Crucifix generally attributed to him in San Polo in Rosso (near Gaiole in Chianti).[2]

No. 567 would seem to pre-date the Crucifix in Arezzo (Badia of SS. Flora e Lucilla), which is also generally attributed to Segna,[3] and which probably dates from *c.*1319:[4] the figures in No. 567 are less elongated, the terminals not barbed, and the body of Christ less dramatically collapsed.

Probably deriving from the Arezzo Crucifix is a similar one in San Francesco, Pienza. Stubblebine[5] attributes this to an assistant of Segna, active in his workshop, whom he dubs the 'Pienza Cross Master'. He attributes No. 567 to this master,[6] although suggesting that it could have been executed in Segna's shop. Carli[7] also saw a close connection between No. 567 and the Pienza Crucifix.

The relationship between No. 567 and the various works by Segna and his workshop is made the more difficult to define[8] by the damaged condition of No. 567.

PROVENANCE: From the Vanni Collection in Siena.[9] Purchased with other pictures from the Lombardi–Baldi Collection, Florence, 1857.[10]

REFERENCES:

1. J. H. Stubblebine, *Duccio di Buoninsegna and His School*, Princeton, 1979, p. 132 and fig. 313.
2. Stubblebine, loc. cit., and fig. 314.
3. Stubblebine, op. cit., p. 133 and figs. 315–18.
4. Segna was working in the Badia of SS. Flora e Lucilla at that date. See M. Salmi, 'Il Crocefisso di Segna di Bonaventura ad Arezzo', *L'Arte*, XV, 1912, p. 34 (Stubblebine, loc. cit., gives the date as 1321).
5. Stubblebine, op. cit., p. 146 and figs. 349–51.

6. Stubblebine, op. cit, pp. 146–7 and figs. 349–56.
7. Enzo Carli, *Dipinti Senesi del Contado e della Maremma*, Siena, 1955, p. 55.
8. See also Carli, loc. cit., note 7.
9. National Gallery 1858 catalogue, no doubt on information supplied to Eastlake.
10. For details concerning the Lombardi–Baldi Collection see Appendix I.

SPINELLO ARETINO
active 1373, died 1410/11

From Arezzo. On some confused indications by Vasari, he has been said to have been born *c.*1333; but he may have been born after 1345. Vasari (edition of 1568)[1] claims to have read a date 1361 on one of his pictures. First surely recorded in 1373 in Arezzo. In 1386 he was a member of the Arte dei Medici e Speziali, Florence.[2] He indeed settled in Florence for some time, but without breaking his connection with Arezzo; active also in

Pisa and Siena. His date of death seems to be 1411 rather than 1410.[3] Several authenticated works exist.

REFERENCES:
1. Vasari, *Vite* (ed. Milanesi, Florence, 1878), I, pp. 677 ff.
2. For early works see A.R. Calderoni Masetti, *Spinello Aretino Giovane*, Florence, 1973.
3. U. Pasqui, 'Pittori aretini vissuti dalla metà del sec. XII al 1527', *Rivista d'Arte*, 1917–18, pp. 63–4.

276 *Two Haloed Mourners*
(Fragment from the Burial of St John the Baptist)

Plate 65

Fresco. 50 (19¾) square.

The figures are in fair state for a fresco of this date; part of the background at the top is new.

In 1348 Vanni Manetti wrote instructions in his will that his chapel in the Carmine in Florence should be painted; he was still alive in 1357.[1] The decoration, as carried out, consisted principally of six scenes of the Life of St John the Baptist. The Carmine was largely destroyed by fire on 28/9 January 1771. These frescoes suffered comparatively little from the fire itself; and Thomas Patch in 1772 published engravings of the scenes (Fig. 17).[2] Patch's engravings are a very rough rendering of the style of the originals; but there is no doubt at all that he copied the compositions with considerable exactness, marking with some care on his engravings the parts where the *intonaco* had peeled off (leaving the underdrawing visible), and the parts that had been renewed.

Patch further sawed off from the walls some fragments of the original frescoes; the rest or most of the rest was presumably destroyed in the reconstruction of the church. No. 276 is from the *Burial of St John the Baptist*; a haloed figure from the same fresco is in the Ammanati Chapel in the Camposanto, Pisa.[3] There are five other fragments from the series in the same chapel in Pisa; the head of Christ from the *Baptism*, two angels from the same, the head of St Zacharias from the *Naming of St John*, the harpist from the Herod scene, and the head of St Elizabeth from the *Visitation*.[4] Part of the serving-maid behind St Elizabeth in the last scene is now in the Boymans-van Beuningen Museum, Rotterdam.[5] Salome from the Herod scene, and a group of three women with the Infant Baptist from the *Naming of St John* are in Liverpool.[6] Herod's head from the *Feast of Herod* was on the American art market.[7] There is also a fragment in Pavia claimed to be from the same series.[8]

The subject of the Burial of the Baptist is rather uncommon. In the present fresco several of the figures taking part in the burial, including the two in No. 276, have haloes; according to the Bible, the Baptist was buried by his own disciples. Some of the Apostles had been disciples of the Baptist, but there does not appear to be a text indicating that Apostles (or some other saints) took part in the burial; haloed figures do, nevertheless, sometimes occur in pictures of the subject.[9] The two figures in No. 276 were on the right of the composition.

The frescoes in the Manetti Chapel in the Carmine were ascribed by Vasari to Giotto.[10] Doubt about this attribution had already been expressed before the date of

Manetti's will (1348) was known. The fragments were ascribed to Spinello Aretino by Vitzthum,[11] and this attribution has been generally accepted. Procacci dates them soon after 1387;[12] van Os and Prakken[13] date them c.1390, and Boskovits c.1390–5.[14]

PROVENANCE: Sawn from the wall of the Manetti Chapel, known as the Chapel of St John the Baptist or St Lucy, in the Carmine in Florence after the fire of 1771 by T. Patch, as explained above. Bought from Patch by Charles Towneley, 7 February 1772.[15] Greville Collection sale, 31 March 1810 (lot 76).[16] Collection Samuel Rogers by 1818;[17] exhibited at the British Institution, 1848 (no. 87); purchased at the Rogers sale, 3 May 1856 (lot 721).

REFERENCES:

1. See Vasari, *Vite* (ed. Milanesi, Florence, 1878), I, p. 376. An elaborate account of these frescoes is given by Ugo Procacci, 'L'incendio della Chiesa del Carmine del 1771', *Rivista d'Arte*, 1932, pp. 141 ff.; esp. pp. 212 ff.

2. Thomas Patch, *The Life of Giotto*, Florence, 1772, nos. XI, VI, III. Small reproductions of Patch's engravings are given by Procacci, loc. cit., figs. 6–11.

3. Reproduced by Procacci, loc. cit., fig. 15. All the pieces in the Camposanto in Pisa were given by Carlo Lasinio; see R. Grassi, *Descrizione . . . di Pisa*, II, 1837, p. 174.

4. For two of them, see R. van Marle, *The Development of the Italian Schools of Painting*, III, The Hague, 1924, figs. 331 and 332; all the other pieces in Pisa are reproduced by Procacci, loc.cit.

5. Lord O'Hagan sale, 19 May 1939 (lot 73), as Sienese School; photograph in the National Gallery archives. In the van Beuningen Exhibition in Rotterdam, 1949 (*Honderd jaar Museum Boymans Rotterdam: Meesterwerken uit de verzameling D. G. van Beuningen*, Rotterdam, 1949, no. 78); catalogue of the van Beuningen Collection by D. Hannema, 1949 (no. 78) and pl. 116, wrongly as *The Virgin*; H. W. van Os and Marian Prakken, *The Florentine Paintings in Holland 1300–1500*, Maarssen, 1974, p. 103 (63). See also R. Longhi, 'Il più bel frammento dagli affreschi del Carmine di Spinello Aretino', *Paragone*, 131, November 1960, pp. 33–5.

6. Liverpool (Roscoe Collection); they were both bought in at the William Roscoe sale, 27 September 1816 (lots 6, 7), as Giotto; Brockwell's catalogue, 1928, no. 55 as Florentine and no. 79 as A. Lorenzetti; reproduced by Procacci, loc. cit., figs. 16, 17. Ralph Fastnedge in the Liverpool *Bulletin*, October 1954, p. 42, nos. 30–1 and *Cleaned Pictures*, Liverpool, 1955, nos. 2–3. *Foreign Catalogue, Walker Art Gallery, Liverpool*, Liverpool, 1977, pp. 205–6, nos. 2752 and 2753.

7. Federico Zeri, 'Italian Primitives at Messrs Wildenstein', *The Burlington Magazine*, CVII, 1965, p. 255, fig. 55, and Adams, Davidson and Company, 1967, *Catalogue*, p. 29 (77).

8. Procacci, loc. cit, p. 223 and fig. 18, as from the *Decollation*. It does not correspond with the figure of St John as indicated in Patch's engraving of this scene; indeed, according to Patch, the *intonaco* had fallen away in this region, and nothing but the underdrawing on the wall had been left. Procacci believes that the fragment now in Pavia must have been loose after the fire, and that it was removed before Patch made his engraving.

9. For the biblical texts, see Matthew xiv, 12, and Mark vi, 29. The scene occurs in the background of the fresco of the *Feast of Herod* in the Baptistery at Castiglione d'Olona, and one of the figures there does seem to have a halo; see the reproduction given by R. Longhi, 'Fatti di Masolino e di Masaccio', *Critica d'Arte*, July–December 1940, pl. 127, fig. 30. In the burial scene in a series in Albizzate, two of the figures have haloes; reproduced in *Rivista d'Arte*, 1941, p. 157. Haloed figures carry the headless body in a fragmentary fresco in the Oratorio di San Giovanni, Urbino; Zampetti, *Gli Affreschi di Lorenzo e Jacopo Salimbeni* etc., Urbino, 1956, p. 26 and pl. XXXIV, considers this one of the frescoes in the Oratory later than those of the Salimbeni.

10. Vasari, loc. cit. in note 1 (1550 edition, p. 141).

11. G. Vitzthum, 'Un ciclo di affreschi di Spinello Aretino perduto', *L'Arte*, IX, 1906, pp. 199 ff.

12. Procacci, loc. cit, pp. 226 ff.

13. Van Os and Prakken, loc. cit.

14. M. Boskovits, *Pittura Fiorentina alla Vigilia del Rinascimento, 1370–1400*, Florence, 1975, p. 437.

15. In a letter to the National Gallery, Francis Russell records an entry in the account books of Charles Towneley on 7 February 1772: 'Paid Mr. Patch for 4 pieces in fresco by Giotto taken from the wall of the Church of the Carmini lately Burnt at Florence. Scudi 48.' Russell points out that this confirms that Towneley also owned the two fragments now in Liverpool and that now in Rotterdam. For the Rotterdam fragment see also the introductory note to the Lord O'Hagan sale of 1939 and the catalogue of the British Institution Exhibition, 1848 (*Catalogue of Pictures by Italian, Flemish, Dutch, French, and English Masters*, London, 1848, no. 95).

16. As Masaccio.

17. H. Tresham and William Young Ottley, *The British Gallery of Pictures*, 1818, pl. 1.

1216 *St Michael and Other Angels* *Plate 62*
(Fragment from the Fall of Lucifer)

Fresco transferred to canvas. 116 × 170 (45¾ × 67).[1]

Much damaged. For the commentary and PROVENANCE see No. 1216B below.

1216A *Decorative Border* *Plate 63*
(Fragment from the Fall of Lucifer)

The donor in a white religious habit kneels between medallions of a saint and angel. Inscribed: +HOC.OPUS.FECIT.FIERI.XPO–FANUS.HU.

Fresco transferred to canvas. Approximately 56 × 154 (22 × 60½).

Much damaged. For the commentary and PROVENANCE see No. 1216B below.

1216B *Decorative Border* *Plate 64*
(Fragment from the Fall of Lucifer)

Medallions of a saint and angel. Inscribed: .UCII.CA. ANNO (?) DNI., followed at some distance by III, possibly part of the day of the month.

Fresco transferred to canvas. Approximately 56 × 127 (22 × 50).

Much damaged.

The left-hand side of No. 1216B seems to join on to the right-hand side of No. 1216A. All three pieces are from a large fresco of the *Fall of Lucifer*; another fragment is in the Galleria in Arezzo.[2] The whole composition (without the decorative border) was engraved (Fig. 20)[3] before it was broken up and mostly destroyed. No. 1216 was not cut horizontally from the fresco; the right-hand end was considerably higher than the left-hand end, the angle of the bottom edge being at about 20° to the horizontal.

The fresco was painted for the Compagnia di Sant'Angelo or San Michele Arcangelo in Arezzo.[4] Vasari tells the story that Spinello made his Lucifer so horrible that it gave him bad dreams, so that he soon died;[5] Gombosi, however, doubts a late date,[6] and Berenson[7] thinks the execution is from Spinello's studio.

Spinello's fresco of the same subject in San Francesco, Arezzo, contains a St Michael not very dissimilar to No. 1216.

PROVENANCE: From the Compagnia di Sant'Angelo or San Michele Arcangelo, Arezzo, as explained above; this Confraternity was suppressed in 1785,[8] and the three fragments were removed from the wall in 1855 on the instructions of Sir Austen Henry Layard, who had acquired them.[9] Exhibited in Manchester, 1857 (Provisional Catalogue, nos. 184 and 195; Definitive Catalogue, no. 39); and in South Kensington, 1869 (nos. 2–4). Presented by Sir Henry Layard, 1886.[10]

REFERENCES:

1. Size from the 1929 catalogue; No. 1216 has not been examined out of its frame with reference to the present entry.

2. Arezzo, 1921 catalogue, no. 8; photograph in the National Gallery archives. From the right-hand side, about half-way up.

3. Carlo Lasinio, *Affreschi Celebri del XIV e XV Secolo*, Florence, 1841, pl. XXXII (bound as pl. XXVII in the National Gallery copy); the engraving is actually dated 1821, after drawings by Paolo Lasinio. A copy by Ermini, also without the border, is reproduced by U. Pasqui and U. Viviani, *Guida illustrata di Arezzo e Dintorni*, 1925, fig. 110.
4. See note 8.
5. Vasari, *Vite* (ed. Milanesi, Florence, 1878), I, p. 692 (1550 edition, p. 208). According to the Arezzo catalogue of 1921, the district where the fresco was situated is still known as the *borgo dei diavoli*.
6. G. Gombosi, *Spinello Aretino*, Budapest, 1926, p. 91.

7. Berenson, 1932 *Lists*.
8. Numerous papers concerning this confraternity are in the Archivio di Stato in Florence (*Compagnie Soppresse*, indexed under San Michele Arcangelo). According to the index, it would appear most unlikely that any of these papers would throw any light on the date or origin of Spinello's fresco.
9. See *L'Arte*, 1912, p. 449, and the Layard MSS in the National Gallery. For an account of the fresco not long before its removal from the wall see Lord Lindsay, *Sketches of the History of Christian Art*, II, London, 1847, pp. 319–20.
10. For the history of the Layard Collection see Appendix II.

See also FLORENTINE School, No. 3120.

TUSCAN School

4741 *The Virgin and Child with Two Angels* *Plates 67 and 68*
(Wing of a diptych)

Inscribed on the background: $\overline{\text{MP}}$ $\overline{\theta\text{V}}$.

Reverse: a painted Cross with triangles and circles at the ends of the four arms. Also, in a nineteenth-century hand, *Giunta Pisano / Secolo XII.*

Wood. The main part of the picture is 30 × 21.5 ($11\frac{3}{4}$ × $8\frac{1}{2}$), rounded top. The size of the panel, which was entirely covered with gold or paint, is 36.5 × 26.5 ($14\frac{3}{8}$ × $10\frac{1}{2}$). Hinge marks on the right, about 5.4 cm. from the top and the bottom, are visible at the back (on the left when seen from the back).

Very good condition.

The motif of the Virgin and Child embracing, as on No. 4741, occurs frequently in Byzantine and early Italian painting.[1] The Cross on the reverse may be distantly derived from Crosses of two types, found on Byzantine ivories.[2]

 There is a picture in the Szépmüvészeti Múzeum, Budapest, representing *Christ on the Cross* (Fig. 21), of the same size as No. 4741, with similar compartments on the front, and with the same Cross painted on the reverse.[3] Garrison suggested that the two panels formed a diptych, with No. 4741 at the left, the Budapest picture (hinge marks on the left) at the right.[4]

 No. 4741 was traditionally ascribed to Giunta Pisano (active 1229–54), and was considered in the 1939 Supplement to the National Gallery catalogue to be in his tradition.[5] Sandberg Vavalà rather doubtfully associated No. 4741 with a picture in Pisa, the namepiece of the 'Master of San Martino'.[6] Offner (oral communication, 1947)

associated it with a picture in Santa Maria Maggiore in Florence, classed as by, or in the following of Coppo di Marcovaldo (active 1260–74).[7] Garrison called it Sienese under strong Pisan influence.[8] Coor-Achenbach called it circle of Guido da Siena and dated it *c*.1270.[9] It seems, at present at least, impossible to make satisfactory attributions for pictures such as No. 4741, or even to define for sure from what district of central Italy (Pisa, Florence, Siena, etc.) they come. Most recently see Kermer.[10]

Stolen in 1970.

PROVENANCE: Purchased *c*.1890[11] in Assisi by W. B. Chamberlin, by whom presented, 1934.

REFERENCES:

1. See C. H. Weigelt in *Art Studies*, VI, 1928, pp. 195 ff., and E. Sandberg Vavalà, *L'Iconografia della Madonna col Bambino nella Pittura Italiana del Dugento*, Siena, 1934, pp. 57 ff. (p. 60, no. 173 is No. 4741).

2. One type seems sometimes to record Constantine's Vision of the Cross; the other type, less like the Cross on No. 4741, seems to record the Cross of Constantine in the Forum in Byzantium. See Adolph Goldschmidt and Kurt Weitzmann, *Die Byzantinischen Elfenbeinskulpturen*, II, *Reliefs*, 1934, pp. 22–3 and pl. LXIII. E. B. Garrison, *Italian Romanesque Panel Painting*, Florence, 1949, p. 107, refers to the circles at the ends of the Cross as the heavenly *cibi*, or Foods of Grace; but this seems to be a mistake (letters from H. Buchthal in the National Gallery archives).

3. Budapest, catalogue by G. von Térey, I, *Byzantinische, Italienische, etc. Meister*, 1916, p. 7, no 18c, with reproduction; 1937 catalogue in Hungarian, p. 260, no. 31, with reproduction.

4. Garrison, op. cit., nos. 272, 273.

5. The catalogue entry in the 1939 Supplement, which contains many of the references given here, was written by P. Pouncey.

6. Sandberg Vavalà, op. cit., 1934, p. 60, no. 173. For the picture in Pisa, see G. Sinibaldi and G. Brunetti, *Mostra Giottesca*, Florence 1937, 1943, pp. 79 ff., with reproductions; Garrison, op. cit., no. 392, as Raniero di Ugolino.

7. Sinibaldi and Brunetti, op. cit., pp. 205 ff., with reproductions; Garrison, op. cit., no. 219.

8. Garrison, op. cit., no 273.

9. G. Coor, 'Ducento-Gemälde aus der Sammlung Ramboux', *Wallraf-Richartz Jahrbuch*, XVI, 1954, pp. 79 ff.

10. W. Kermer, *Studien zum Diptychon in der sakralen Malerei*, Düsseldorf, 1967, no. 16, p. 25 and Abb. 22. He calls it circle of Guido da Siena(?) and dates it to the 1280s. See also H. Belting, *Das Bild und sein Publikum im Mittelalter. Form und Funktion früher Bildtafeln der Passion*, Berlin, 1981, pp. 30 ff.

11. The documents in the National Gallery archives indicate that this is the probable date.

UGOLINO DI NERIO
active 1317–27, died 1339(?)

Sienese School. There is no doubt that Ugolino di Nerio is identical with the Ugolino of Siena who signed the high altarpiece of Santa Croce, Florence. All the pictures here catalogued as by Ugolino are fragments of that work; other fragments of it exist, and are referred to in the commentary following No. 6486; the panel bearing the signature still existed in the nineteenth century (see below), but is now missing. Ugolino is documented in Siena in 1325 and 1327.[1] Vasari[2] says that Ugolino died in Siena; in the first edition of his *Vite* he gives the date as 1339, in the second edition as 1349, but it is uncertain whether he had good authority for either date.

The Santa Croce altarpiece is Ugolino's only authenticated work, but other pictures have been attributed to him. The most important of these are perhaps the polyptychs in Williamstown[3] and Cleveland[4] (see below), which contain the design and iconography of the Santa Croce altarpiece in embryo. It is clear from the style of the Santa Croce

altarpiece that Ugolino was a close follower, probably a pupil, of Duccio, the compositions of some of the scenes being derived, with simplifications, from his *Maestà* (see DUCCIO, Nos. 1139, 1140, 1330 in the present catalogue). Vasari said of him 'tenne sempre in gran parte la maniera greca'.

REFERENCES:
1. P. Bacci, *Dipinti Inediti e Sconosciuti di Pietro Lorenzetti, Bernardo Daddi etc. in Siena e nel Contado*, Siena, 1939, pp. 123–51.
2. Vasari, *Vite* (ed. Milanesi, Florence, 1878), I, pp. 453–5.
3. J. Pope-Hennessy, *Heptaptych: Ugolino da Siena*, Stirling and Francine Clark Art Institute, Williams-town, Mass., 1962.
4. H. S. Francis, 'An altarpiece by Ugolino da Siena', *The Bulletin of the Cleveland Museum of Art*, 48, 1961, pp. 195–203. For other attributions to Ugolino see J. H. Stubblebine, *Duccio di Buoninsegna and His School*, Princeton, 1979, pp. 157–82.

1188 *The Betrayal of Christ*
(Predella panel from an altarpiece)

Plate 69

Centre, Judas kisses Christ; left, St Peter cuts off the ear of Malchus.

Wood. Painted surface 34.5×53 ($13\frac{1}{2} \times 21$). The size of the panel is 40.5×58.5 (16×23), including 1.25 cm. along the bottom, which has been added as restoration.

The panel is in very good condition except for a few scattered damages and scratches.

The frame, with the possible exception of the outer moulding all round (see No. 4191), is original. Much of the gilding on the frame is new. The back is roughly gessoed and painted. Towards the left edge (as seen from the back) is a vertical batten mark, exposing bare wood.

Cleaned in 1970.

The composition corresponds fairly closely with the panel of the same subject in Duccio's *Maestà*.

For the altarpiece from which this predella panel comes see pp. 108–16 below.

PROVENANCE: For the provenance until the Ottley sale of 1847, see the commentary following No. 6486 below. Warner Ottley sale, 30 June 1847 (lot 11), with four other predella panels, bought by Browne, i.e. bought in. Ottley sale, 24 June 1850 (lot 55), with all the rest of the predella, bought by Russell. Collection the Revd J. Fuller Russell, where seen by Waagen in 1851.[1] Exhibited in Manchester, 1857;[2] Provisional Catalogue, no. 12 with the rest of the predella; Definitive Catalogue, no. 25a. Exhibited at the RA, 1878 (no. 178).[3] Fuller Russell sale, 18 April 1885 (lot 117), purchased out of the Clarke Fund for the National Gallery.

REFERENCES:
1. G. F. Waagen, *Treasures of Art in Great Britain*, II, London, 1854, p. 462.
2. Label on the back.
3. Label on the back.

1189 *The Way to Calvary*
(Predella panel from an altarpiece)

Plate 70

Christ carrying the Cross is in the centre; the Maries are on the left.

Wood. Painted surface 34.5×53 ($13\frac{1}{2} \times 21$). The size of the panel is 40.5×58.5 (16×23).

Most of the paint is in very good condition, but there are a number of scattered damages and scratches.

The frame, with the probable exception of the outer moulding all round, is original. The bottom moulding is definitely a replacement. Much of the gilding on the frame is new. The back is roughly gessoed and painted. A vertical strip just off centre exposes bare wood where a batten has been removed.

Cleaned in 1971.

For the altarpiece from which this predella panel comes, see pp. 108–16 below.

PROVENANCE: For the provenance until the Ottley sale of 1847, see the commentary following No. 6486 below. Warner Ottley sale, 30 June 1847 (lot 11), with four other predella panels, bought by Browne, i.e. bought in. Ottley sale, 24 June 1850 (lot 55), with all the other predella panels, bought by Russell. Collection the Revd J. Fuller Russell, where seen by Waagen in 1851.[1] Exhibited in Manchester, 1857;[2] Provisional Catalogue, no. 12, with the rest of the predella; Definitive Catalogue, no. 25c. Exhibited at the RA, 1878 (no. 184).[3] Fuller Russell sale, 18 April 1885 (lot 119), purchased out of the Clarke Fund for the National Gallery. Exhibited in Birmingham, 'Italian Art', 1955 (no. 108).

REFERENCES:
1. G. F. Waagen, *Treasures of Art in Great Britain*, II, London, 1854, p. 462.
2. Label on the back.
3. Label on the back.

3375 *The Deposition* Plate 71
(Predella panel from an altarpiece)

The Maries, Sts John, Nicodemus and Joseph of Arimathaea are present. On the Cross is the inscription (I)C.XC, for Jesus Christ, instead of the usual I.N.R.I.

Wood. Painted surface 34.5×52.5 ($13\frac{1}{2} \times 20\frac{3}{4}$). The size of the panel is 40.5×58.5 (16×23).

The panel is in very good condition.

The frame, with the possible exception of the outer moulding all round (see No. 4191), is original. Much of the gilding on the frame is new.

The back was completely overpainted some time before 1857, which is the date of the earliest label.

Cleaned in 1970.

The composition corresponds fairly closely with the panel of the same subject in Duccio's *Maestà*.

For the altarpiece from which this predella panel comes, see pp. 108–16 below.

PROVENANCE: For the provenance until the Ottley sale of 1847, see the commentary following No. 6486 below. Warner Ottley sale, 30 June 1847 (lot 11), with four other predella panels, wrongly called *The Crucifixion*, bought by Browne, i.e. bought in. Ottley sale, 24 June 1850 (lot 55), with all the other predella panels, bought by Russell. Collection the Revd J. Fuller Russell, where seen by Waagen in 1851.[1] Exhibited in Manchester, 1857;[2] Provisional Catalogue, no. 12, with the rest of the predella; Definitive Catalogue, no. 25d. Exhibited at the RA, 1878 (no. 186).[3] Fuller Russell sale, 18 April 1885 (lot 120), bought by Wagner. Lent by Henry Wagner

to the New Gallery, 1893–4 (no. 26),[4] and to the Burlington Fine Arts Club, 1904 (no. 10); presented by Henry Wagner, 1918.

REFERENCES:
1. G. F. Waagen, *Treasures of Art in Great Britain*, II, London, 1854, p. 462.
2. Label on the back.
3. Label on the back.
4. Label on the back.

3376 *Isaiah* *Plate 74*
(Pinnacle from an altarpiece)

Inscribed across the background, the letters being much effaced: YSA / .AS. He holds a scroll, on which remain the letters (A)RI and NOMEN; these are the remains of an inscription from Isaiah vii, 14: *Ecce virgo concipiet, et pariet filium, et vocabitur nomen ejus Emmanuel.*

Wood. Painted surface 34 × 25 (13½ × 10), pointed top. The size of the panel is 46 × 32 (18 × 12½). The panel is *c.* 5 cm. thick. The bottom strip, 4.5 cm. wide, still partly covered with fabric, is a separate piece of wood; this appears to have formed part of the lower part of the panel. After the dismantling of the altarpiece, this strip was at some stage detached and an intervening section disposed of. The strip was then re-attached. X-radiographs show the same grain patterns on both pieces of wood, confirming that they were both once part of the same panel. Fragments of modern gesso remain at the bottom outer edge.

Exposed borders *c.* 3 cm. wide at the top and sides, still partly covered with fabric, remain where the outer frame has been removed. The outside top and side edges are roughly gessoed and painted red, except at two points just above the angles at the sides where the rectangular 'shoulders', found in Nos. 6484 and 6485, have been sawn off. The 'shoulders' on each side have holes where the vertical framing elements originally slotted in (see also Nos. 6484 and 6485). The slanting edges have symmetrically placed holes, presumably for slotting in finials, and the tip of the apex has faint traces of a hole which presumably served a similar function (see also Nos. 6484 and 6485).

The condition is poor: there is extensive damage at the top and bottom, although the prophet's face is mostly intact.

The back is plain and not gessoed.

Cleaned in 1970.

For the altarpiece from which this pinnacle comes see pp. 108–16 below.

PROVENANCE: For the provenance until the Ottley sale of 1847, see the commentary following No. 6486 below. Apparently Warner Ottley sale, 30 June 1847 (lot 8), wrongly as St John, bought by Anthony. Collection the Revd J. Fuller Russell, where seen (but not described) by Waagen in 1851.[1] Exhibited at the RA, 1878 (no. 190), size given as 15 × 10 in. Fuller Russell sale, 18 April 1885 (lot 113 or 114), bought by Butler. Charles Butler sale, 25 May 1911 (lot 85), bought by Smith for Henry Wagner.[2] Presented by Henry Wagner, 1918.

REFERENCES:

1. G. F. Waagen, *Treasures of Art in Great Britain*, II, London, 1854, p. 462. Some comment on the various errors of reference to this picture is made in the commentary to No. 6486 below.
2. A letter from Henry Wagner of 20 December 1911 (apropos of the gift of pictures Nos. 2862 and 2863 to the National Gallery) confirms this.

3377 *Sts Simon and Thaddeus (Jude)* Plate 77
(Fragment of an altarpiece)

The names are inscribed on the background; for the figure on the left only . . . ON is now legible, for the figure on the right S. THA.

Wood, top corners cut. The size of the compartments containing the large figures is 43 × 22.5 (17 × 8⅞) each, trefoil tops. The size of the strip along the bottom is 9 × 53 (3½ × 20⅞). The size of the panel is 66 × 57 (26 × 22½), top corners cut; the panel is apparently the original panel, and is in one piece as seen from the back. The total size of the front, including all the framing, is 70.5 × 62.5 (27¾ × 24½); the total of the front measured inside the frame is 61 × 53 (24 × 21).

There are extensive losses in both compartments, but what paint does remain is in good condition and both faces are intact. Some losses in the band of quatrefoils. All the outer moulding of the frame is new. The sill appears to be original, but is largely regilded.

The panel has a rounded trefoil in the centre, while all the equivalent surviving panels (e.g. No. 3473) have pointed trefoils.

Cleaned in 1971–2.

The reading of what remains of the letters for the saint on the left is difficult. In the first edition of this catalogue, it was given as C(O?), for St James; but . . . ON for St Simon is to be accepted as certain, since, as Coor-Achenbach points out,[1] the types of the Apostles in Ugolino's altarpiece correspond closely with those in Duccio's *Maestà*, where the names are clear.

For the altarpiece from which No. 3377 comes, see pp. 108–16 below.

PROVENANCE: For the provenance until the Ottley Sale of 1847, see the commentary following No. 6486 below. Warner Ottley sale, 30 June 1847 (lot 6, probably, which was bought by Anthony). Collection the Revd J. Fuller Russell, where seen by Waagen in 1851.[2] Exhibited in Manchester, 1857, not in the Provisional Catalogue; Definitive Catalogue, no. 27.[3] Exhibited at the RA, 1878 (no. 189). Fuller Russell sale, 18 April 1885 (lot 110), bought by Wagner. Lent by Henry Wagner to the New Gallery, 1893–4 (no. 76),[4] and to the Burlington Fine Arts Club, 1904 (no. 2); presented by Henry Wagner, 1919. Exhibited at the National Gallery, NACF Exhibition, 1945–6 (no. 27).

REFERENCES:

1. Gertrude Coor-Achenbach, 'Contributions to the Study of Ugolino di Nerio's Art', *Art Bulletin*, XXXVII, 1955, p. 158.
2. Waagen (*Treasures of Art in Great Britain*, II, London, 1854) gives no description, but it can be deduced with fair certainty that he saw No. 3377.
3. The label of the Manchester exhibition is still on the back of the picture.

4. Wrongly called Sts Mark and Thomas. The two Apostles on No. 3377 have usually been left anonymous; at the Burlington Fine Arts Club in 1904, one of the figures was called 'probably St James the Less'.

3378 *Two Angels* *Plate 73B*
(Fragment of an altarpiece)

Wood. The size of the painted spandrels is 27.2 × 53.2 (10½ × 21). It is *c.* 1 cm. thick and was originally glued and nailed onto a larger piece, *c.* 5 cm. thick, which has been drastically shortened and from which the outermost moulding is missing at top and sides and which now measures 28.5 × 57.2 (11¼ × 22½). At the top right-hand side of this main panel is a tapering dowel hole *c.* 10 cm. long; at the top left-hand side is the tip of a dowel hole *c.* 2 cm. long (see also No. 6486). Below the angels is an arch of bare wood *c.* 4 cm. wide, where the frame of the main panel has been removed. The remaining part of the main panel still has patches of original linen. The spandrel piece was detached from the main panel in 1970 and re-attached in 1984.

The condition of the angels and gold background is good.

Cleaned in 1970.

For the altarpiece from which this fragment comes, see pp. 108–16 below.

PROVENANCE: Possibly Warner Ottley sale, 30 June 1847, bought by Anthony.[1] Collection the Revd J. Fuller Russell, where seen by Waagen(?).[2] Exhibited at the RA, 1878 (no. 183). Fuller Russell sale, 18 April 1885 (lot 115), bought by Wagner. Lent by Henry Wagner to the Burlington Fine Arts Club, 1904 (no. 3); presented by Henry Wagner, 1919.

REFERENCES:
1. Cf. the commentary to No. 6486 below; all these lots passed into the Fuller Russell Collection.
2. G. F. Waagen, *Treasures of Art in Great Britain*, IV, London, 1857, p. 285. Waagen (p. 284) records No. 3378 and No. 4191 below as having been acquired by the Revd J. Fuller Russell after 1854; but No. 4191 appeared with all the other predella panels in the Ottley sale of 1850, and the lot is marked in the auctioneer's copy of the catalogue as being bought by Russell.

3473 *Sts Bartholomew and Andrew* *Plate 78*
(Fragment of an altarpiece)

The names are inscribed on the background: (Bar)THOLO/MEU and SAN/DREAS.

Wood, top corners cut. The size of the compartments containing the figures is 43 × 22.5 (17 × 8⅞) each, trefoil tops. The size of the panel is 55.5 × 56 (21⅞ × 22), top corners cut; the total size of the front, including all the framing, is 62 × 70 (24¼ × 27½).

The condition is good, except for scattered losses in the figure of St Bartholomew and two large losses in the gilding on either side of his head.

The inner moulding at the top edge and most of that on the slanting edges is original, as is that of the columns and the sill. All the rest of the outer frame is new. The ends of the sill were originally bevelled (like No. 3377) but have been squared off with an added piece. The gilding of the sill is largely new. The band of quatrefoils is a modern replacement.

The spandrels are stippled and a rosette punch runs down the dividing column.

Cleaned in 1971–2.

The two figures, especially St Bartholomew, are derived from the representations of the same saints on Duccio's *Maestà*.[1]

For the altarpiece from which No. 3473 comes, see pp. 108–16 below.

PROVENANCE: For the provenance until the Ottley sale of 1847, see the commentary following No. 6486 below. Warner Ottley sale, 30 June 1847 (lot 4), bought by Bromley Davenport. Seen in the Davenport Bromley Collection by Waagen;[2] sale, 12 June 1863 (lot 5), bought by Anthony. Collection of Lord Crawford, 1877.[3] Exhibited at the RA, 1878 (no. 182), lent by Lord Crawford; again at the Burlington Fine Arts Club, 1904 (no. 6); presented by the Earl of Crawford and Balcarres, through the NACF, 1919.

REFERENCES:
1. C. H. Weigelt, *Sienese Painting of the Trecento*, Florence, n.d., pls. 18 and 19.
2. G. F. Waagen, *Treasures of Art in Great Britain*, III, London, 1854, p. 374.
3. Label on the back: 'The Earl of Crawford, Dunecht House, Aberdeen, 22 December 1877.'

4191 *The Resurrection* *Plate 72*
(Predella panel from an altarpiece)

Wood. The size of the picture is 34.5 × 52 ($13\frac{1}{2}$ × $20\frac{1}{2}$). The size of the panel is 40.5 × 56.5 (16 × $22\frac{1}{4}$); this excludes a narrow strip added down the right-hand side, but includes an insertion in the right-hand bottom corner, size 15 × 5.5 (6 × $2\frac{1}{4}$), with a slanting top.

Badly cracked in some areas. A damage in Christ's neck and some deep scratches on His face.

The outermost moulding is certainly new, except for the base moulding where small damages have exposed fabric, indicating that this is original.

The back is gessoed and painted. There are no batten marks.

Cleaned in 1971.

For the altarpiece from which this predella panel comes, see pp. 108–16 below.

PROVENANCE: For the provenance until the Ottley sale of 1847, see the commentary following No. 6486 below. Warner Ottley sale, 30 June 1847 (lot 11), with four other predella panels, bought by Browne, i.e. bought in. Ottley sale, 24 June 1850 (lot 55), with all the other predella panels, bought by Russell. Collection the Revd J. Fuller Russell, where seen by Waagen.[1] Exhibited in Manchester, 1857;[2] Provisional Catalogue, no. 12, with the rest of the predella; Definitive Catalogue, no. 25f. Exhibited at the RA, 1878 (no. 188).[3] Fuller Russell sale, 18 April 1885 (lot 122), bought by White. C. Holden-White sale, 16 January 1925 (lot 105), bought by Martin. Presented by Viscount Rothermere, 1926.

REFERENCES:
1. G. F. Waagen, *Treasures of Art in Great Britain*, IV, London, 1857, p. 285. Cf. note 2 to No. 3378 above.
2. Label on the back.
3. Label on the back.

6484 *Moses* *Plate 75*
(Pinnacle from an altarpiece)

Inscribed across the background: MOYSES. He holds a scroll inscribed: VIDEBAM QUE RUBUS ARDEBAT / ET NŌ CŌMBUREBATUR (Exodus iii, 2).

Poplar. Total height 54.4 (21¼), width 31.4 (12¼); height from 'shoulder' to base 32.5 (12¾). The panel is *c.* 5 cm. thick. The pinnacle retains the original gable moulding at the top. The fabric of the main panel extends over this moulding under the gesso and the gilding. The vertical moulding at both sides has been removed, revealing borders of ungilded gesso and fabric, *c.* 3 cm. wide. Nail holes at each corner in the exposed borders show where the vertical framing element was attached on each side.

The outside edges have at some stage been gessoed over and painted red. However, X-radiographs reveal that, as in Nos. 3376 and 6485, there were once dowel holes in the 'shoulder' at each side and at the apex of the pinnacle for slotting in framing elements and finials. But those in the slanting edges are not symmetrically placed as in No. 3376. See also No. 6485 for the same features.

The back is ungessoed.

The condition is good except for a large loss just above the scroll, centre right, and scattered smaller losses elsewhere.

Cleaned in 1983–4.

For the altarpiece from which this pinnacle panel comes see pp. 108–16 below.

PROVENANCE: As No. 6485: seen by Waagen in the Ottley Collecton in 1837;[1] paired with 'Aaron' (*David*) in the Warner Ottley sale, 30 June 1847 (lot 7); bought by Edward, i.e. bought in; offered again, paired with 'Aaron' in the Ottley sale 1850 (lot 57); purchased by Herbert Cook from a dealer in Cheltenham in 1910;[2] lent by Cook to the Exhibition of Old Masters, Grafton Galleries, 1911, no. 1;[3] on loan to Manchester City Art Gallery, 1964–82;[4] purchased through Christie's by private treaty sale from the Trustees of the Doughty House Trust, 1983.

REFERENCES:
1. Waagen described seeing four gabled pinnacles, each with a half-length holy figure. See G. F. Waagen, *Kunstwerke und Künstler in England*, I, 1837, pp. 393–5.
2. Tancred Borenius (ed. H. Cook), *A Catalogue of the Paintings at Doughty House Richmond*, I, *Italian Schools*, London, 1913, pp. 3 ff.
3. Label on the back.
4. Label on the back.

6485 *David* *Plate 76*
(Pinnacle from an altarpiece)

Inscribed across the background, almost completely effaced: DA. He holds a scroll, on which remain the letters: DE … S … TUI … PON / M (This presumably read originally *De fructe ventris tui ponam super sedem tuam*, Psalm 131, 11.)

Poplar. Total height 55.3 (21¾), width 31.1 (12½), the height from the 'shoulder' to the base is 32.5 (12¾). The panel is *c.* 5 cm. thick. The pinnacle retains the original gable

moulding at the top. The fabric of the main panel extends over this moulding under the gesso and gilding. The vertical moulding at both sides has been removed, revealing borders of ungilded gesso and fabric, *c.* 3 cm. wide. Nail holes at each corner in the exposed borders show where the vertical framing element was attached on each side.

The outside edges have been at some stage gessoed over and painted red. However, X-radiographs reveal that, as in Nos. 3376 and 6484, there were once dowel holes in the 'shoulder' at each side and at the apex of the pinnacle for slotting in framing elements and finials. But those in the slanting edges are not symmetrically placed as in No. 3376 (see also No. 6484) and were perhaps never used.

The back is not gessoed.

There is an extensive loss in the lower half of the painting and also a large loss to the left of the prophet's head.

Cleaned in 1983–4.

For the altarpiece from which this pinnacle comes see pp. 108–16 below.

PROVENANCE: Seen by Waagen in the Ottley Collection in 1837;[1] probably identifiable with the 'Aaron' paired with *Moses* in the Warner Ottley sale, 30 June 1847 (lot 7); bought by Edward, i.e. bought in; offered again in the Ottley sale, 1850, again as 'Aaron' paired with *Moses* (lot 57); purchased by Herbert Cook from a dealer in Cheltenham in 1910;[2] lent by Cook to an Exhibition of Old Masters, Grafton Galleries, 1911, no. 4;[3] on loan to Manchester City Art Gallery, 1964–82; purchased through Christie's by private treaty sale from the Trustees of the Doughty House Trust, 1983.

REFERENCES:
1. Waagen described seeing four gabled pinnacles, each with a half-length holy figure. G. F. Waagen, *Kunstwerke und Künstler in England*, I, 1837, pp. 393–5.
2. Tancred Borenius (ed. H. Cook), *A Catalogue of the Paintings at Doughty House Richmond*, I, *Italian Schools*, London, 1913, pp. 3 ff.
3. Label on the back.

6486 *Two Angels* *Plate 73A*
(Fragment of an altarpiece)

Wood. The painted spandrel, which measures 53 × 25.5 (20¾ × 10) and which is *c.* 1 cm. thick, is still mounted on its original panel, 56.5 × 27 (22¼ × 10½) and *c.* 5 cm. thick. The panel has been cut at the bottom and lost its original outer mouldings at the sides and top. There is a dowel hole at the left edge of this main panel, but not at the right edge.

There are no traces of gesso on the back of the main panel. The original moulding of the arch below the spandrels still exists; most of the gilding is original. The original fabric which still covers the main panel stretches over the moulding, under the gesso and gilding. (See also No. 3378 for many of these features.)

The condition is generally good, except for large losses at the left edge, most of the right-hand angel's halo, mouth and chin.

For the commentary on the altarpiece from which this panel comes see below.

PROVENANCE: It may be presumed that No. 6486 has the same provenance as Nos. 6484 and 6485. The spandrel

angels were originally part of the main tier of the Santa Croce altarpiece, above the figure of St Louis which may or may not have been among the four main tier saints seen by Waagen in the Ottley Collection (see the discussion below) – the angels are not specifically itemised in the Ottley sales of either 1847 or 1850; purchased by Herbert Cook from a dealer in Cheltenham in 1910;[1] on loan to Manchester City Art Gallery, 1964–82; purchased through Christie's by private treaty sale from the Trustees of the Doughty House Trust, 1983.

REFERENCE:
1. Tancred Borenius (ed. H. Cook), *A Catalogue of the Paintings at Doughty House Richmond*, I, *Italian Schools*, London, 1913, pp. 3 ff.

HISTORY AND RECONSTRUCTION OF THE ALTARPIECE

The attribution of the above fragments to Ugolino di Nerio rests on their having been part of the altarpiece painted for the main Franciscan church in Florence, Santa Croce, which once bore Ugolino's signature. Vasari first surely recorded the existence of Ugolino's altarpiece in the first edition of his *Vite*, 1550.[1] In July 1566 the authorities of Santa Croce demanded, and were granted, leave to move the high altar forward into the church, to remove the altarpiece and to substitute a ciborium or a Crucifix; a ciborium on Vasari's designs, and executed by Dionigi Nigetti, was placed on the high altar on 7 April 1569.[2] Ugolino's altarpiece was lost sight of, until identified in the Upper Dormitory of Santa Croce at the end of the eighteenth century by Della Valle.[3]

Della Valle saw the altarpiece apparently intact, and left some description of it; he described it as echoing the architecture of the church and singled out for specific mention *St Paul*, with an angel (in the spandrel) at the tip of his sword, the predella showing the Passion of Christ including the *Last Supper*, the *Betrayal*, the Virgin in the fourth compartment (i.e. in the *Way to Calvary*), the fifth compartment with the *Deposition*, and the *Entombment*. In the centre of the main tier he described the *Virgin and Child* with the signature below: *Ugolinus de Senis me pinxit*.

On the basis of Della Valle's description and the descriptions of fragments in private collections in the nineteenth century, and of other surviving fragments (see below), several critics have attempted reconstructions of the altarpiece,[4] the most recent being that of Gardner von Teuffel.[5]

However, in 1978 Loyrette[6] published a drawing (Fig. 22),[7] made in the eighteenth century (*c*.1785–9) for Séroux d'Agincourt (1730–1814), which showed the appearance of the altarpiece, apparently after it had been taken down from the high altar and re-assembled. Technical evidence proves that this drawing precisely reflects the original construction (Fig. 23) of the altarpiece, with the probable exception of the frame (see below).

The drawing clearly shows that the altarpiece was a heptaptych with half-length figures. In the main tier was the *Virgin and Child* at the centre, fairly damaged. On the Virgin's right, reading from the centre outwards, were *St Paul*, *St John the Baptist* and a Franciscan saint (*Anthony*) – the latter in extremely poor condition. On the Virgin's left, reading from the centre outwards, were *St Peter*, *St Francis* (in poor condition) and *St Louis of Toulouse*. In the spandrels above each main tier figure were angels. Above the main tier figures were paired figures of saints and Apostles and in the gabled pinnacles above them single prophets. Above the main centre panel was a *Crucifixion* (reflecting the

dedication of the church). The predella panels, reading from left to right, were the *Last Supper*, *Betrayal*, *Flagellation*, *Way to Calvary*, *Deposition*, *Entombment*, and *Resurrection*. From a comparison with surviving pieces, particularly, for example, with the surviving spandrel angels where every single angel is in a different pose (see below), it seems that with one exception, the copyist was accurate. (For further comment on the drawing, see below.)

By the eighteenth century some parts of the altarpiece were already in bad condition, and at the beginning of the nineteenth century all(?) the parts considered worth preserving are stated to have been bought by an Englishman and imported into England.[8] In 1835 Waagen[9] visited the W. Young Ottley Collection and noted the following fragments: from the main tier, a fragment of the *Virgin and Child*, and 'five' of the side panels; from the upper tier, 'three' sets of coupled figures; of the pinnacles, four panels. Waagen also saw the signature *Ugolinus de Senis me pinxit* which, he noted, accorded with that recorded by Della Valle, and which was at that time attached to the picture now No. 1189 of the National Gallery. He also saw seven predella panels with scenes from the Life of Christ, from the *Last Supper* to the *Resurrection*.

The fragment of the *Virgin and Child* seems not to have been identified since being seen by Waagen. Waagen's account of the remaining fragments is often accepted as correct, but there was probably an error in his notes. The fragments catalogued for the Warner Ottley sale on 30 June 1847 were as follows:[10] all seven predella panels; from the main tier, *three* saints (Sts John Baptist, Peter and Paul); from the upper tier, *five* paired saints (two of which pairs were named as Philip and James, and Andrew and Bartholomew); and four other panels, which seem clearly to have been pinnacles, containing Moses, Aaron, St John and Daniel. It seems probable that Waagen recorded five items from the main tier and three from the upper tier, but should have written three from the main tier and five from the upper tier; then his account, except for the missing fragment of the *Virgin and Child*, would correspond with what was catalogued in the Ottley Collection in 1847 and with the fragments which survive today (see below).

The history of the altarpiece since the Ottley sale in 1847 is best arranged according to the individual items.

PREDELLA. All seven panels, the (1) *Last Supper*, (2) *Betrayal*, (3) *Flagellation*, (4) *Way to Calvary*, (5) *Deposition* (wrongly called the *Crucifixion* at the 1847 sale), (6) *Entombment* and (7) *Resurrection*, which were lots 10, 11 and 81 of the 1947 Ottley sale (bought in), reappeared as lot 55 of the Ottley sale on 24 June 1850, bought by (the Revd J. Fuller) Russell. As their subsequent history is not complex, it is sufficient here to state that (1) is in the Lehman Collection, Metropolitan Museum of Art, New York;[11] (2) is National Gallery, No. 1188; (3) is Gemäldegalerie, Berlin, no. 1635A;[12] (4) is National Gallery, No. 1189; (5) is National Gallery, No. 3375; (6) is Gemäldegalerie, Berlin, no. 1635B;[13] (7) is National Gallery, No. 4191.

MAIN TIER. The *Virgin and Child*, as already remarked, did not appear in the 1847 Ottley sale, nor in the sale of 1850; its present whereabouts is unknown. Coor-Achenbach first identified the spandrels from above it, showing angels, in the Los Angeles County

Museum.[14] The three saints (lot 1 of the 1847 sale, bought in) and lot 56 of the 1850 sale, apparently again bought in, are now in the Gemäldegalerie, Berlin.[15] These three panels have arched tops; in the spandrels above are angels. Two further fragments of angels alone, without the main figures, have survived; both are now in the National Gallery, Nos. 3378 and 6486. These made no individual appearance in the 1847 or 1850 sales, but it seems possible that No. 3378 was sold attached to the lower side of one of the sets of coupled saints forming the upper tier[16] (see also below).

UPPER TIER. The five pieces in the 1847 sale were as follows:

Lot 2, Two saints with books, in Gothic panel compartments, bought Anthony.

Lot 3, Philip and James, bought Anthony.

Lot 4, Andrew and Bartholomew, bought Bromley Davenport.

Lot 5, Two saints, bought Edward.

Lot 6, Two saints, bought Anthony.

Lot 2 is identifiable as Gemäldegalerie, Berlin, no. 1635C; lot 3 as Gemäldegalerie, Berlin, no. 1635D; lot 4 as National Gallery, No. 3473. Lots 5 and 6 are probably Berlin, no. 1635E, and National Gallery, No. 3377, the National Gallery picture being probably lot 6 rather than lot 5.[17]

PINNACLES. In the 1847 sale appeared:

Lot 7, Moses and Aaron, bought Edward.

Lot 8, St John ⎫
Lot 9, Daniel ⎬ bought Anthony.

These fetched even smaller prices than the pieces of the upper tier, and are clearly only the pinnacles. Lot 7 was bought in, and reappeared as lot 57 of the 1850 sale, again apparently bought in; it is clearly identical with *Moses* and *David* now in the National Gallery, Nos. 6484 and 6485. Lots 8 and 9, being bought by Anthony, presumably passed into the Fuller Russell Collection (cf. note 17). They are presumably identical with the pictures from the upper part of the altarpiece, obscurely described by Waagen in 1854:[18] 'the youthfully conceived St John alone, and the head of the (other) only seen.' All the Fuller Russell Ugolinos were in an exhibition at the RA in 1878; the two pictures described by Waagen must be no. 175, A Saint, small half figure, $18\frac{3}{4} \times 10\frac{1}{2}$ in.; no. 190, A Saint, small half figure, 15×10 in. These appeared in the Russell sale, 18 April 1885, lot 113, A Saint, and lot 114, A Saint, both bought by Butler. They reappeared in the Charles Butler sale, 25 May 1911: lot 84, Daniel, The Prophet, in a loose red robe over a green dress, holding in his left hand a scroll, on which is an inscription, $18\frac{1}{2} \times 10\frac{1}{4}$ in., bought Carfax; and lot 85, A Prophet, in red and green robes, holding a scroll, $13\frac{1}{2} \times 10$ in., bought Smith (for Wagner). The former is in the Johnson Collection in Philadelphia; the other is in the National Gallery (No. 3376). The only difficulty about these identifications is that Waagen seems to have recorded the Johnson *Daniel* (which has the name inscribed) as a St John. The 1847 sale catalogue records both Daniel and St John; it seems reasonable to suppose that the *Daniel* was then correctly identified, and that the figure then supposed to be St John is National Gallery, No. 3376 (who is in fact Isaiah). It seems therefore that once again Waagen made a muddle of his notes; on seeing

110

the two pictures, he was presumably told that one was St John, never took in the name of Daniel at all, applied the name of St John to the wrong picture and left the other unnamed.

Every part of Ugolino's altarpiece catalogued in the Ottley sale of 1847 can be identified with a subsequently recorded picture. The parts seen by Waagen in 1835 in the Ottley Collection, but not in the 1847 sale, are: the fragment of the central panel, representing the *Virgin and Child*; the signature, which was then attached to National Gallery, No. 1189, but which is now missing; and possibly, but not probably, the two single figures of saints from the main tier originally attached to No. 3378 and No. 6486, namely *St Francis* and *St Louis of Toulouse*.

An *Isaiah* not recorded to have been in Ottley's possession, but sometimes claimed to be part of the Santa Croce altarpiece, is in Dublin, no. 2012.[19] The identification is impossible, since *Isaiah* already appears in National Gallery, No. 3376.

Judging by the drawing, among the missing panels the *St Anthony*, *Crucifixion* and the top-left pinnacle (Ezekiel?)[20] were evidently already in the eighteenth century in an irreparable state. However, the head of *St Francis* in the main tier and the entire panel of *St Louis of Toulouse* were apparently in good condition[21] and the spandrel angels Nos. 3378 and 6486 appear to have been severed from the main panel just above the haloes, so the missing panels may still survive. Of the band of quatrefoils above the main tier, two are missing. Of the paired saints above the quatrefoils, only one pair is missing (Sts Clare and Thomas).[22] Of the pinnacles, the centre right (Jeremiah?)[23] was apparently still in reasonable condition in the eighteenth century.

In reconstructing the altarpiece, it has been found, as mentioned above, that technical evidence confirms the arrangement shown in the eighteenth-century drawing.[24]

Surviving as it does complete, with its sequence chronologically determined, the predella showing seven scenes from the Passion of Christ is the most unequivocal feature of any reconstruction. The seven scenes are all of equal measurements, *c.* 58.5 cm. wide. Gardner von Teuffel pointed out that this corresponds to one *braccio*.[25] When the replacement for the marble altarblock for the main altar of Santa Croce was ordered in 1566/7,[26] the width of the one in place was given as seven *braccia*: either the measurements of the altarblock suggested the division of Ugolino's polyptych into seven, or the block was made to match the altarpiece. There would, however, probably have been some overhang on either side, supported by the lateral buttresses proposed by Gardner von Teuffel. Already Coor-Achenbach noted the discrepancy in width between the Los Angeles spandrel angels (75 cm. wide) which went above the *Way to Calvary*, and inferred that decorative strips (*c.* 10 cm. wide) carrying the arms of the donor (see below) went on either side of the central predella panel.[27] In each other predella panel, the painted surface corresponds in width to the painted surface of the main tier. Therefore the predella panels were aligned under each respective main panel,[28] probably with the frames abutting. The frames of the predella panels in the National Gallery either are original or have been built up on the original mouldings. X-radiographs show that these mouldings were applied to a probably single horizontal panel which formed the predella. On the back the predella was roughly gessoed and painted, with battens positioned on

alternate panels, namely the *Entombment, Way to Calvary* and *Betrayal*, placed at intervals of *c.* 100 cm., and not continued in the main panels above. They were probably intended to anchor the predella within its containing frame. Both the *Last Supper* and *Resurrection* have an identical damage in the outer lower corner,[29] suggesting that this may have been occasioned by the removal of the supporting lateral buttresses, proposed by Gardner von Teuffel, and confirming that they were the terminal panels. The total width of the altarpiece would have been *c.* 428 cm.

Technical evidence proves that the arrangement of the rest of the altarpiece was exactly as shown in the drawing. First, with regard to the vertical arrangement, X-radiographs have been taken of all the surviving panels[30] and show that the four tiers (including the band of quatrefoils) were each painted on a continuous plank of wood.[31] In each case the individual grain pattern of the wood confirms the arrangement shown in the drawing. So the spandrel angels No. 6486 above the lost *St Louis of Toulouse* had above them *Mathias* paired with *Elizabeth of Hungary*, and above them was *Daniel*.[32] The spandrel angels No. 3378 above the lost *St Francis* had above them *Sts Simon and Thaddeus* (No. 3377) (Fig. 24) and a now lost prophet, perhaps Jeremiah (see above). *St Peter* had above him *Sts James Major and Philip*, and above them was *Moses* (No. 6484). St Paul had above him *Sts Bartholomew and Andrew* (No. 3473), and above them was *David* (No. 6485). Above *John the Baptist* were *Sts Matthew and James Minor*, and above them *Isaiah* (No. 3376).[33]

The lateral relationship of each vertical unit to the other has also been correctly shown in the drawing. Since the copyist was so accurate in copying the iconography, each lot of spandrel angels, as mentioned above, can be individually identified.[34] The pair of angels (No. 3378) which went above the lost *St Francis* is still mounted on the severed top section of the main panel: at the top right-hand corner is a tapering cylindrical dowel hole, and at the top left-hand corner traces of such a hole. The pair of angels (No. 6486) which went above the lost *St Louis of Toulouse*, shown in the drawing on the right of St Francis, is still attached to the severed top section of the main tier: at the top left-hand corner it has a hole to the left which exactly matches the hole at the right of No. 3378, confirming that these two panels were adjacent and locked together by tapering cylindrical dowels. No. 6486 has no hole to the right which indicates that it was indeed the outermost panel as shown in the drawing.[35] X-radiographs show that all the vertical units were locked together in this way. The dowel holes were not symmetrically or systematically placed and this confirms that matching dowel holes certainly mean that panels were adjacent. So, for example, the dowel holes of the panels showing *St John the Baptist* and *St Paul* only correspond if St John the Baptist is placed to the left of St Paul, as in the drawing, and not the other way round. The correspondence of dowel holes evident in the X-radiographs made of all surviving fragments confirms the accuracy of the arrangement shown in the drawing.

Iconographically it makes sense that St Paul should balance St Peter and that St John the Baptist, patron saint of Florence and precursor of Christ, should balance St Francis, post-cursor of Christ or *alter Christus*. St John the Baptist was also St Francis's patron saint.[36] And the two main Franciscan saints, Anthony and Louis of Toulouse, balanced each other.

Gardner von Teuffel pointed to several suspect elements of the frame as shown in the drawing, and proposed that the drawing had been made after at least the partial dismantling of the altarpiece.[37] It may be that the way in which the altarpiece was originally assembled meant that the vertical framing elements dividing the polyptych into seven were the first to be removed, and may no longer have existed when the drawing was made. The evidence comes from the exposed vertical borders of the *Moses* and *David* panels (Nos. 6484 and 6485). Both panels retain their original side edges:[38] the borders exposed by the removal of the side vertical frames show that the panels were covered with fabric and gesso right up to the very edges, and that the gilding extended quite a way (6 mm.) beyond the incised line marking the position of the outer frame. (In the diagonal top gable mouldings the fabric extends *over* the mouldings, as is usual in Tuscan Trecento frames, which were normally applied and gilded before the actual painting of the main surface began.) Nail holes at each corner of the exposed borders show where the vertical frames were attached on each side. At the 'shoulders' on each side were dowel holes where the pinnacles were slotted in. All the evidence suggests that in the case of the pinnacles the vertical elements of the frame were the *last* to be added. Applied to the whole altarpiece, it could suggest that the seven vertical units were fashioned separately, and then assembled, perhaps even *in situ*: they were locked together with horizontal dowels and then secured with vertical frames concealing the joins at the front.[39] This would have meant that the vertical dividing mouldings were fairly easy to remove in the dismantling of the altarpiece. This could also explain why the frame shown in the drawing is relatively plain.[40] The evidence of the pinnacle panels, Nos. 3376, 6484 and 6485 (see separate entries), suggests that the original frame had finials.

It was Davies who first noted that the altarpiece was probably commissioned by the Alamanni family.[41] They had the patronage of the main altar of Santa Croce until at least 1439, as is shown in an inventory of the chapels published by Hall.[42] And the altarpiece is supposed still to have borne their arms in 1575.[43] There seems to have been some dispute over the demarcation of patronage around the high altar between the Alamanni and Alberti families in the 1370s,[44] since the Alberti had the patronage of the transepts and the apse.

The precise date of the commission is not known. It seems likely that the Santa Croce altarpiece came after the now lost altarpiece painted by Ugolino for the high altar of Santa Maria Novella, which was probably commissioned in 1320, and certainly before 1324.[45]

REFERENCES:

1. Vasari, *Vite*, 1550 ed., p. 154; 1568 ed., p. 143; Milanesi's 1878 ed., I, p. 454. It is perhaps recorded earlier as a Giotto in the Anonimo Magliabechiano, ed. Frey, 1892, p. 52.

2. See F. Moisè, *Santa Croce di Firenze*, Florence, 1845, pp. 122–4, and Agostino Lapini, *Diario Fiorentino* (ed. G. O. Corazzini), 1900, p. 163. See also *Der Literarische Nachlass Giorgio Vasaris* (ed. K. and H. W. Frey), II, Munich, 1930, p. 549, and F. Moisè, op.

cit., pp. 173–4. A storm in 1512 caused damage near the high altar, but presumably not to Ugolino's altarpiece; see *Diario Fiorentino di Luca Landucci* (ed. Iodoco del Badia), 1883, p. 320, and G. Richa, *Notizie Istoriche delle Chiese Fiorentine*, I, Florence, 1761, p. 60 (date given as 1514).

3. Della Valle, *Lettere Senesi*, II, Rome, 1785, p. 202.

4. Fundamental to the study of Ugolino is the article by Coor-Achenbach, who has been proved remark-

ably accurate in her reconstruction of the Santa Croce altarpiece. See G. Coor-Achenbach, 'Contributions to the Study of Ugolino di Nerio's Art', *Art Bulletin*, XXXVII, 1955, pp. 153–65.

5. C. Gardner von Teuffel, 'The buttressed altarpiece: A forgotten aspect of Tuscan fourteenth century altarpiece design', *Jahrbuch der Berliner Museen*, 21, 1979, pp. 21–65. She summarises the surviving panels and their literature.

6. H. Loyrette, 'Une source pour la reconstruction du polyptyque d'Ugolino da Siena à Santa Croce', *Paragone*, 343, September 1978, pp. 15–23.

7. Rome, Vat. Lat., 9847, f. 92r.

8. Vasari, *Vite* (ed. Milanesi, Florence, 1878), I, p. 454. It may be that the English purchaser there mentioned was Young Ottley himself, who was living in Italy *c.*1791–9. If the date of sale is really after 1799, the purchaser could still have been Ottley, unless it were proved that he never returned to Italy. The friary was suppressed in 1810; cf. Moïse, op. cit. in note 2, pp. 410 ff. For all the Berlin panels see also the forthcoming catalogue by M. Boskovits (note 12 below). Dr Erich Schleier kindly allowed the present writer to see the galley proofs of the entries on the Santa Croce altarpiece.

9. G. F. Waagen, *Kunstwerke und Künstler in England*, I, 1837, pp. 393–5. The complicated provenance of the panels in the Ottley Collection and their subsequent history was worked out by Martin Davies.

10. Martin Asscher allowed Martin Davies access to the auctioneer's copies of the sale catalogues of 1847 and 1850, which he possessed; the Frick Library of New York also kindly sent a typescript of part of the sale catalogue of 1847.

11. See Keith Christiansen, 'Fourteenth-century Italian altarpieces', *The Metropolitan Museum of Art Bulletin*, XL, 1, 1982, pp. 20–2. See also J. Pope-Hennessy, *The Robert Lehman Collection. I. Italian Paintings*, The Metropolitan Museum of Art, New York, 1987, pp. 8–11.

12. M. Boskovits (ed. and trs. E. Schleier), *Gemäldegalerie Berlin. Katalog der Gemälde. Frühe Italienische Malerei*, Berlin, 1988, pp. 163–76.

13. Boskovits, loc. cit.

14. Coor-Achenbach, loc. cit., pp. 156 and 158 and fig. 7.

15. Boskovits, loc. cit.

16. In fact, there does not seem to be proof that No. 3378 was ever in the Ottley Collection, but it seems most unlikely that it was not. The fragment No. 6486, formerly in the Cook Collection, was bought in 1910 in Cheltenham, together with two pinnacles of *Moses*, No. 6484, and *David*, No. 6585. It may be that these three fragments had been sold from the Ottley Collection only shortly before, and that they are the same as the undescribed fragments of the upper tier, stated by Langton Douglas to have been owned *c.*1908 by Col. Warner Ottley (J. A. Crowe and G. B. Cavalcaselle (ed. Douglas), *A New History of Painting in Italy*, III, London, 1908, p. 24). It should be added that according to Martin Asscher's copy of the Ottley sale catalogue of 1847 there were two uncatalogued lots, lot 100 bought for 10 guineas by E. O(ttley) and lot 101 bought for 8 guineas by Hickman; but there is no indication at all of what pictures were included in these lots.

17. Anthony seems to have been acting as agent for the Revd J. Fuller Russell, whereas Edward was buying in for the Ottley family; and one set of paired saints in Berlin could (as far as is known) have remained in the Ottley Collection until the beginning of the present century, whereas National Gallery No. 3377 could not. The question of what Ugolinos did remain in the Ottley Collection is complicated by a list of pictures supplied to the National Gallery in 1899 by Col. Warner Ottley. The only Ugolinos in the list are: (a) Two Saints with Books in Gothic panel Compartments, (b) Philip and James (2), and (c) Two Saints (2). It is difficult to believe that pictures exactly corresponding with the above could have been in the Ottley Collection in 1899; it may be noted that Col. Ottley's descriptions tally with lots 2, 3 and 5 of the 1847 sale, but lots 2 and 3 seem to have passed from Fuller Russell (sold 1885) to Charles Butler (sold 1911).

18. G. F. Waagen, *Treasures of Art in Great Britain*, II, London, 1854, p. 462.

19. 1956 catalogue, no. 1112; reproduced by Coor-Achenbach, loc. cit., fig. 14.

20. In the Williamstown polyptych, which is attributed to Ugolino and is close in iconography to the Santa Croce polyptych, and which was also painted for a Franciscan house, *Ezekiel* balances *Daniel*, *Jeremiah* balances *Isaiah* (and *Moses* balances *David*). See J. H. Stubblebine, *Duccio di Buoninsegna and His School*, Princeton, 1979, fig. 450 and p. 166.

21. Both Loyrette (art. cit., p. 18, n. 2) and Gardner von Teuffel (art. cit., p. 48, n. 69 and figs. 24 and 25) cite three engravings, made by Baccanelli in 1647 and published by Catalano in 1652, showing Sts Anthony, Francis and Louis of Toulouse, which derived from the Santa Croce altarpiece, but with the figures reversed (with the exception of St Louis' crozier) – perhaps due to the process of engraving.

22. Presumably Sts Clare and Elizabeth of Hungary were introduced among the Apostles in lieu of Sts Peter and Paul, who were already shown in the main tier. St Thomas completes the twelve Apostles.

23. See note 20.

24. See Dillian Gordon and Anthony Reeve, 'Three Newly-Acquired Panels from the Altarpiece for Santa Croce by Ugolino di Nerio', *National Gallery Technical Bulletin*, 8, 1984, pp. 36–52. This article

forms the basis for the following discussion.

25. Gardner von Teuffel, art. cit., p. 56, n. 82. It is interesting that the altarpiece follows the Florentine and not the Sienese *braccio*. See J. White, *Duccio. Tuscan Art and the Medieval Workshop*, London, 1979, p. 49, for the difference.

26. M. B. Hall, *Renovation and Counter-Reformation: Vasari and Duke Cosimo in Sta. Maria Novella and Sta. Croce 1565–1577*, Oxford, 1979, p. 170.

27. Coor-Achenbach, art. cit., p. 156.

28. Gardner von Teuffel (art. cit., p. 65) noted the 'striking disjunction between the scene divisions and the upper panels' in the eighteenth-century drawing, where a gap is shown between each predella scene. It seems probable that the altarpiece had already been dismantled by the time the drawing came to be made. Probably each predella scene had been separated and although the copyist saw each one and accurately represented its appearance, he had to reconstruct its original position. This he could easily do by following the chronological sequence. See also below.

29. Also noted by Christiansen, art. cit., p. 21.

30. The present compiler is extremely indebted to the Gemäldegalerie in Berlin, and in particular to Dr Erich Schleier, for organising at her request the X-radiography of all the panels from the altarpiece in their possession and for placing them at her disposal. The compiler is also grateful to the Los Angeles County Museum and the Philadelphia Museum of Art, for supplying X-radiographs of their panels.

31. Although Gardner von Teuffel (art. cit., p. 65) states that No. 3473 consists of two pieces of wood, this is in fact not so: it is a single plank which has split vertically in two.

32. The only iconographical inaccuracy in the drawing appears to be the Daniel, which shows a bearded prophet without a cap, rather than a young prophet (following the usual iconography for Daniel), although the pose is the same. Loyrette rejects the Philadelphia *Daniel* (art. cit, p. 23). However, X-radiographs confirm that it belongs to this altarpiece.

33. The Berlin main tier panels were variously cut and then wrongly re-assembled. *St John the Baptist* and *St Paul* were separated from the tier above *with* the band of quatrefoils still attached to them, whereas in the cutting of the *St Peter* panel the band of quatrefoils was left attached to the Apostles above (*James Major and Philip*). Loyrette's photographic montage (art. cit., figs. 22 and 23) confuses the placing of these quatrefoil bands. It also omits two of the surviving pinnacles. Loyrette's arguments (art. cit., p. 19, n. 16) against the National Gallery *Isaiah* panel do not seem justifiable.

34. Loyrette (art. cit., p. 19, n. 17) inexplicably rejects No. 6486.

35. This panel also has no evidence of dowel holes at the right-hand side, as shown in X-radiographs.

36. See Eve Borsook, *The Mural Painters of Tuscany*, 2nd revised ed., Oxford, 1980, p. 29, n. 9.

37. Gardner von Teuffel, art. cit, p. 65. She particularly noted the drip-moulding at capital level. It is difficult to understand why Gardner von Teuffel should claim that the copyist mismanaged the proportions of the central panel to the lateral panels when these are in fact exactly right.

38. The sides of the *Isaiah* pinnacle No. 3376 have been scraped down to the bare wood.

39. Norman Muller, in a letter to the National Gallery, points out that the Berlin panels have unusual batten marks. It may be that the horizontal battens, applied to each panel separately, jutted out and locked into the adjacent panel's batten. It is possible that the altarpiece was painted in Siena and assembled in Florence, as, for example, with Sassetta's altarpiece painted in Siena and sent to San Sepolcro (Davies, op. cit. in note 41, p. 509, n. 15).

40. One puzzling feature of Della Valle's description is why he described the frame as 'ricca di ornati' (Della Valle, loc. cit.) if most of it had indeed been removed by that time.

41. Martin Davies, *National Gallery Catalogues, The Earlier Italian Schools*, London, 1951, p. 410. The present writer has not been able to find out anything about the Alamanni, except that they lived, as could be expected, near Santa Croce. In 1340 a *Franciscus quondam Cionis Alamanni popoli S. Lucia dei Magnoli* made his will in favour of his wife Margherita and son Nellus de Bardis (Florence, Biblioteca Nazionale, Poligrafo Gargani, Cod. 299, Cl. 37, Magliabech. f. 38–9).

The arms of the family are illustrated in a nineteenth-century (?) list of Florentine families buried in Florentine churches. Burial of members of the Alamanni family in Santa Croce is recorded 1354–1529 and the arms given as 'campo bianco' with 'liste azzure' (see Florence, Biblioteca Nazionale, Cod. 150, Cl. 26, Magliabech. f. 35ᵛ).

42. Hall, op. cit, p. 154.

43. See a letter written in 1575 in A. Lorenzoni (ed.), *Carteggio Artistico Inedito di D. Vinc. Borghini*, Florence, 1912, p. 102; cited by Davies, op. cit., p. 536, n. 2.

44. Moisè, op. cit., p. 125, n. 1.

45. See J. Cannon, 'Simone Martini, the Dominicans and the Early Sienese Polyptych', *Journal of the Warburg and Courtauld Institutes*, XLV, 1982, pp. 69–93, esp. pp. 87–91. See also under ANDREA DA FIRENZE, No. 5115.

The Santa Maria Novella altarpiece may well have included the Dublin *Isaiah* (see above) since this panel, which measures the same in width as *Isaiah* No. 3376, must have come from a comparably big

altarpiece. Cannon suggests a width of 428 cm. (op. cit., p. 90) on the evidence of the surviving altar frontal.

Cannon describes it as 'smaller and less impressive' than the Santa Croce altarpiece because of Vasari's minor account. However, Vasari clearly had a vested interest in focusing attention on the altarpiece his ciborium was replacing. The two altarpieces were probably identical in size.

UMBRIAN School (?)

4143 *A Saint*
(Fragment)

Plate 79

He seems to be turning over the pages of a book with his right hand.

Fresco transferred to canvas. 80×65 ($31\frac{1}{2} \times 25\frac{1}{2}$).

Much damaged.

For the commentary and PROVENANCE see No. 4145 below.

4144 *A Saint*
(Fragment)

Plate 80

Seated at a desk, a pen in his left hand, gazing upwards as if to receive inspiration.

Fresco transferred to canvas. 77.5×61.5 ($30\frac{1}{2} \times 24\frac{1}{2}$).

Much damaged.

For the commentary and PROVENANCE see No. 4145 below.

4145 *A Bishop Saint*
(Fragment)

Plate 81

Holding a book.

Fresco transferred to canvas. 78×65 ($30\frac{3}{4} \times 25\frac{1}{2}$).

Much damaged.

The three fragments, Nos. 4143–5, are each within a medallion, and perhaps formed part of the framing of some large composition. Some modern inscriptions scratched into No. 4145 (1488 / .D. VLISSES *de* . . ., etc.) suggest that No. 4145 was, when on the wall, within convenient reach.

A fourth fragment, obviously of the same series, is in the Museum of Historic Art in Princeton.[1] A fifth (*Christ?*) was in 1933 owned by Torquato Malagola, Rome.[2]

Nos. 4143–5 are stated to come from the Palazzo del Podestà, Piazza Vittorio Emmanuele (now Piazza del Comune), Assisi;[3] the fifth fragment is stated to come from the Palazzo del Capitano del Popolo, Assisi, which is a more correct name. The building is also known as the Palazzo del Comune, apparently. Several other frescoes from this building, including one of several riders, are now on deposit in the Pinacoteca in Assisi;[4] none of them seems connected with Nos. 4143–5.

Nos. 4143–5 were ascribed by Sir Charles Holmes[5] to the following of Pietro Cavallini (born 1250? – still living 1308); but they appear to be works of the middle or even late fourteenth century. The hand may be Umbrian.

PROVENANCE: Stated, as explained above, to be from the Palazzo del Capitano del Popolo, Assisi; removed from the wall in 1923. Purchased from G. Dudley Wallis, 1926.

REFERENCES:

1. Photograph in the National Gallery archives; size, 80 × 65; subject, a bearded saint, called St John.
2. Photograph and information in the National Gallery archives; size, 56 × 66.
3. Document in the National Gallery archives. It is possible that they had been uncovered not very long before being removed from the wall in 1923; Mariano Guardabassi, *Indice-Guida dei Monumenti Pagani e Cristiani . . . nella Provincia dell'Umbria*, 1872, p. 27, mentions only frescoed coats of arms in the Palazzo del Capitano del Popolo, Assisi.

4. They are the property of the Cassa di Risparmio di Perugia. For a list of the frescoes, see Emma Zocca, *Catalogo delle Cose d'Arte e di Antichità d'Italia*, Assisi, 1936, pp. 256–7; the one with riders is referred to by R. van Marle, *The Development of the Italian Schools of Painting*, V, The Hague, 1924, p. 436 (Italian edition, I, p. 419).
5. Sir Charles Holmes, 'Three early Italian frescoes', *Festschrift für Max J. Friedländer*, 1927, pp. 209 ff.; and National Gallery catalogue, 1929.

VENETIAN School

3543 *St Jerome in a Landscape* Plate 82

His book is inscribed: IRAM / VINCE / PATIĒ / CIA. AM̄ / SIĒCIAZ / SCRIPT / RARVM / CARNIS / VINSIA. / NŌ AMAB.

Cypress(?).[1] Painted surface 34.5 × 27 ($13\frac{1}{2}$ × $10\frac{1}{2}$); excluding an edging partly gilded of about 6 mm. all round except at the top, where the new gold presumably covers it.

Good condition except for a circular patch by the lion's head, and the new gold background.

The text is derived from a sentence by St Jerome, 'Iram vince patientia: AMA SCIENTIAM Scripturarum, et carnis vitia non amabis.'[2]

According to van Marle,[3] it is of the Veneto-Byzantine School, probably of the second quarter of the fourteenth century; according to Minns,[4] it is Venetian of the late fourteenth century. Pallucchini[5] calls it Veneto-Byzantine, end of the fourteenth century.

PROVENANCE: Given by Ruskin to William Ward; purchased from him by Alfred A. de Pass,[6] by whom exhibited at the Burlington Fine Arts Club, 1905 (no. 8),[7] and presented, 1920.[8]

REFERENCES:

1. Letter from B. J. Rendle, of the Forest Products Research Laboratory, in the National Gallery archives.
2. St Jerome's works in Migne, *Patrologia Latina*, vol. 22, col. 1078.
3. R. van Marle, *The Development of the Italian Schools of Painting*, IV, The Hague, 1924, p. 39.
4. N. P. Kondakov, *The Russian Ikon*, Oxford, 1927, p. 74, note by Minns.

5. R. Pallucchini, *La Pittura Veneziana del Trecento*, Venice and Rome, 1964, p. 216 and fig. 678.
6. Label on the back. William Ward (1829–1908), copyist of Turner, was closely associated with Ruskin; a volume of Ruskin's letters to him was published in 1922, but the compiler did not find any reference to No. 3543.
7. As Niccolò di Buonaccorso.
8. As Sienese School.

3893 *Pietà* — Plate 83

Christ is against the Cross and in the Tomb; two angels with censers. Inscribed: .I.N.R.I.

Poplar.[1] Original painted surface, 43.5 × 27.5 ($17\frac{1}{8}$ × $10\frac{3}{4}$), cusped top. The rest of the panel has been covered with new gold; its rounded top has been slightly shaved. Total size 52.5 × 30 ($20\frac{3}{4}$ × 12).

The original part of the picture is on the whole in good condition.

The subject is derived from the legend of 'Cristo di San Gregorio'; Christ is said to have appeared to St Gregory the Great at Mass in Rome, in Santa Croce in Gerusalemme or elsewhere. The original image in Santa Croce was engraved by Israel von Meckenem, and corresponds for the most part with the present picture.[2] For a discussion of the iconography of the Man of Sorrows see Belting.[3]

The attribution to the Venetian School is retained from the 1929 catalogue and 1961 revision. Ascribed by Berenson (oral communication, 1927) to Niccolò da Guardiagrele.[4] Pallucchini[5] calls it Veneto-Byzantine, second half of the fourteenth century, and relates it stylistically to the work of Jacobello di Bonomo.

PROVENANCE: Charles Butler sale, London, 25 May 1911 (lot 15),[6] bought by (Henry) Wagner, by whom presented, 1924.[7]

REFERENCES:

1. Letter from B. J. Rendle, of the Forest Products Research Laboratory, in the National Gallery archives.
2. Cf. E. Mâle, *L'Art Religieux de la Fin du Moyen Age en France*, 2nd ed., Paris, 1922, pp. 98 ff. Mâle reproduces the engraving (Bartsch, vol. 6, no. 135), which is inscribed: *Hec ymago contrefacta est ad instar et similitudinem illius prime ymaginis pietatis custodite in ecclesia sancte crucis in urbe romana quam fecerat depingi sanctissimus gregorius pontifex magnus propter habitam ac sibi ostensam desuper visionem*. For further references, see Campbell Dodgson, *Woodcuts of the XV Century in the British Museum*, I, 1934, no. 112, and E. Panofsky, 'Imago Pietatis', *Festschrift für Max J. Friedländer*, 1927, pp. 261 ff.
3. Hans Belting, *Das Bild und sein Publikum im Mittelalter. Form und Funktion früher Bildtafeln der Passion*, Berlin, 1981, *passim*.
4. His signed picture is reproduced by R. van Marle, *The Development of the Italian Schools of Painting*, IV, The Hague, 1924, p. 453.
5. R. Pallucchini, *La Pittura Veneziana del Trecento*, Venice and Rome, 1964, p. 216 and fig. 674.
6. As School of Cimabue.
7. As Venetian School.

Appendix I
The Lombardi–Baldi Collection

The Lombardi–Baldi pictures were acquired in 1857, and the following account was given by Charles Eastlake in the *Report of the Director of the National Gallery* for 1857–8 (printed in 1867):

NEGOTIATION respecting a Portion of the LOMBARDI–BALDI COLLECTION OF WORKS by early Italian Masters.

A collection of pictures, consisting of specimens of early Italian, and more particularly of Tuscan Masters, had been gradually formed in Florence, from the year 1838, chiefly by Signor Francesco Lombardi and Signor Ugo Baldi.

The first printed catalogue was dated 1844. From time to time, after that date, the collection received important additions, and, in some instances, inferior works were exchanged for better examples of the masters.

A second enlarged catalogue was printed in 1845; after which time the descriptions of additional pictures were furnished in a printed supplement and in manuscript.

The number of specimens finally amounted to about 100; but as many were of small dimensions, or of inferior interest, the importance of the series was at no time commensurate with its extent. The most valuable works contained in it, forming about a fourth part of the entire Gallery, conferred on it, however, a merited reputation.

The existence and character of the Lombardi–Baldi Collection were known to the Trustees of the National Gallery as early as 1847.

It does not appear that any person connected with the National Gallery had an opportunity of seeing and reporting on the collection till I inspected it in 1855. But during the Session of 1853, Lord John Russell being then the organ of the Government in the House of Commons, a correspondence on the subject took place between the Treasury (through the Foreign Office), the Hon. P. Campbell Scarlett, then acting for Her Majesty's Minister at Florence, and the Trustees of the National Gallery.

In a letter, dated Florence, 20th March 1853, addressed by Mr D. Lewis Franklin to Lord John Russell, and which was referred to the Trustees (Minutes, 2nd May 1853), the collection was estimated at 15,000*l*., including the expense of its transfer to England. On inquiry, it appeared, from a letter from the Hon. P. Campbell Scarlett, dated Florence, 19th May 1853, that the price demanded for the collection by the proprietors was 12,000*l*., and that probably the offer of a lower sum would not be refused.

On the 18th July 1853 (minutes of that date), Mr Spence, an English artist residing chiefly in Florence, being for a time in London, attended at a meeting of the Trustees by their request, and furnished information respecting the pictures referred to, at the same time expressing his opinion of their importance.

On the 1st of August following (Minutes of that date), the Trustees, aware that the proprietors refused to separate the collection, came to the conclusion that, with the information before them, it was not expedient to proceed with the question.

The above particulars represent the extent of the inquiries that were made respecting the Lombardi–Baldi Gallery previously to 1855.

Without reference to that collection, attention was particularly directed, in 1853, to the expediency of forming, by means of a chronological series of works by early masters, an historical foundation for a complete gallery of pictures. That view was taken by the Select Committee on the National Gallery in 1853, and a passage in the Report itself of that Committee, in which such opinion is expressed, thus concludes: 'Your Committee think that the funds appropriated to the enlargement of the collection should be expended with a view not merely of exhibiting to the public beautiful works of art, but of instructing the public in the history of that art, and of the age in which, and the men by whom, those works were produced.' (Report, &c., 1853, p. xvi.)

This opinion was embodied, leaving a due latitude to the Trustees and Director, in the Treasury Minute, dated 27 March 1855, re-constituting the establishment of the National Gallery.

The same opinion had been before expressed, in a debate on the National Gallery on the 8th of March 1853, by Lord John Russell, at that time the organ of the Government in the House of Commons, as follows: 'There is one object which I have more than once stated in this House as worth striving for, an object which ought not to be attended with much difficulty; I mean the obtaining of a collection of works by the early Italian masters, many of which are indeed very beautiful in themselves, but which have a further value as showing the progress which led afterwards to the beautiful creations of Raphael and Da Vinci.' (Hansard's Parl. Debates, vol. CXXIV, p. 1314.)

Meanwhile the proprietors of the collection in Florence before referred to, while they declined to dispose of separate specimens, continued to ask so high a price for the entire gallery as to prevent the most willing bidders from coming to terms with them.

In the autumn of 1855, when I first saw the Lombardi–Baldi pictures, I found the proprietors still unwilling to separate the collection. It appeared, therefore, that the only mode of obtaining possession of the best specimens would be to buy the whole gallery, and afterwards to sell the less important part of it.

In 1856 an Act of Parliament was passed 'to extend the powers of the Trustees and Director of the National Gallery, and to authorise the sale of Works of Art belonging to the Public.'

This seemed to remove the chief impediment to the acquisition of the Florentine Gallery in question. About the same time I received several letters from Members of the House of Commons of 1856, recommending the purchase. Further experience was, however, considered desirable, and the unsuccessful result of a sale of part of the Krüger pictures in February 1857 showed the difficulty of so disposing of works 'unfit for or not required as part of the National Collection.'

Under these circumstances, being duly authorised, I made another attempt in the autumn of 1857 to induce the proprietors to dispose of a portion of their gallery, and finally succeeded.

The number of works selected is strictly 22; but one of those works, originally a vast altarpiece by Orcagna, now consists of the chief portion in three compartments, and nine

pictures in separate frames. The number of distinct pictures is therefore 31. Other altarpieces include many pictures, large and small, in one frame-work; the entire number, reckoning these as separate works, amounts to more than 60. The price paid for this portion of the collection was 7,000*l.*, with banker's commission, 7,035*l.*

In the selection thus made, considerable difficulty was experienced, on the one hand, in confining such selection to the specimens which I considered the most eligible, and, on the other, in meeting the expectations of the proprietors by a proposal which, by including a sufficient number of works at a sufficient price, should reconcile them to the separation of their gallery. All the justly celebrated and all the most historically valuable pictures in the collection were comprehended; and notwithstanding the difficulty adverted to of stopping at that point, scarcely any others were admitted. The unsightly specimens of Margaritone and the earliest Tuscan painters were selected solely for their historical importance, and as showing the rude beginnings from which, through nearly two centuries and a half, Italian art slowly advanced to the period of Raphael and his contemporaries. In some few cases different names are, on good grounds, substituted for those given by the late proprietors.

Appendix II
The Layard Collection

Most of the pictures in the Layard Collection were acquired by Sir Austen Henry Layard (1817–1894) in Italy, and had already been brought by him to London by 1869. Layard was appointed in that year our Minister in Madrid. He thereupon lent most of his pictures and a few objects of art to the South Kensington Museum; after a short time, most or all of the collection was transferred to Dublin, where it remained for some years. In October 1874, Layard bought Palazzo Cappello in Venice. He continued to be our Minister in Madrid until 1877, and then was stationed until 1880 in Constantinople; but many of the pictures were sent to Venice in 1875 and 1876, most of them from Dublin, a few from Madrid. A few were kept in London.

Layard died in 1894. He had already in 1886 presented to the National Gallery three fragments of a fresco by Spinello Aretino (Nos. 1216, 1216A and 1216B). In his will, he bequeathed to the National Gallery his pictures other than portraits, with a life-interest to Lady Layard. In 1900, she handed over to the National Gallery (from the part of the collection in London) a fresco now ascribed to Montagna (No. 1696). She died in 1912. A selection of pictures from the London house was accepted by the Trustees in 1913. The pictures from Venice were not incorporated in the National Gallery until 1916, partly because of export difficulties from Italy, partly because of a dispute concerning the meaning of the word 'portraits' in Layard's will.

The Layard pictures belonging to the Nation are now divided between the National and Tate Galleries. The inventory numbers of all the pictures are: 1216, 1216A and B; 1696; 2946–2956 inclusive; 3066–3132 inclusive.

A bust of Layard, made by J. W. Wood in 1881, was presented to the National Gallery in 1943 by Vice-Admiral Arthur John Layard Murray; inventory number, 5449.

REFERENCES:
Layard MSS in the National Gallery; British Museum, Department of MSS, Add. MS 38966, letters from Layard to Morelli (e.g. 21 May 1874; 8 October 1874; 16 March 1875; 3 June 1876); A. Venturi in *L'Arte*, 1912, pp. 449 ff. Among general accounts of the collection may be cited G. Frizzoni in the *Gazette des Beaux-Arts*, 1896, II, pp. 455 ff., and G. Lafenestre and E. Richtenberger, *Venise*, pp. 303 ff.

List of Paintings acquired since the 1961 Revision of the Catalogue

Follower of DUCCIO	6386
MASTER of the BLESSED CLARE	6503
Attributed to the MASTER of ST FRANCIS	6361
UGOLINO di Nerio	6484
UGOLINO di Nerio	6485
UGOLINO di Nerio	6486

List of Attributions changed from the 1961 Revision of the Catalogue

Old attribution	Inventory number	New attribution
Ascribed to BARTOLO di Fredi	3896	GIOVANNI di Nicola
Follower of DUCCIO	565	MASTER of the CASOLE FRESCO
FLORENTINE School	5930	ALLEGRETTO Nuzi
Ascribed to Agnolo GADDI	568	Attributed to Agnolo GADDI
Ascribed to LORENZO Veneziano	3897	Attributed to LORENZO Veneziano
Style of ORCAGNA	569–78 1468	Ascribed to JACOPO di Cione and Workshop
Style of ORCAGNA	3894	MASTER of the LEHMAN CRUCIFIXION
SIENESE School	4491 4492	MASTER of the PALAZZO VENEZIA MADONNA
VENETIAN School	4250	DALMATIAN School

Iconographic Index

The figures of the Trinity are not indexed; nor is the Virgin Mary, except for Scenes of her Life (Section 3) and the *Maestà*.

4. SAINTS OF THE NEW TESTAMENT PERIOD AND LATER

The figures are noted as beatified or canonised; this may not in every case be recognised by the Church.

Some saints of the New Testament period appear normally in certain scenes; in many such cases the scenes are indexed in the previous section, but the individual saints are not indexed below.

Giovanni da Milano 1108

Giusto de' Menabuoi 701

Ascribed to Jacopo di Cione and 569
Workshop

Ascribed to Jacopo di Cione and 1468
Workshop

Attributed to Lorenzo 3897
Veneziano

Master of the Blessed Clare 6503

Nardo di Cione 581

Ascribed to Niccolò di Pietro 579
Gerini

St John the Evangelist

Ascribed to Andrea di Bonaiuto 5115
da Firenze

Duccio 1330

Ascribed to Jacopo di Cione and 569
Workshop

Margarito of Arezzo 564

Master of the Blessed Clare 6503

(?) Nardo di Cione 581

Ascribed to Niccolò di Pietro 579
Gerini

Style of Segna di Bonaventura 567

St John also appears in scenes
of the Passion, such as the
CRUCIFIXION (Section 3). *See also*
APOSTLES and EVANGELISTS

St John Gualberto

(?) Ascribed to Jacopo di Cione 569
and Workshop

St Joseph

Giusto de' Menabuoi 701

Also appears in scenes of the
NATIVITY etc. and of the Life of
the Virgin (Section 3)

St Joseph of Arimathaea

Appears in some Passion scenes,
especially the DEPOSITION (Section 3)

St Jude

See ST THADDEUS

St Julian

(?) Ascribed to Jacopo di Cione 569
and Workshop

Kings (or Magi)

Sts Balthasar, Caspar and Melchior

Ascribed to Jacopo di Cione and 569
Workshop

See also ADORATION OF THE KINGS
under NATIVITY in Section 3

St Lawrence

Style of Giovanni da Milano 1108

(?) Giusto de' Menabuoi 701

Ascribed to Jacopo di Cione and 569
Workshop

St Longinus

Identified with the soldier who pierced
Christ's side on the Cross.
See CRUCIFIXION in Section 3

St Lucy

Style of Giovanni da Milano 1108

(?) Ascribed to Jacopo di Cione 569
and Workshop

St Luke

Ascribed to Andrea di Bonaiuto 5115
da Firenze

Style of Giovanni da Milano 1108

(?) Ascribed to Jacopo di Cione 569
and Workshop

See also EVANGELISTS

Magi

Sts Balthasar, Caspar and Melchior

See under KINGS; *also* ADORATION OF
THE KINGS under NATIVITY in
Section 3

St Marcellus

(?) Ascribed to Pietro Lorenzetti 1113

St Margaret

Giusto de' Menabuoi 701

Margarito of Arezzo 564

Maries (or holy women)

Often present at scenes of the Passion,
such as the CRUCIFIXION. In Section
3 there is an index reference for
MARIES AT THE SEPULCHRE.

St Mark

Ascribed to Andrea di Bonaiuto 5115
da Firenze

5. SCENES FROM THE LIVES OF THE SAINTS

Index of Provenance by Patrons and Collectors

Index of Provenance by Location

Index by Year of Acquisition

Index by Inventory Number

PLATES

PLATE I

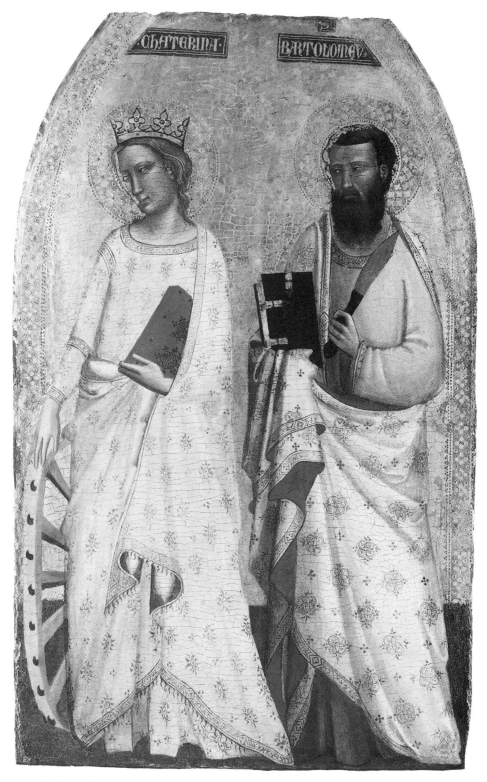

Ascribed to Allegretto Nuzi, *Sts Catherine and Bartholomew* (No. 5930)

PLATE 2

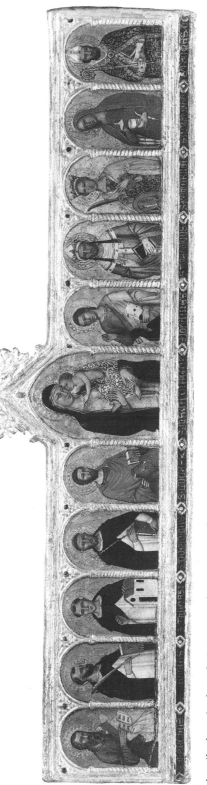

Ascribed to Andrea di Bonaiuto da Firenze, *The Virgin and Child with Ten Saints* (No. 5115)

PLATE 3

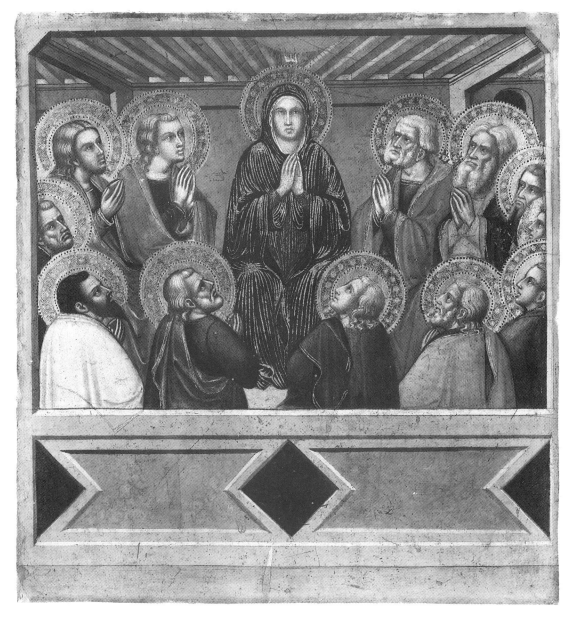

Barnaba da Modena, *Pentecost* (No. 1437)

PLATE 4

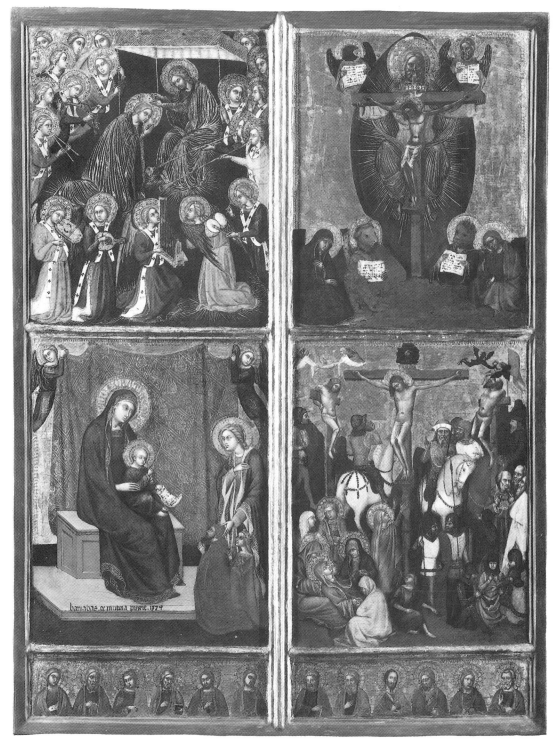

Barnaba da Modena, *The Coronation of the Virgin; The Trinity; The Virgin and Child; The Crucifixion* (No. 2927)

PLATE 5

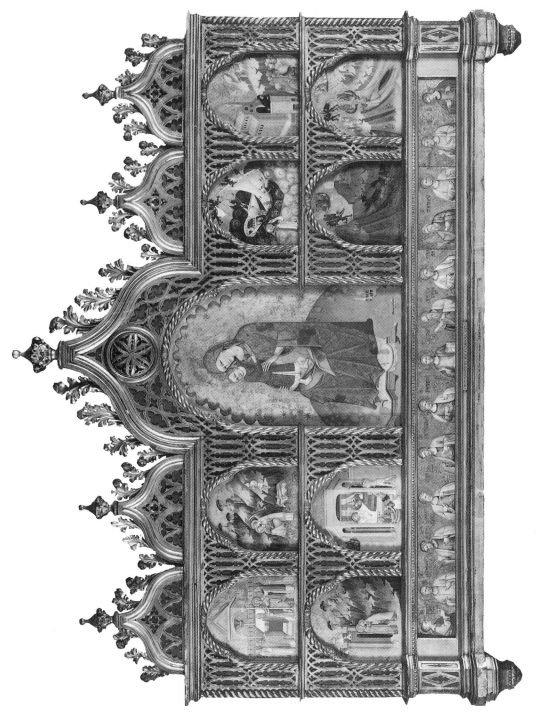

Dalmatian School, *Altarpiece of the Virgin Mary* (No. 4250)

PLATE 6

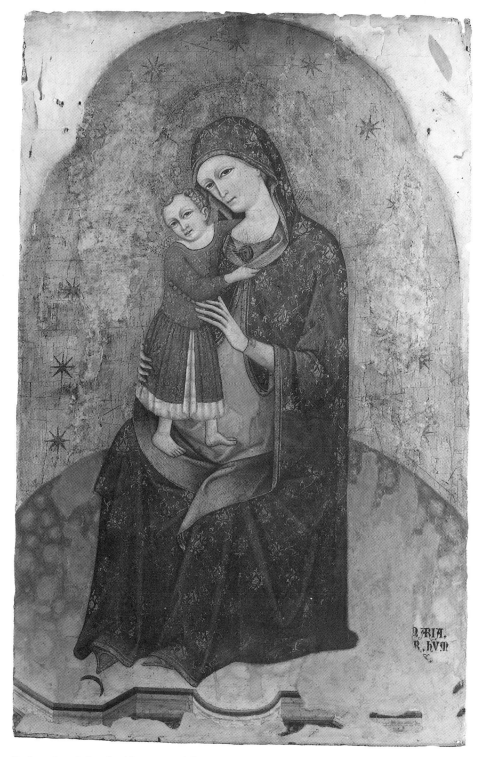

Dalmatian School, *Altarpiece of the Virgin Mary* (No. 4250). Centre panel:
The Virgin and Child.

PLATE 7

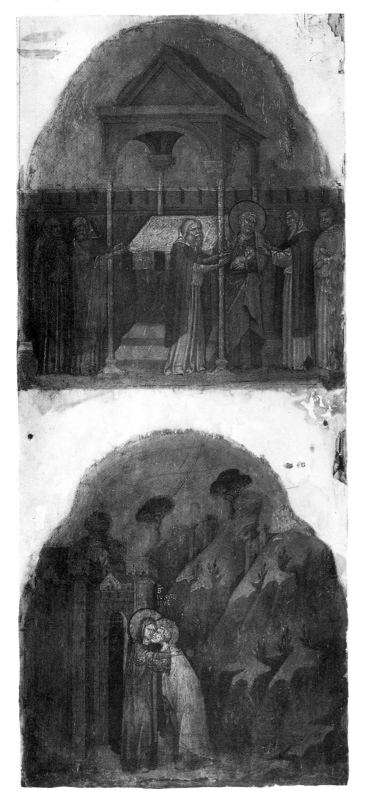

Dalmatian School,
Altarpiece of the Virgin Mary
(No. 4250). Outer left panel:
top, *St Joachim's Offering
Rejected*;
bottom, *The Meeting at the
Golden Gate*.

PLATE 8

Dalmatian School,
Altarpiece of the Virgin Mary
(No. 4250). Inner left panel:
top, *The Angel appearing to
St Joachim*;
bottom, *The Birth of the
Virgin*.

PLATE 9

Dalmatian School,
Altarpiece of the Virgin Mary
(No. 4250). Inner right
panel:
top, *Helsinus Saved from
Shipwreck*
bottom, *A French Canon
Drowned by Devils.*

PLATE 10

Dalmatian School,
Altarpiece of the Virgin Mary
(No. 4250). Outer right
panel:
top, *Helsinus preaching in
favour of the Celebration of the
Conception*;
bottom, *The Canon Restored
to Life by the Virgin*.

PLATE II

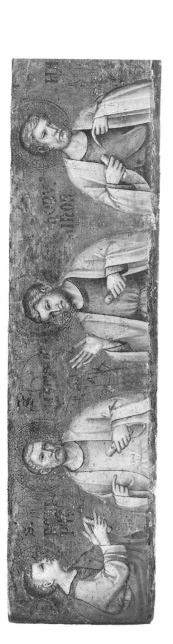

Dalmatian School, *Altarpiece of the Virgin Mary* (No. 4250). Predella panels: *Christ and the Twelve Apostles.*

PLATE 12

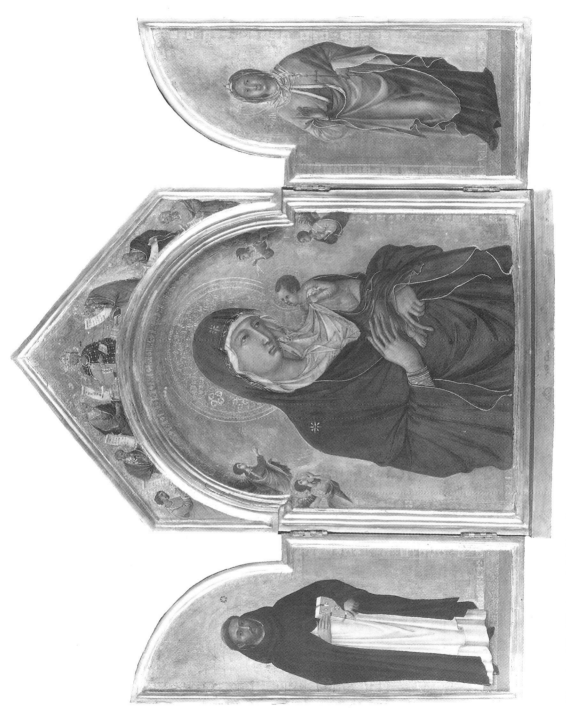

Duccio, *The Virgin and Child with Saints* (No. 566)

PLATE 13

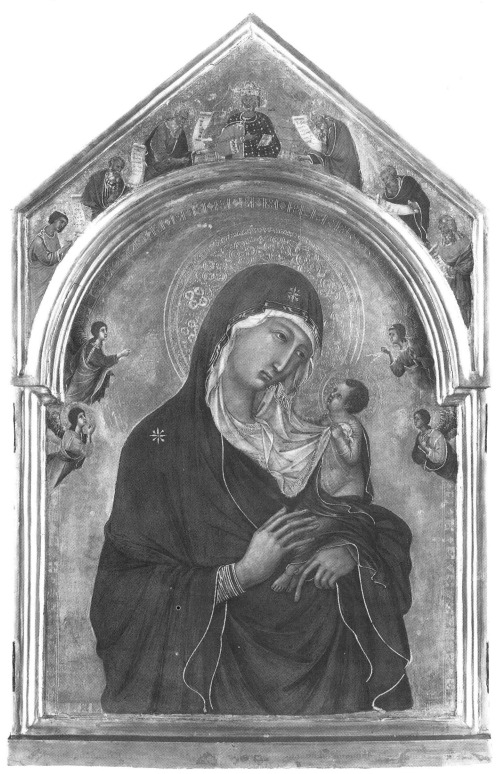

Duccio, *The Virgin and Child with Saints* (No. 566). Centre panel: *The Virgin and Child.*

Duccio, No. 566. Closed.

PLATE 15

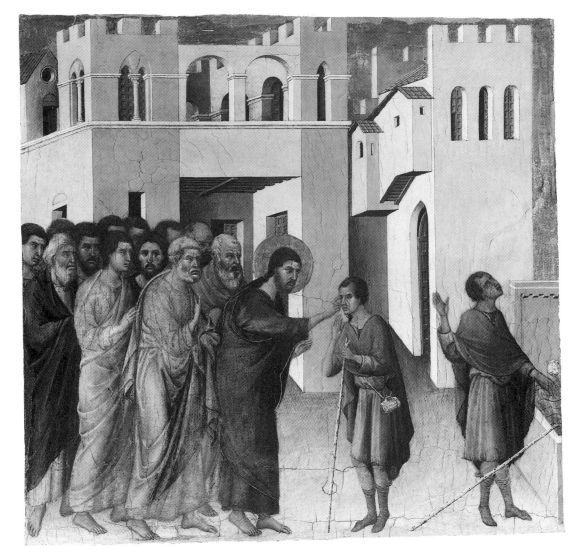

Duccio, *Jesus opens the Eyes of a Man born Blind* (No. 1140)

PLATE 16

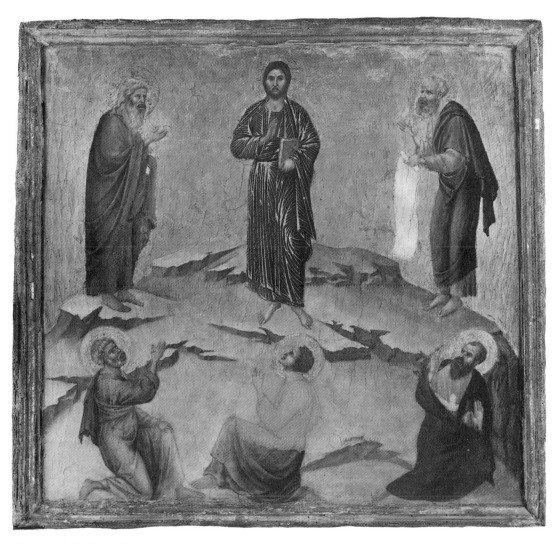

Duccio, *The Transfiguration* (No. 1330)

PLATE 17

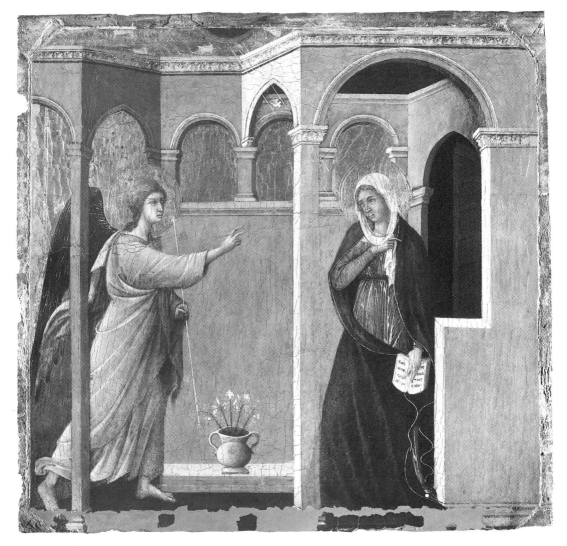

Duccio, *The Annunciation* (No. 1139)

PLATE 18

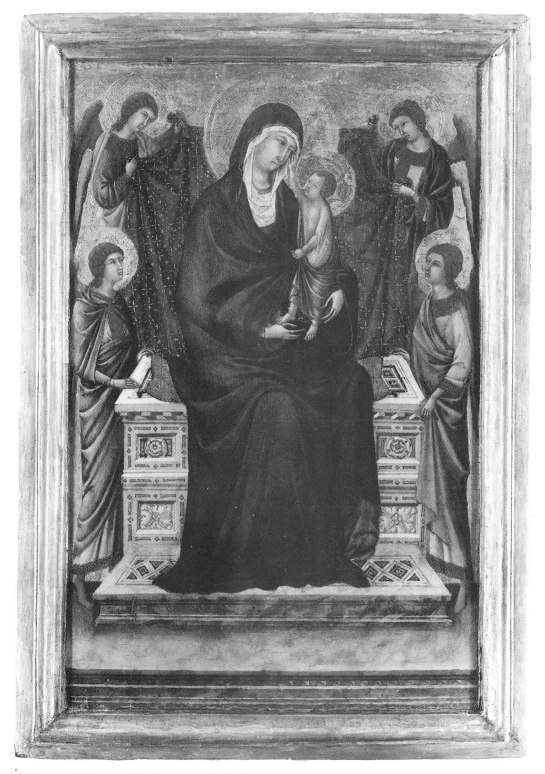

Follower of Duccio, *The Virgin and Child with Four Angels* (No. 6386)

PLATE 19

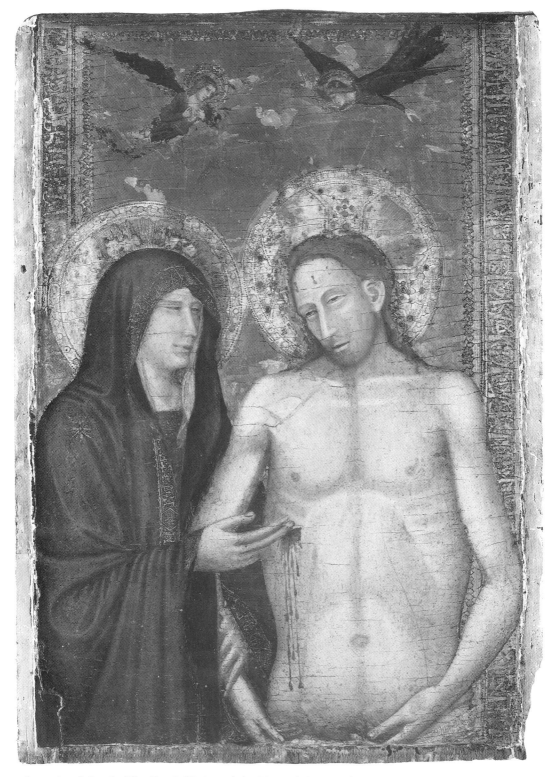

Florentine School, *The Dead Christ and the Virgin* (No. 3895)

PLATE 20

Florentine School, No. 3895. Reverse.

PLATE 21

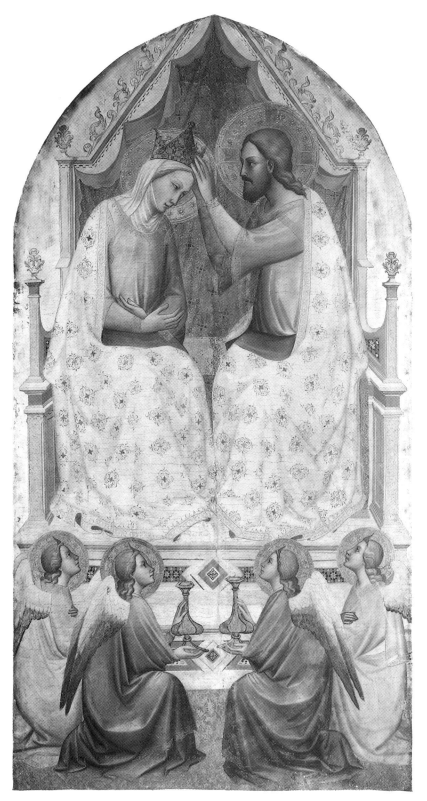

Attributed to
Agnolo Gaddi,
*The Coronation of
the Virgin*
(No. 568)

PLATE 22

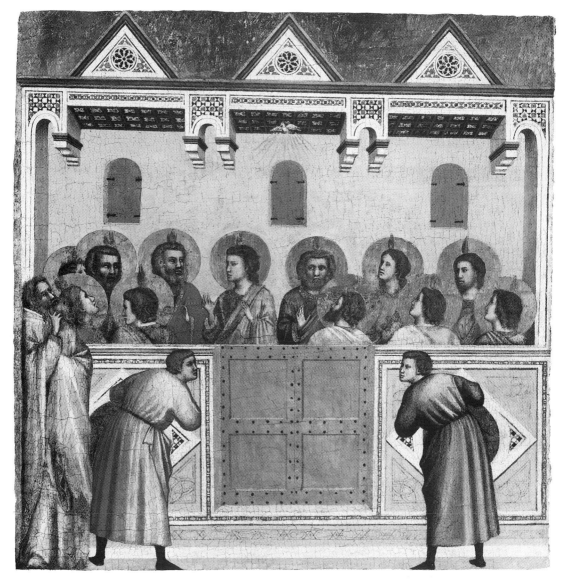

Ascribed to Giotto, *Pentecost* (No. 5360)

PLATE 23

Giovanni da Milano,
The Virgin
(No. 579A)

PLATE 24

Giovanni da Milano,
St John the Baptist
(No. 579A)

PLATE 25

Giovanni da Milano,
Christ of the Apocalypse
(No. 579A)

PLATE 26

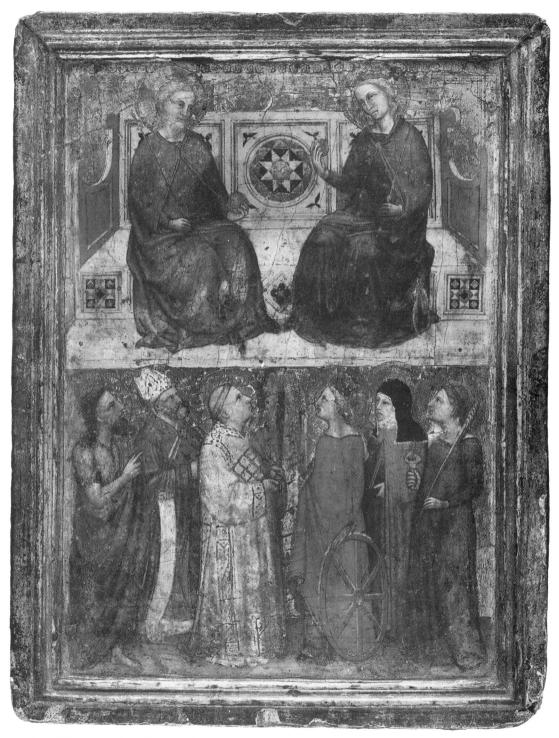

Style of Giovanni da Milano, *Christ and the Virgin with Saints* (No. 1108)

PLATE 27

Giusto de' Menabuoi, *The Coronation of the Virgin and Other Scenes* (No. 701)

PLATE 28

Giusto de' Menabuoi, *Scenes from the Lives of Joachim, Anna and the Virgin* (No. 701).
Closed.

PLATE 29

Giovanni di Nicola, *St Anthony Abbot* (No. 3896)

PLATE 30

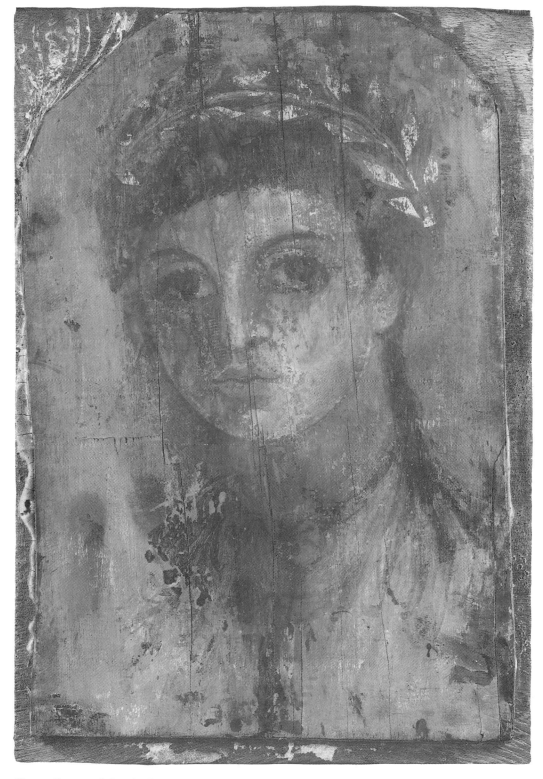

Greco-Roman School, *A Young Woman with a Wreath* (No. 5399)

PLATE 31

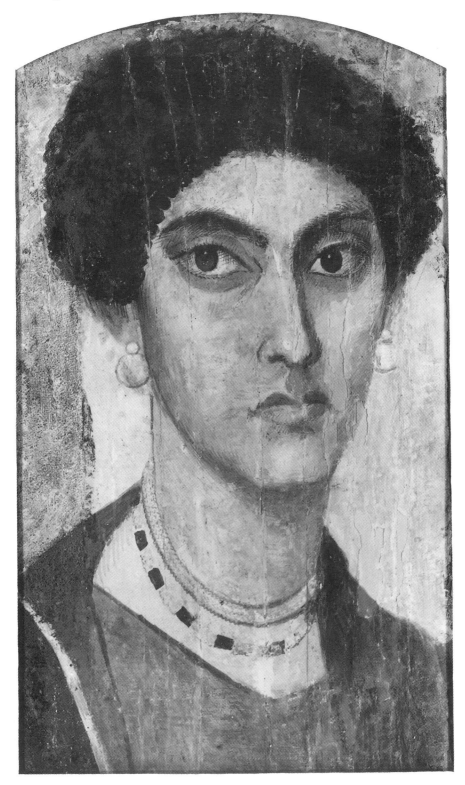

Greco-Roman School, *A Young Woman* (No. 3931)

PLATE 32

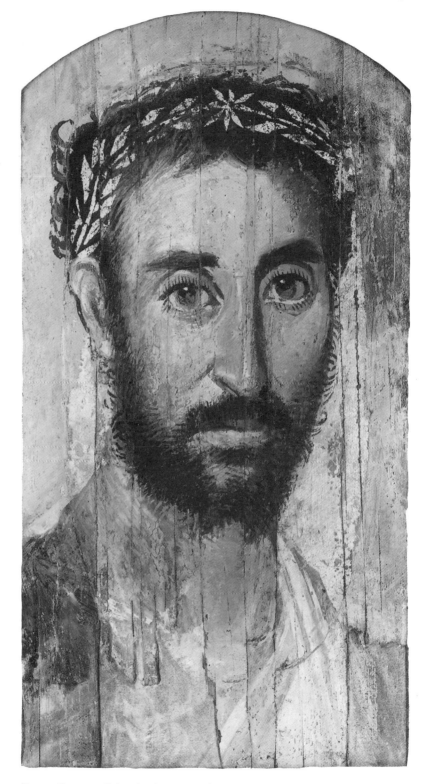

Greco-Roman School, *A Man with a Wreath* (No. 3932)

PLATE 33

Ascribed to Jacopo di Cione and Workshop, *The Crucifixion* (No. 1468)

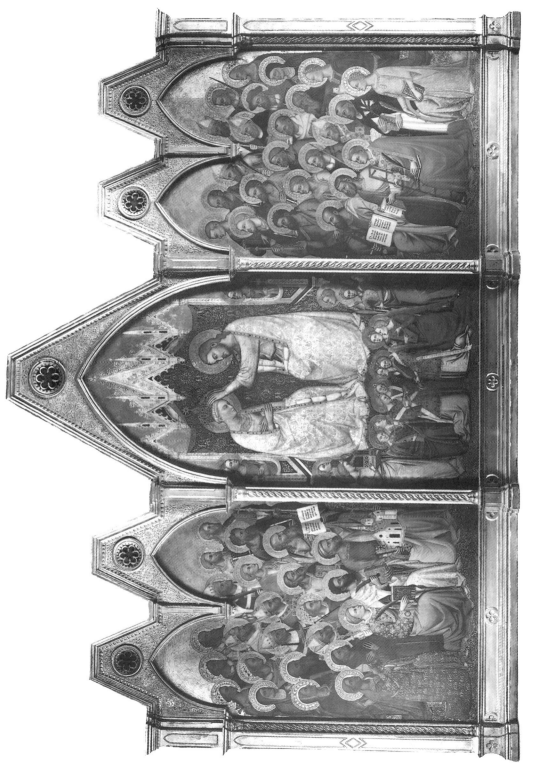

PLATE 34

Ascribed to Jacopo di Cione and Workshop, *The Coronation of the Virgin, with Adoring Saints* (No. 569)

PLATE 35

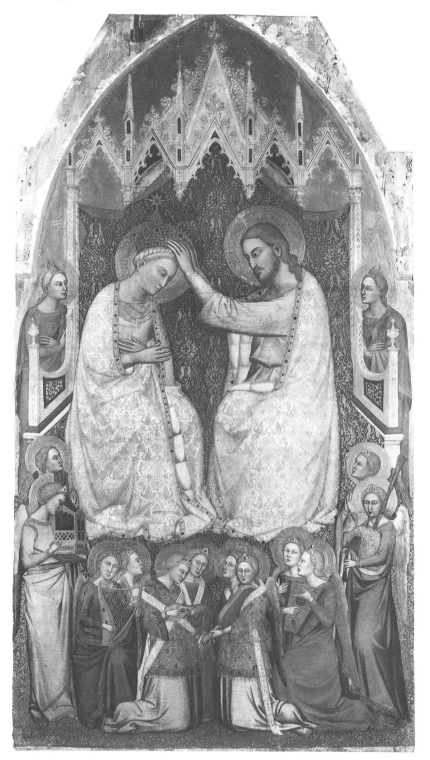

Ascribed to Jacopo di Cione and Workshop, *The Coronation of the Virgin* (No. 569). Centre panel.

PLATE 36

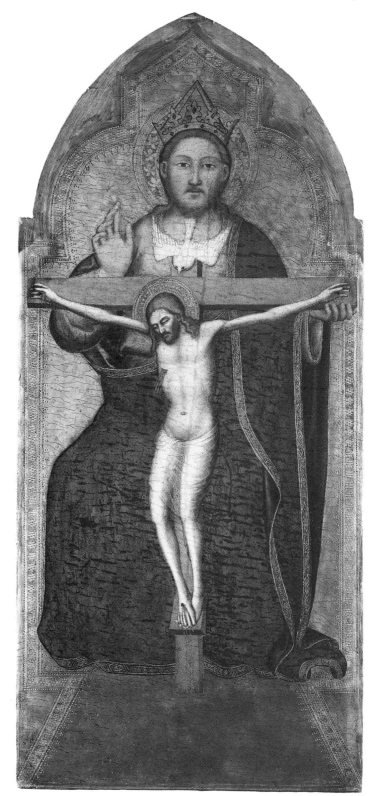

Ascribed to Jacopo di
Cione and Workshop,
The Trinity (No. 570)

PLATE 37

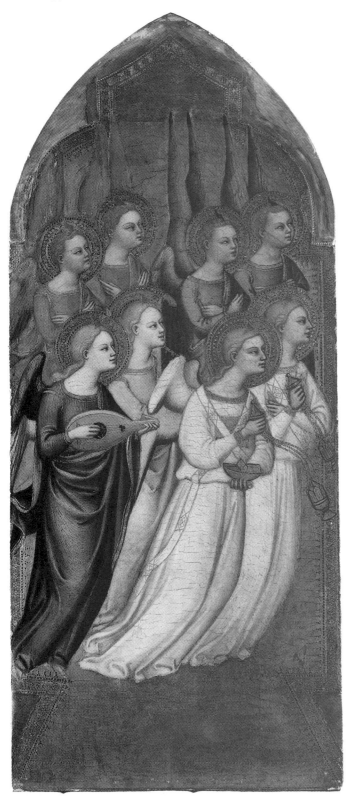

Ascribed to Jacopo di Cione
and Workshop,
*Seraphim, Cherubim and
Adoring Angels*
(No. 571)

PLATE 38

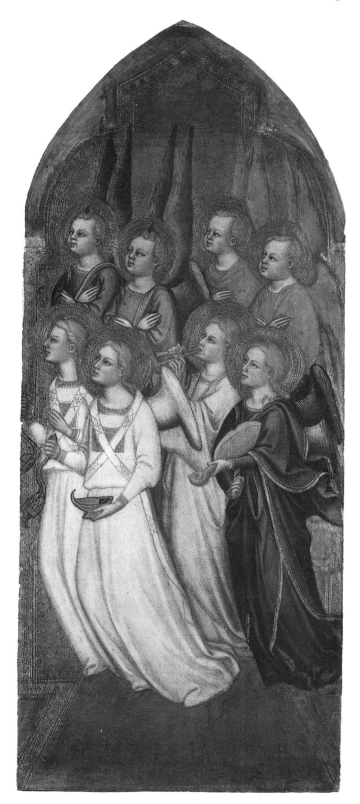

Ascribed to Jacopo di
Cione and Workshop,
*Seraphim, Cherubim and
Adoring Angels*
(No. 572)

PLATE 39

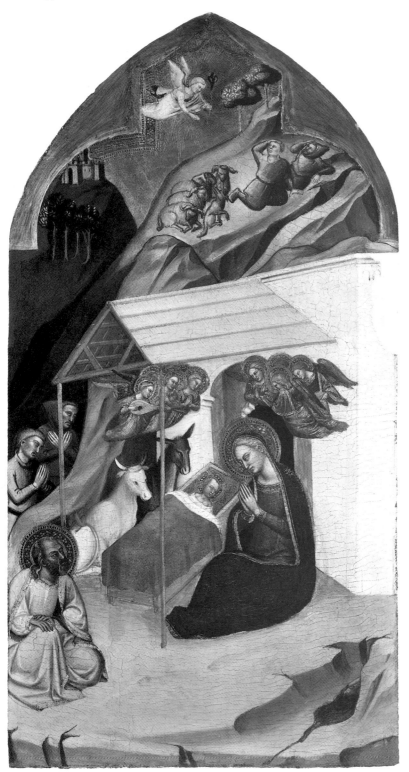

Ascribed to Jacopo di Cione and Workshop, *The Nativity, with the Annunciation to the Shepherds and the Adoration of the Shepherds* (No. 573)

PLATE 40

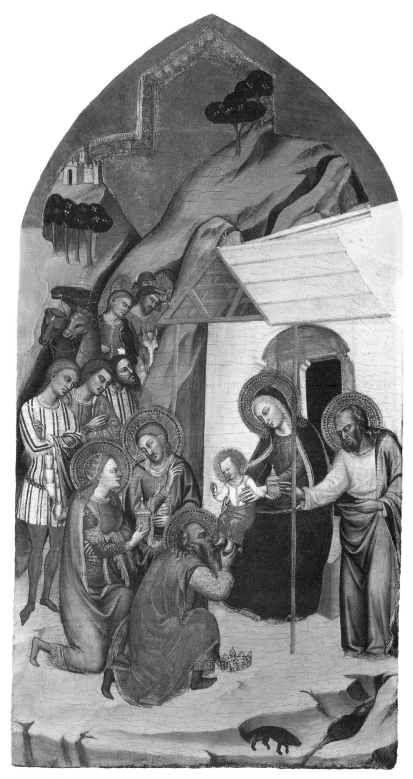

Ascribed to Jacopo di Cione and Workshop, *The Adoration of the Magi* (No. 574)

PLATE 41

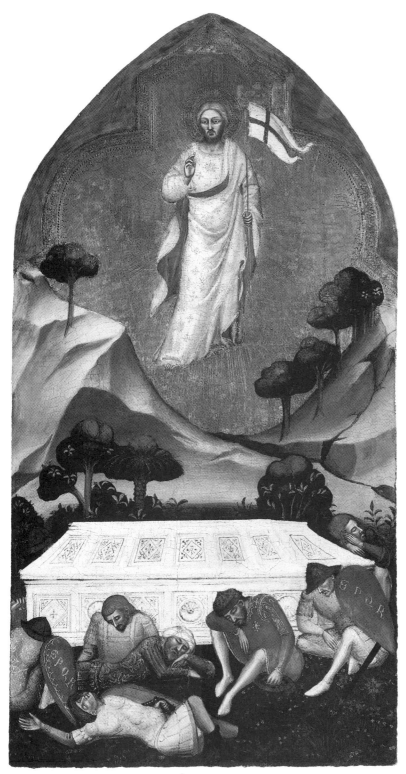

Ascribed to Jacopo di Cione and Workshop, *The Resurrection*
(No. 575)

PLATE 42

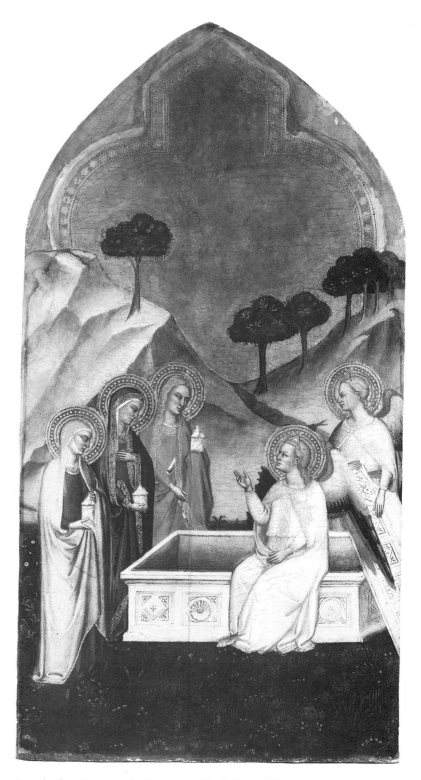

Ascribed to Jacopo di Cione and Workshop, *The Maries at the Sepulchre* (No. 576)

PLATE 43

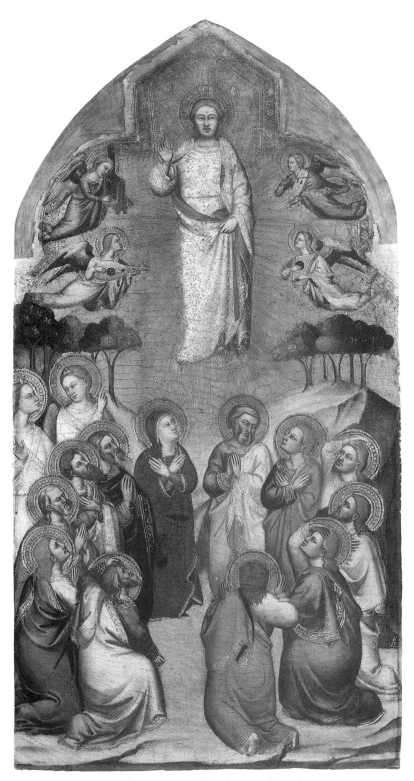

Ascribed to Jacopo di Cione and Workshop, *The Ascension*
(No. 577)

PLATE 44

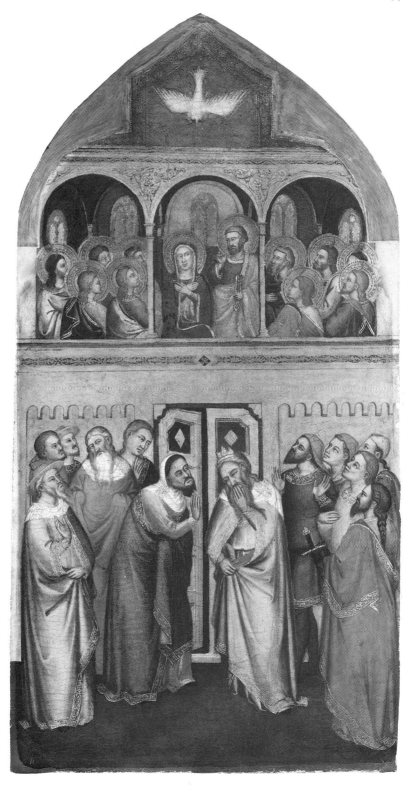

Ascribed to Jacopo di Cione and Workshop, *Pentecost* (No. 578)

PLATE 45

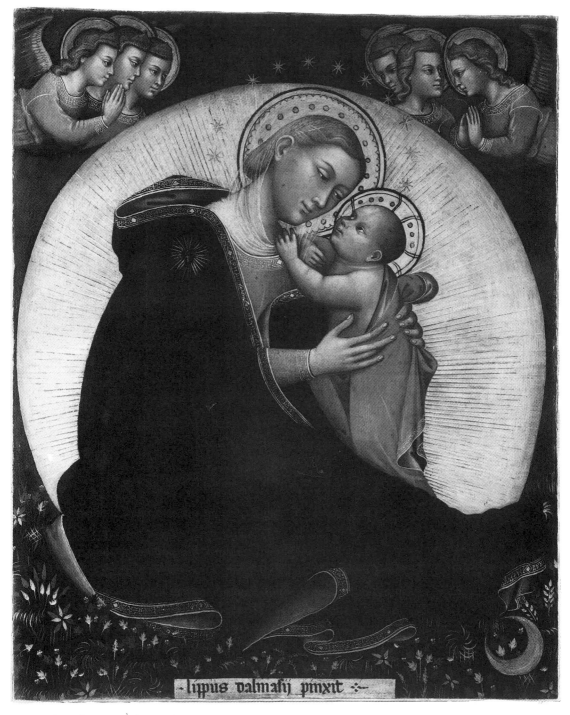

Lippo di Dalmasio, *The Madonna of Humility* (No. 752)

PLATE 46

Ambrogio Lorenzetti, *A Group of Poor Clares* (No. 1147)

PLATE 47

Workshop of Pietro Lorenzetti, *A Crowned Female Figure (St Elizabeth of Hungary?)* (No. 3071)

PLATE 48

Workshop of Pietro Lorenzetti, *A Female Saint in Yellow* (No. 3072)

PLATE 49

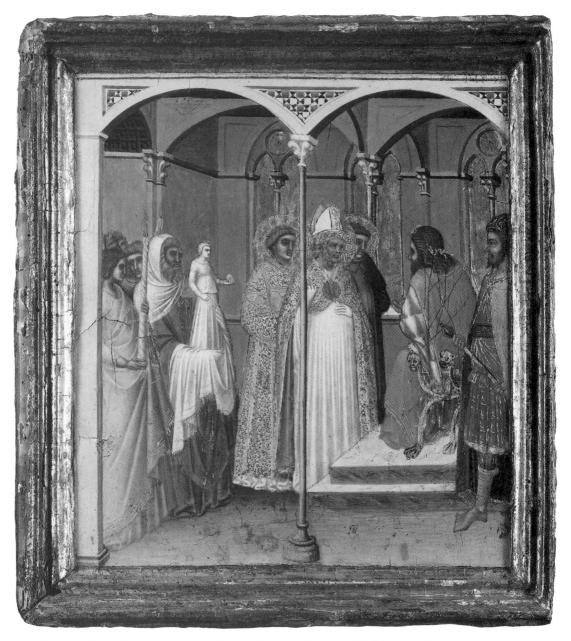

Ascribed to Pietro Lorenzetti, *St Sabinus before the Governor (?)* (No. 1113)

PLATE 50

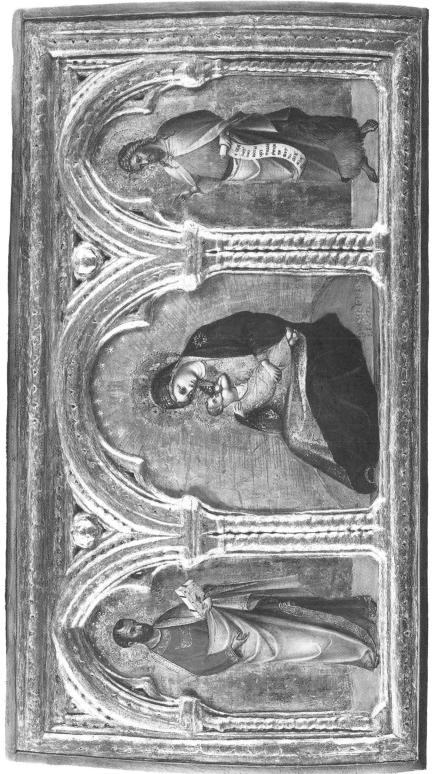

Attributed to Lorenzo Veneziano, *The Madonna of Humility with Sts Mark and John the Baptist* (No. 3897)

PLATE 51

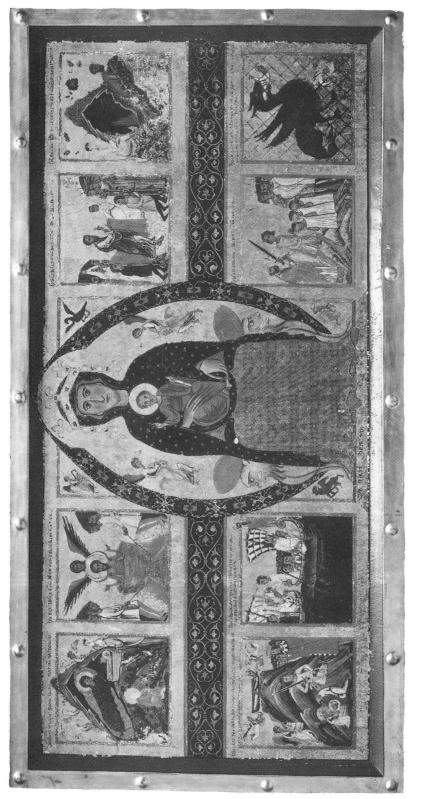

Margarito of Arezzo, *The Virgin and Child Enthroned, with Scenes of the Nativity and the Lives of Saints* (No. 564)

PLATE 52

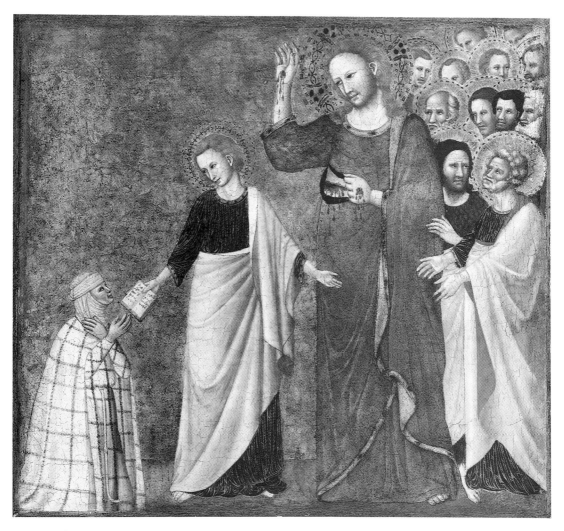

Master of the Blessed Clare, *Vision of the Blessed Clare of Rimini* (No. 6503)

PLATE 53

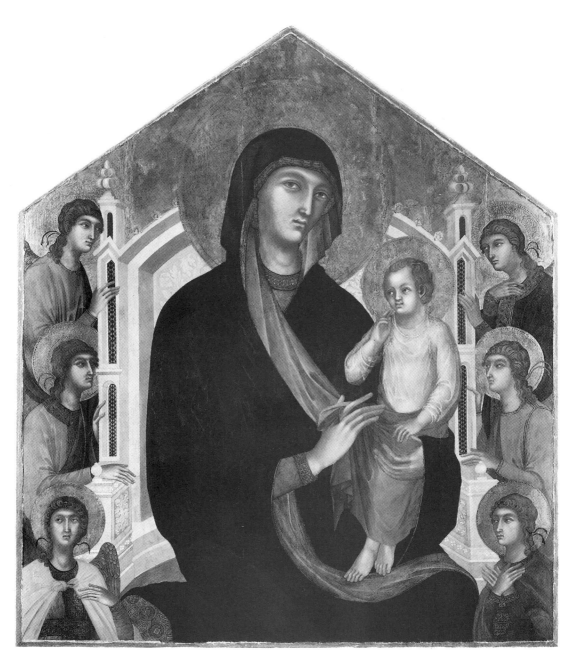

Master of the Casole Fresco, *The Virgin and Child with Six Angels* (No. 565)

PLATE 54

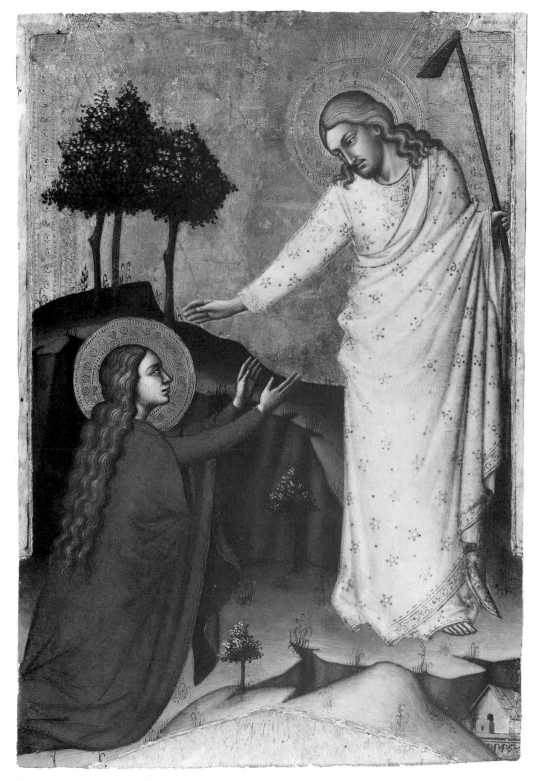

Master of the Lehman Crucifixion, *'Noli me Tangere'* (No. 3894)

PLATE 55

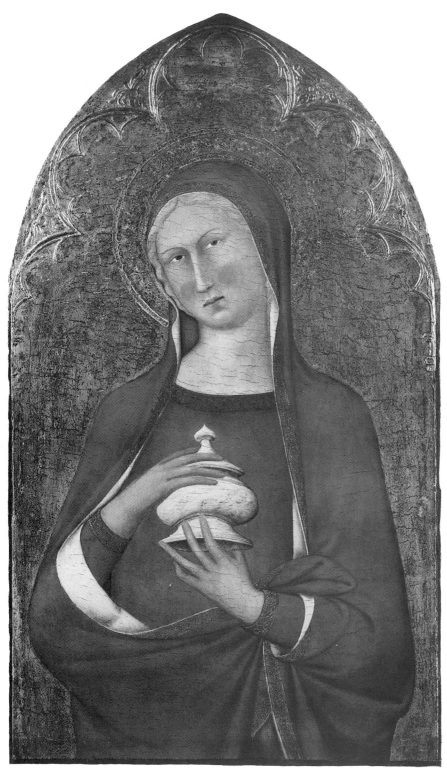

Master of the Palazzo Venezia Madonna, *Mary Magdalene* (No. 4491)

PLATE 56

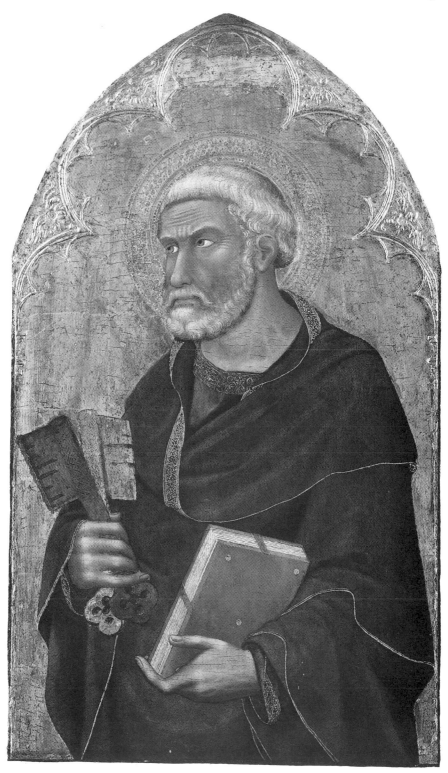

Master of the Palazzo Venezia Madonna, *St Peter* (No. 4492)

PLATE 57

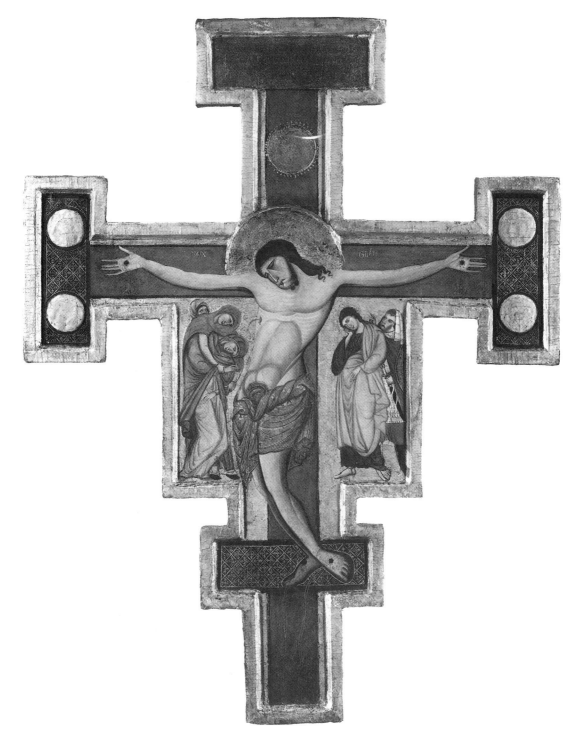

Attributed to the Master of St Francis, *Crucifix* (No. 6361)

PLATE 58

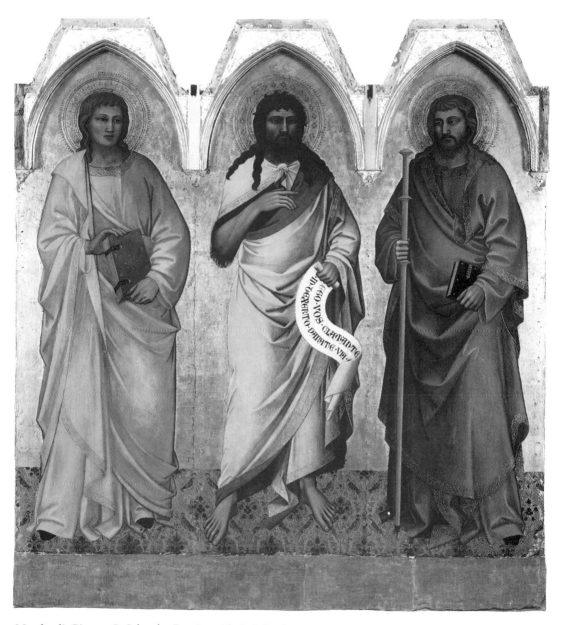

Nardo di Cione, *St John the Baptist with St John the Evangelist (?) and St James* (No. 581)

PLATE 59

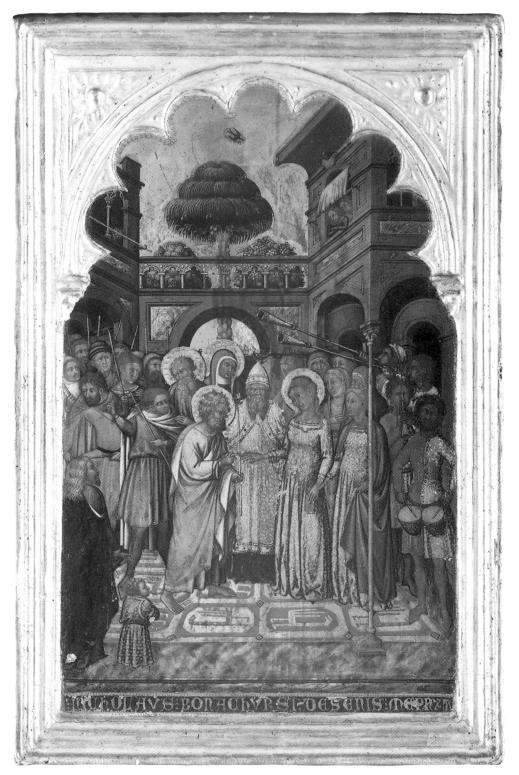

Niccolò di Buonaccorso, *The Marriage of the Virgin* (No. 1109)

PLATE 60

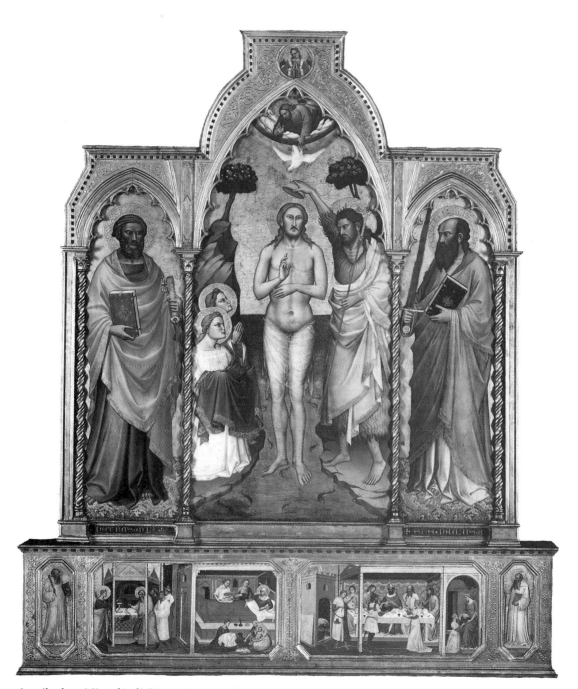

Ascribed to Niccolò di Pietro Gerini, *The Baptism of Christ, with Sts Peter and Paul* (No. 579)

PLATE 61

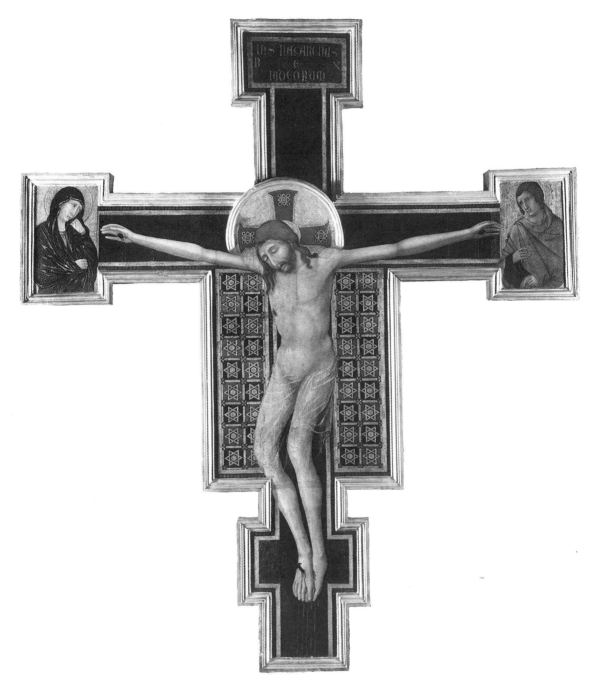

Style of Segna di Bonaventura, *Crucifix* (No. 567)

PLATE 62

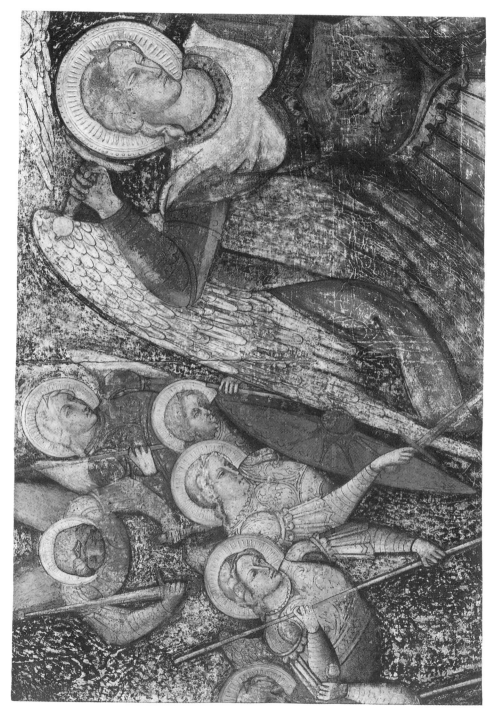

Spinello Aretino, *St Michael and Other Angels* (No. 1216)

PLATE 63

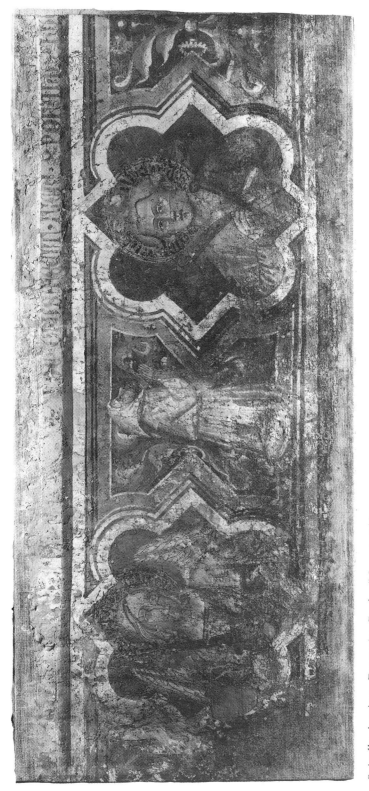

Spinello Aretino, *Decorative Border* (No. 1216A)

PLATE 64

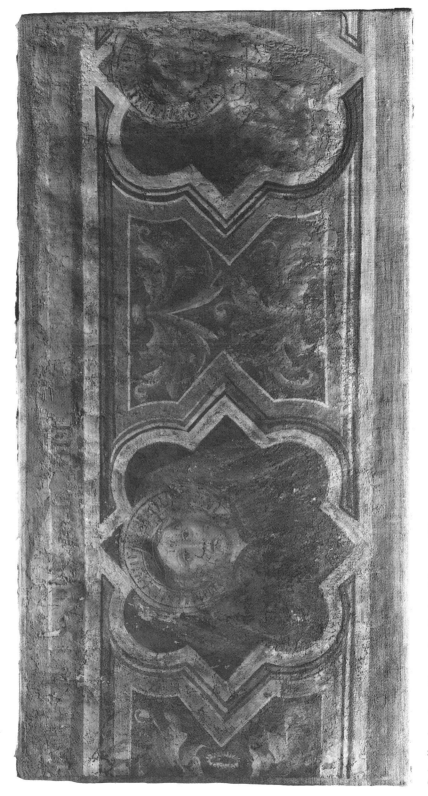

Spinello Aretino, *Decorative Border* (No. 1216B)

PLATE 65

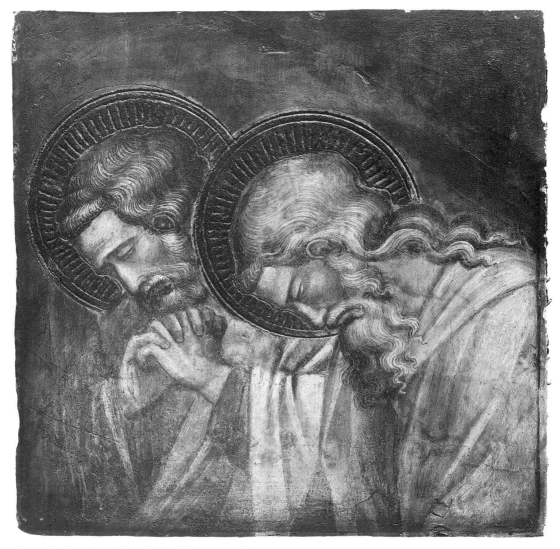

Spinello Aretino, *Two Haloed Mourners* (No. 276)

PLATE 66

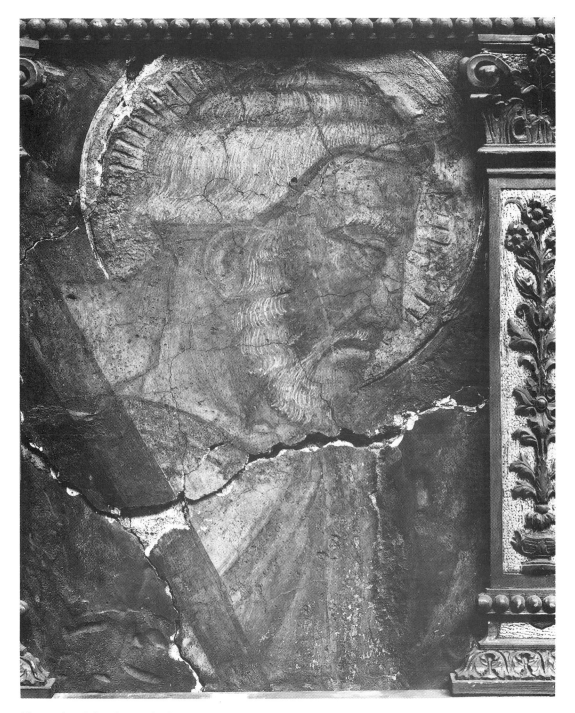

Florentine School, *Head of a Male Saint* (No. 3120)

PLATE 67

Tuscan School, *The Virgin and Child with Two Angels* (No. 4741)

PLATE 68

Tuscan School, No. 4741. Reverse.

PLATE 69

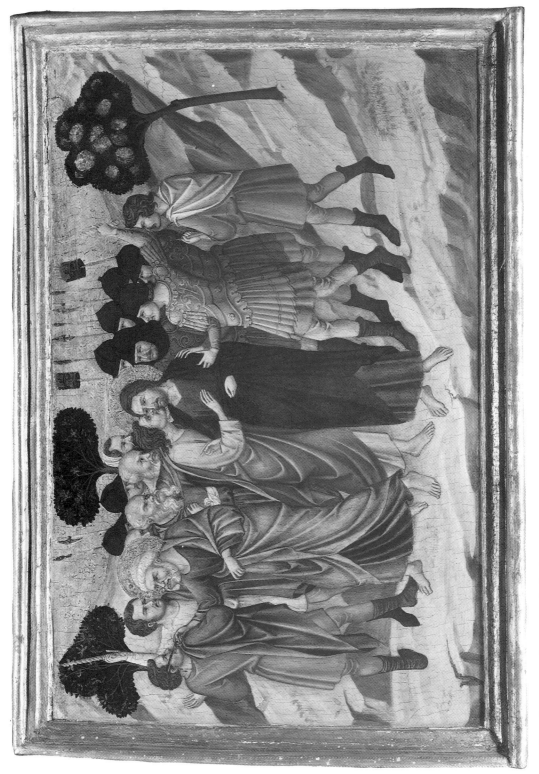

Ugolino di Nerio, *The Betrayal of Christ* (No. 1188)

PLATE 70

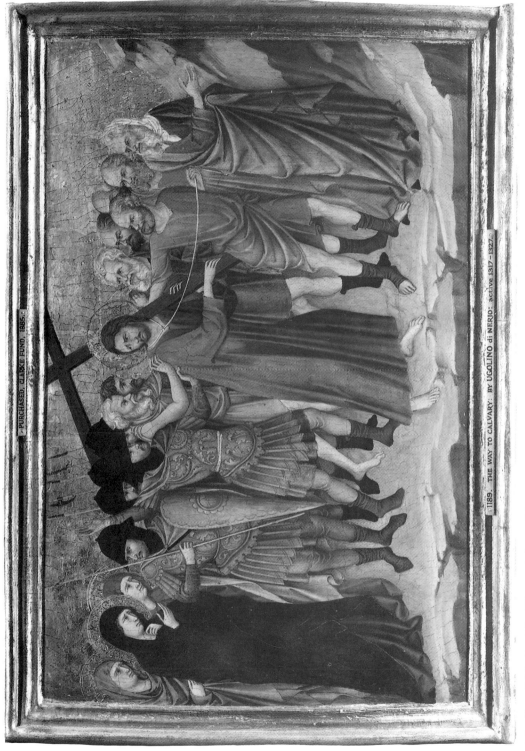

Ugolino di Nerio, *The Way to Calvary* (No. 1189)

PLATE 71

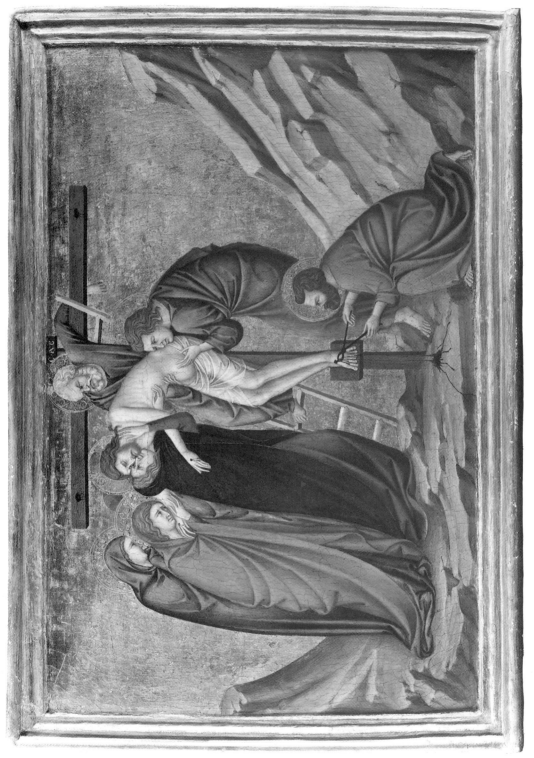

Ugolino di Nerio, *The Deposition* (No. 3375)

PLATE 72

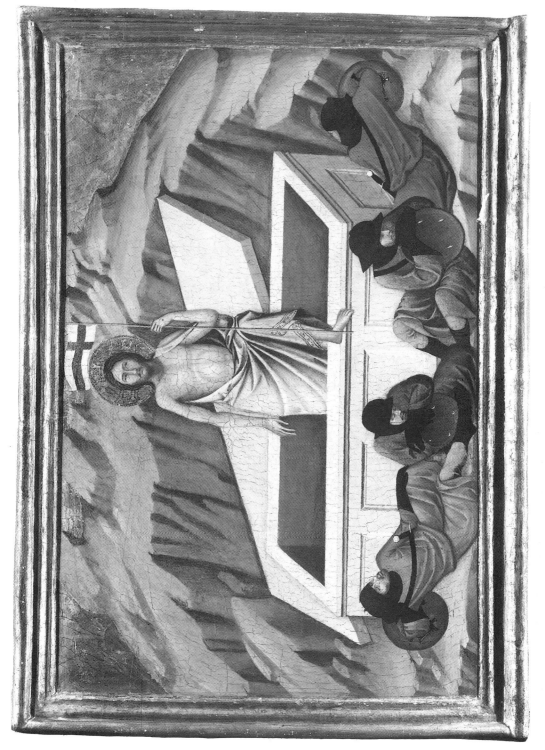

Ugolino di Nerio, *The Resurrection* (No. 4191)

PLATE 73

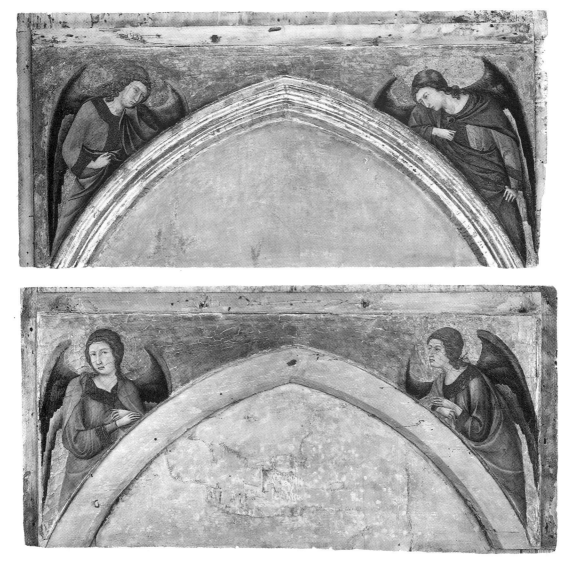

A (above): Ugolino di Nerio, *Two Angels* (No. 6486)
B (below): Ugolino di Nerio, *Two Angels* (No. 3378)

PLATE 74

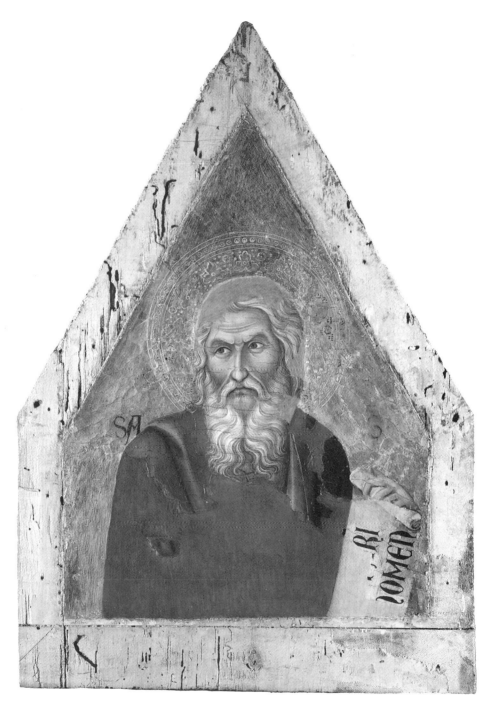

Ugolino di Nerio, *Isaiah* (No. 3376)

PLATE 75

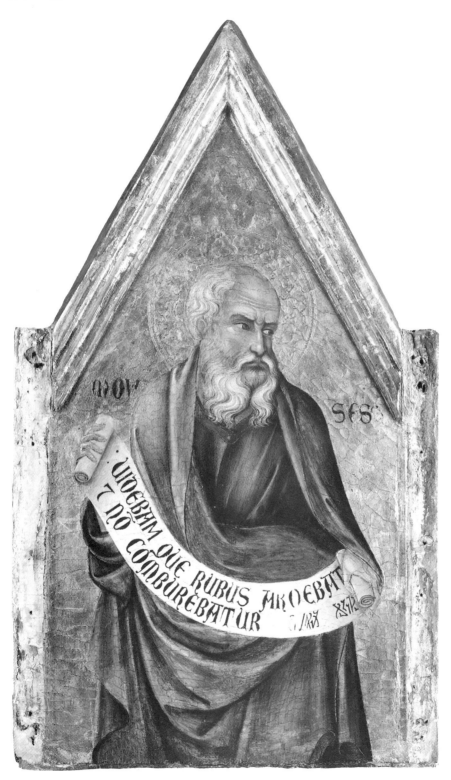

Ugolino di Nerio, *Moses* (No. 6484)

PLATE 76

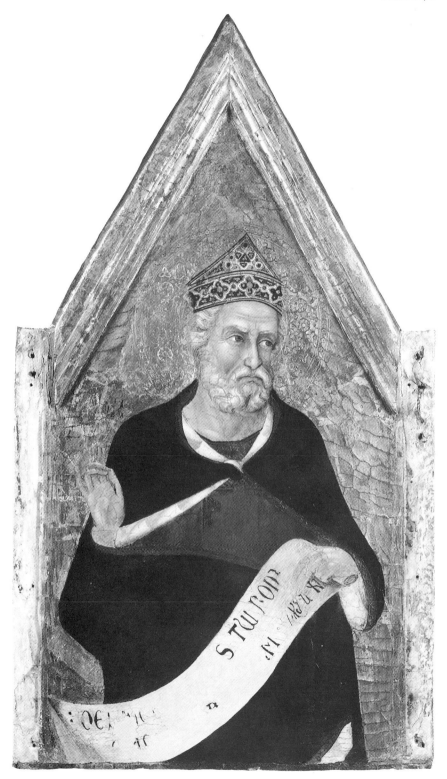

Ugolino di Nerio, *David* (No. 6485)

PLATE 77

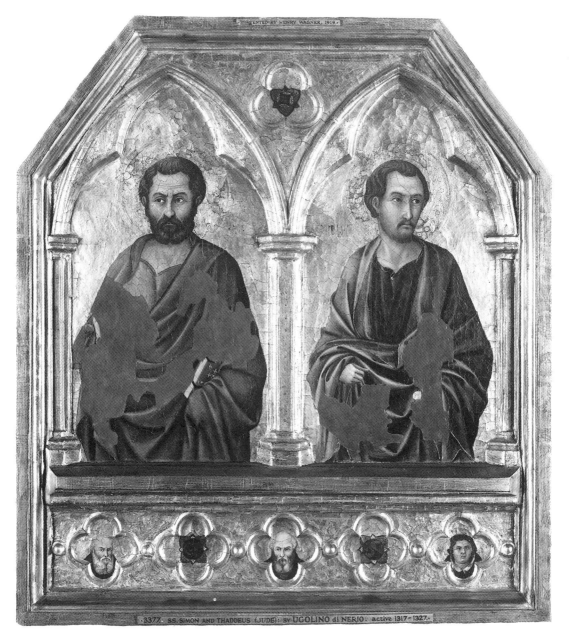

Ugolino di Nerio, *Sts Simon and Thaddeus (Jude)* (No. 3377)

PLATE 78

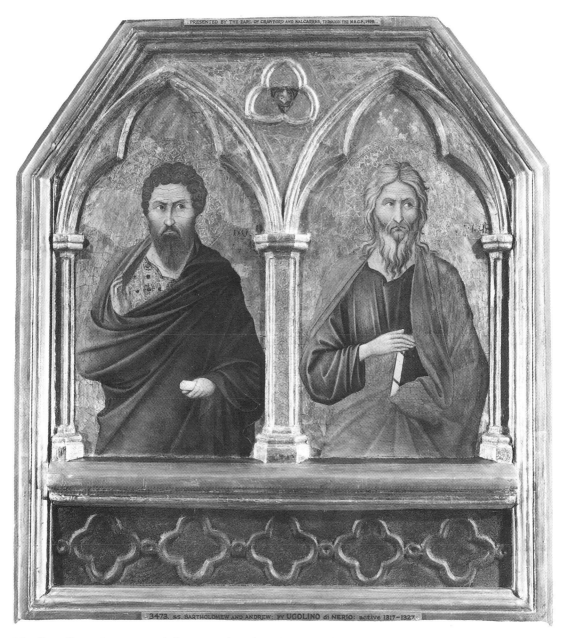

PRESENTED BY THE EARL OF CRAWFORD AND BALCARRES, THROUGH THE N.A.C.F. 1919.

3473. SS. BARTHOLOMEW AND ANDREW: BY UGOLINO di NERIO: active 1317-1327.

Ugolino di Nerio, *Sts Bartholomew and Andrew* (No. 3473)

PLATE 79

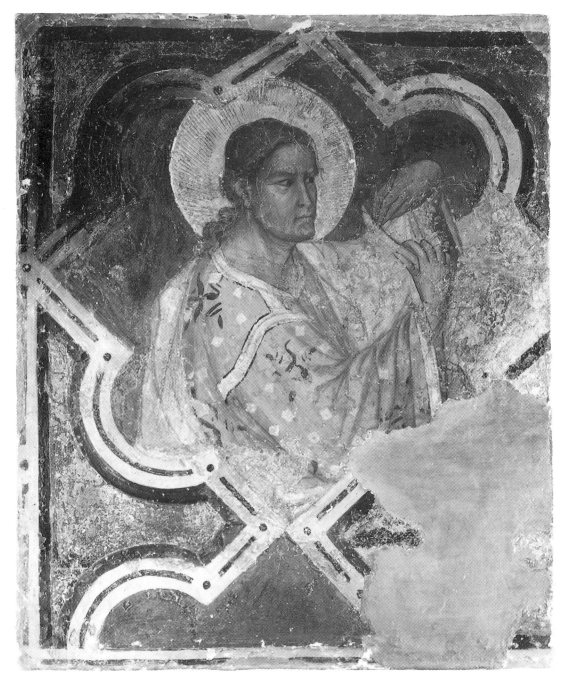

Umbrian School (?), *A Saint* (No. 4143)

PLATE 80

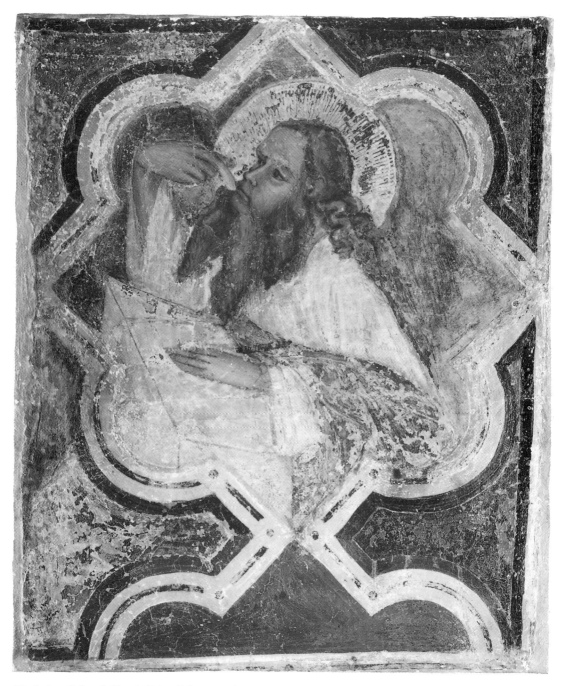

Umbrian School (?), *A Saint* (No. 4144)

PLATE 81

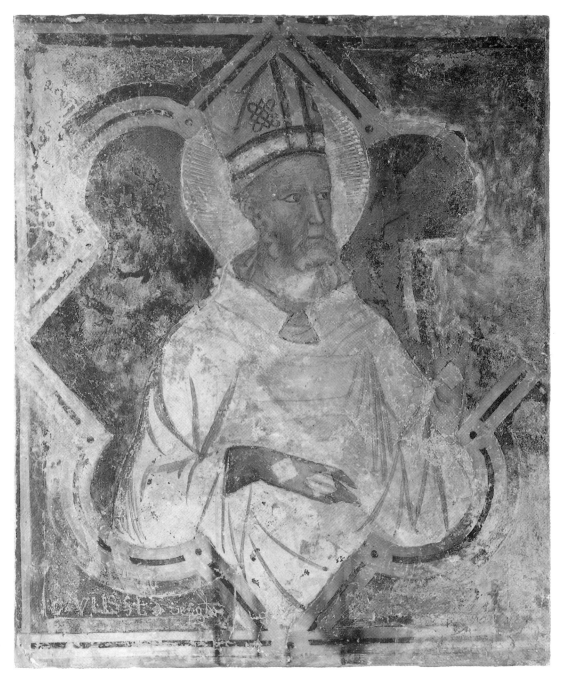

Umbrian School (?), *A Bishop Saint* (No. 4145)

PLATE 82

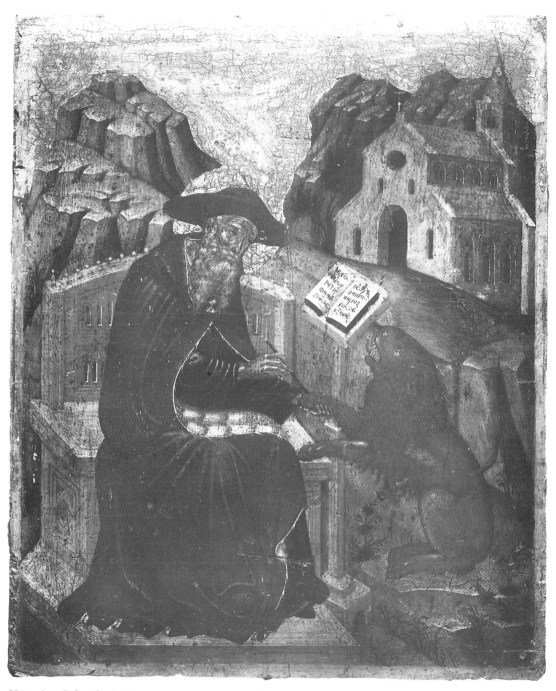

Venetian School, *St Jerome in a Landscape* (No. 3543)

PLATE 83

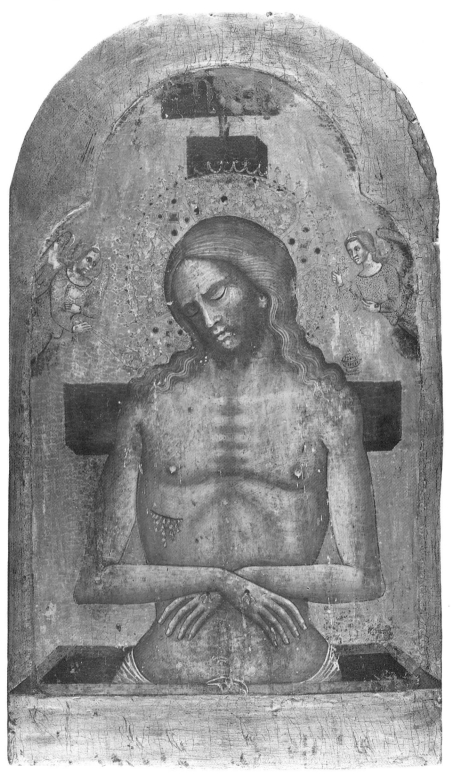

Venetian School, *Pietà* (No. 3893)

FIGURES

FIGURE I

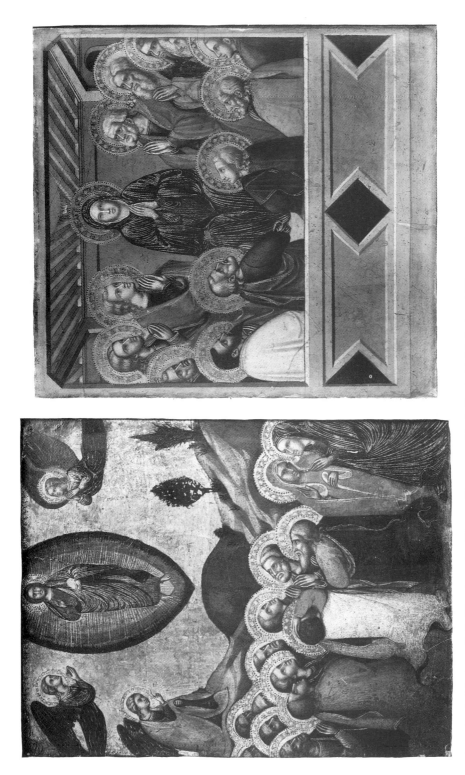

Barnaba da Modena: (left) The Ascension (Rome, Pinacoteca Capitolina); (right) Pentecost (No. 1437)

FIGURE 2

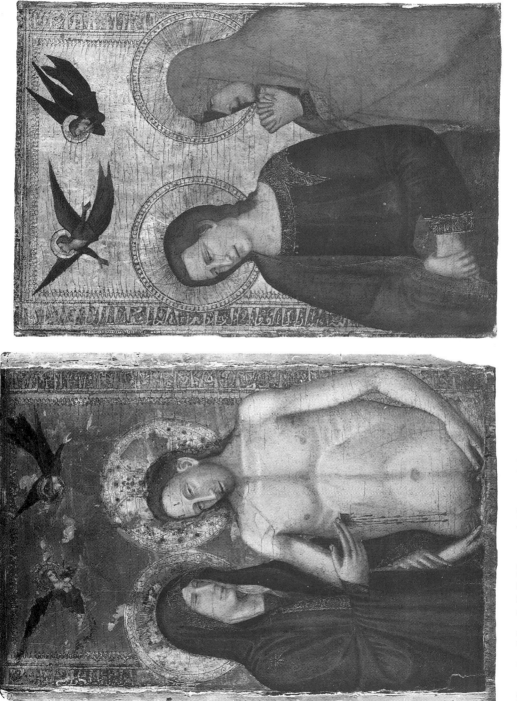

Florentine School: (*left*) *The Dead Christ and the Virgin* (No. 3895); (*right*) *Sts John the Evangelist and Mary Magdalene* (New York, The Metropolitan Museum of Art, Robert Lehman Collection)

FIGURE 3

Duccio, the front of the *Maestà*. Reconstruction by White. See No. 1139.

FIGURE 4

Duccio, the back of the *Maestà*. Reconstruction by White. See Nos. 1140 and 1330.

FIGURE 5

Ascribed to Giotto: (*above, left to right*) *The Nativity cum Epiphany* (New York, The Metropolitan Museum of Art), *The Presentation* (Boston, Isabella Stewart Gardner Museum), *The Last Supper* (Munich, Alte Pinakothek), *The Crucifixion* (Munich, Alte Pinakothek); (*below, left to right*) *The Entombment* (Florence, Villa I Tatti, Berenson Collection), *The Descent into Limbo* (Munich, Alte Pinakothek), *Pentecost* (No. 5360)

FIGURE 6

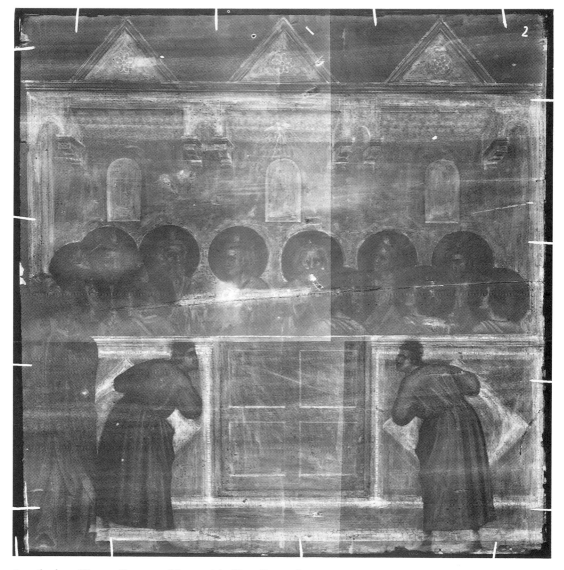

Ascribed to Giotto, *Pentecost* (No. 5360). X-radiograph.

FIGURE 7

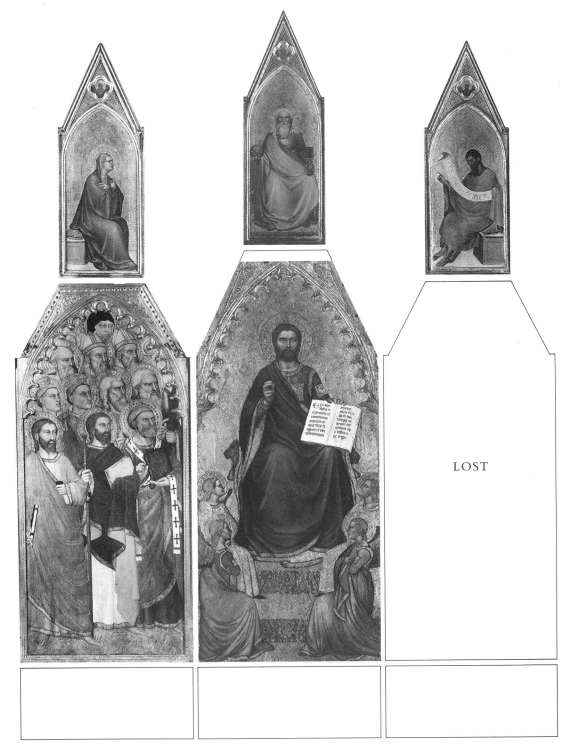

LOST

Giovanni da Milano: (*above, left to right*) *The Virgin, Christ of the Apocalypse, St John the Baptist* (all No. 579A); (*main tier left*) *Saints* (Turin, Galleria Sabauda); (*main tier centre*) *Christ Enthroned* (Milan, Pinacoteca di Brera). Reconstruction after Boskovits.

FIGURE 8

Vincenzo Torrigiani, *San Pier Maggiore, Florence* (present whereabouts unknown). See Ascribed to Jacopo di Cione and Workshop, Nos. 569–78.

FIGURE 9

1 Seraphim, Cherubim and Adoring Angels (No. 571)

2 The Trinity (No. 570)

3 Seraphim, Cherubim and Adoring Angels (No. 572)

4 St Luke (?)

5 The Nativity, with the Annunciation to the Shepherds and the
 Adoration of the Shepherds (No. 573)

6 The Adoration of the Magi (No. 574)

7 The Resurrection (No. 575)

8 The Maries at the Sepulchre (No. 576)

9 The Ascension (No. 577)

10 Pentecost (No. 578)

11 St Matthew (ex London, Hutton Collection)

12 St Mark (?)

13 St Paul the First Hermit (Brussels, Van Gelder Collection)

14 St Romuald (Brussels, Van Gelder Collection)

15 Adoring Saints (No. 569)

16 The Coronation of the Virgin (No. 569)

17 Adoring Saints (No. 569)

18 St John the Evangelist (Brussels, Van Gelder Collection)

19 St Stephen (ex London, Hutton Collection)

20 St Mary Magdalene (ex London, Hutton Collection)

21 The Calling of St Peter (?)

22 The Taking of St Peter (Providence, Rhode Island School of Design,
 Museum of Art)

23A St Peter in Prison (Philadelphia, Museum of Art, Johnson Collection)

23B The Liberation of St Peter (Philadelphia, Museum of Art, Johnson
 Collection)

24 St Peter raising the Son of Theophilus (Rome, Pinacoteca Vaticana)

25 The Chairing of St Peter at Antioch (Rome, Pinacoteca Vaticana)

26A The Trials of St Peter (ex Lugano, Schloss Rohoncz Collection)

26B The Last Meeting of St Peter and St Paul in Rome (ex Lugano,
 Schloss Rohoncz Collection)

27 The Crucifixion of St Peter (Rome, Pinacoteca Vaticana)

28 The Beheading of St Paul (Milan, Galleria Edmondo Sacerdoti)

FIGURE 9

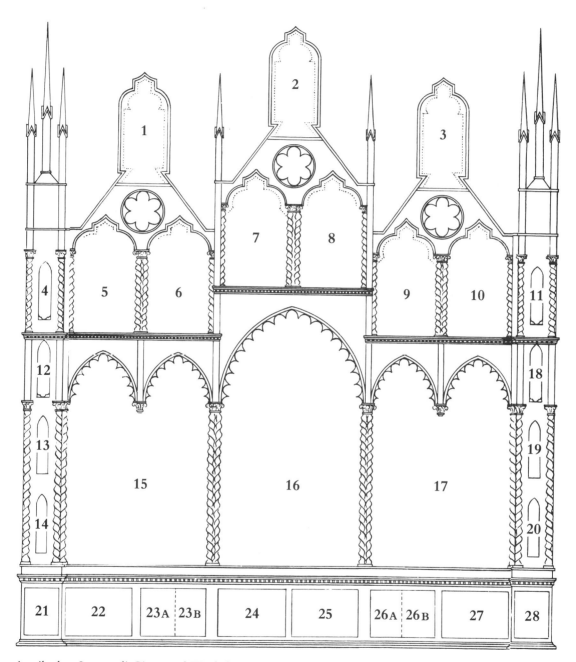

Ascribed to Jacopo di Cione and Workshop, San Pier Maggiore altarpiece. Reconstruction after Offner and Steinweg. See Nos. 569–78.

FIGURE 10

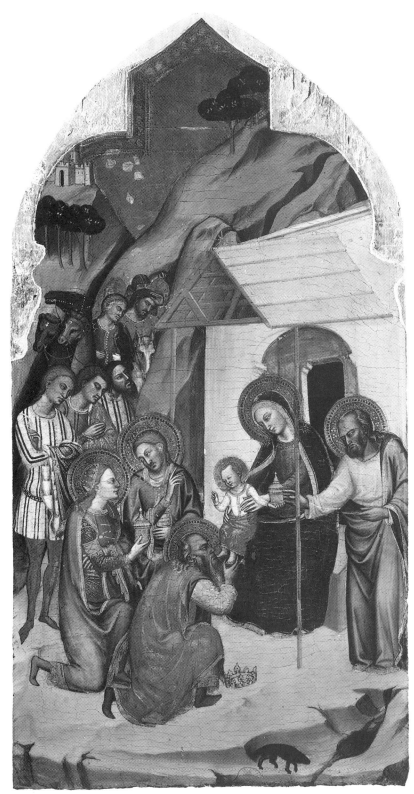

Ascribed to Jacopo di
Cione and Workshop,
*The Adoration of the
Magi* (No. 574).
After cleaning and
before restoration.

· FIGURE 11

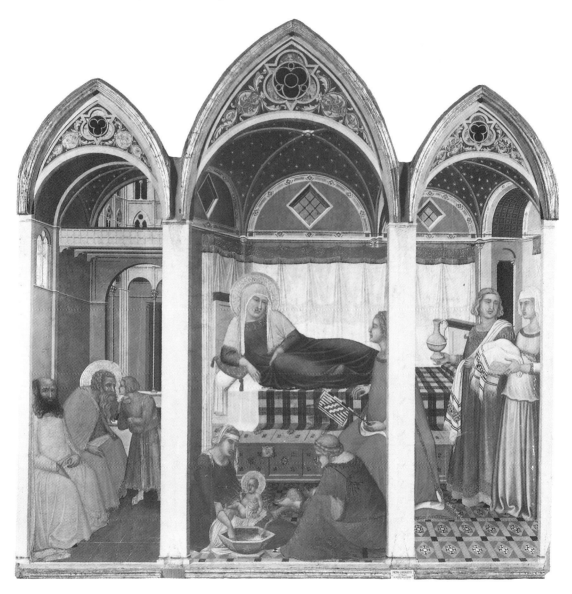

Pietro Lorenzetti, *The Birth of the Virgin* (Siena, Museo dell'Opera del Duomo). See No. 1113.

FIGURE 12

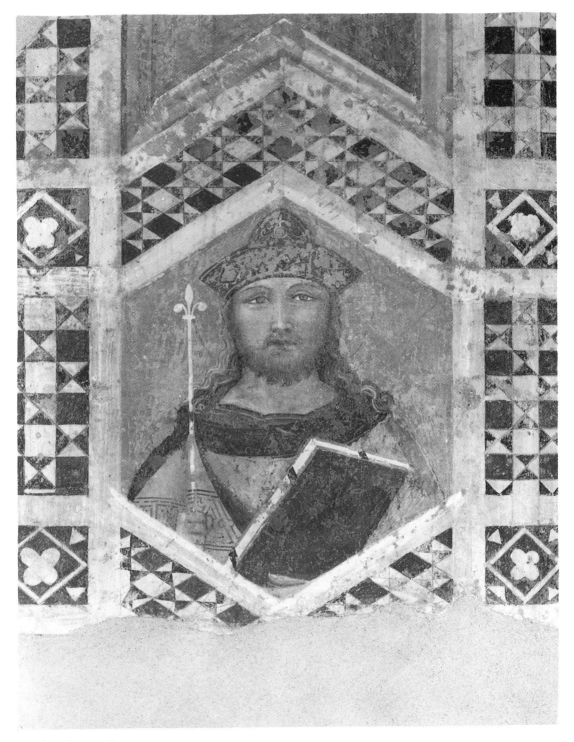

Attributed to Ambrogio Lorenzetti, *Head of a King*, fresco fragment (Siena, Pinacoteca Nazionale).
See Workshop of Pietro Lorenzetti, Nos. 3071 and 3072.

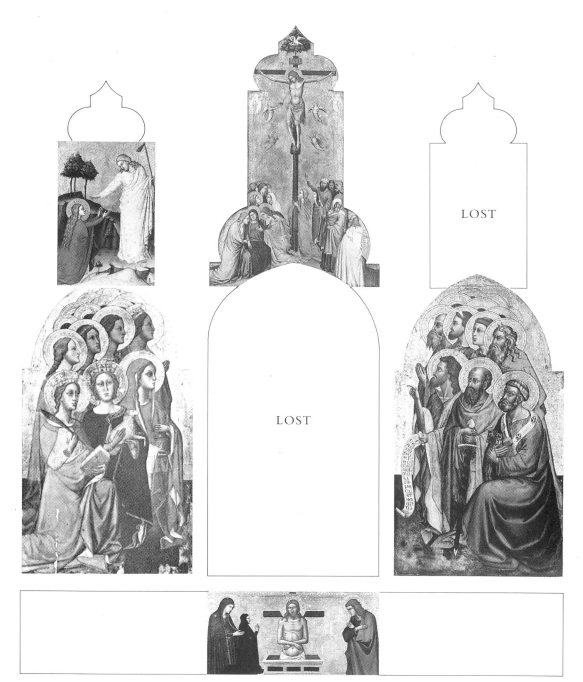

FIGURE 13

Master of the Lehman Crucifixion: *(above left)* *'Noli me Tangere'* (No. 3894); *(above centre)* *The Crucifixion* (New York, The Metropolitan Museum of Art, Robert Lehman Collection); *(main tier left)* *Female Saints* (Rome, private collection, reproduced from Boskovits); *(main tier right)* *Male Saints* (Luxemburg, Musée d'Histoire et d'Art); predella, *Man of Sorrows* (Denver, Denver Art Museum, Kress Collection). Reconstruction after Boskovits.

FIGURE 14

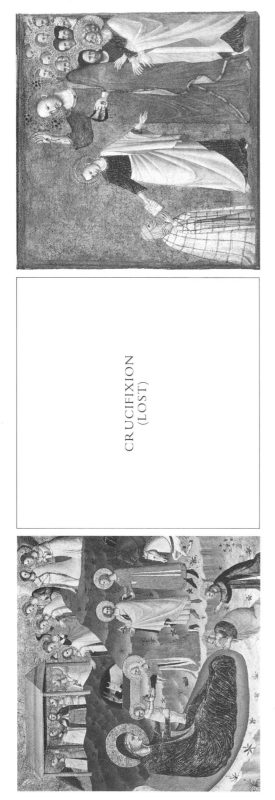

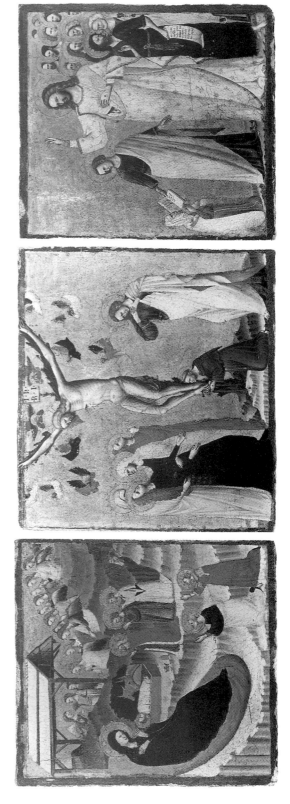

CRUCIFIXION
(LOST)

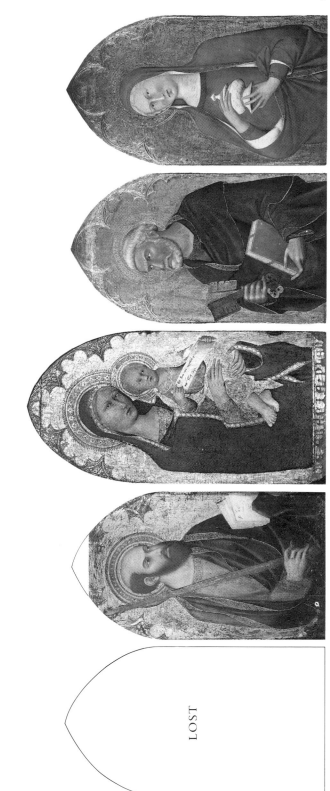

FIGURE 15

A (top): The Master of the Blessed Clare: (left) The Adoration of the Magi (Coral Gables, The Lowe Art Museum, University of Miami); (right) The Vision of the Blessed Clare of Rimini (No. 6503)

B (above): Riminese School: (left to right) The Adoration, Crucifixion and Vision of the Blessed Clare of Rimini (Ajaccio, Musée Fesch). See The Master of the Blessed Clare, No. 6503.

Master of the Palazzo Venezia Madonna: (left to right) St Paul (private collection), The Virgin and Child (Rome, Galleria Nazionale, Palazzo Barberini), St Peter (No. 4492), Mary Magdalene (No. 4491)

FIGURE 16

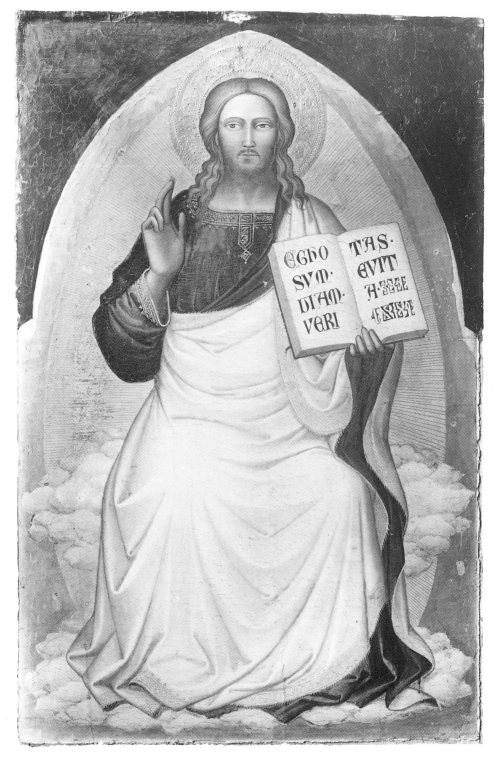

Ascribed to Niccolò di Pietro Gerini, *The Blessing Redeemer* (Munich, Alte Pinakothek). See No. 579.

FIGURE 17

Thomas Patch, engraving after Spinello Aretino, including the
Beheading and Burial of St John the Baptist. See No. 276.

FIGURE 18

Niccolò di Buonaccorso: (*left to right*) *The Presentation of the Virgin* (Florence, Uffizi), *The Marriage of the Virgin* (No. 1109), and *The Coronation of the Virgin* (New York, The Metropolitan Museum of Art, Robert Lehman Collection)

FIGURE 19

Niccolò di Buonaccorso: *(left) The Marriage of the Virgin,* reverse (No. 1109); *(right) The Coronation of the Virgin,* reverse (New York, The Metropolitan Museum of Art, Robert Lehman Collection).

FIGURE 20

Carlo Lasinio, engraving after Spinello Aretino of the *Fall of Lucifer*. See Nos. 1216, 1216A and 1216B.

FIGURE 21

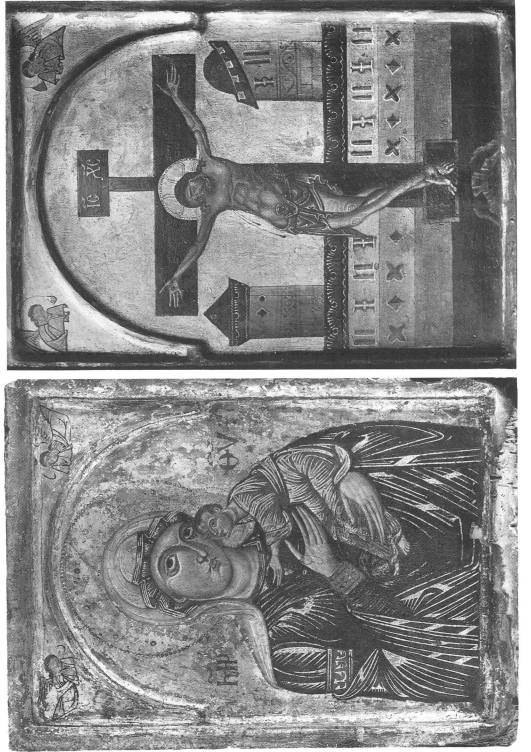

Tuscan School: (*left*) *The Virgin and Child with Two Angels* (No. 4741); (*right*) *Christ on the Cross* (Budapest, Szépművészeti Múzeum)

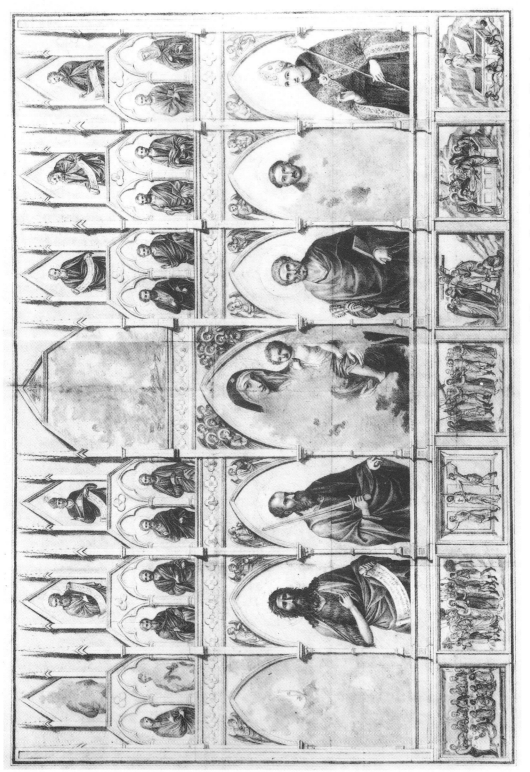

FIGURE 22

Eighteenth-century drawing of Ugolino di Nerio's Santa Croce altarpiece (Rome, Biblioteca Apostolica Vaticana). See Nos. 1188 et al.

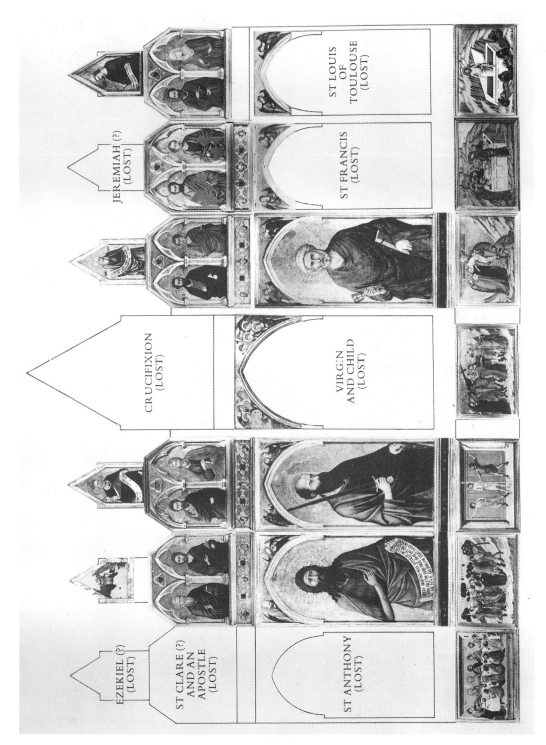

FIGURE 23

ST LOUIS OF TOULOUSE (LOST)

ST FRANCIS (LOST)

JEREMIAH (?) (LOST)

CRUCIFIXION (LOST)

VIRGIN AND CHILD (LOST)

EZEKIEL (?) (LOST)

ST CLARE (?) AND AN APOSTLE (LOST)

ST ANTHONY (LOST)

Ugolino di Nerio, Santa Croce altarpiece. Reconstruction. See Nos. 1188 et al.

FIGURE 24

Ugolino di Nerio: (*above*) *Sts Simon and Thaddeus* (No. 3377); (*below*) fragment of *Two Angels* (No. 3378). Composite X-radiograph.

Acknowledgements

The author and the National Gallery are grateful to the following individuals and institutions for permission to reproduce material:

Boston, Isabella Stewart Gardner Museum (Fig. 5)

Budapest, Szépmüvészeti Múzeum (Fig. 21)

Coral Gables, University of Miami, The Lowe Art Museum (Fig. 14: Gift of the Samuel H. Kress Foundation)

Denver, Denver Art Museum (Fig. 13)

Florence, Gabinetto Fotografico della Soprintendenza ai Beni Artistici e Storici (B.A.S.) di Firenze (Fig. 18)

London, Professor John White (Figs. 3 and 4)

Luxemburg, Musée d'Histoire et d'Art, Musées de l'Etat du Grand-Duché de Luxembourg (Fig. 13)

Milan, Soprintendenza per i Beni Artistici e Storici (Fig. 7)

Munich, Direktion der Bayerischen Staatsgemäldesammlungen (Figs. 5 and 16)

New York, The Metropolitan Museum of Art (Fig. 2: Robert Lehman Collection, 1975 [1975.1.102]; Fig. 5: John Stewart Kennedy Fund, 1911 [11.126.1]; Fig. 13: Robert Lehman Collection, 1975 [1975.1.65]; Figs. 18 and 19: Robert Lehman Collection, 1975 [1975.1.21])

New York, New York University, Institute of Fine Arts (extract on pp. 51–2 from *A Critical and Historical Corpus of Florentine Painting* by Richard Offner and Klara Steinweg)

Paris, Service photographique de la réunion des musées nationaux (Fig. 14)

Rome, Biblioteca Apostolica Vaticana (Fig. 22)

Rome, Pinacoteca Capitolina (Fig. 1)

Rome, Soprintendenza per i Beni Artistici e Storici (Fig. 15)

Siena, Opera della Metropolitana di Siena (Fig. 11)

Turin, Soprintendenza per i Beni Artistici e Storici (Fig. 7)